Modern and Contemporary Art at Dartmouth:
Highlights from the Hood Museum of Art

Modern and Contemporary Art at Dartmouth: Highlights from the Hood Museum of Art

Edited by Brian P. Kennedy and Emily Shubert Burke

With an introductory essay by Emily Shubert Burke

Hood Museum of Art, Dartmouth College
Hanover, New Hampshire

University Press of New England
Hanover and London

© 2009 by the Trustees of Dartmouth College
All rights reserved

Published by
Hood Museum of Art, Dartmouth College
Hanover, NH 03755
www.hoodmuseum.dartmouth.edu
and
University Press of New England
One Court Street, Lebanon, NH 03766
www.upne.com

Modern and Contemporary Art at Dartmouth: Highlights from the Hood Museum of Art was published to coincide with an exhibition of the same title held at the Hood Museum of Art from September 26, 2009, through March 15, 2010. Some of the objects in this publication did not appear in the exhibition.

This publication and its related exhibition were organized by the Hood Museum of Art, Dartmouth College, and generously funded by Hugh Freund, '67, Margaret Fellner Hunt '78, Richard Reiss Jr. '66 and Bonnie F. Reiss P'83, Stephen A. Lister '63, Anne A. and Russell K. Mayerfeld P'08, the Homma Educational Access Fund, and the Leon C. 1927, Charles L. 1955, and Andrew J. 1984 Greenebaum Fund.

Communications and Publications Manager: Nils Nadeau
Copyeditors: Aimee Caruso and Nils Nadeau
Designer: Dean Bornstein

All object photography is by Jeffrey Nintzel except as follows: cat. 9, fig. 1, Bruce White; cat. 40, Dartmouth College Library; cat. 45 and p. vi courtesy of the Henry Fonseca Trust, Santa Fe, New Mexico; cat. 62, fig. 1, Gilcrease Museum, Tulsa, Oklahoma; cat. 64, Félix de la Concha; cat. 89, Lynton Gardiner; cat. 90, courtesy of Daniel Weinberg Gallery, Los Angeles; cats. 92 and 93, Lynn Bohannon; cat. 97 and cat. 97, fig. 1, Bruce Beasley; cat. 98, Lawrence Fane; cat. 99, David Allison, courtesy of Galerie LeLong; cat. 103, fig. 1, courtesy of Magdalene Odundo; cat. 105, Robert Wedemeyer, courtesy of Alison Saar and LA Louver Gallery, Venice, California; cat. 110, Mark Corliss; cat. 125, courtesy of Lorna Simpson; cat. 127 courtesy of Zach Feur Gallery; cat. 128, courtesy of Sara Meltzer Gallery; cat. 130, fig. 1, Jeanne-Claude; cat. 134, courtesy of Williamstown Art Conservation Center; cat. 137, fig. 1, John Bigelow Taylor, NYC; cat. 149, Lyle Peterzell; cat. 243, courtesy of George Tice; cat. 257, courtesy of Catherine Edelman Gallery; cat. 259, courtesy of Maria Magdalena Campos-Pons and Howard Yezerski Gallery; cat. 263, courtesy of Charles Cowles Gallery; cat. 264, courtesy of Renée Cox; cat. 268, courtesy of Subhankar Banerjee; cat. 275, courtesy of Edwynn Houk Gallery.

Color separations by Professional Graphics, Rockford, Illinois
Printed and bound by Tien Wah Press (PTE) Limited, Singapore

Front cover: Ellsworth Kelly, *Green-White,* 1961 (cat. 25)
© Ellsworth Kelly; EK 263.
Frontispiece: Edward Ruscha, *Standard Station, Amarillo, Texas,* 1963 (cat. 26)
Opposite the foreword: Henry Fonseca, *Coyote Woman in the City,* 1979 (cat. 45)
Back cover: Joel Shapiro, *untitled (Hood Museum of Art),* 1989–1990 (cat. 91)
© Joel Shapiro/Artists Rights Society (ARS), New York

Library of Congress Cataloging-in-Publication Data

Hood Museum of Art.
 Modern and contemporary art at Dartmouth : highlights from the Hood Museum of Art / Brian Kennedy and Emily Burke.—1st ed.
 p. cm.
 Published to coincide with an exhibition held at the Hood Museum of Art, Dartmouth College, Hanover, N.H., Sept. 26, 2009–Mar. 15, 2010.
 Includes bibliographical references and index.
 ISBN 978-1-58465-786-6 (cloth: alk. paper)—ISBN 978-1-58465-787-3 (pbk.: alk. paper)
 1. Art, Modern—20th century—Exhibitions. 2. Art, Modern—21st century—Exhibitions. 3. Art—New Hampshire—Hanover—Exhibitions. 4. Hood Museum of Art—Exhibitions. I. Kennedy, Brian P., 1961– II. Burke, Emily (Emily S.), 1979– III. Title. IV. Title: Highlights from the Hood Museum of Art.
 N6487.H3H66 2008
 709.04'00747423—dc22 2009012331

Contents

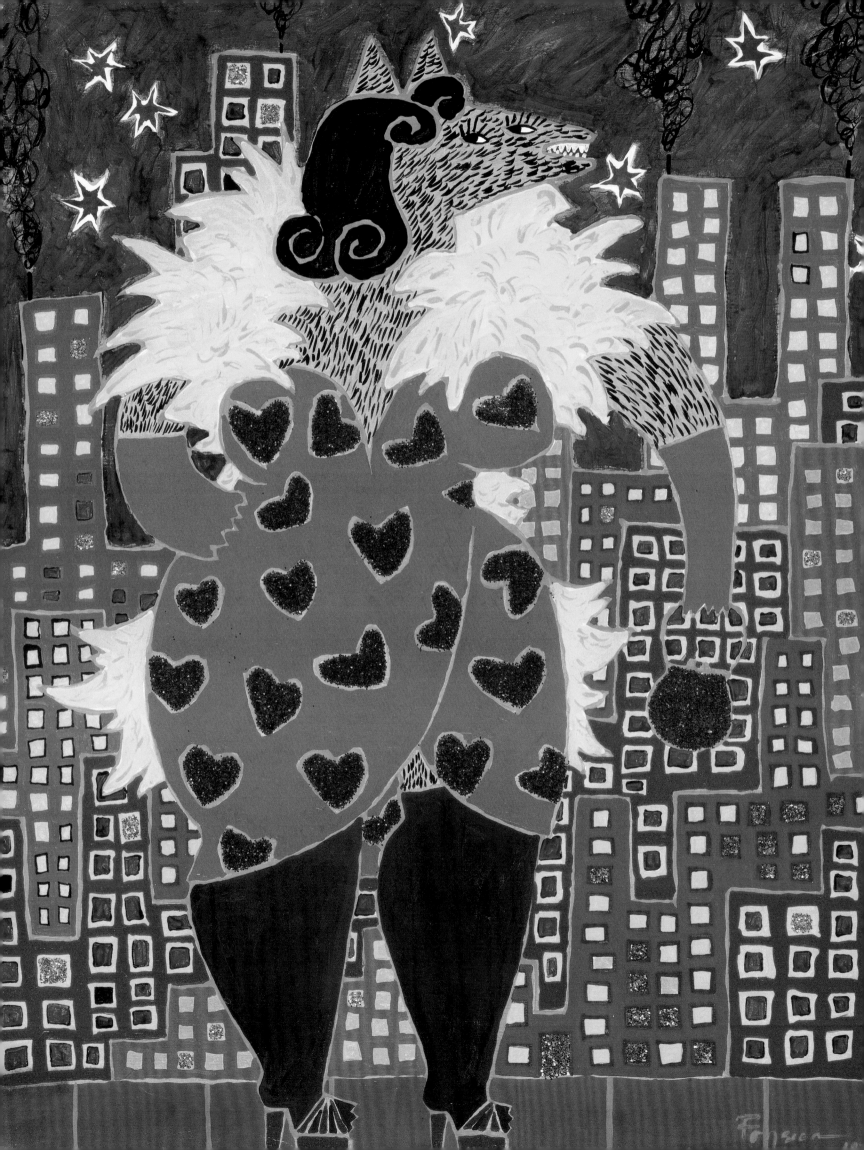

Foreword

Modern and contemporary art has long held an important position at Dartmouth, led by faculty, staff, and administrators who care deeply about the art of their time. Curricular connections have driven a number of projects, and a desire to initiate transformative moments has propelled an extraordinary legacy of art on campus. In 1930, Artemas Packard, chairman of the Art Department, and Churchill P. Lathrop, a young member of the faculty, invited José Clemente Orozco to exhibit his latest prints and drawings in Carpenter Hall. Packard and Lathrop, seeing the great potential of having an artist working on campus with students, invited Orozco back. The result was the truly remarkable mural *The Epic of American Civilization*. Following in the footsteps of Packard and Lathrop, directors of the Hopkins Center galleries and the Hood Museum of Art have prioritized bringing artists to campus to create works of art and connect with students. Most recently, Wenda Gu and Félix de la Concha have mounted ambitious projects on Dartmouth's campus, engaging the community with their timely subject matter and striking installations.

In tracing the development of the Hood's collection since the mid-twentieth century, the key to its progress has been the vision of the museum's directors. Each director has served informally as curator of contemporary art and in doing so has exerted influence over the role that contemporary art has played on the campus. Their legacies can be traced through the very objects that constitute the Hood's holdings. Over the years, our collections have grown in response to the ever-changing needs of larger and more diverse audiences, with a distinctive teaching mission guiding the museum and its interactions with the evolving academic and social communities of Dartmouth College.

The value of students being taught by professional artists was first recognized with the founding in 1905 of Dartmouth's Studio Art Department (established as the Department of Art and Archaeology, it was later designated the Visual Studies Department in 1984, and the Studio Art Department in 1990). This department's artist-in-residence program has also played an important role in bringing contemporary artists to campus. Fashioning a community of creativity, Studio Art continues to be a major driver for the arts on campus.

The construction of the Hood in 1985 physically connected the art museum's new building to the Hopkins Center for the Arts and the Studio Art Department, providing further opportunities for collaborating on contemporary art projects. The Hood's room layout, conceived classically to fit the traditional art collections of the time but with one huge soaring space for contemporary art,

quickly developed to include a frequently used study-storage center and smaller galleries devoted to contemporary art.

This book responds to the history of our modern and contemporary art holdings and looks to the future for these collections. Again, curricular connections play an important role as we meld traditional fine arts and new media, reflecting the growth of the Film and Media Studies Department (first appearing in 1988 as the Department of Drama and Film Studies, establishing its independence as the Department of Film Studies in 1992, renamed Film and TV Studies in 1999, and Film and Media Studies in 2008). In 2008, the college inaugurated the Sherman Fairchild Distinguished Professorship in Digital Humanities. This expansion of arts media will allow the Hood to broaden its exhibition opportunities and explore alternative spaces on campus.

Modern and Contemporary Art at Dartmouth is the third in a series of comprehensive exhibitions and catalogues showcasing the permanent collection of the Hood Museum of Art. Inaugurated in 2007 with *American Art at Dartmouth,* and followed by *European Art at Dartmouth* a year later, this series of projects surveys the extraordinary breadth and depth of the permanent collection and highlights key works from the holdings, only a fraction of which are on view in the museum's galleries at any one time, though many are used throughout each year for classes in the study-storage center. *Modern and Contemporary Art at Dartmouth* focuses on post-1945 painting, sculpture, works on paper, new media, and photography, but it is not a catalogue raisonné of the museum's post-1945 holdings. Rather, it is an examination of highlights, revealing the eclectic nature of our collection and the long history of modern and contemporary art on Dartmouth's campus.

As the previous two catalogues in this series have demonstrated, the American collections have grown steadily since the founding of Dartmouth College in 1769, while the European collections grew exponentially in the years following the opening of the Hood Museum proper. The objects that comprise our modern and contemporary collections were acquired serendipitously through some unique opportunities and aided by a generous base of supporters, many of whom are alumni. I thank, most of all, those who have donated works of art and funds to the museum and acknowledge the encouragement and support of Dartmouth's administration and the museum's Board of Overseers. In particular, I extend warm thanks to former President James Wright and Provost Barry Scherr. The invaluable dedication and leadership of Jonathan L. Cohen, Class of 1960, Tuck 1961, chairman of the Hood Museum of Art Board, is much appreciated. This publication was made

possible with the generous support of Hood Museum of Art Board members Hugh Freund '67 and Margaret Fellner Hunt '78, and Richard Reiss Jr. '66 and Bonnie F. Reiss P'83, also a member of the Hood Museum of Art Board. The exhibition received support from funds provided by Stephen A. Lister '63, Anne A. and Russell K. Mayerfeld P'08, the Homma Educational Access Fund, the Leon C. 1927, Charles L. 1955, and Andrew J. 1984 Greenebaum Fund, and the Daura Foundation.

Both the exhibition and publication reached fruition with the involvement of the museum's talented staff members, and I would like to echo the thanks to them expressed in the acknowledgments that follow. Two require mention here, however: Kathy Hart and Emily Burke. Kathy is now associate director and Barbara C. and Harvey P. Hood 1918 Curator of Academic Programming, but over many years she has held the torch high for modern and contemporary art, pursuing several major acquisitions and overseeing many exhibitions. We thank her for the extraordinary commitment, support, advice, and scholarship she brings to her many activities. Emily Burke, assistant curator for special projects, was employed specifically to work on *Modern and Contemporary Art at Dartmouth*. While the selection of works and the curating of the exhibition involved Kathy's and my oversight and extensive participation, this publication is largely Emily's work. From the research and writing of the insightful introductory essay and many of the entries on individual works to the organization of the entries by invited experts and multiple other tasks, Emily has done an outstanding job for which we are indebted and most appreciative.

The Hood Museum of Art, as part of a college with a predominantly undergraduate student population, strives constantly to be contemporary. Every year brings to campus fresh young minds, alive to possibility. We hope to continue to inspire, educate, and collaborate with our students, faculty, and the broader community of the Upper Valley, building on past experience and providing ever-present access to the works of the world's art practitioners, past and present, but with a special emphasis on what is happening now.

Brian P. Kennedy
Director

Acknowledgments

As the third in a series of publications, this catalogue benefited greatly from the impressive volumes that preceded it. A strongly collaborative project, *Modern and Contemporary Art at Dartmouth* is the result of much hard work at the hands of many. First and foremost, credit must be given to Director Brian P. Kennedy for undertaking this monumental endeavor, securing the financial resources needed to see this publication to fruition, and most importantly, adding his own scholarship and passion for contemporary art to the project. Also vital to this project was Katherine Hart, associate director and Barbara C. and Harvey P. Hood 1918 Curator of Academic Programming, whose dedication to guiding it from conception to completion fueled both the publication and exhibition.

Each of the Hood Museum of Art's former directors (excluding Richard Teitz, who was living abroad and unfortunately unable to contribute) volunteered their time and memories in interviews and written entries. This speaks not only to their personal loyalty to their previous home institution but also to the quality of their time at Dartmouth. That they were willing to give back so much is a testament to the unique and truly special place that is the Hood Museum of Art. Additionally, Peter Smith and Richard Stucker, respectively the previous director of the Hopkins Center and assistant director of the Hopkins Center and Hood Museum, provided us with an invaluable firsthand administrative background on the arts at Dartmouth. Varujan Boghosian, former professor of studio art, and George Shackelford, Dartmouth Class of 1977, offered the key perspectives of professor and artist, and student and museum curator.

Many other members of the Hood Museum staff also contributed to the success of this project. Juliette Bianco, assistant director, collection curators Bonnie MacAdam and Bart Thurber, and former curator Barbara Thompson offered invaluable advice and contributed important institutional history along the way. Kathleen O'Malley worked tirelessly and with unfailing good humor to organize and oversee photography for this project. Jeffrey Nintzel, Dartmouth Class of 1973, who has managed photography for the Hood since before the building opened, provided permanent collection images, a crucial contribution to this catalogue. Nils Nadeau skillfully directed the publication process, shaping a very rough manuscript into an elegant and comprehensive documentation of our modern and contemporary collections. Kellen Haak, Dartmouth Class of 1979, facilitated the conservation of a number of key works, and Deborah Haynes helped research the collection with her carefully managed records. Karen Miller organized a myriad of details and deadlines, while Patrick Dunfey created a compelling exhibition design, realized with the help of preparators John Reynolds and Matt Zayatz. Rachel Tardelli Vermeal promoted the exhibition with enthusiasm and energy, Nancy McLain carefully oversaw the financial details, and Lesley Wellman organized an effective education program for the accompanying exhibition.

Over the course of this project, a number of Dartmouth student interns and volunteers have provided us with vital support. Stephanie Trejo, Class of 2010, proved herself to be an enthusiastic and dedicated research assistant, bringing an unwavering attention to detail to the project. Elizabeth Bildner, Class of 2008, Abigail Weir, Williams College Class of 2008, and Kristine Ericson, Williams College Class of 2010, also offered assistance along the way, researching, drafting entries, and juggling the finer points of compiling the manuscript.

Dartmouth's first-rate academic community helped make this publication possible. At Rauner Library, Photographic Records Specialist Patricia Cope provided historical images for the catalogue, and Archival Specialist Barbara Krieger fielded our research queries with ease and good nature. Within the Studio Art Department, Brenda Garand, chair of the department, gave invaluable encouragement, while Gerald Auten, Director of Exhibitions and Senior Lecturer in Studio Art, assisted us with a very useful history of the artist-in-residence program at Dartmouth.

Current and former Hood Museum staff members contributed significant work to this publication, including Kristin Garcia, Katherine Hart, Mark D. Mitchell, and Barbara Thompson, as well as former directors Jan van der Marck, Jacquelynn Baas, James Cuno, Timothy Rub, Derrick Cartwright, and current director Brian P. Kennedy. Within the Dartmouth community, Professors Phoebe Wolfskill and Mary Coffey and Associate Dean Katharine Conley each added their research and perspectives. We have relied heavily on the help of scholars outside of the Dartmouth community as well. Bonnie Clearwater, Museum of Contemporary Art, North Miami; Robert Cozzolino, Pennsylvania Academy of the Fine Arts; Monroe Denton, School of Visual Arts; Emmie Donadio, Museum of Art, Middlebury College; Joseph Houston, Columbus Museum of Art; Steven Henry Madoff, Yale University School of Art; and Joseph Sanchez, Institute of American Indian Arts, generously shared their scholarship and expertise, adding a chorus of unique voices to this catalogue.

Warm gratitude is due to our designers, editors, and publishers. Special thanks go to Kristin Rose, who patiently transcribed each of the interviews conducted for this project. This publication's

polished appearance is due to the talented design skills of Dean Bornstein. University Press of New England, guided by director Mike Burton, ensured the timely production and expert handling of the many details surrounding the publication and distribution of *Modern and Contemporary Art at Dartmouth*. We also extend our thanks to ProGraphics for their meticulous prepress preparation of the catalogue's images.

We owe thanks to our generous Board of Overseers and other donors who for the last sixty years have helped to grow this collection of modern and contemporary art through countless gifts of funds and objects. These benefactors include alumni, Upper Valley residents, and national collectors. Truly this publication and accompanying exhibition are the result of a remarkable collaboration, and our gratitude extends to everyone who helped to realize them.

Emily Shubert Burke
Assistant Curator for Special Projects

Dartmouth Collects Modern and Contemporary Art, 1934–2009

Emily Shubert Burke

The importance of teaching with visual objects is nothing new at Dartmouth; in fact, its beginnings can be traced back to the school's founding president, Eleazer Wheelock, who in 1772 was collecting objects for the College's museum.[1] Modern and contemporary art has been a course topic and popular subject of exhibition for nearly a century on the Dartmouth College campus. Hand in hand with this comes a legacy of art that continually sparks debate, producing a lasting effect on the daily lives of community members. Certainly, the art of our time never fails to create transformative moments or give a healthy jolt to a relatively isolated northern New England community. With this legacy in mind, and the evolution of the arts facilities at Dartmouth having already been discussed at length in *American Art at Dartmouth* and *European Art at Dartmouth*,[2] this publication will focus on those more

recent artworks themselves, and on the story of how Dartmouth's modern and contemporary art came to be the celebrated collection it is today.

In 2005, Hood Director Brian P. Kennedy invited Chinese artist Wenda Gu to visit Dartmouth College and explore the possibility of executing an art project on campus. Two years later, Gu's huge site-specific installations *united nations: the green house* and *united nations: united colors* (figs. 1 and 2) opened in the Baker and Berry Libraries, two of the most trafficked areas on campus. Part of his ongoing global *united nations* hair monuments project, *the green house* and *united colors* comprised an expansive sculpture created with hair collected in 2006 from thousands of Dartmouth College students, faculty, staff, and Upper Connecticut River Valley community members.[3] Gu's hair sculptures allow him to investigate the contrasting tendencies of nationality and globalism. His installations at Dartmouth stimulated diverse reactions over the ensuing months, ranging from disgust and indignation to appreciation and humor. Most importantly, unlike any art exhibition in recent memory at Dartmouth, contemporary or otherwise, students and community members were inspired to react, debate, and make their feelings toward this work of art publicly known through newspaper articles, countless emails, and even a Facebook group. Grabbing national and international attention, Gu's contemporary art event energized and even transformed this highly popular location, energizing the campus.

Fig. 1. *united nations: the green house*, 2007, a site-specific installation by Wenda Gu in Baker Library main hall, Dartmouth College. Photo by Jeffrey Nintzel.

Fig. 2. Wenda Gu working on the installation of *united nations: the green house*, 2007, Baker Library, Dartmouth College. Photo by Kawakahi Amina.

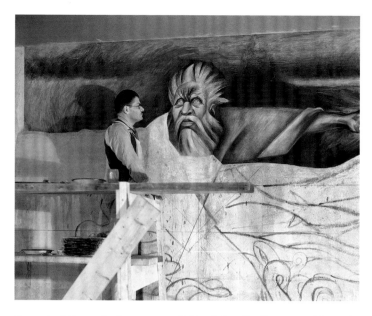

Fig. 3. José Clemente Orozco on scaffold painting *The Departure of Quetzalcoatl* in the basement of Baker Library, June 1932. Courtesy of Dartmouth College Library. Photo by Adrian N. Bouchard.

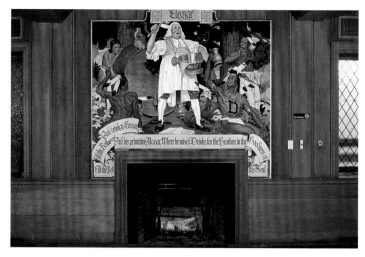

Fig. 4. Walter Beach Humphrey, *Mural Illustrating Richard Hovey's "Eleazar Wheelock"* (panel 1), 1938, oil on canvas. Commissioned by Trustees of Dartmouth College; P.939.19.1. Courtesy of Hood Museum of Art. Photo by Adrian N. Bouchard.

Yet Wenda Gu's *united nations* is not the first instance of such challenging art events at Dartmouth. It is merely the latest in a long history of projects both within the confines of the gallery walls and elsewhere around campus that were designed to allow students to interact with the art of their time and spark dialogue. In fact, the experience of Gu's transgressive project eerily parallels the events surrounding José Clemente Orozco's mural series *The Epic of American Civilization* (fig. 3), executed in Baker Library in 1934. *Boston Sunday Post* critic John F. Coggswell summarized the reaction to Orozco's counter-establishment vision of the development of North America in 1934:

Hardly had José Clemente Orozco swung his brush in its last sweeping stroke and affixed to the finished production his signature and the date, which was late last February, before the altercation broke out. An alumnus, of a class way back in the early '90s, saw a photographic reproduction of some of the panels of the fresco . . . There being no chance to pass a law about it, he did the next best thing—wrote a letter to a newspaper, an epistle filled with recrimination, opprobrium, condemnation, and many near cuss words . . . Another alumnus took up the cudgel on behalf of the paintings, and advised the original protestor to keep his shirt on and not get all het up . . . And that's just about the way the brain-child of José Clemente Orozco affects the more excitable of those who view it; they're either strong for it or consider it a blot upon an otherwise attractive building. Of course, there are those, too, who look upon the work, grin a bit or gape a bit and pass on unmoved to praise or vituperation.[4]

Coggswell's description of the 1934 reactions to Orozco's murals resonate all too well with the response to Gu's installation seventy-three years later. Contemporary art projects at Dartmouth have indeed stimulated the exchange of ideas, transformed spaces, and left a lasting mark upon their viewers.

Orozco's murals provoked a diametrically opposed response to them in the form of another mural, painted just a few years later. In the mid-1930s American illustrator Walter Beach Humphrey, Dartmouth Class of 1914, proposed painting a series of murals (fig. 4) in Thayer Hall to illustrate the College drinking song "The Song of Eleazor Wheelock," written by Richard Hovey, Dartmouth Class of 1885. This Dartmouth-centered mural cycle was designed to stand in direct contrast to the recently completed and politically divisive murals by Orozco in Baker Library. Hovey's mural shows Eleazar Wheelock, the founder of Dartmouth College, bringing "five hundred gallons" of rum into the New England woods and serving it to Native Americans.

With the beginning of the Native American Program, Native American Studies, and coeducation in the early 1970s, the murals (along with the Dartmouth Indian mascot) came under increased scrutiny, causing widespread debate on campus. Their controversial depiction of drunken Native Americans and half-clothed women (one of whom reads a book upside down) offended many and caused the College administration to limit access to the artwork. Beginning in 1983 and continuing for a decade, they were covered, to be unveiled only for commencement and reunions. In 1992, Michael Dorris, the chairman of Native American Studies at Dartmouth, spoke to a group of students, faculty, and scholars at the conclusion of a conference held on the five hundredth anniversary of Columbus's landfall in America. He spoke about Dartmouth's original charter and the mythologizing of the school's history of educating "Indian youth," in turn relating the murals to that history. In response to the accusation that the murals had been censored, he replied that like any work in a museum's vault, they should be brought out for viewing and discussion. The Native American Council, asked to reconsider the murals and their status, recommended uncovering them for educational purposes, and since then this has been done, for example to accommodate a

recent first-year seminar on the Hovey and Orozco murals and their intertwined histories. Once again, a contemporary and site-specific public work repeatedly raised important discussions around campus.

This tradition of contemporary art as an instigator for dialogue, conflict, and transformative moments can be traced from the time of Orozco's murals to today, primarily through the collections that reside within the Hood Museum of Art. Yet this legacy also lives on through the works of art displayed around Dartmouth's campus, the nearly one hundred years of exhibitions that have highlighted the value of the art of their time, the support for modern and contemporary art from generous alumni and the museum's Board of Overseers, and the dedicated attention of both gallery and museum directors, who have guided all related acquisitions and programming.

The Early Years of Modern and Contemporary Art on Campus

We were brash and liked the kind of contemporary art which created an interest among the students. I am most proud of the fact that I introduced a large number of the Dartmouth graduates to the value of art as a lifetime enjoyment. Not many of the students were going to be professionally involved with the arts after graduation (although quite a few have become art collectors and museum directors). I feel the College and the galleries have a responsibility toward any alumni who are active in art, whether they be artists or teachers.[5]

— Jerry Lathrop

Jerry was a real champion of contemporary art at that time and so the collection was pretty strong in twentieth-century art . . . Jerry was an eloquent defender of Orozco and contemporary art right up until the time he died. He was very strong in that way, so I think contemporary art always had its defenders on campus.[6]

— Jacquelynn Baas

A passionate advocate of modern and contemporary art, Churchill Lathrop came to Dartmouth in 1928 as a young instructor of art with an interest in contemporary art (fig. 5). Jerry, as he was affectionately called, remained at the College until 1969 as a professor and as director of the art galleries, a position he had accepted in 1934.[7] In 1928, with the help of a grant from the Carnegie Corporation, Lathrop founded what would become the Sherman Art Library, and in 1932, with the help of Art History Department Chair Artemas Packard, he initiated Dartmouth's artist-in-residence program.[8]

Galleries for the display of art were first opened in Carpenter Hall, the location of the Art Department, in 1929 (fig. 6). Lathrop described the times: "We were brash and liked the kind of contemporary art which created an interest among the students. We exhibited cubism, surrealism, and impressionism, which was

Fig. 5. Churchill "Jerry" Lathrop, Director of Carpenter Hall Galleries, 1933–66. Courtesy of Dartmouth College Library. Photo by Adrian N. Bouchard.

Fig. 6. Carpenter Hall Galleries, 1950. Courtesy of Dartmouth College Library. Photo by Adrian N. Bouchard.

gathering interest around the country: however, there was very little contemporary American art exhibited in the early '30's."[9] It was Packard and Lathrop who initially invited Orozco to come to Dartmouth, a scheme that more than met its goal of confronting students with the art of their own time and resulted in a work that has had an enduring impact on a relatively quiet and rural campus.

Dartmouth's Art Department had been teaching "modern art" since 1905, when Homer Eaton Keyes, Class of 1900, was appointed assistant professor of the subject. Lathrop described Keyes's approach to art history with great admiration: "His point of view was a broad humanistic one, seeing art as a natural part of a full life, as a useful aid to discrimination, vision, wit and human understanding."[10] Following closely in Keyes's footsteps was George Breed Zug, professor of modern art from 1913 to 1932, who added

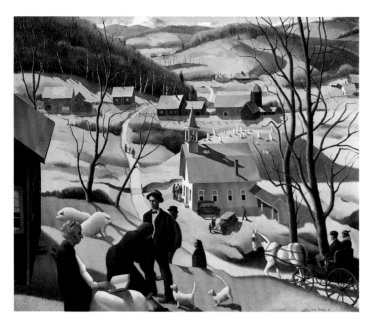

Fig. 7. Paul Starrett Sample, *Beaver Meadow*, 1939, oil on canvas. Gift of the artist, Class of 1920, in memory of his brother, Donald M. Sample, Class of 1921; P.943.126.1. Photo by Jeffrey Nintzel.

classes in art history and criticism, photography, and the graphic arts.

Further engaging students with contemporary art was the artist-in-residence program, which began in 1929 at the behest of Lathrop and a number of students who wanted to study studio art. At the time there were only instructors of art history, and studio activities had no academic standing, nor could they receive academic credit. President Hopkins tapped a discretionary tutorial fund recently given to the College by Mr. John D. and Mrs. Abby Aldrich Rockefeller Jr., whose son, Nelson Aldrich Rockefeller, had just won a senior fellowship and elected to spend his entire senior year (1929–30) studying art history intensively in Carpenter Hall.[11] This provided the monies for Carlos Sanchez, a Dartmouth graduate of the Class of 1923 and a rising young painter, to coach students and practice his own art in the Carpenter Studios from 1931 to 1933. Orozco soon followed with his own two-year stay, during which he exposed students to the complex process of mural painting in fresco and created *The Epic of American Civilization*.

In the late 1930s the program was born officially when painter Paul Sample (fig. 7) was given a lifetime appointment as full professor and artist-in-residence at the College. The residency took its current structure in the fall of 1962, after the completion of the Hopkins Center, which included space for both the creation and exhibition of the artist-in-residence's art. On campus for the entire ten-week term, these artists would exhibit their art in the gallery, work in the studio, and interact with students and community members, thereby exposing students to the life and practice of contemporary artists. Joseph Albers (cat. 23), Buckminster Fuller, Robert Rauschenberg (cat. 163), Walker Evans (cat. 239), Judy Pfaff (cat. 183), Alison Saar (cat. 105), and Magdalene Odundo

(cat. 103) are just a few of the artists who have participated since the program's inception. (See the back matter for a complete list.)

The energetic momentum for the arts created by Orozco's presence and the artist-in-residence program was disrupted by the entry of the United States into war in 1941. As Jerry Lathrop explained, "During World War II, 1941–1946, Dartmouth was primarily a training institution for U.S. Navy and Marine officers and cadets. There were still a few civilians at the College and instruction in art did not entirely cease, but the art faculty put its major time and effort into teaching Naval History, Military Map Making, or Physics."[12] Yet the postwar boom at Dartmouth allowed for a record number of students to enroll in art history classes, an expansion of the art faculty, and a wider range of art courses available for academic credit.

As director of the art gallery, Lathrop sought to encourage students and community members to engage with the art of their time in a number of ways, and he realized that he had to reach outside the gallery walls to connect with his audiences. In 1958, at the behest of Lathrop, Dartmouth began to take part in an experimental program through the International Graphic Arts Society (IGAS), a nonprofit based in New York that was devoted to "fostering the development, understanding, knowledge, and appreciation of the graphic arts," and through the support of the Rockefeller Foundation.[13] The IGAS collection of contemporary American, European, and Japanese prints was then rented out to students, faculty, and staff for the academic year, allowing for modern and contemporary art to be a part of the daily lives of campus community members.

The 1960s and the Hopkins Center

In summary, it is apparent that both our Art Department and our Art Collection have passed their spindling youth and are now of age. Both are entering, in the 1960s, into a period of lusty growth and experimental exploration.[14]

— Jerry Lathrop, 1960

The inauguration of the Hopkins Center for the Arts in 1962 embodied the "lusty growth and experimental exploration" that Lathrop predicted, as the existing facilities for the exhibition of art at Dartmouth doubled in size. Yet the building itself also stood as a work of modern art in the midst of a campus that was relatively homogenous architecturally, injecting art in and of itself into the everyday life of the college. Wallace K. Harrison, the internationally renowned architect of the Hopkins Center, and his wife, Ellen, demonstrated their belief in the art of their time by donating over 140 works of modern art anonymously and in honor of their lifelong friend and fellow collector Nelson Rockefeller, Dartmouth Class of 1930.[15] By placing Dartmouth's post office as well as classrooms and a snack bar within the Hopkins Center, students had no choice but to walk through the modernist building and

Fig. 8. Hans Hofmann, *Summer*, 1949, oil on paper mounted on canvas. Gift of Remsen M. Kinne III, Class of 1952; P.991.19.1. Photo by Jeffrey Nintzel.

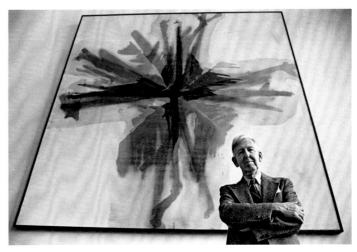

Fig. 9. Churchill "Jerry" Lathrop, Director of Carpenter Hall Galleries, 1933–66, with one of his "collections," Kenneth Noland's *Shallows*. Courtesy of Dartmouth College Library. Photo by Adrian N. Bouchard.

experience Dartmouth's attempt at a confluence of the arts. It is not insignificant that the Hopkins Center's Beaumont-May Gallery opened with an exhibition of paintings by Hans Hofmann (fig. 8), an artist who also served as a dynamic speaker on abstract painting at the celebration of the building's opening, the Convocation of the Arts. Modern and contemporary art was a principal component of the Hopkins Center's mission and plainly visible in its public face.

Following the opening of the Hopkins Center, its Jaffe-Freide and Beaumont-May Galleries continued to prominently feature exhibitions of modern and contemporary art, in part due to the artist-in-residence program. Jerry Lathrop and curator Ellen Mary Jones organized solo shows highlighting artists such as Paul Sample, Tal Streeter, Frank Stella (cat. 180), Alice Neel (cat. 36), Thomas George (cat. 151), Ilse Bischoff, and George Tooker (cat. 34), providing opportunities for the acquisition of works directly from the exhibitions. The majority of all acquisitions, however, continued to arise from the generous gifts of many Dartmouth alumni, who supported the arts program. Almost from the beginning of the Carpenter Gallery, one of the most crucial endowments for the acquisition of modern and contemporary art was a fund established in October 1940 by Julia Whittier, the daughter of longtime Dartmouth Professor of Intellectual and Moral Philosophy and Political Economy Clement Long; the fund continues to support acquisitions to this day.[16]

As Hood Curator of European Art Bart Thurber discussed at length in his exhibition catalogue *European Art at Dartmouth,* Evelyn and William B. Jaffe, Class of 1964H and parents of three Dartmouth students, proved to be key allies in increasing the role of the visual arts on the campus. The couple donated a number of modernist works to the permanent collection, sponsored the Jaffe-Friede Gallery in the Hopkins Center, and established a purchase fund that continues to allow for the acquisition of many modern

and contemporary works of art; their legacy is so great, in fact, that when the Hood Museum of Art was later built, the William B. Jaffe and Evelyn A. Jaffe Hall Galleries were named in their honor. A benefactor of both the Metropolitan Museum of Art and the Museum of Modern Art, New York, William Jaffe, as the first chairman of the Hopkins Center Art Advisory Committee (formed in 1960), was instrumental in bringing other prominent art world figures into the fold as supporters for the arts at Dartmouth, including Alfred H. Barr and Dominique de Menil.[17]

An unwavering advocate for the art of his time, Lathrop was incredibly effective in initiating and sustaining another important relationship that continues to nurture contemporary art acquisitions at the Hood Museum of Art today. In 1960, Lathrop was introduced to William Rubin, chief curator and director of the Painting and Sculpture Department at the Museum of Modern Art, New York, when a former student of Lathrop's, Bertram Geller, Class of 1937, was in the process of selling Jackson Pollock's *Mural on Indian Red Ground,* 1950, to Rubin. As part of the transaction, the Geller Fund was formed to provide support for the acquisition of works of art for the College's collection. Rubin admired the level of Dartmouth's commitment to the arts, as shown by the building of the Hopkins Center and its visual arts galleries and activities, later writing, "I have a soft spot in my heart for Dartmouth's art program."[18] Attempting to encourage the further development of the Hopkins Center, Rubin loaned three paintings each summer from 1961 to 1971 for exhibition in the Carpenter Art Galleries and the Hopkins Center Art Galleries. These works, prized pieces from his own personal collection, included paintings by Jackson Pollock, Franz Kline, Adolph Gottlieb, Barnett Newman, and Clyfford Still.

In an extraordinary legacy of giving, Rubin would go on to donate to Dartmouth such monumental modernist works as Mark Rothko's *Lilac and Orange over Ivory* (cat. 8) and Kenneth Noland's

Shallows (cat. 18; fig. 9). In 1973, when Rubin sold the Pollock he had bought from Bertram Geller, he voluntarily assigned a portion of the profit to the College, and an endowment fund was established in his name. Since its inception, the William S. Rubin Fund has provided for the acquisition of more than seventy works of art, mostly modern and contemporary.

Julian J. and Joachim Jean Aberbach were also considerable supporters of the arts program, beginning in 1958. The brothers were owners of the Aberbach Fine Art Gallery in New York City and, as representatives of twentieth-century European artists such as Bernard Buffet, took an interest in the exhibitions at Dartmouth that featured the work of their artists. Over the next twenty years, the Aberbachs would go on to donate an incredible array of modern and contemporary paintings, including Ellsworth Kelly's *Green-White* (cat. 25), Alex Katz's *Supper* (cat. 44), Fernando Botero's *The Butcher Table (La Mesa del Carnicero); Still Life with Pig's Head* (cat. 37), and Jean Dubuffet's *Topography with a Nest of Stones (Topographie au nid de pierres)* (cat. 108). Similarly, Herbert G. Swarzman, Class of 1958, wrote to Jerry Lathrop about giving several works of art, with "the intent to make donations of prints by 'current artists.'"[19] This overture would ultimately result in a significant gift of contemporary prints by Robert Morris, Donald Judd, and Jasper Johns, among others.

Jerry Lathrop retired in 1969 and was replaced by Truman Brackett, one of his former Dartmouth students and the assistant director of the galleries from 1962 to 1966, acting director from 1966 to 1968, and director of the Hopkins Center Galleries from 1968 to 1973. In 1970, Brackett organized the landmark exhibition *The Protean Century, 1870–1970: A Loan Exhibition from the Dartmouth College Collection, Alumni and Friends of the College* at M. Knoedler & Company, Inc., in New York. Brackett stated emphatically, "That we did not solicit loans for the exhibition from a larger number of alumni and friends can be attributed to limitations imposed by the available space, and more significantly, our desire to include selections from the Dartmouth College Collection to suggest something of the strength upon which we seek to build."[20] *The Protean Century* examined a critical one-hundred-year period in the visual arts while demonstrating both the strength and the needs of the arts program at Dartmouth, in the process celebrating its advocates and encouraging others to offer their further support through financial and art donations. The organization of and events surrounding *The Protean Century* marked a turning point in the promotion and prominence of Dartmouth's collection, not only among alumni but also in the center of the art world at the time, New York City.

The Jan van der Marck Years

Well, there was the di Suvero controversy. There was the Beverly Pepper controversy. There was a mild Nonas controversy. The reason of it all was the campus being considered common property and you cannot invade that . . . The fight at Dartmouth was always with art on the campus, but it really is the old fight between nature and culture.[21]

— Jan van der Marck

The fall of 1974 proved to be an important moment for contemporary art at Dartmouth. On September 1 of that year, what was formerly called the Hopkins Center Art Galleries and the College Museum came to be known as the Dartmouth College Galleries and Collections, marking a shift toward independence for the galleries from the Hopkins Center. This day also marked the arrival of Jan van der Marck as director of the galleries. Van der Marck, an activist curator and museum professional who had previously worked at the Museum of Contemporary Art in Chicago and had participated in environmental artist Christo's *Valley Curtain Project,* differed in background from the art historians who had directed the galleries before him. With an international perspective on contemporary art, van der Marck brought an ambitious, bold exhibitions and acquisitions program to Dartmouth, particularly marked by the installation of a number of outdoor sculptures around campus. Like his predecessor Jerry Lathrop, van der Marck believed it was imperative for students to be confronted with the art of their time in their everyday lives, and public sculpture emerged as the primary vehicle for accomplishing this educational goal.

In the fall of 1976, van der Marck oversaw the installation of *X-Delta* (cat. 75), a monumental sculpture by Mark di Suvero gifted by Kent Klineman, Class of 1954, an attorney and art collector from New York. *X-Delta* was first placed on the lawn in front of Sanborn Library, stirring controversy among the students, faculty, and community members who failed to see any aesthetic merit in the work (fig. 10). Once again, parallels were made between the appearance of Orozco's murals on the walls of Baker Library four decades before, the reactions that erupted from their unveiling, and the problems with the placement of di Suvero's iron I-beam sculpture in the midst of a highly traveled section of campus. These reactions included sending countless letters to the editor, publishing articles in the school and local newspapers, printing and wearing t-shirts of support, and even building a spoof of the sculpture from trash and "installing" it on the green (fig. 11). Over the course of the next ten years, *X-Delta* would be re-sited twice more, and stories of moving the sculpture in the dead of night have become a permanent part of the lore of contemporary art at Dartmouth.

While van der Marck was defending the placement of di Suvero's sculpture on campus, he was also working with sculptor Beverly Pepper on a commission for another site-specific work (fig. 12).[22] With the help of grants from both the National Endow-

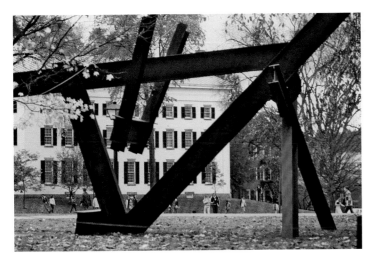

Fig. 10. Mark di Suvero, *X-Delta,* 1970, iron, steel, wood. Gift of Hedy and Kent M. Klineman, Class of 1954; S.976.72. Here the sculpture is situated on the green in front of Baker Library and next to Sanborn Hall in 1976. Courtesy of Dartmouth College Library. Photo by Adrian N. Bouchard.

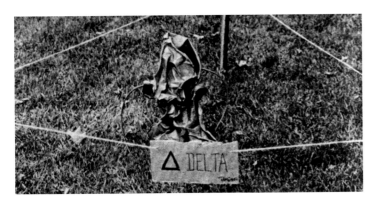

Fig. 11. *X-Delta* parody, 1976, anonymously posted on the Baker Library lawn. Courtesy of the "Dartmouth Newsletter." Photo by Duane Peterson.

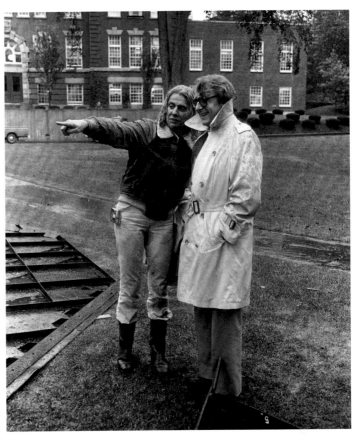

Fig. 12. Director of the Museum and Galleries of Dartmouth College Jan van der Marck and sculptor Beverly Pepper on the future site of *Thel*, 1977. Courtesy of Jan van der Marck.

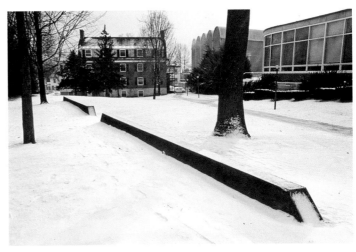

Fig. 13. Richard Nonas, *Telemark Shortline*, 1976, Georgia oak. Gift of Holly and Horace Solomon; S.976.1. Courtesy of Dartmouth College Library. Photo by Adrian N. Bouchard.

ment for the Arts and the Fairchild Foundation, Beverly Pepper designed and built *Thel* (cat. 82) in front of Sherman Fairchild Physical Sciences Center from 1975 to 1977. Like di Suvero's installation, the 135-foot steel sculpture was met with both appreciation and disdain. A deciding factor influencing its acceptance, however, was its dedication by Joan Mondale, wife of U.S. Vice-President Walter Mondale and honorary chairwoman of the Federal Council of the Arts and Humanities. *Thel* was inaugurated with a sense of fanfare and propriety that placed it in a more professionalized light than *X-Delta* had been, or perhaps, in fact, the campus had been prepared by di Suvero's sculpture and was now better equipped to respond to another contemporary work in its midst.

Only a few months after *Thel* was commissioned, van der Marck asked Richard Nonas to install one of his trademark minimalist sculptures on the lawn between Hopkins Center and Wilson Hall (the future location of the Hood Museum of Art; fig. 13). *Telemark Shortline* (cat. 84), composed of two wooden beams placed directly on the ground, soon became a popular bench of sorts and blend-

ed more seamlessly into the everyday life on Dartmouth's campus than *X-Delta* or *Thel* had been able to. Building further upon his desire to have students interact with contemporary art, van der Marck taught courses in this subject through the Art Department. His students included Maxwell Anderson and George Shackelford, two interns whose experiences working with van der Marck

(and passion for art) would help lead them to their own successful careers in the art museum world. Shackelford later described his experience with the arts at Dartmouth in the late 1970s:

It was an institution with a collection but without a museum and Jan, it strikes me, was the first person to come to think that in fact the College could have something that would be like a museum. As a result, he took steps to try to professionalize the staff . . . In terms of modern and contemporary manifestations, I would point out, really, two things. One was Jan's Herbert Bayer exhibition, *Herbert Bayer: From Type to Landscape*, in 1977 [fig. 14], which was extraordinary and so beyond the understanding of almost everybody who came to see it. You know, it's a show that probably should have been at MoMA instead, but there it was at Dartmouth. Jan had this ambition to shake things up and to move beyond the expectations of the ordinary in the Upper Valley community . . . The second thing I would particularly highlight was the presentation of Jennifer Bartlett's *Rhapsody* in the Jaffe-Friede Gallery. It was just amazing to have this big hot-off-the-press piece—literally straight from SoHo to Hanover—something that didn't happen very often at many college museums.[23]

In part, what made these rather controversial sculpture installations around campus possible again and again, despite opposition from the community, was an administration that was quite supportive of the arts. Peter Smith, director of the Hopkins Center from 1969 to 1981, and Richard Stucker, assistant director of the Hopkins Center from 1975 to 1980 and again from 1985 to 1987, and assistant director of the Hopkins Center and Hood Museum from 1980 to 1985, were both particularly encouraging with regard to an arts program that included contemporary art.[24] Leading the Hopkins Center at a time when its very presence on campus excited a certain amount of energy for the arts, Peter Smith reported directly to Provost Leonard Reiser, another advocate for the arts. Living up to the potential of the relatively new arts center and raising the profile of the arts on campus required an incredibly supportive and trusting administration, as Smith explained:

I think perhaps the broadest statement is that I was encouraged by, first of all, President Dickey, by Leonard Rieser as provost and dean of faculty, and, to the extent that he came into the picture because he wanted to, by John Kemeny [Dartmouth president from 1970 to 1981] as well. I think it's fair to say that I was made to feel that my role at Dartmouth as director of the Hopkins Center should be as close as it was sensible to make it to the role of the director of athletics. I saw it as my job to make the activities that were housed in the Hopkins Center as much a part of the life of as many students as possible as the gym and the field house were also parts of the lives of students.[25]

With the consistent backing of Dartmouth's presidents, provosts, and deans, projects such as the installation of Mark di Suvero's or Beverly Pepper's sculptures were ultimately made possible on campus. Jerry Lathrop, first director of the galleries but also a full professor in the Art Department, straddled both the academic

Fig. 14. Installation view of a sculpture in the exhibition *Herbert Bayer: From Type to Landscape*, Hopkins Center Galleries, 1977. Photo courtesy of the Hood Museum of Art.

and gallery worlds, and his successor, Truman Brackett, was able to do the same. At times, however, Jan van der Marck's status as a museum professional first and a part-time professor second, combined with his rather avant-garde artistic tastes, would result in clashes with the then more conservative Art Department, causing friction with the faculty and administration.

Beyond placing contemporary art around campus, van der Marck was also instrumental in bringing a pivotal collection of Fluxus art to Dartmouth. In 1978 he organized *Fluxus: A Tribute to George Maciunas,* an exhibition of several dozen works honoring the founder of the Fluxus movement that included gifts that would come to form the George Maciunas Memorial Collection (fig. 15). Fluxus, a little known (and little understood) art movement in New York and throughout Europe in the early 1960s, is most closely related to Dada in its anti-art philosophy. The Hood Museum of Art now holds one of the more important collections of works from this movement, thanks to van der Marck's personal

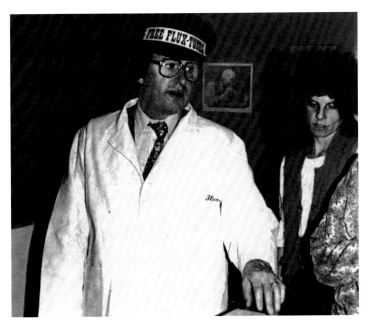

Fig. 15. Jan van der Marck, Director of the Museums and Galleries of Dartmouth College, giving a "Flux-tour" of the exhibition *Fluxus: A Tribute to George Maciunas*, 1978. Courtesy of the "Dartmouth Newsletter." Photo by Bruce Goodman.

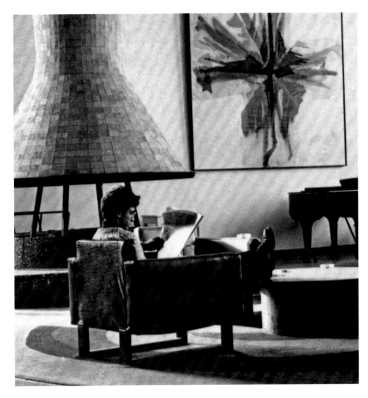

Fig. 16. Student sitting at the Top of the Hop with Kenneth Noland's *Shallows* in the background, Hopkins Center for the Arts, 1978. Photo courtesy of Aegis.

relationships with the artists and his push to invite them to donate generously in memory of Fluxus's founder, Maciunas, who died in 1978.

As funding for modern and contemporary acquisitions was severely limited, additions to the permanent collection were nearly all opportunistic. Unable to seek a comprehensive or encyclopedic collection in prints, painting, sculptures, or works on paper in the early years, administrators and curators of the galleries and museum developed an eclectic collection based largely on alumni gifts. Van der Marck began his tenure at Dartmouth having important relationships already in place with a number of contemporary art dealers in New York, including Leo Castelli, the Aberbachs, the Sonnabends, and Holly Solomon, which led to gifts from the dealers themselves as well as connections with their collectors, who were encouraged to donate to Dartmouth. Such friendships resulted in gifts of, for example, Ronald Davis's *Three Box-G* (cat. 116), Dan Flavin's *untitled (to Elita and her baby, Cintra)* (cat. 76), and Richard Nonas's *Telemark Shortline* (cat. 84).

A further key acquisition came from alumnus James Meeker, Class of 1958, in memory of Lee English, also a member of the Class of 1958 and a fellow Texan and close friend. In 1976, Meeker donated Ed Ruscha's *Standard Station, Amarillo, Texas*, 1963 (cat. 26), a painting that would become a cornerstone of the Hood Museum of Art's permanent collections. Meeker tells fond stories of driving around the campus green and spotting *Standard Station* (and other contemporary works) spectacularly lit in the Top of the Hop, the dramatic public second-floor space in the modernist Hopkins Center (fig. 16).

In addition to bringing international and art-world stars to Dartmouth, the programming of the galleries (and the Hood Museum of Art) has long supported and promoted the work of local artists. Beginning in 1947 and lasting for twenty years, the Dartmouth Galleries and Carpenter Galleries held an annual exhibition featuring members of the New Hampshire Art Association and, later, any artist who lived within a fifty-mile radius of Hanover. In 1976, the tradition was reinvigorated through the initiation of the juried *Regional Selections* exhibitions series. An annual show of fine arts assembled from artists in Vermont and New Hampshire, *Regional Selections* came to be a way for the Hood Museum of Art to connect with its local communities, and it would continue biannually through 1996 when the model was reconceived and began to include guest curators. Jan van der Marck explained the series he initiated:

We had every year a regional exhibition, because I feel if you operate in a particular cultural environment, one that is somewhat isolated, you know, [such as] the Hanover area, you ought to at least look at what artists in the region were doing. And with so many teaching institutions, inevitably there were so many practicing artists who were also teachers, who would like to see their stuff shown. And so these regional exhibitions drew a great talent from the area. I was fascinated by what I found. I visited studios in the area and artists came to me, and so the regionals really were important to me.[26]

Van der Marck's activist nature and dedication to "pushing the envelope," particularly through contemporary art that challenged its audience, was not always well received on campus. In 1980, the

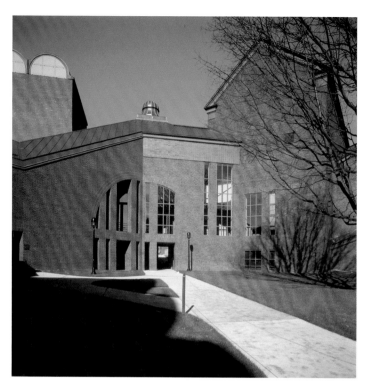

Fig. 17. Hood Museum of Art, opened 1985, Charles Moore and Chad Floyd, architects. Photo by the Hood Museum of Art.

director would move on to become the founding director of the Center for Fine Arts in Miami (now the Miami Art Museum). Yet he left an important legacy of bringing contemporary art to Dartmouth, moving art outside the walls of its galleries, requiring the community to engage with the art of their time on a daily basis, and promoting a basic educational mission as the driving force behind the galleries' every action. In his time Dartmouth received an unprecedented number of modern and contemporary works, and his international curatorial perspective and expertise brought the College's galleries to a new level of professionalism and prestige.

The Hood Museum of Art: "A Gymnasium of Perception"

Jan van der Marck had so softened everybody up [to contemporary art on campus]! He was showing really radical stuff for that era . . . One of the things that I want to emphasize—something I think in recent years has become even stronger—is the Dartmouth philosophy of bringing artists to campus, starting with Orozco. Because it's not just confronting students with contemporary art, it's bringing students into contact with artists, actual working artists. That is an essential part of the equation . . . You really can't separate the art from the artists. I think what's important for students is to have the experience of both, because unless you have the opportunity to speak with and learn from artists, you aren't going to really understand where the art's coming from.[27] —Jacquelynn Baas

Due in part to van der Marck's sometimes divisive projects, the Dartmouth galleries initially adopted a more introverted philosophy and planned less contemporary art programming in the years

following his departure. It was an interesting time for the art galleries on campus nevertheless, as talk of their expansion increased and support for the arts flourished within the administration. In 1976, Peter Smith, director of the Hopkins Center, wrote of the need for a new facility "devoted to the exhibition and contemplation of works of art . . . to teach students the kind of connoisseurship and visual discrimination which can make the crucial difference for artist and art historian alike, as well as for the future patron, collector, critic, trustee or curator."[28] The primary funders for the newly planned fine arts museum were Barbara C. and Harvey P. Hood, Dartmouth Class of 1918, member of the College's Board of Trustees from 1941 to 1967, and advisor to two College presidents; Ernest Martin Hopkins, for whom the Hopkins Center is named; and John Sloan Dickey, who was largely responsible for the concept of the Hopkins Center at Dartmouth. Barbara carefully implemented her husband's ultimate bequest, and several members of the Hood family continue to be avid supporters of the museum today. The Hood Museum of Art (fig. 17) featured a study center, teaching and research-oriented galleries and storage spaces, and a gallery, designed specifically with the exhibition of contemporary art in mind, that was named in honor of Churchill P. Lathrop.

After an exhaustive search for a director of the galleries that lasted more than a year and a half (during which time Richard Stucker served as acting director), Richard Teitz was hired. An art historian and the former director of the Worcester Art Museum, Teitz was director of the galleries and the first director of the Hood Museum of Art from August 1, 1981, to March 1984. During this transition time for both the buildings and the institutions, Teitz's main focus was on fundraising for the future Hood Museum of Art. In the years leading up to the opening of the Hood, a number of key donors began relationships with the institution. Hugh Freund, Class of 1967, wrote a letter to Teitz in 1981, introducing himself and offering to share his collection: "Over the past seven years I have collected contemporary art and sculpture, Amish quilts, American furniture, and folk art."[29] Since that time, Freund has donated nearly sixty works of modern and contemporary art, demonstrating a notably strong commitment to the work of minimalists and women artists, including Karin Davie (cat. 58), Ellen Gallagher (cat. 219), and Donald Sultan (cat. 178), among many others.

A. Marvin Braverman, Class of 1929 and a member of the Alumni Council, was another collector motivated to donate to Dartmouth by the planning for the Hood Museum of Art. In 1982, he wrote to Teitz, "In the meantime, I think about the new museum and wonder if those associated with it would like the sculpture in my house."[30] Braverman went on to bequeath ten postwar British sculptures to the Hood, creating a unique pocket in the collection of important international artists such as Lynn Chadwick (cat. 68), Kenneth Armitage (cat. 66), and Reg Butler (cat. 67). In May 1984, Miriam and Sidney Stoneman, Class of 1933 and

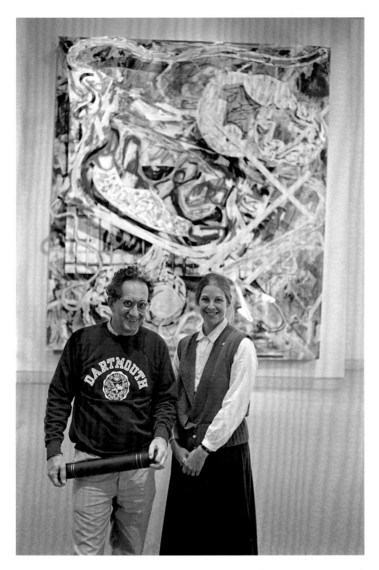

Fig. 18. Artist-in-residence Frank Stella and Director of the Hood Museum of Art Jacquelynn Baas in front of his work of art *Shreds* in the Lathrop Gallery, 1985. Courtesy of the Dartmouth College Library. Photo by Stuart Bratesman.

Director in March 1985. The building, designed by Charles Moore and Chad Floyd of Centerbrook Architects, is a post-modernist work of art in and of itself, and contemporary art lay at its heart. The building plans called for not only the Lathrop Gallery, with its soaring ceilings designed specifically to accommodate large contemporary paintings and sculpture, but also an area at the entrance courtyard to the museum that included space reserved for the commissioning of a significant sculpture.

Marking the inauguration of the Hood in 1985, painter Frank Stella was honored with Dartmouth's doctoral degree and asked to deliver the school's convocation speech. Having made his "Dartmouth Series" while artist-in-residence during the summer months of 1963, following the opening of the Hopkins Center, Stella now found himself addressing the student body as the Hood Museum of Art opened for the first time (fig. 18). Highlighting the importance of both a proper exhibition space for works of art and the opportunity for academic and artistic scholarship to occur within the campus community, Stella argued:

I'm sure I'm here today to agree that we all agree that a university must have an art museum. It seems too that we would all agree that the museum is as much a necessary educational tool as it is a natural and desirable expression of our culture . . . There is no question that visual education has become an important part of our educational philosophy. We know we have to see to think. We know we have to use all of our senses to understand our experience and expand our knowledge. In the context of a university where these self-evident truths are put into practice every day, I want to make a special plea for the support of a special institution—the university art museum, the gymnasium of perception.[31]

Stella explicitly outlined the mission of the Hood Museum of Art to provide the space and the opportunity for engagement with works of art by members of the Dartmouth and local communities, a mission that would drive the institution for years to come.

Baas, an art historian with a specialty in nineteenth-century art, was already interested in contemporary art, but she found that interest notably furthered by her time at Dartmouth. In order to invigorate the arts on campus, Baas built upon two legacies of contemporary art that had met with resistance at their beginnings: the Orozco murals and the George Maciunas Collection. She arrived at the Hood in time for the fiftieth anniversary of the Orozco murals, an occasion that was much celebrated in contrast to the sentiment evoked at its debut. In an attempt to re-energize interest in *The Epic of American Civilization* and modern and contemporary art in general, Baas oversaw the purchase of nearly three hundred of Orozco's preparatory drawings.[32] The lead gift toward this monumental acquisition came from Raphael and Jane Bernstein, who were also the primary donors behind the educational space in the new museum, the Bernstein Study-Storage Center. Furthermore, the Bernsteins gifted five paintings and collages by renowned artist Romare Bearden shortly after the Hood's opening.

member of the Board of Overseers at the Hopkins Center from 1982 to 1985, founded an acquisitions fund for twentieth-century American art purchases. Miriam had long been a collector of contemporary prints and American antiques, and the endowment given by her and her husband, Sidney, has made possible the purchase of nearly forty works of art in the last twenty years, including Sean Scully's *Wall of Light, Summer* (cat. 63), Lawrence Fane's *Mill Piece* (cat. 98), and Jackson Pollock's *Untitled (Bald Woman with Skeleton)*.

Following both the furor over van der Marck's challenging contemporary art and the rearrangement of various areas of the arts program as the Hood Museum of Art developed beyond its embryonic stage, attention turned to building collections and exhibitions for the fledgling museum rather than bringing art to other campus locations. Planning and building the museum of fine arts kept the new director, Jacquelynn Baas, entirely occupied as she transitioned from Chief Curator and Acting Director to

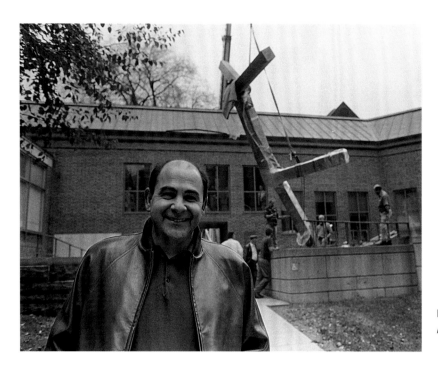

Fig. 19. Joel Shapiro during the installation of *untitled (Hood Museum of Art)*, 1989–90, bronze. Photo by Stuart Bratesman.

The other major initiative in modern and contemporary art at this time focused on the Fluxus group, expanding upon the initial collection begun by Jan van der Marck. Baas explained, "[Van der Marck] was collecting things nobody else was at that time; he showed a lot of foresight. If anything, I think I tried to continue that. Fluxus seemed to be something that no other museum in the U.S. was collecting, so that was the other goal for me, to continue to build on what Jan had begun in that area."[33] Dr. Abraham M. Friedman and his son Ken were instrumental in building the Fluxus collection, donating close to 150 works soon after the Hood opened. Ken, an art theorist and artist, had worked with George Maciunas and hoped to help build a collection that engaged with the concerns and practices of the artists who formed this movement.

By deliberately collecting work by a group of artists who were not of the mainstream, Baas underscored a key issue underlying the development of any modern and contemporary art collection: the availability of objects in an active commercial market. During the 1980s and 1990s, skyrocketing prices for modern and contemporary art, and especially painting and sculpture, meant that more than ever the Hood relied on the generosity of its donors to augment acquisitions. With this in mind, one of the first exhibitions that Baas organized at the Hood Museum of Art was a celebration of a previous key donor. *Thank You, Wallace K. Harrison*, on view from March 16 through April 28, 1985, commemorated Harrison's numerous gifts of modern and contemporary art to the permanent collection, as well as the melding of his Hopkins Center building with the new museum. The courtyard space linking these two buildings, as previously mentioned, was designated for a sculptural commission. Peter and Kristen Bedford, whose daughter was a member of the Class of 1989, were instrumental in funding both the courtyard and the sculpture that would soon fill it. Baas originally began talks with sculptor Peter Shelton. After she left to become director of the Berkeley Art Museum and Pacific Film Archive in 1988, however, the next director, James Cuno, decided to commission Joel Shapiro to create a work for the space, which became the monumental bronze sculpture *untitled (Hood Museum of Art)*, 1989–90 (cat. 91; fig. 19).

In 1987, Baas and curator Phylis Floyd organized *The Ivan Albright Collection*, an exhibition of recent gifts by the artist's widow. Incorporating an extensive array of prints, drawings, and watercolors, some of which were made while Albright was a visiting artist at Dartmouth in 1969, this exhibition underscored the importance of both contemporary art and regional connections to the young museum (Albright had lived in Woodstock, Vermont, for many years).

The 1990s

It was a very exciting time [at Dartmouth], in which the museum was new and a major triumph on the part of the College. Jackie Baas, who preceded me, had enjoyed the great support of the president, Jim Freedman, and [there was] a willingness to participate in the life of the museum by the faculties of the Art History Department and the Studio Art Department. So in hindsight, I remember it only as a very vibrant time, and I know that subsequently, under the direction of Timothy Rub, it really matured in its program within the College and its outreach within the region.[34]
— James Cuno

During my tenure as director we focused on defining and then broadening what the museum should be doing as a teaching institution. If there is anything that I am most satisfied by, it was the growth of the museum

in that area. It became a richer and more productive academic resource for the College—far more so than most other academic museums at the time—in large measure because we were focused, in significant and often quite creative ways, on what it fully meant to be a teaching museum.[35]

 —Timothy Rub

James Cuno served as director of the Hood Museum of Art, and informally as the curator of contemporary art, from August 1, 1989, to May 31, 1991. Although Cuno's first love as a scholar involved graphic work from the time of the French Revolution and the first half of the nineteenth century, he had a great interest in contemporary art and curated a Jasper Johns exhibition at UCLA when he was head of the Grunwald Center for the Graphic Arts from 1986 to 1988. Cuno explained his role in relation to contemporary art while at Dartmouth:

I think we always wanted to be sensitive to the responsibility we had to build a comprehensive collection in order to support the teaching mission of the Department of Art History and generally of the College, but there were three reasons to be particularly sensitive to contemporary art. One was the Studio Art Department itself, a robust department with large numbers of students and faculty making contemporary art, obviously. The second was a legacy of the Hopkins Center and the exhibition program commissioned for Dartmouth by the director Jan van der Marck. The third was the sense that we believed that students needed to be confronted with the art of their times, that the art of the past came to them with a pedigree that they respected already, but that the art of their time, the art of the new, did not, and that challenged them even more because they had to assess these objects, this art, on their own terms without the advantage of a proven pedigree of quality and importance.[36]

For Cuno, this focus on contemporary art translated into an ambitious period of exhibitions, acquisitions, and educational programs. Soon after his arrival at Dartmouth, the director was introduced to Werner Kramarsky and his wife, Sarah, the parents of a Dartmouth student, and collectors with an unparalleled eye for young, up-and-coming minimalist and post-minimalist artists. The friendship that evolved between Cuno and the Kramarskys resulted in the donation of more than one hundred works on paper by artists such as Sara Sosnowy (cat. 61), Liza Phillips (cat. 159), Frank Badur (cat. 160), and Jene Highstein (cat. 156).

Cuno repeatedly used contemporary art as a forum for engaging Dartmouth students. Inspired by Kramarsky's collection and his generosity toward and overall philosophy about young artists and students, Cuno proposed organizing an exhibition with Dartmouth students drawn from the collections of the Hood and several private lenders. In the winter term of 1990, students in the Museum Studies Seminar taught by Cuno were asked to consider a series of contemporary drawings with which to make both an exhibition and a catalogue entitled *Minimalism and Post-Minimalism: Drawing Distinctions*. These students not only researched and

wrote about the works but also visited Kramarsky's collection and the studio of sculptor Joel Shapiro, who was then designing the piece that would be installed in the Bedford Courtyard. That same year, Sol LeWitt designed a drawing for a long gallery wall near the entrance to the Hood. *Wall Drawing #655* (cat. 80, fig. 1) was executed by LeWitt's studio assistant David Higginbotham with the help of two Dartmouth students and a member of the museum's preparatory staff, Louise Glass, allowing them to observe firsthand the creative process of an internationally renowned contemporary artist.

As an art museum on the campus of an Ivy League college with top-tier business and medical schools, the Hood was seen primarily to serve an academic audience, but the institution's educational mission has continued to develop and expand with regard to Dartmouth's campus. In 1990, Katherine W. Hart was hired as the Curator of Academic Programming, the first such post, it is believed, in any American college or university. Her role was to act as the liaison between the Hood Museum of Art and the professors and students of Dartmouth. In an effort to ensure that the collections were viewed and utilized as a vital curricular resource, she established important and lasting relationships with interested College parties. Hart came to the Hood with a curatorial background in modern and contemporary art, and in 2000 she began sharing responsibility for it with the director. Today, the Hood serves as an exciting learning resource for everyone on campus, offering faculty from many departments the opportunity to teach using original works of art, internships for interested students, and an array of lectures, exhibitions, and programming geared toward engaging the academic community.

Following Cuno's departure in 1991 to lead the Harvard University Art Museums, Associate Director Timothy Rub was named director, taking on the informal role of curator of contemporary art as well. With the Hood Museum of Art now built and fully operational, Rub was faced with establishing both an infrastructure for the institution and a presence on campus. Perhaps the most important legacy of Rub's eight-year tenure as director was his push to grow the Hood's endowment, which nearly tripled in that time. It must also be noted that during the decade from 1990 to 2000, the Hood Museum of Art's personnel grew exponentially, from a full-time staff of ten people to twenty-four people in the year 2000.

Exhibitions during both Cuno's and Rub's tenures heavily involved contemporary art. *Subject(s): Prints and Multiples by Jonathan Borofsky, 1982–1991* (fig. 20) was initiated by Cuno during his time as director and then carried out with the oversight of Timothy Rub in 1991. Cuno selected the works for this collaborative show and, with scholar Ruth Fine, authored the significant catalogue as well. In 1995, Suzanne Gandell, associate director, with the assistance of three Dartmouth interns—August Lopez, Ronald Martinez, and Jennifer Skoda—organized *Image and Self in Contemporary Native American Photoart,* bringing together an

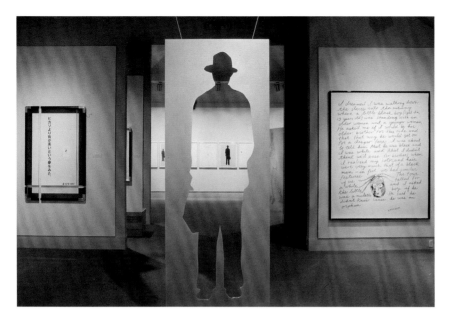

Fig. 20. The exhibition *Subject(s): Print and Multiples, by Jonathan Borofsky,* Hood Museum of Art, 1992, with *Man with Briefcase,* center. Photo by Jeffrey Nintzel.

exciting group of twentieth-century Native American artists. In 1999, Rub brought to the Hood the landmark traveling exhibition *Transience: Chinese Experimental Art at the End of the Twentieth Century,* the first exhibition presented in the United States to focus on contemporary experimental art from the People's Republic of China.[37] Under Rub's direction, curatorial fellow Amy Ingrid Schlegel curated *Post-Pastoral: New Images of the New England Landscape* in 1998 as a new incarnation of the *Regional Selections* series, signaling an important change in how contemporary art from the region was shown at the Hood. Similarly, in 2000 Rub recruited Anne Majusiak and Inez McDermott as guest curators to organize *The Art of Craft,* an exhibition of eighteen artists from New Hampshire and Vermont.

Due to the generosity of alumni and friends of the museum, a number of acquisitions funds were established in the 1990s that continue to support modern and contemporary art today. In 1994, the Virginia and Preston T. Kelsey, Class of 1958, Fund was initiated, and since then it has provided for the purchase of works such as Joyce Scott's *Mammy Under Undue Influence* (cat. 106), Juan Muñoz's *Hombre Colgado Pie (Figure Hanging From One Foot)* (cat. 102), and Alison Saar's *Caché* (cat. 105). That same year, the Sondra and Charles Gilman Jr. Foundation Fund was established to support the acquisition of contemporary American photography. An anonymous gift in 1996 initiated the Contemporary Art Fund, a general acquisitions fund that has afforded the opportunity to buy such disparate works as Alfredo Jaar's *The Eyes of Gutete Emerita* (cat. 123) and George Tooker's *Study for Women and Men Fighting* (cat. 34, fig. 1). Works bought through the Olivia H. Parker and John O. Parker, Class of 1958, Acquisitions Fund, a general purchase fund also endowed in 1996, reflect the donors' preference for contemporary photography; photographs by Malick Sidibé (cat. 229), Justine Kurland (cat. 262), and Abelardo Morell (cat. 266) were added to the collection as a result of its generous support.

Rub's interests in contemporary art centered on developing the works on paper collection. Drawings and prints by David Smith (cat. 138), Christopher Brown (cat. 192), Lucian Freud (cat. 185), Tony Cragg (cat. 186), and Brice Marden (cat. 191) were acquired and included in the exhibition *A Decade of Collecting, 1985–1995: Contemporary Prints from the Hood Museum of Art* (fig. 21). Other significant contemporary acquisitions included the purchase of a major sculpture, Ursula von Rydingsvard's *Bowl with Pleats* (cat. 99), following an exhibition of her work at the Hood in 1999 and a partial purchase and gift from the Dedalus Foundation, Inc., of two works by Robert Motherwell (cat. 12).

A New Millennium for Contemporary Art at Dartmouth

I think that it is our art. We should all have a stake in it and we have got to care about it. This is the art that is going to represent us to future generations. While I was at the Hood, championing contemporary things, I think there was the predictable mix of responses to seeing a great deal of this work in a concentrated period of time. Some people were exhilarated by it. Some people were questioning it . . . I think as a museum director you have to keep your eye on what is best for the institution overall, and I think that there were people who were extremely stimulated and engaged by having exposure to these works and probably some for whom it fed into a kind of skepticism that they already had about contemporary art. I was never too worried about the latter point of view, since it has existed broadly in any historical moment.[38]

— Derrick Cartwright

The development of a strategic plan was essential for the Hood Museum: redefining our purpose and focusing on collection priorities, plans for exhibitions, academic and public programming, publications, the website, and of course the Hood building itself. We need to continue to provide experiences of the visual arts that everyone in Hanover can remember with clarity, moments that cause us to think and make our

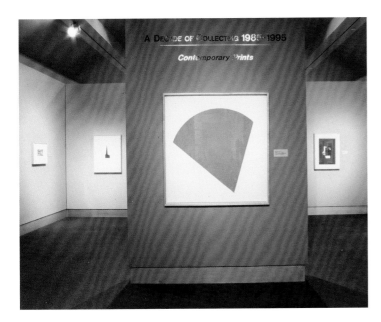

Fig. 21. The exhibition *A Decade of Collecting, 1985–1995: Contemporary Prints,* Hood Museum of Art, 1995. Photo by Jeffrey Nintzel.

hearts beat a bit faster. These are wonderful moments, through which the visual arts help each one of us, as one of the Hood's distinguished donors, Alvin Gutman, Class of 1940, noted: "to live a full and balanced life."[39]
— Brian P. Kennedy

Timothy Rub left Dartmouth in 1999 to become the director of the Cincinnati Art Museum, and Margaret Dyer Chamberlain, then Dartmouth's associate provost, served as interim director for the next year while Kathy Hart took over responsibility for the contemporary art collection. Hart began to focus on adding works that had social or political content, as well as examples of conceptual and performance art documentation, as these were elements that were clearly missing from the collection. Derrick Cartwright began his tenure as director of the Hood in January 2001 and, given his own interest in contemporary art, took up as the informal curator in this area, sharing the duties with Hart. Placing the collection, and specifically modern and contemporary art, into a global context was his primary goal:

I felt that there was some risk . . . and I want to say this very carefully . . . there is a risk that if you are located in a remote part of northern New England, of not recognizing the institution in a global context. As a result, I really wanted to support Barbara's [Barbara Thompson, then Curator of African, Oceanic, and Native American Collections] ideas for collecting African art, especially contemporary African art. I also felt that there had been an especially vital moment in modern art history that took place at Dartmouth College and I wanted to see that Latin American presence Orozco brought forward into the twenty-first century. So in small ways we dealt with this, by commissioning Rupert Garcia to re-do his portrait of Orozco for the College, and to acquire a few of his works, to bring [Luis] Gispert into the collection, to look more directly at Latin American art as a distinct, if latent, strength of the museum. That felt right to me at the time; indeed, it still feels absolutely right to me.[40]

Along with this global focus came a curatorial desire to bring new media into the collection that was spearheaded by Hart, and video works by Bill Viola (cat. 124), Luis Gispert (cat. 127), and Lorna Simpson (cat. 125) were soon acquired through purchase. Booked by Kathy Hart during her time as interim director, *Reservation X: The Power of Place,* an exhibition organized by the Canadian Museum of Civilization, Hull, Quebec, and on view in 2001 at the Hood, featured multimedia installations by seven Native American artists from the United States and Canada that explored the effects of mainstream culture on Native American identities. A year later, the Hood and the Department of Art History invited the Swiss artist group *relax* to create a remarkable public art project on campus. Curated by Adrian Randolph and Angela Rosenthal of the Department of Art History, *for sale* was a multicomponent and multimedia installation that extended from the Dartmouth Green to the museum's galleries, incorporating the experiences of residents of Hanover and the surrounding region.

Mitchell Friedman, Class of 1974, emerged as an important donor during Cartwright's time as director because of his experiences at the school as an undergraduate. An art student, Friedman had the remarkable opportunity of working with artist-in-residence Jim Dine, assisting him in the print room in the Hopkins Center. After graduating, Friedman went on to become Dine's master etcher, and twenty years later he donated a number of Dine's prints to the Hood, as well as works by Lowell Nesbitt (cat. 288) and Wolf Kahn (cat. 153), among others. The chance to work side by side with a renowned artist affected Friedman's life to a great degree, benefiting the student, the artist, and the institution that brought them together. As Cartwright acknowledged, "In my mind, the Hood will always remain one of the great, if not the greatest, teaching museums in the country and certainly belongs on a global level in terms of its engagement with students."[41] Providing similar occasions for students to interact with artists and the art of their time has certainly persisted since the time of Churchill P. Lathrop as a primary focus of each Hood director.

In 2001, Cartwright inaugurated another program aimed at engaging Dartmouth students. Every eight weeks, one of the museum's senior student interns is given the walls in the Hood's entrance lobby for a mini-exhibition drawn from the museum's collections. *A Space for Dialogue: Fresh Perspectives on the Permanent Collection from Dartmouth's Students* represents a unique opportunity for the museum's interns to choose objects, research them, write descriptive labels and a brochure, work with staff members to design the installation, and conduct a public gallery talk.

Cartwright and Juliette Bianco, Assistant Director at the Hood Museum of Art, also organized *Regional Selections 30* in 2002. A thirty-year celebration of the tradition of exhibiting the work of regional artists, this show allowed the Hood to connect again with artists who were living and working in the community. Picking a dozen local arts organizations with whom to work, Cartwright

and Bianco invited their executive directors to select the best artists in their own cities for inclusion in the exhibition.

Exhibitions drove a number of modern and contemporary acquisitions during Cartwright's tenure. In preparation for the exhibition and catalogue *Marks of Distinction: Two Hundred Years of American Drawings and Watercolors from the Hood Museum of Art,* Cartwright pushed to bring more women artists into the permanent collection. To augment the show and the ongoing yearlong celebration commemorating the Hood's twentieth anniversary, works by Eva Hesse (cat. 146), Agnes Martin (cat. 148), and Joan Mitchell (cat. 140) were added to the Hood's collection. Barbara Thompson's exhibition *Black Womanhood: Images, Icons, and Ideologies of the African Body,* conceived during Cartwright's tenure and organized for exhibition during Brian P. Kennedy's tenure in 2008, provided another opportunity to expand the Hood's contemporary collections on a global level. Both before and after the exhibition's debut, many included works were acquired, including those by Wangechi Mutu (cat. 122), Berni Searle (cat. 135), Malick Sidibé (cat. 229), Senzeni Marasela (cat. 275), and Renée Cox (cat. 263).

Cartwright accessioned an archive of works created between 1949 and 2002 by Sonia Landy Sheridan as a gift from the artist (cat. 118 and 119) in 2004. The collection includes thirty-one different media, among them drawings, paintings, prints, and photographs from the earlier years along with dozens of new media material such as telecopier, copier, and computer artwork.

In 2004, Cartwright organized a yearlong presentation of contemporary art at the Hood entitled *New Art Now. Lateral Thinking: Art of the 1990s* (fig. 22), an exhibition on loan from the San Diego Museum of Contemporary Art, began the year with work by forty contemporary artists from North, South, and Central America, Cuba, Africa, China, and Europe, including Matthew Barney, Vanessa Beecroft, Roman de Salvo, Zhang Huan, William Kentridge, Byron Kim, Vik Muniz, and Cindy Sherman, many of whose works had not been shown in the Upper Valley region before. Exhibitions highlighting the work of Jean Michel Basquiat and Ouattara Watts; Luis Gispert; and Ghada Amer, Shahzia Sikander, Mona Hatoum, Y. Z. Kami, Jananne Al-Ani, Walid Raad, and Michal Rovner rounded out the bold program and incorporated visits to campus by a number of the artists.

After Derrick Cartwright left for the directorship of the San Diego Museum of Art at the end of 2004, Katherine Hart served as interim director. During this transitional time, she organized *Celebrating Twenty Years: Gifts in Honor of the Hood Museum of Art,* an exhibition that brought together a number of recent outright and promised gifts, including works by Jennifer Bartlett (cat. 50), Carolee Schneemann (cat. 120), Paul Chan, and Andres Serrano, that had been generously offered by Dartmouth alumni and friends in honor of the museum's first twenty years.

In 2005, Brian P. Kennedy, formerly the director of the National Gallery of Australia (1997–2004) and assistant director of the

Fig. 22. The exhibition *Lateral Thinking: Art of the 1990s,* Hood Museum of Art, 2004. From left to right: David Hammons, *Champ,* 1989, and Roman de Salvo, *Power Maze with Sconce,* 1998. Photo by Jeffrey Nintzel.

Fig. 23. Peter Irniq's *inuksuk,* 2007. Photo by the Hood Museum of Art.

Fig. 24. The exhibition *El Anatsui: GAWU,* Hood Museum of Art, 2007. Photo by Jeffrey Nintzel.

National Gallery of Ireland (1989–1997), was hired to lead the Hood Museum of Art as its director and chief curator, and to serve informally as its curator of contemporary art. Kennedy, a native of Dublin, came to the Hood with an inherently global perspective and has continued to build on Cartwright's policy of "collective collecting," working with his fellow curators Barbara Thompson and Katherine Hart on the acquisition of works such as Zanele Muholi's *Sex ID Crisis,* Alison Saar's *Caché* (cat. 105), and Alfredo Jaar's *The Eyes of Gutete Emerita* (cat. 123). For an academic museum with an already extensive collection, the Hood's curators and director felt at this time that it made perfect sense to acquire contemporary art from diverse regions of the world, reflecting an era of almost instantaneous cultural exchange. Kennedy has brought works into the collection from across the centuries and in many curatorial areas, including contemporary art by, for example, Sean Scully (cat. 63), Sana Musasama (cat. 92, 93, and 94), Lawrence Fane (cat. 98), Fiona Foley (cat. 270), and Nina Katchadourian (cat. 128).

Kennedy has increased the endowment funds for contemporary art with support from museum donors Sondra Gilman and Ceslo Gonzalez-Falla P'68, Vene '40 and Mary Bert Gutman, Pamela J.

Joyner '79 P'10, David '67 and Liz Lowenstein, David Reynolds '49, P'73 and '78, and DG'04, and Bonnie and Rick Reiss P'83. He has also sought to build upon the success of the *Space for Dialogue* concept founded by his predecessor. He secured a significant endowment from the Dartmouth Class of 1967 that took over funding of the project from the Class of 1948. He also expanded the premise of the series to include student projects elsewhere on campus, adding a significant dimension to the over fifty student-curated exhibitions at the Hood itself.

Perhaps most importantly, Kennedy has consistently encouraged the Hood Museum of Art to celebrate the legacy of modern and contemporary art on Dartmouth's campus and look beyond the walls of the actual museum. He has encouraged site-specific sculptures, exhibitions in buildings other than the Hood proper, and an ambitious program of in-house shows that reflects the increasingly diverse community that is Dartmouth.

In 2005, Kennedy invited installation artist Wenda Gu to work in the Baker and Berry Libraries, resulting in a successful Dartmouth chapter for the controversial and long-running *united nations* project. In April 2007, Hood administrators invited the first commissioner of the vast Indigenous-run province of Nunavut in Canada, Peter Irniq, to build an *inuksuk* in front of McNutt Hall (which houses the Admissions Office; fig. 23). This commission coincided with two exhibitions focused on the Arctic, *Thin Ice: Inuit Traditions within a Changing Environment,* organized by the Hood, and *Our Land: Contemporary Art from the Arctic,* the first major exhibition of contemporary art to emerge from the Nunavut Government, organized by the Peabody-Essex Museum in Salem, Massachusetts. The *inuksuk,* a stone tower assembled in the likeness of a person, has for thousands of years served the Inuit peoples as a beacon, a symbol of survival, and "wayfinder" through Arctic lands. As Irniq explained, "Some *inuksuit* [plural] have windows, indicating that they point to something important. Through the window of this *inuksuk,* students can see from the Admissions Office across to the place where they will one day graduate from Dartmouth. They'll be able to look at their futures and to contemplate what they might do."[42] Again, contemporary art became a mode for engaging students in a well-traveled area of campus. Later that same year, *Peaceful Serenity* by Allan Houser (cat. 95) was sited in front of Sherman House, the location of Dartmouth's Native American Studies Program. Houser, the first Chiricahua Apache child in his family to be born out of captivity in the twentieth century, is regarded as one of the century's most important Native American artists; he had come to Dartmouth College as an artist-in-residence in 1979. Most recently, Kennedy has overseen the reconstitution of Richard Nonas's *Telemark Shortline* (cat. 84), which was dismantled in 1982 to prepare the site for the future Hood Museum of Art. In addition, Richard Serra's work *Two-Plate Prop* has been placed in the Darling Courtyard of the Hopkins Center, where its minimal and material character has attracted great interest from today's students.

Fig. 25. Brian P. Kennedy, Director of the Hood Museum of Art, with artist Sean Scully in the Lathrop Gallery during the exhibition *Sean Scully: The Art of the Stripe*, 2008. Courtesy of Dartmouth College Library. Photo by Joseph Mehling.

In the last few years, and in keeping with the late-1970s boom in art around campus, there has been a re-energizing of the Studio Art Department's artist-in-residence program and its symbiotic relationship with the Hood. Artists represented in exhibitions or in the permanent collection at the Hood have accepted residencies in the program (and vice versa), including Magdalene Odundo, who was in residence in fall 2008 following her solo 2007 exhibition *Resonance and Inspiration* at the Hood; Subhankar Banerjee, who was in residence in winter 2009 following his solo 2007 exhibition *Resource Wars in the American Arctic* at the Hood; and Jane Hammond and Andrew Moore, from whose artist-in-residence exhibition in 2006 the museum purchased works for the permanent collection. The Hood staff hosts luncheons and public talks with artists-in-residence that have brought the faculty and museum staff together in a shared purpose. In 2008, Kennedy inaugurated what will be an ongoing series of single-artist shows with catalogues celebrating the work of longtime studio art professors at Dartmouth, emphasizing how important it is for students to see a fully curated examination of their teachers' artistic output. *Immanence and Revelation: The Art of Ben Frank Moss* began the series in fall 2008, and Esme Thompson will continue it in 2011.[43] The Hood has also begun to implement a policy of purchasing at least one key work by each studio art professor for the College's collection.

The contemporary art exhibition programming of the last five years responds to Kennedy's international museum experience and to the diversity of the Dartmouth community; shows such as *Dreaming Their Way: Australian Aboriginal Women Painters; El Anatsui: GAWU* (fig. 24); and *Sean Scully: The Art of the Stripe* (fig. 25) received acclaim for their aesthetic appeal as well as their

academic relevance.[44] Other exhibitions reflecting the Hood's interest in contemporary art have involved paintings, photography, videos, digital media, and sculpture from East Asia; Native American basketry from Maine; and contemporary international photography.[45] Kennedy has made a strong push to promote the permanent collection as well through a series of publications and exhibitions that celebrate the Hood Museum of Art's highlights and build upon the collection's strengths. This catalogue is the third in the series and establishes the history of modern and contemporary art at Dartmouth as equally worthy of documentation and scholarship as renowned American, European, and Native American collections. The Hood's contemporary art collections continue to remain a cornerstone of the Hood's acquisition, exhibition, and programming plans.

Looking toward the Future

As the Hood Museum of Art prepares for its twenty-fifth birthday in 2010, one of its priorities continues to be honoring the institution's legacy of placing modern and contemporary art at the heart of its programming. While acquisitions and operating endowments have grown since the museum's opening, and especially in recent years, the collections continue to require attention and augmentation, and particularly so in the case of the modern and contemporary collection, which evolved without the oversight of a full-time curator and was largely formed through gifts. We continue to rely on the generosity of our donors to fill the gaps that exist in this area to counter the realities of a competitive commercial market in contemporary art.

The Hood Museum of Art is once again at an important crossroads, because contemporary art remains an important catalyst for discussion, dialogue, and engagement across an increasingly diverse and constantly evolving campus. Over many years it has been demonstrated repeatedly that the art of our time evokes widespread reactions, exciting disparate groups on campus through the placement of even one work of art. Just as the Lathrop Galleries were earmarked for the exhibition of contemporary art when the Hood was built, now we look anew at the campus for additional venues for the display of works of art, so that students can continue to be confronted with the art of their own time on a daily basis.

NOTES

1. See W. Wedgwood Bowen, *A Pioneer in the Wilderness* (Hanover, N.H.: The Dartmouth College Museum, 1958), p. 1.

2. See Barbara J. MacAdam, *American Art at Dartmouth: Highlights from the Hood Museum of Art* (Hanover, N.H.: Hood Museum of Art, Dartmouth College, and University Press of New England, 2007), and T. Barton Thurber, *European Art at Dartmouth: Highlights from the Hood Museum of Art* (Hanover, N.H.: Hood Museum of Art, Dartmouth College, and University Press of New England, 2008).

3. Juliette Bianco, "Wenda Gu at Dartmouth: The Making of an Installation," in *Wenda Gu at Dartmouth: The Art of Installation,* Juliette Bianco,

David Cateforis, Eleanor Heartney, Allen Hockley, and Brian P. Kennedy (Hanover, N.H.: Hood Museum of Art, Dartmouth College, and University Press of New England, 2008), p. 16.

4. John F. Coggswell, "Bitter War over Dartmouth's Murals," *Boston Sunday Post,* April 22, 1934.

5. Arthur R. Blumenthal, "Art at the College: 50 Years of Art at Dartmouth," *The Dartmouth,* November 3, 1978.

6. Emily Burke, interview with Jacquelynn Baas, May 19, 2008.

7. A note about the various names of the art galleries and museums at Dartmouth: Carpenter Hall, the building that housed the Art Department, included space for the exhibition of fine art (the Carpenter Art Gallery), while Wilson Hall contained the Dartmouth College Museum, the natural history collections. When the Hopkins Center for the Arts opened in 1962, the fine art galleries expanded into the new space there as well. As of September 1, 1974, what was formerly called the Hopkins Center Art Galleries and the Dartmouth College Museum came to be known as the Dartmouth College Galleries and Collections. In 1976, the institution's name changed yet again to the Dartmouth College Museum and Galleries. Its current name, the Hood Museum of Art, was initiated by the opening of the actual bricks and mortar museum in 1985.

8. Churchill P. Lathrop, "To Promote Interest and Education in Art," *Dartmouth Alumni Magazine,* January 1951, p. 82.

9. Arthur R. Blumenthal, "Art at the College: 50 Years of Art at Dartmouth," *The Dartmouth,* November 3, 1978.

10. Churchill P. Lathrop, "To Promote Interest and Education in Art," *Dartmouth Alumni Magazine,* January 1951, p. 18.

11. Abby Aldrich Rockefeller, a leading collector of her time, gave more than one hundred works to the College collection in 1935. This foundational gift included primarily American paintings, watercolors, drawings, and sculpture representing both folk art and modernist traditions.

12. Churchill P. Lathrop, "Artists-in-Residence: A History," June 1983, p. 3.

13. "Dartmouth Has Part in IGAS Prints Program," *Valley News,* Lebanon, N.H., September 17, 1958.

14. Churchill Lathrop, "The Dartmouth Collection," 1960, p. 10.

15. For further discussion see T. Barton Thurber, *European Art at Dartmouth: Highlights from the Hood Museum of Art* (Hanover, N.H.: Hood Museum of Art, Dartmouth College, and University Press of New England, 2008), p. 15.

16. For a history of this fund see Barbara J. MacAdam, *Marks of Distinction: Two Hundred Years of American Drawings and Watercolors from the Hood Museum of Art* (Hanover, N.H.: Hood Museum of Art, Dartmouth College, and Hudson Hills Press LLC, 2005), pp. 34–35.

17. Thurber, pp. 14–15. Evelyn Jaffe Hall, a New York arts patron and avid collector of European paintings, sculpture and antique furniture, Chinese porcelain, pre-Colombian artifacts, and Renaissance drawings, was also the sister-in-law of Joseph Hazen, another important member of the Hopkins Center Art Advisory Group. The members of the Group in 1960 were William B. Jaffe, chairman, Alfred H. Barr Jr., D. Herbert Beskind, Richard F. Brown, Frank Caro, Leo Castelli, Russell Cowles, Mrs. John de Menil, Elizabeth Greenfield, Joseph H. Hazen, Alex Hillman, William Bright Jones, John Rood, James J. Rorimer, Modie J. Spiegel, and Daniel L. Wildenstein.

18. Personal letter from William Rubin to Jacquelynn Baas, March 7, 1985.

19. Personal letter from Herbert G. Swarzman to Churchill Lathrop, October 10, 1966.

20. *The Protean Century, 1870–1970: A Loan Exhibition from the Dartmouth College Collection, Alumni and Friends of the College,* exhibition catalogue, n.p.

21. Emily Burke, interview with Jan van der Marck, May 8, 2008.

22. It is significant to note that a female sculptor was selected for this major commission only three years after Dartmouth had become a coeducational institution.

23. Emily Burke, interview with George Shackelford, September 23, 2008.

24. Although the Hood Museum of Art was not yet built, administrative positions were in place as planning progressed.

25. Emily Burke, interview with Peter Smith, July 22, 2008.

26. Emily Burke, interview with Jan van der Marck, May 8, 2008.

27. Emily Burke, interview with Jacquelynn Baas, May 19, 2008.

28. Jacquelynn Baas, *Treasures of the Hood Museum of Art, Dartmouth College* (Hanover, N.H.: Hood Museum of Art, Dartmouth College, 1985), p. 19.

29. Letter from Hugh Freund to Richard Teitz, September 29, 1981.

30. Letter from A. Marvin Braverman to Richard Teitz, April 5, 1982.

31. Frank Stella, "Convocation Speech," September 23, 1985.

32. For further information on this project, see Jacquelynn Baas, "'The Epic of American Civilization': The Mural at Dartmouth College," in *José Clemente Orozco in the United States, 1927–1934,* eds. Renato González Mello and Diane Miliotes (Hanover, N.H.: Hood Museum of Art, Dartmouth College, in association with W. W. Norton and Company, 2002), 142–85.

33. Emily Burke, interview with Jacquelynn Baas, May 19, 2008.

34. Emily Burke, interview with James Cuno, May 16, 2008.

35. Emily Burke, interview with Timothy Rub, July 16, 2008.

36. Emily Burke, interview with James Cuno, May 16, 2008.

37. *Transience: Chinese Experimental Art at the End of the Twentieth Century* was curated by Wu Hung and organized by the David and Alfred Smart Museum of Art, University of Chicago. After being on view at the Smart Museum from February 18 to April 18, 1999, the exhibition traveled to the University of Oregon Museum of Art, Eugene, where it was displayed from July 17 to September 12, 1999, and then to the Hood Museum of Art, Dartmouth College, Hanover, N.H., where it was on view from October 13 to December 9, 1999.

38. Emily Burke, interview with Derrick Cartwright, May 12, 2008.

39. Brian P. Kennedy, "Letter from the Director," *Hood Museum of Art Quarterly,* Autumn 2005, p. 1.

40. Emily Burke, interview with Derrick Cartwright, May 12, 2008.

41. Ibid.

42. Sharon Reed, interview with Peter Irniq, March 2007.

43. See Joshua Chuang, Brian P. Kennedy, Bruce Herman, Jeffrey Lewis, and Gregory Wolfe, *Immanence and Revelation: The Art of Ben Frank Moss* (Hanover, N.H.: Hood Museum of Art, Dartmouth College, 2008).

44. *Dreaming Their Way* was organized by the National Museum of Women in the Arts, Washington, D.C.; *El Anatsui* was organized by Oriel Mostyn Gallery in North Wales, United Kingdom; and *Sean Scully* by the Hood Museum of Art. See also Brian P. Kennedy, *Sean Scully: The Art of the Stripe* (Hanover, N.H.: Hood Museum of Art, Dartmouth College, 2008).

45. *Spirit of the Basket Tree: Wabanaki Ash Split Baskets from Maine,* on view from December 20, 2008, to June 28, 2009; *Focus on Photography: Works from 1950 to Today,* on view from January 13 to March 8, 2009; and *Past in Reverse: Contemporary Art in East Asia,* organized by the San Diego Museum of Art, on view at the Hood from January 14 to March 12, 2006.

Catalogue

Published sources relevant to each entry appear in abbreviated form at the conclusion of the entry, with full citations listed in the bibliography. Several of the catalogue entries draw heavily on unpublished label copy or other texts drafted by Hood staff members and Dartmouth students, past and present. Authors are listed below:

JB	Jacquelynn Baas
ESB	Emily Shubert Burke
DRC	Derrick Cartwright
BC	Bonnie Clearwater
MKC	Mary K. Coffey
KC	Katharine Conley
RC	Robert Cozzolino
JC	James Cuno
MD	Monroe Denton
ED	Emmie Donadio
KMG	Kristin Monahan Garcia
KWH	Katherine Hart
JH	Joseph Houston
BK	Brian P. Kennedy
SHM	Steven Henry Madoff
MDM	Mark Mitchell
TR	Timothy Rub
JS	Joseph Sanchez
BT	Barbara Thompson
JVDM	Jan van der Marck
AHW	Abigail Hebble Weir
PW	Phoebe Wolfskill

PAINTING

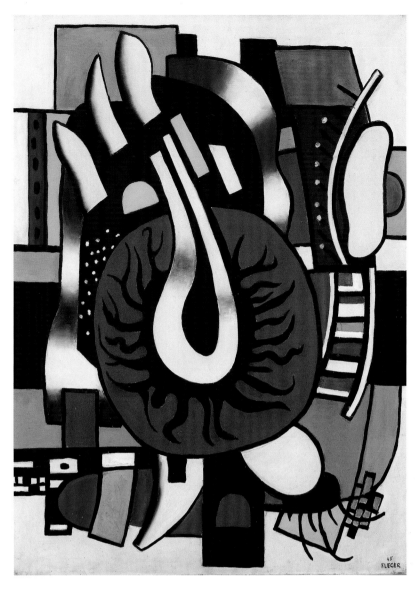

1. Fernand Leger, French, 1881–1955

*Composition in Red and Black
(Composition en rouge et noir),* 1945

Oil on canvas, 5⅜ x 38¼ inches
Gift of Wallace K. Harrison, Class of 1950H; P.967.18
© 2009 Artists Rights Society (ARS), New York/ADAGP, Paris

Fernand Leger studied in Paris for three years at the start of the twentieth century, attending both the École des Beaux-Arts and the Académie Julian. After finishing his formal education he rejected the academic and impressionist styles taught by his instructors, developing a mode of painting that was linked variously to cubism, surrealism, futurism, and the purism of Amédée Ozenfant and Le Corbusier. Leger's early style was marked by his interest in conveying sensation and experience through overlapping planes of brilliant color.

In 1914, at the outset of World War I, Leger was mobilized for service in the French army. His time in the military had a significant impact on the next four decades of his artistic career. Leger viewed these years as catalytic, stating:

> I was stunned by the sight of the breech of a 75 millimeter in the sunlight. It was the magic of light on the white metal. That's all it took for me to forget the abstract art of 1912–1913. The crudeness, variety, humor, and downright perfection of certain men around me, their precise sense of utilitarian reality and its application in the midst of the life-and-death drama we were in . . . made me want to paint in slang with all its color and mobility.

Always a proponent of modernity, Leger focused on the visual excitement and actual potential of the machine age, rather than the psychological impact of the war. Using bold color and strong black outlines, Leger turned away from the work of Georges Braques and Pablo Picasso, depicting isolated objects of industrialized city life. In his streamlined factories and mechano-human forms Leger expressed a sense of power and excitement.

At the end of the 1920s Leger gradually began to incorporate more organic and irregular shapes into his works, juxtaposing various forms from everyday life. *Composition in Red and Black,* dating from 1945, is dominated by a vibrant red central circle with black wiggling protrusions. Behind it is an abstracted cityscape, featuring paved roads and towering skyscrapers. In the upper right is a tall smokestack, perhaps from an ocean liner, and a tube-like form that exemplifies the artist's treatment of the abstracted human figure. Leger is frequently described as a precursor to the late-twentieth-century Pop Art movement, and this painting's focus on everyday culture and strong graphic quality underscore that connection.
[Nérét, 1993: 66 (quotation)] AHW

2. Adolph Gottlieb, American, 1903–1974

Black Enigma, 1946

Oil on canvas, 25⅛ x 32¼ inches
Bequest of Lawrence Richmond, Class of 1930; P.978.163
Art © Adolph and Esther Gottlieb Foundation/Licensed by VAGA,
New York, NY

"Different times require different images. Today when our aspirations have been reduced to a desperate attempt to escape from evil, and times are out of joint, our obsessive, subterranean and pictographic images are the expression of the neurosis which is our reality." Adolph Gottlieb published this description of his art in 1947, shortly after the end of World War II and in the thick of the "Pictographs" series (1941–around 1953) that included *Black Enigma*. Ironically, Gottlieb's lucid defense of his own work—as well as that of his fellow abstract expressionists—contradicted the obscurity of the art itself.

The onset of World War II had transformed Gottlieb's approach to art. Inspired to action, Gottlieb abandoned his early debts to postimpressionism as well as to the lyricism of his friend Milton Avery. During the late 1930s and early 1940s, he turned increasingly to surrealism and the writings of psychoanalyst Carl Jung in search of more potent and immediate artistic expression. (Gottlieb

was interested in the work of both Jung and Sigmund Freud, but it was to Jung that his wife Esther pointed as his primary influence in the early Pictographs). Gottlieb contended with the war in ancient, primitive, and mythological terms using symbols and subjects that he identified with the foundations of human experience. In a defining statement of abstract expressionism, Gottlieb, writing with Mark Rothko, observed in 1943 that "only that subject matter is *valid which is tragic and timeless.*"

Black Enigma is, as its title suggests, among the darkest of the Pictographs. It deals almost purely with malice, evil, and aggression. A helmeted, armored figure at the left grins in profile with jagged teeth, which are a recurring motif in the composition. At the lower right, a circle suggests an open mouth in a primal scream. The dominant female figure at the center, identified by her breast forms, looks directly outward at the viewer and is perhaps a victim of the figures at the left. As in all of the Pictographs, however, Gottlieb employs these totemic, compartmentalized forms allusively, suggesting known shapes and subjects and yet withholding full understanding in its aptly titled enigma. [Gottlieb 1947: 43 (quotation); MacNaughton 1981: 32; Alloway and MacNaughton 1981: 169 (quotation)]

MDM

3. Pierre Daura, Spanish, 1896–1976

What is in a Painting?, 1947–53

Watercolor on heavy wove paper, 7½ x 10⅞ inches
Gift of Martha R. Daura; W.2002.53.11

Catalan-American artist Pierre Daura resided in France from 1914 to 1939, painting alongside the leading avant-garde artists of his day. With Uruguayan-Catalan artist Joaquín Torres-García (1874–1949) and Belgian artist and theorist Michel Seuphor (1901–1999), Daura formed the artistic group Cercle et Carré (Circle and Square) in Paris in 1929. The group consisted of about eighty international artists who referred to themselves as "Constructivists" and promoted geometric construction and abstraction as opposed to the irrationality of surrealism. In 1939, after serving in the Spanish Republican army to fight Franco forces, Daura moved with his American wife to Virginia, where he taught art at a number of institutions. Daura never lost sight of his Spanish artistic origins, which traditionally emphasized rich colors carefully orchestrated throughout the pictorial field. His work moves seamlessly between objective and non-objective representations and demonstrates the artist's command of various media, particularly painting, drawing, and engraving.

Despite his detachment from surrealism, this movement's ambition to explore the unconscious is evident in *What is in a Painting?* The intimate scale of the vibrantly colored painting, in addition to its dream-state subject matter, breaks widely with Daura's oeuvre. Defined by crisp, black lines, this watercolor is more reminiscent of the artist's etchings and stands apart from Daura's landscape and nonfigurative work.

In his diary, Daura wrote, "Will I ever be able to bring out what is deep in my subconscious?" His obvious use of surrealist language in *What is in a Painting?,* evident in multiple dislocations of space and a focus on a woman's body, may be an attempt to answer this question. A line of striped poles protrudes from a body of water and two compasses hover above the surface. The divisions of water, land, and sky recall the divide between consciousness and unconsciousness that so compelled the surrealists. An anonymous woman hangs suspended above the water, her body bisected by calipers that grasp her side. With eyes closed in a dream- or death-like state, her hair is transformed into curling smoke that rises into the night sky, while a stream of blood seeps into the water.

[Schmalenbach 1985: 38 (quotation)] ESB

25

4. Rufino Tamayo, Mexican, 1899–1991

Portrait of Rosalind Richards, 1948

Oil, charcoal, and pastel on gessoed Masonite, 48 x 36 inches
Gift of Lois and H. W. Broido Jr., Class of 1951, Tuck 1952, and
Eric Richards; P.2004.13
© D. R. Rufino Tamayo/Herederos/México/2008 Fundación
Olga y Rufino Tamayo, A.C.

Rufino Tamayo, often referred to as the "fourth Great," was the
only modernist artist in Mexico to achieve the international ac-
claim of the "three Greats"—Diego Rivera, José Clemente Orozco,
and David Alfaro Siqueiros—during his lifetime. Slightly younger
than his muralist peers, Tamayo was a vocal opponent of the po-
lemical style of painting they advocated. Throughout his career,
Tamayo lobbied for an art that was both "Mexican" and "univer-
sal." And through his unique combination of postwar figuration
and the painterly values of the School of Paris, most would argue
that he achieved it.

Tamayo's *Portrait of Rosalind Richards* represents the artist's
singular ability to integrate the formal lessons of French *belle pein-
ture* with the more sober legacies of pre-Columbian statuary. Like
the many female portraits painted by Picasso, Tamayo's rendering

of Rosalind Richards betrays a classicism that converts his good
friend and patron into an iconic presence. He has simplified her
chair so that it perfectly echoes her solid form, while smoothing
the planes of her face into a mask with a sharp brow and dark ab-
sences where her eyes should be. He has also stylized her curls into
a lyrical series of spiraling arcs, the one blaze of color in an other-
wise muted palette. The mysterious calm that suffuses the portrait
emanates from Tamayo's masterful control of tonality and line.
Working with oil, charcoal, and pastel, Tamayo modulates his hues
with a subtle variation that discloses the gessoed Masonite's hard,
scumbled surface. His emphasis on the physicality of his materials
and working surface reminds us of Tamayo's commitment to the
plastic values of "pure painting."

By the late 1940s, Tamayo had begun to abstract the figure in
compositions that evoked the anxiety of industrialized war, the
nuisances of modern technology, or the terrible sublimity of the
cosmos. However, *Portrait of Rosalind Richards* harkens back to his
earlier style. We can attribute this to the demands of portraiture,
a genre that all of the Mexican artists of Tamayo's generation de-
pended upon in the absence of a strong private market and spotty
public patronage. Unlike Frida Kahlo, who responded to the dis-
advantages of her disability and gender by converting portraiture
into a highly personalized assertion of the self, Tamayo's portraits
reflect his need to bend his aesthetic committments to the repre-
sentational needs of his sitter. It would seem that in commemo-
rating the wife of Irving Richards, the entrepreneur who brought
Russell Wright's modern dinnerware to the mass market, Tamayo
eschewed the distortions of form and vibrant palette that charac-
terize his postwar painting. Instead he integrated Richards's love
of design into Rosalind's coiffure, making her the embodiment
of Wright's elegant lines and soft curves. Like his hero, Picasso,
Tamayo understood that a portrait commemorates not simply
the sitter's likeness but also the plastic values of the artist's mytho-
poetic vision. MKC

5. Roland Dorcely, Haitian, born 1930

Mother and Son, before 1957

Tempera on composition board, 48⅜ x 32⅛ inches
Gift of Diana J. and Professor Emeritus H. Wentworth Eldredge, Class of 1931;
P.984.39.3

Roland Dorcely is one of the most important figures in Haiti's avant-garde movement of the 1950s. Like many aspiring Haitian artists, Dorcely joined the Centre d'Art (Art Center) in 1946. The Centre d'Art helped self-taught Haitian artists—such as Hector Hyppolite, Philome Obin (fig, 1), Rigaud Benoit, Castera Bazile and Wilson Bigaud—find art materials and connect with international markets. The same year that Dorcely joined the Centre d'Art, he became the first Haitian artist sent by the Duvalier government to Paris, France, to study with Fernand Leger and Andre Masson.

In 1950, Dorcely joined a group of Haitian painters, including Luckner Lazard and Diedonne Cedor, in breaking away from the primitivist ideologies promoted by the Centre d'Art. Their new gallery, the Foyer des Arts Plastiques (Hall of Plastic Arts), established a parallel movement of social realism called "Realism of Cruelty," which used modernist aesthetics to expose the oppressive conditions in Haiti. Four years later, the same three artists founded the Brochette Gallery in the southern suburb of Port au Prince. The Brochette centered on a group of avant-garde artists and intellectuals embracing the problems of painting and literature to highlight Haiti's socio-political environment.

The Brochette was one of the most important artistic and cultural movements since the Centre d'Art, but success lasted only a few years. Their openly critical approach ran contrary to Haiti's increasingly oppressive conditions and government ideologies. From 1962 to 1963, the rising dictatorship slowly disintegrated the Brochette, which eventually disappeared completely from the Haitian art scene. For many, including Dorcely who returned to Paris in 1962, exile became the only option for artistic freedom. Dorcely returned to Haiti in 1969, where he continued to work in a personal style combining the Parisian school influences with typical scenes of daily life in Haiti. BT

Fig. 1. Philome Obin, Haitian, 1892–1986, *La Fossette vers 1897: Les Bourgeois du Cap revenant de leurs habitations,* 1958, oil on panel, 24 x 30 inches. Bequest of Jay R. Wolf, Class of 1951; P.976.205.

6. Byron Browne, American, 1907–1961

Monolith, 1951

Oil on canvas, 20⅞ x 24 inches
Gift of Robert S. Engelman, Class of 1934; P.960.90.3

Byron Browne studied at the National Academy of Design in the late 1920s, and upon graduating he emerged as a passionate and early advocate of American abstract art. As the Great Depression took hold across the country, regionalist artists such as Grant Wood popularized scenes of rural American life. Few galleries were willing to show abstract art, yet Browne turned toward Paris and the European avant-garde in a move away from traditional painting genres, famously tearing up his own award-winning still life. Through his own experimentation and activism, he devoted himself to promoting modernism in America. Not only did he spearhead the development of organizations such as the American Abstract Artists (AAA) with contemporaries such as Willem De Kooning and Arshile Gorky, he also picketed the Museum of Modern Art in response to its exclusion of American abstract painters.

Browne studied first the cubism of Georges Braque and Pablo Picasso and then the surrealism of Joan Miró. He generated a style of his own, later influenced by abstract expressionism. Following the production of murals for the Works Progress Administration/

Federal Art Project (WPA) and the eventual establishment of a WPA-supported gallery for abstract art, Browne began to gain renown for his work. Today Browne is viewed as an artist who was integral to the development of New York as the center of the art world at mid-century.

Monolith demonstrates Browne's many influences as well as his personal vision of abstraction. With its focus on the totemic image at its center and the heavy framing brushstrokes on each of the four sides, *Monolith* contains many elements of a traditional composition. In Browne's mind, there could be no such thing as pure abstraction: all art came from nature and the everyday world. His art, he wrote, was made up of "poetic gestures concerning things seen and felt." This idea is manifest in the multiplying organic forms spread across the page, perhaps referencing the shapes of Miró. The dynamic brushstrokes and bold colors, as well as the sculptural buildup of paint in the central form, link Browne with the abstract expressionist movement. [Paul 1979: 12, 6 (quotations)]

AHW

28

7. Victor Vasarely, French, 1908–1997

Yapura, 1951–56

Oil on canvas, 43⅜ x 39¼ inches
Gift of Wallace K. Harrison, Class of 1950H, in honor of Nelson A. Rockefeller, Class of 1930; P.966.2

Victor Vasarely, a Hungarian émigré who spent most of his life in France, was one of the most innovative and prolific artists of the Op Art movement. *Yapura,* perhaps Vasarely's earliest abstract optical illusion, is the work of an artist at a stylistic juncture. He has reduced the simplest natural shapes of pebbles and wavelike undulations to geometric forms, linking the work to the naturalism of Vasarely's Denfert, Belle Isle, and Gordes periods.[1] At the same time, the severity of the black-and-white tones and the composition's convex illusion are early indications of the future direction of the artist's work.

Vasarely's geometric figures deceive the eye, their shifting forms stimulating an individual visual experience for each viewer. "La plastique cinetique," or kinetic plastic art—the term the artist coined to describe his work—encompasses both his technical means of expression and his desire to articulate contemporary mobility through a strictly visual means of organization. Through his version of geometrical abstraction, Vasarely sought direct access to the subconscious of the viewer, and the dimensions and contrasts of his works are meant to immediately overwhelm. As he implies here, people no longer had the time to contemplate:

> The stake is no longer the heart, but the retina; the refined mind becomes the subject of experimental psychology. Sharp black-white contrasts, the unendurable vibration of complementary colors, the flickering of rhythmed networks and permuted structures . . . the role of which is no longer to create wonder or to plunge us into a sweet melancholy, but to stimulate us and to provide us with wild joys. [Joray and Vasarely 1965: 163 (quotation)]

ESB

1. As Vasarely experimented with developing his geometric abstract style, he was influenced by the white tiled walls of the Paris Denfert-Rochereau metro station (his Denfert period), pebbles and shells found during his vacation on the Breton coast set the stage for his Belle Isle period, and the cubic houses he saw during his summers in Gordes in Provence-Alpes-Côte d'Azur provided the forms for his Gordes period. [Joray and Vasarely 1965]

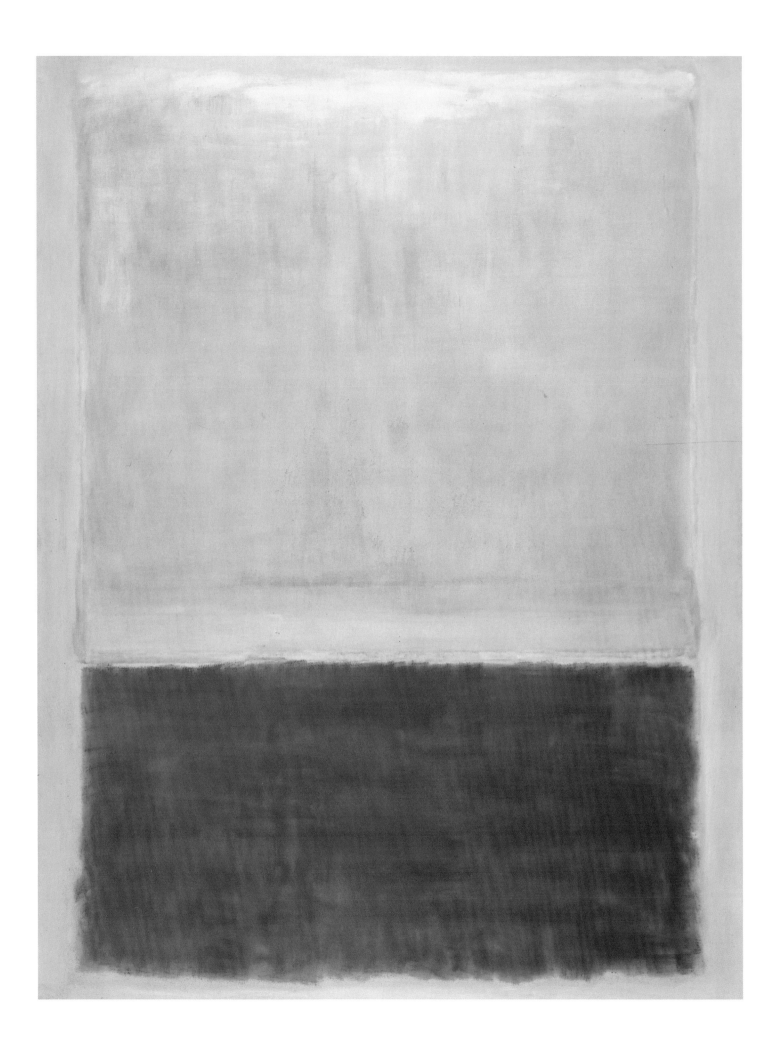

8. Mark Rothko, American, 1903–1970

Lilac and Orange over Ivory, 1953

Oil on canvas, 117½ x 91½ inches
Gift of William S. Rubin; P.961.123
© 2009 Kate Rothko Prizel & Christopher Rothko/Artists Rights Society (ARS), New York

Lilac and Orange over Ivory is a prime example of Mark Rothko's signature composition of luminous rectangles stacked horizontally on a monochromatic field. Characteristically, the canvas is large in scale, so as to create an intimate experience for the viewer. Like many other abstract expressionists, Rothko aimed to create a truly original statement that was universal and roused the viewer's primal instincts and emotions. His work evolved from figuration in the 1920s and 1930s to symbolic and surrealistic imagery in the early 1940s and, ultimately, abstraction in the mid-1940s. By the time his signature composition appeared in 1949, he had eliminated all of the elements from his work that he considered extraneous to his goal. Instead, he concentrated on the plasticity of paint to produce a tactile space that would appeal to the viewer's sense of touch, the most elemental means for comprehending one's environment. Rothko achieved an exciting tension in his painting by altering the width, length, and tangible weight of the rectangles, and modulating thin layers of pigments so that they optically shift position in depth. All the action in the canvas takes place in a very shallow space—the colored ground almost rivals the picture plane, leaving just enough room for the rectangles to expand and contract.

The arrangement of color and form is essential to the impact of Rothko's paintings. There has been some debate over which way this, and other Rothko paintings, should be displayed. In his article "Dis-Orientation: Rothko's Inverted Canvases," Jeffrey Weiss examines the orientation of Rothko's paintings in relation to the artist's process and artistic intent. The author comes to the conclusion that inversion was not just a practical, logistical, or technical maneuver attributable to Rothko's working methods but was conceptually idiomatic to the character and meaning of his work. Weiss notes that in some cases a double signature by the artist appears to sanction both orientations of a canvas (it should be noted that *Lilac and Orange over Ivory* has only one signature on reverse, indicating the lilac at the top), supporting the argument that Rothko viewed and treated the canvas as an object. Painting with equal attention given to each edge and corner, Rothko's work of this time seems almost deliberately calculated to imply rotation. Does inversion or rotation of the canvas change the effects or contradict the intentions of Rothko's work? Weiss asserts that

destabilization and disorientation were chief forms of experience in Rothko's art, apart from the subject of inversion, and throughout his work the artist subjects the principles of orientation and gravity to existential stress.

When the work was donated to Dartmouth College in 1961 by William Rubin, it was titled in the statement of gift "*Lilac and Orange over Ivory*," yet the first two colors were reversed for unknown reasons when the work was referred to in later documentation. The work was installed in an exhibition at the Museum of Modern Art, New York, in 1961 with the artist's participation, titled *No. 8,* and hung with the orange band of color on the bottom of the canvas. It was likewise reproduced in MoMa's exhibition catalogue and in a catalogue by the Whitechapel Art Gallery, London, the same year with this orientation. In 1978, the work was exhibited at the Solomon R. Guggenheim Museum, New York, in the opposite orientation, and a label on the painting's stretcher indicates the orange rectangle as the top of the canvas. Rothko's signature on the reverse of the canvas contradicts this orientation, and it is unclear why or precisely when the painting was hung and reproduced with the orange at the top. David Anfam's catalogue raisonné of Mark Rothko's paintings, published in 1998, reproduces the work as "*No. 8 (Lilac and Orange over Ivory) {Orange and Lilac over Ivory}*" with the orange at the bottom. In this orientation, the symmetrical arrangement of the forms provides stability to the image, while the large lilac rectangle, bearing downward, keeps the orange field from floating away. Drips visible in the lilac paint indicate that much or perhaps all of this section was executed with the lilac at the bottom of the canvas. Rotation of the canvas during execution makes sense because Rothko's very thin dilutions of paint were given to run. As Weiss has shown, Rothko also experimented with orientation before settling on a final decision for exhibition. Recently, after removing the backing of the painting, assessing all of its markings, and re-examining our records, the Hood Museum of Art decided to reproduce and exhibit the work as *Lilac and Orange over Ivory,* as it is believed was the artist's intention in 1953. [Weiss 2005; Whitechapel Art Gallery 1961 and Selz 1961; Solomon R. Guggenheim Museum 1978; Anfam 1998]

BC, BK, ESB

9. Matta, Chilean, 1911–2002

A Pinch of Earth, 1953

Oil on canvas, 41 x 46¼ inches
Gift of Thomas George, Class of 1940; P.965.74
© 2009 Artists Rights Society (ARS), New York/
ADAGP, Paris

In the early 1950s, Roberto Echaurren, known as Matta, was living in Rome, but he would soon return again to the surrealists in Paris. He had first encountered them in the 1930s, having left his native Chile with a degree in architecture to serve as an assistant to Le Corbusier in 1933–34. During World War II he would join André Breton, Yves Tanguy, André Masson, and others in departing Europe for the United States, where he had his first exhibition and would remain throughout the 1940s. In New York, Matta exercised a significant influence on abstract expressionists such as Arshile Gorky, Jackson Pollock, and Robert Motherwell. With the surrealists, however, Matta shared a Freudian perspective focused on "psychological morphologies," his version of surrealist "psychic automatism," and involved seeing "within one's self." By the mid-1940s he had begun to incorporate responses to the desolation inflicted by war and social injustice into his work.

A Pinch of Earth features bonelike, biomorphic forms in a dark, moody dreamscape characterized by turbulence, defiance, and hope. Matta's emerging desire to reflect social reality anchors the image along a recognizable horizon, over which a rising sun's glimmer expands to intermingle with shooting sparks from a force field of colorful lights, linking day and night, or this side of the horizon and what lies beyond. Insect-like creatures encased in gauzy cocoons energize the strange landscape, which is further galvanized by an oddly realistic human fist caught in defiant motion. The architectural shape of the force field evokes another untitled work

from 1949, pictured here, in which the viewer's perspective hovers over a cityscape, at once enveloped by and excluded from it via a Moebius-like continuum of realities. The combination of perspectives reflects Matta's enduring allegiance to surrealism at a time when the movement was reasserting its political activism without sacrificing its dedication to chance and to dreams. KC

Fig. 1. Matta, *Untitled*, 1949, oil on canvas, 31 x 38⅝ inches. Gift of Mr. and Mrs. Thomas R. George, Class of 1940; P.998.48. © 2009 Artists Rights Society (ARS), New York/ADAGP, Paris.

10. Pierre Jean Louis Soulages, French, born 1919

Untitled, 1953–54

India ink, graphite, 29⅝ x 20⅝ inches
Gift of Evelyn A. and William B. Jaffe, Class of 1964H; P.959.137.4
© 2009 Artists Rights Society (ARS), New York/ADAGP, Paris

Asked about his art movement affiliation, Pierre Soulages declared, "There can only be one school for a painter—the school of freedom." Throughout his long career Soulages has remained firmly attached to this belief that it is through the maintenance of a self-driven style that an artist becomes important. While loosely linked to the French movement of Tachisme, a lyrical reaction to cubism that was concurrent with abstract expressionism in America, Soulages rejects close associations with any particular style, insisting upon painting that stems from a single brushstroke, not from a preconceived notion of what art should be. Scholar James John Sweeney puts it well when he notes that Soulages is linked: "To French greats from Fouquet through Poussin and Cezanne, in this monolithic integrity of vision and purpose, this courage to carry on constantly in his own lane and to work out an idiom which is only his."

Raised in the village of Rodez, Soulages imparts into his work the rhythms and monumentality of the local Romanesque architecture, epitomized by the Sainte Foy abbey-church in nearby Conques. An added sense of weight and time comes perhaps from the ancient ruins of the region, remnants of stone structures and enigmatic pictographs. As in much of his work, in *Untitled* Soulages sternly restricted his palette to black and white. He allowed each brush stroke to call forth the next, rather than working from a preparatory drawing. His broad swathes of black impasto contrast boldly with the white ground. In combination with the sharp definition of the massive black lines, the stops and starts that occur as the brushstrokes collide with the edge of the canvas create the impression of containment. Within the heaviness of the starkly bounded strokes, there is sense of potential energy. The composition stands calmly in balance, but the force of the painter and his strokes is palpable. By adding texture to the paint's surface through back and forth movements of the brush, Soulages causes light to reflect out of the darkness, creating a surprising and enticing luminosity. [Ashton 1957 (quotation); Sweeney 1968: 14 (quotation)]

AHW

33

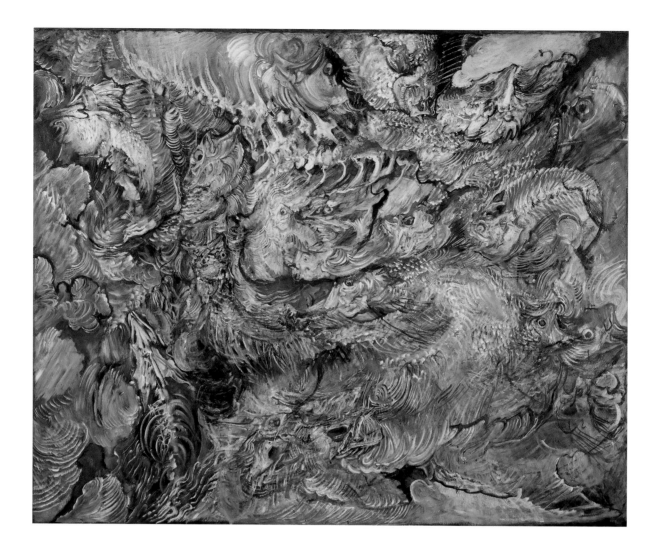

11. Hyman Bloom, American, born 1913

Blue Seascape, 1955–56, repainted 1980

Oil on canvas, 48⅛ x 60 inches
Gift of Dorothy Thompson, in memory of Lawrence Thompson, Class of 1941;
2005.64.1

Hyman Bloom spent the first seven years of his life in Latvia before immigrating to America with his family in 1920. His early childhood was marked by conflict and violence. The Orthodox Jew community was almost always on the receiving end, whether at the hands of the Germans and the Russians, or the Bolsheviks and their anti-Communist opponents. His family settled in Boston, the city that would remain his artistic center throughout his career. While he questioned many of the tenets of his religious upbringing later in life, his spirituality continued to have a powerful presence in his work.

After taking drawing classes at the Boston Museum of Fine Arts, Bloom, alongside Jack Levine, studied under Harold Zimmerman and Denman Ross. The influence of the three men lasted for much of Bloom's career. With Levine, Bloom became associated with the development of the style known as Boston Expressionism. Bloom drew upon his imagination and his interest in the supernatural, always striving to tell a story through his work. He rendered macabre subjects such as corpses and religious figures from the Jewish tradition with the same dynamically sweeping brushstrokes and radiantly contrasting colors, contemplating mortality and the possibility of transcendence. Everpresent in his work is the tension between the dangerous and the beautiful. Through a blend of abstract, surreal, and figurative forms Bloom expressed his personal understanding of the discovery of self through the transformative power of art, saying, "The inside of the body is a fascinating place. The outside is always being tended and primped, but whatever is outside originates inside."

Although his work generally concentrated on religious themes, starting in the mid-1970s, while living above the Legal Seafoods restaurant in Boston, Bloom began to explore forms from the ocean. He infused these compositions with the same turbulent energy and swirling colors of his other works. One of five such works, *Blue Seascape* depicts the natural world "as a heightened state of mind." In the seascape, the contours dissolve easily into one another. The high pitch of the complementary colors adds to the painting's vivacity. [Thompson 1996: 23, 10 (quotations)]

AHW

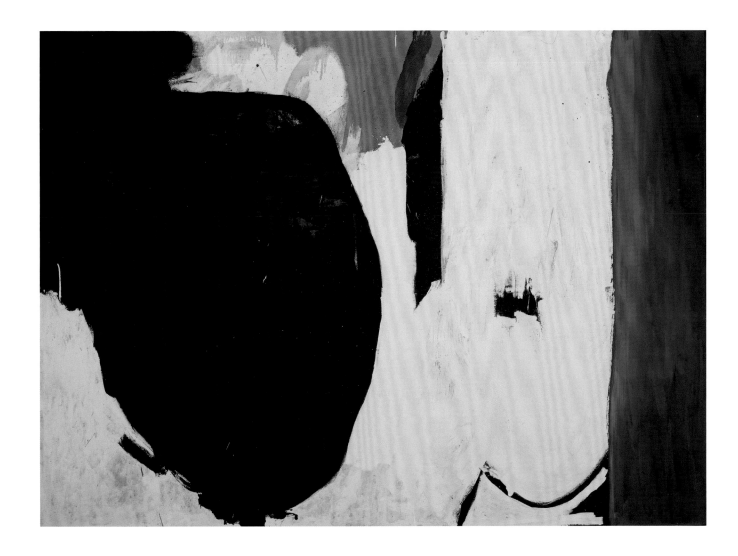

12. Robert Motherwell, American, 1915–1991

Chambre d'Amour, 1958

Oil on linen, 66 x 91 inches
Partial purchase through gifts from Melville Straus, Class of 1960, and the
Lathrop Fellows, and a partial gift of the Dedalus Foundation, Inc.; P.996.21.1
Art © Dedalus Foundation, Inc./Licensed by VAGA, New York, NY

In the summer of 1958, Robert Motherwell—recently married for the third time—spent several months working in the small fishing port of St. Jean-de-Luz in southeastern France near the Spanish border with his new wife, the painter Helen Frankenthaler. *Chambre d'Amour* was painted there during a period of great productivity that marked the opening of a new chapter in the artist's career. While it is tempting, and certainly appropriate, to associate the title that Motherwell gave to this work with the conjugal happiness he felt at this time, *Chambre d'Amour* no doubt refers, ironically and more darkly, to a famous beach in Anglet, to the north of St. Jean-de Luz, and a nearby cave of the same name close to which two lovers were said to have drowned.

The late 1950s—and, in particular, the period during which *Chambre d'Amour* was created—witnessed a flowering of Motherwell's art, one that was marked by a broader and more experimental approach to painting than had characterized his work up to that point. In addition to continuing to paint variations on the pictorial theme titled *Elegy to the Spanish Republic* (and producing some of his finest works in this series), he also explored several different visual motifs and created some of the most aggressively gestural works of his career.

The compositional elements of *Chambre d'Amour,* most notably the large black oval to the left and the broad, blue vertical band on the right, are closely related to the Spanish elegies and may represent a reworking of a canvas that was once intended to be part of this series. On the other hand, like many other paintings that Motherwell produced in that year, it pushes in several new directions and is uncharacteristically rough and assertive, both in terms of its draftsmanship and the handling of paint. "Painting," he once noted, "must be sensual—that is its nature—but it must not be pleasing or decorative. The artist's essential function is to retain integrity at any cost in an essentially corrupt world which seduces and destroys all of us." [Arnason 1982: 11 (quotation)]

TR

35

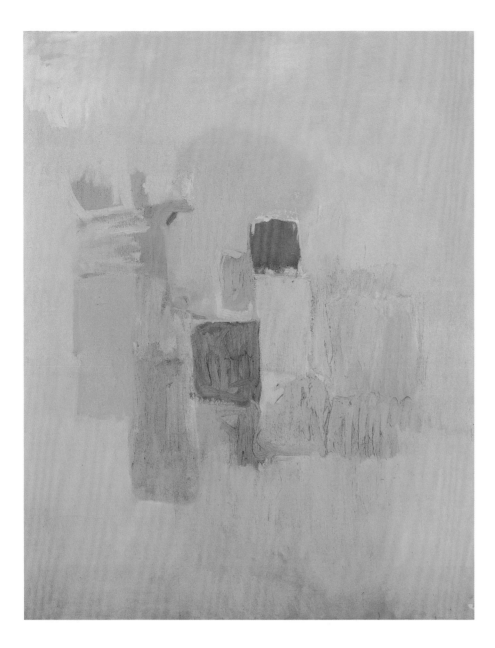

13. Esteban Vicente, American,
1903–2001

The Yellow World, 1958

Oil on canvas, 60 x 48 inches
Gift of Evelyn A. and William B. Jaffe, Class of 1964H;
P.964.205

Esteban Vicente was born in Spain and studied at the Academy of Fine Arts of San Fernando in Madrid. Like many young artists of his day, he was drawn to the art world of Paris and moved there in 1929, where he met his fellow expatriate Picasso. Vicente, however, worked independently of the Spanish painters in Picasso's circle, and continued to paint directly from nature, focusing on landscapes. In the late 1930s, after a short period painting camouflage on trucks for the Republican anti-fascist forces in Spain, he moved to New York City, where he retained a studio for the rest of his career.

It was here that he first came into contact with the group of artists known as the New York School. Painting large abstract canvases, Vicente gained prominence with his inclusion in *Talent 1950,* an exhibition curated by Meyer Schapiro and Clement Greenberg for the Sam Kootz Gallery that also featured Elaine de Kooning, Franz Kline, and Larry Rivers. Through Vicente's paintings one can trace the currents of cubism, abstract expressionism, and color

field painting, yet he did not consider himself an "action painter" or a color field artist. Rather than revering the flat surface or framing edge of the painting, Vicente stressed the paint itself: "The pigment is a very complicated thing. It works very much the same as sound in music. So you have to understand the material and have a feeling for it. And when you have that, at the end it becomes a part of yourself . . . when you look at the raw pigment . . . it has a very sensuous quality to the eye and you feel it."

The Yellow World is one of a small group of works Vicente painted in the mid- to late 1950s that reveals a careful orchestration of subtle variations of color within the same tonal range. This experimentation with color would consume him for the next four decades. An energetic composition of dense, interlocking shapes, *The Yellow World* is dominated by a well-worked surface, bold yet elegant color combinations, and staccato rhythms that belie the many artistic movements influencing the artist at the time. [Frank 1995: 48 (quotation)] ESB

14. Enrico Baj, Italian, 1924–2003

The Grand Uniform (The General), 1958

Oil, glass, rope, medals, and fabric collage on canvas, 51 x 37⅞ inches
Gift of Ernestine and Herbert S. Ruben; P.976.284

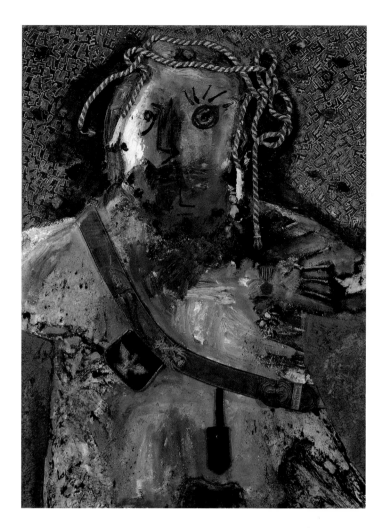

The flamboyant Enrico Baj, in his heyday, had followers and collectors from Milan to Paris and London to Chicago, but not, remarkably, in Rome or New York. As critic Christopher Masters described, "His vivid, often nightmarish, images and outspoken writings were a constant challenge to artistic and political orthodoxies." Lawyer, internationalist, stylistic inventor, pamphleteer, and political activist, Baj alienated the powers that be in those places while garnering the critical admiration of the likes of Marcel Duchamp and André Breton in the 1960s, and Umberto Eco and Jean Baudrillard in more recent times. He loved to bait and challenge, and his targets included the French generals in Algeria, the organizers of the Venice Biennale, Richard Nixon, the police commissioner of Milan, and ultimately the Italian prime minister, to whom he devoted an elaborate spoof, *Berluskaiser,* in 1994. A friend of poets, he illustrated a host of books with original graphics; generous to colleagues, he made "duo-paintings" with Asger Jorn, Lucio Fontana, Pierre Alechinsky, and Corneille, among others.

Baj may be best known for his generals, hulking warriors portrayed against tapestry backgrounds and proudly exhibiting their insignia, sashes, and medals. Another Milanese fabulist, Giuseppi Archimboldi, had set a precedent in the sixteenth century by portraying librarians whose heads and bodies were composed of books or gardeners put together with fruit and vegetables. In that same spirit, Baj constructed a series of anthropomorphic furniture pieces with wood veneer and actual accessories against brocade backgrounds.

My first encounter with Baj's generals was at the 1962 Seattle World's Fair. Four years later, the Arts Club of Chicago invited me to write the introduction to the catalogue of an exhibition of forty of Baj's painting drawn from Midwestern collections. One of its highlights, I vividly remember, was Mrs. Harry Lewis Winston's *The Grand Uniform.* Ten years later, in the Princeton dining room of Herbert and Ernestine Ruben, the same painting reappeared. My hostess explained that she was Mrs. Winston's daughter and that her mother, whom I had since come to know as Lydia Malbin, had given her the painting. Would Dartmouth, her husband's alma mater, be interested in receiving it as a gift? [Masters 2003 (quotation)] JVDM

Enrico Baj completed forty paintings in the late 1950s and early 1960s that feature a medal-emblazoned military figure. In both his career and his life, Baj was known for his forceful activism. These paintings are overtly topical, commenting on political oppression, the madness of France's war with Algeria, and the generals that made a mess of it. While his painting is figurative and representative, pointing to particular themes rather than to the emotional subconscious, the thickly textured surfaces and roiling colors of Baj's canvases show an affinity with expressionism. *The Grand Uniform (The General)* belonged to a group of generals that drew the attention of the Paris Surrealists, André Breton among them, and Marcel Duchamp and Man Ray in particular, who became fond of the younger artist and subsequently collaborated with him.

AHW

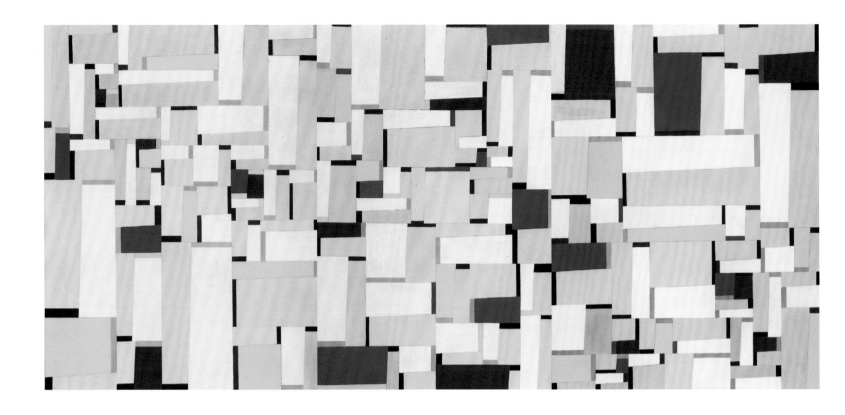

15. Fritz Glarner, American, 1899–1972

Relational Painting #88 (Project for Time-Life Building, New York City), 1958–59

Oil on canvas, panel 1 of 3: 90 x 69½ inches, panel 2 of 3: 90 x 60½ inches, panel 3 of 3: 90 x 68 inches
Gift of Wallace K. Harrison, Class of 1950H, in honor of Nelson Rockefeller, Class of 1930; P.968.100.1–3

Fritz Glarner was born in Zurich, studied painting in Italy, and moved to the United States in 1936. Working in New York, he met other abstract artists and introduced them to De Stijl, the Dutch school of geometric abstraction in which he had been trained. Glarner's *Relational Painting #88*, completed in 1959, is a tripartite oil study for a mural in the lobby of the second Time-Life Building in New York, an integral decorative element in the Rockefeller Center Complex designed by Wallace K. Harrison in 1959–60 (fig. 1). The compatibility of the geometric, nonrepresentational mural with its modern architectural setting suggests a high degree of collaboration between artist and architect.

Glarner's oil study explores the interdependence of color and form in a unified design. Influenced by the work of Dutch artist

Fig. 2. Fritz Glarner, *Tondo Study for a Relational Painting*, 1962, charcoal and colored crayon on wove (Umbria) paper, 20½ x 13¼ inches. Gift of Wallace K. Harrison, Class of 1950H; D.968.8.

38

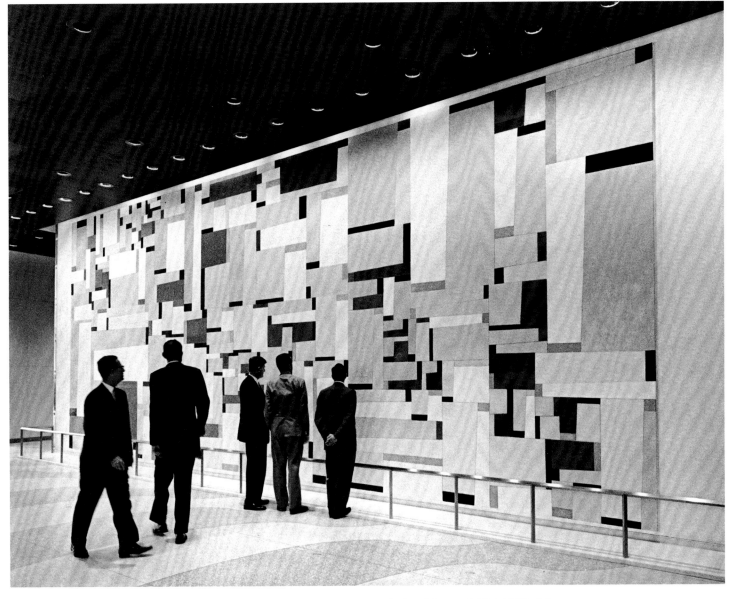

Fig. 1. Visitors viewing *Relational Painting #88* by Fritz Glarner, which decorated the lobby of the new TIME & LIFE building. Photo by Andreas Feininger/Time & Life Pictures/Getty Images.

Piet Mondrian, Glarner adopted Mondrian's simplified vocabulary of forms and colors arranged architecturally without representational reference. In an elegant innovation on this De Stijl style, Glarner adds gray to his primary color palette, as well as canted lines and long diagonals. These modifications enliven the canvas with vigorous movement, add a spatial dimension to the composition, and contradict the static nature of his rectangles. This study asserts its dynamism, geometry, and universality at once.

Tondo Study for a Relational Painting, 1962 (fig. 2) a charcoal and colored crayon drawing, shares the energy of *Relational Painting #88,* and its hastily drawn lines contribute an active sense of rhythm. In both this study drawing and the final painting, Glarner adheres to the De Stijl philosophy of avoiding the use of curved lines because of their perceived emotional associations. Instead, by enclosing the straight lines and rectangles within a circular form, Glarner emphasizes his hard edges and the union of pure color and form that he achieves. ESB

16. Milton Resnick, American (born in the Ukraine), 1917–2004

#8, 1959

Oil on canvas, 51 x 49 inches
Gift of Mr. and Mrs. Howard Wise; P.976.272
© Estate of Milton Resnick, Courtesy of Cheim & Read, New York

Born in Bratslav, Ukraine, in 1917, Milton Resnick immigrated to the United States with his family in 1922. Following several years of schooling at the American Artists School in New York, Resnick worked as a member of the Federal Arts Project in 1938, although he never painted a mural for the program. Drafted into the U.S. Army in 1940 at the outbreak of World War II, Resnick returned to New York in 1945 and immediately began painting in a devotedly abstract fashion.

Like Adolph Gottlieb, Milton Resnick was a member of the first generation of abstract expressionists, working in the late 1940s and early 1950s. Yet unlike Gottlieb, Resnick remained dedicated to their earliest concerns, developing a style of abstraction that explores the properties of paint pigment and its "all-over" application to the canvas. Resnick's work is characterized by an emphasis on the act of painting itself—on the gestural "handwriting" of the artist—and by a lyrical use of color. "The emblems and compositional structures are gone," James Schuyler wrote of Resnick's work in 1960. "He has revolutionized his style by concentrating on the smallest element—the stroke—in the name of joy or beauty."

A delicate but deliberate composition of swirls of color, free from subject matter, #8 is representative of Resnick's paintings of this time. Through his unwavering and lifelong commitment to working in this style, Resnick sought to give meaning to abstraction and make his pictures only of paint, without lines. He explains: "There is no eccentricity in the way I paint . . . I have processes. It's when I pull the brush across that I look for a painting. What I like is for a painting to act in many different directions at once, so strongly that it will shatter itself and open up a small crack, which will suck the world in." [Cathcart 1985: 7 (quotation); Schuyler and Pettet 1998: 184 (quotation)] ESB

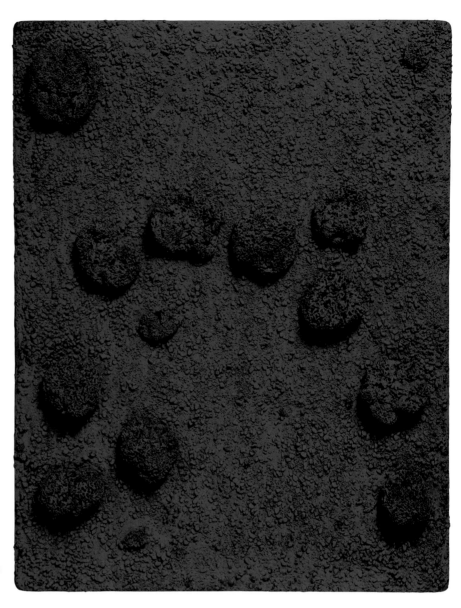

17. Yves Klein, French, 1928–1962

Blue Monochrome Sponge Relief (RE24), 1960

Sponges, pebbles, dry pigment in synthetic resin on wood board, 57¼ x 45⅜ x 3¾ inches
Gift of Mr. and Mrs. Joseph H. Hazen; P.961.288
© 2009 Artists Rights Society (ARS), New York/ADAGP, Paris

At the age of eighteen Yves Klein began making monochromatic paintings in an attempt to fix the "total freedom of pure and sensitive space . . . to see, see with my own eyes, what was visible of the absolute." After ten years of experimenting with a variety of colors, Klein focused on an intense ultramarine blue, a color that for him had associations with the sky and sea of Nice, where his family had spent summer vacations. "International Klein Blue" ("I.K.B.") became the dominant color in his work during his brief but productive career. Blue was for Klein the color of the infinite and of the void—a color "beyond dimensions."

The series of sponge reliefs including *Blue Monochrome Sponge Relief (RE24)* developed from his experimentation with sponges as a means of applying paint. Natural sponges saturated with pigment embodied Klein's ideal of making real the deep, limitless blue of sea, sky, and space. The sponge itself became a metaphor for the ability of the viewer to absorb this ethereal and abstract expanse of color. Klein explains: "The extraordinary capacity of sponges to absorb everything fluid fascinated me. Thanks to the sponges I was going to be able to make portraits of the observers (*lecteurs*) of my monochromes, who, after having seen, after having voyaged in the blue of my pictures, return totally impregnated in sensibility, as are the sponges." In their highly textured, grounded materiality and protruding three-dimensionality, the sponges are able to extend the abstract, flat planes of color into the real space of the viewer.

[Institute for the Arts, Rice University 1982: 111 (quotation)]

ESB

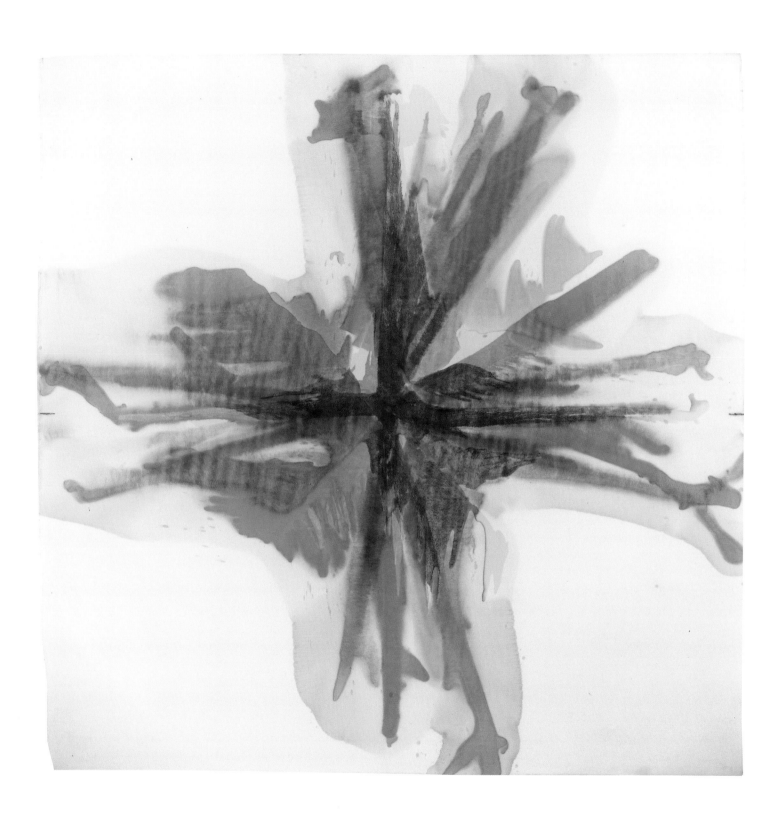

18. Kenneth Noland, American, born 1924

Shallows, about 1960

Oil on canvas, 117¾ x 118 inches
Gift of William S. Rubin; P.961.124
Art © Kenneth Noland/Licensed by VAGA, New York, NY

After serving in World War II, Kenneth Noland began his studies at Black Mountain College on the G.I. Bill in 1946. It was there, in the college's flourishing arts community, that Noland was introduced to both the artistic practice and theories of abstraction and color. While finishing his studies at the college in 1950, Noland became acquainted with Clement Greenberg and Helen Frankenthaler, who were on campus as lecturer and visiting artist, respectively. These encounters, particularly with Frankenthaler, dramatically influenced Noland's production process. A mere decade later, Greenberg proclaimed Noland to be "among the chief proponents of what has come to be known as Color Field painting."

Noland witnessed Frankenthaler's use of thinned oil paint during a trip to her studio, made at the suggestion of Greenberg, in 1953, and realized a new direction for the kind of abstraction he would produce. Noland was influenced by the work of action painters like Jackson Pollock; however, while the action painters maintained the gesture implicit in the production of their work as subject, building upon Frankenthaler's model, Noland created a staining technique that allowed his materials to become the subject of his paintings. With staining, as Noland attests, "the allusions began to be more towards what the painting was made of, how it was made rather than towards subject matter. That became interesting enough that it was possible to eliminate having to make reference to all other subject matter considerations, all allusions beyond the physical reality of the picture."

Re-visioning the notion of compositional space in the painterly tradition, in the mid-1950s Noland's work began to converge in the center of his canvases. *Shallows* reflects this negating of the spatial assumptions of foreground and background, with the saturation of colors pooling in and expanding outward from the core of the canvas in a starburst pattern. Bands radiate from the very center of the canvas. The shape formed by the thinned oil paint alludes to the more structured circles, stripes, and chevrons (fig. 1) that also have defined Noland's career and thus provides an important insight into the artist's stylistic evolution. [Greene 2004: 2 (quotation); Wilkin 1990: 14 (quotation)] KMG

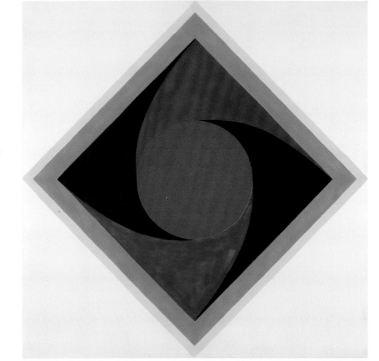

Fig. 1. Kenneth Noland, *Shield,* 1962, acrylic resin on canvas, 117¾ x 118½ inches. Gift of the artist; P.964.87. Art © Kenneth Noland/Licensed by VAGA, New York, NY.

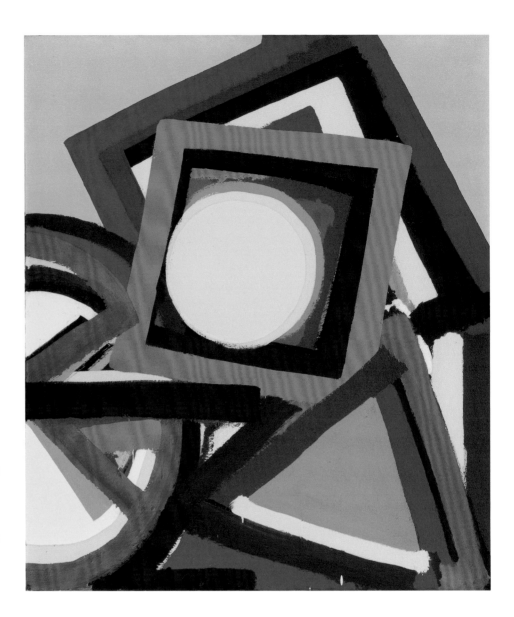

19. Al Held, American, 1928–2005

#9, 1960–61

Acrylic on canvas, 60⅛ x 52⅛ inches
Gift of Remsen M. Kinne III, Class of 1952; P.991.19.2
Art © Al Held Foundation/Licensed by VAGA,
New York, NY

In 1948, twenty years old and having never entered a museum, Al Held joined New York City's Arts Students League and started taking classes. As a Navy veteran, Held was due three years of compensation from the G.I. Bill, so in 1950 he left New York to study in Paris. He returned in 1953 to the full-blown influence of the New York School. Particularly affected by the paintings of Jackson Pollock and Mark Rothko, Held's work was characterized by deep colors, sweeping brushwork, and vigorous fluidity of form. By the end of the decade, however, Held began to move away from gestural abstraction, later stating, "I wanted to do to Abstract Expressionism what Cezanne did to Impressionism." No small task, to Held this meant developing structure, simplifying form, and adding monumentality.

The painting *#9* from the year 1960 exemplifies this stage of Held's continuing evolution as an artist. Concurrent with his stylistic shift was a change in medium, from oil or encaustic to acrylic paint. The fast-drying property of acrylic allowed Held to paint multiple coats and rework the surface without the sculptural build-up and blending associated with abstract expressionism. Instead, his paintings retained a flat and smooth surface, with sharp delineations between the forms. Fitting loosely within the style of post-painterly abstraction, Held sought to make work that was both clean and clear. The majority of artists working in the mode of post-painterly abstraction sought calm, neutral interactions with the canvas' frame. Held's work, on the other hand, maintained a certain expressionism. Through the 1960s, his compositions continued to burst dynamically out from the limits of the picture plane, as the circles and squares of *#9* press forcefully into and beyond the edge of the canvas. This dynamic formal quality reinforces the importance of space, and the focus spreads to the boundaries between painting and viewer. This is further emphasized by the monumental scale, which forces the viewer's movement in space in order to process the entire composition. [Held December 12, 1975: quotation] AHW

20. Richard Joseph Anuszkiewicz, American, born 1930

Lunar, 1967

Liquitex on canvas, 60 x 60 inches
Gift of Evelyn A. and William B. Jaffe, Class of 1964H; P.967.103
Art © Richard Anuszkiewicz/Licensed by VAGA, New York, NY

21. Richard Joseph Anuszkiewicz

From Blue, 1972

Acrylic on canvas, 72 x 72¼ inches
Gift of Henry Feiwel; P.973.384
Art © Richard Anuszkiewicz/Licensed by VAGA, New York, NY

22. Hannes Beckmann, American, 1909–1977

Muted Center (Blue Light), 1965–73

Acrylic on canvas, 40 x 40 inches
Gift of the artist; P.973.118

23. Josef Albers, American, 1888–1976

Study for Homage to the Square (Early Rising), 1961

Oil on composition board, 39 ¾ x 39 ¾ inches
Gift of Ellen and Wallace K. Harrison, Class of 1950H, in honor of
Nelson A. Rockefeller, Class of 1930; P.968.7
© 2009 The Josef and Anni Albers Foundation/Artists Rights Society (ARS),
New York

24. Hannes Beckmann

Aurora, 1967

Acrylic and oil on canvas on board, 42 x 62½ inches
Gift of the artist; P.969.44

20

21

Geometric and hard-edged abstraction gained new momentum in the United States on the heels of abstract expressionism. Eschewing narrative and subjectivity, a significant faction of the postwar formalist painters sought to elicit personal and visceral responses to visual stimuli, privileging the viewer as the ultimate subject of their work. The origin of this perceptual abstraction lay in constructivist practices dating back to the first quarter of the twentieth century, including Russian suprematism and European neoplasticism, aesthetic movements with stated philosophical and spiritual underpinnings. While such traditions were sustained abroad in various forms of non-objective or "concrete" art, their impact in America was felt only after World War II, reaching full force in the restless decade of the 1960s with the dynamic perceptual abstraction of Op Art.

The formal and theoretical principles that defined this burgeoning generation of postwar painters had been conceived several decades earlier at the Bauhaus in Germany. Between 1919 and 1933 the innovative school was a crucible of creativity under the direction

22

23

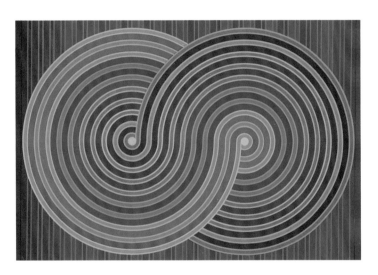

24

of artists like Wasily Kandinsky, Laszlo Moholy-Nagy, and the young Josef Albers, a former student who had risen quickly to the rank of instructor. Albers's preliminary course in design, the *Vorkurs,* attracted students like Max Bill (fig. 1)and Hannes Beckmann, who later became influential teachers in their own right.[1] With the closing of the Bauhaus by the Nazis in 1933, its faculty and students dispersed globally, spreading an egalitarian modernist ideal that united art, craft, and technology. Josef Albers was among the first of them to immigrate to the United States, quickly gaining distinction as an instructor at Black Mountain College in the 1930s and later at Yale throughout the 1950s. His teaching elaborated on his belief that the aim of art should be "the revelation and evocation of vision," a tenet that motivated his own paintings and writings, including the landmark text *The Interaction of Color.*[2]

Among Albers's pupils at Yale were Richard Anuszkiewicz and Julian Stanczak (fig. 2), friends who had traveled from Ohio to New Haven in 1953. There they absorbed Albers's rigorous theory and practice of color and were exposed to new ideas in perceptual psychology, most notably the seminal writings of gestalt psychologist Rudolf Arnheim, who had once visited the Bauhaus in its heyday.[3] Both pupils would be guided by the lessons of Arnheim's 1954 publication *Art and Perception: Toward a Psychology of the Creative Eye,* which explained the psychic effects of form, color and composition, thus suggesting a more dynamic and interactive approach to abstraction.[4] Arnheim demonstrated that "looking at the world proved to require an interplay between properties supplied by the object and the nature of the observing subject."[5] Although Anuszkiewicz and Stanczak remained figurative painters upon their graduation from Yale, their work soon evolved into pure abstraction dominated by unmodulated color placed in highly structured patterns motivated by gestalt theory. Anuszkiewicz exhibited alongside his mentor in the Whitney Museum of American Art's 1962 exhibition *Geometric Abstraction in America,* which paid tribute to Albers as "a powerful and enduring force of inspiration, rediscovered by each generation of artists."[6]

Anuszkiewicz's transformation into a geometric painter was in evidence by the early 1960s in the characteristics of his highly stimulating aesthetic: a square format, periodic linear structures, precisely masked edges, and intense color contrasts, particularly his signature palette of hot/cold complements. Early on, one reviewer noted that "Anuszkiewicz's colored geometry becomes a kind of crazy-quilt corridor into which the eye is drawn and held dizzily as in some enchanted funhouse."[7] This held true throughout the

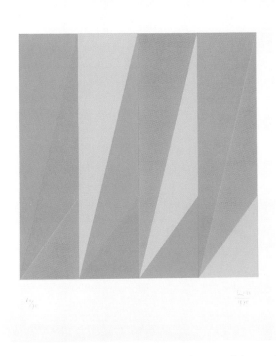

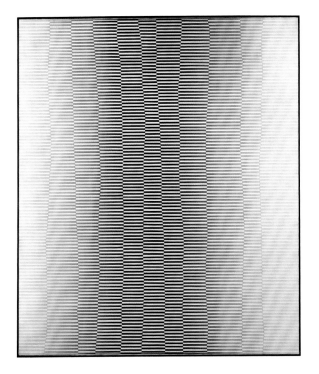

Fig. 1. Max Bill, Swiss, 1908–1994, *Four Colors,* 1975, lithograph, 21¼ x 21¼ inches. Gift of Mr. Eastman Birkett, Class of 1942; PR.980.49. © 2009 Artists Rights Society (ARS), New York/ProLitteris, Zürich.

Fig. 2. Julian Stanczak, American, born 1928, *Consonance,* 1967, acrylic on canvas, 50½ x 43½ inches. Purchased through the Julia L. Whittier Fund; P.968.88.

decade as his paintings became increasingly more complex in their color relationships and spatial ambiguity—compare the electrifying red/blue contrast of *Lunar* (1967; cat. 20) to the broad spectrum of hues radiating from the center of *From Blue* (1972; cat. 21), which nevertheless retains a similar vertiginous power.

While he soon became a leading exponent of perceptual painting who was given extensive coverage in the critical and popular press, Anuszkiewicz was not alone in pioneering an interactive form of abstraction. Other artists exploring optics and kinetics, including Victor Vasarely of France (cat. 7), Jesus Rafael Soto of Venezuela, and Bridget Riley of England (fig. 3), were already exhibiting in Europe, loosely aligned under the banner of "Nova Tendencija" (the New Tendency) as early as 1961.[8] Closer to home, Julian Stanczak was quietly pursuing his own brand of perceptual abstraction in Cincinnati, exploring visual sensation within a limited, often monochromatic palette (fig. 2). Stanczak's first New York exhibition in 1964, titled *Optical Paintings,* gave a name to the new American tendency, which Donald Judd, in his review of Stanczak for *ArtForum,* shortened to "Op Art," the logical successor to Pop Art.[9] When the Museum of Modern Art debuted its popular traveling exhibition *The Responsive Eye* in 1965, which included the young Americans like Anuszkiewicz and Stanczak alongside their counterparts from around the globe, perceptual art gained the status of a full-fledged international movement, and "Op" became a household term.[10] The popular reception, and ensuing critical backlash, was due in great measure to Op Art's democratic stance.[11] Although it represented a critical step in the

development of abstraction from Monet to Malevich to Albers, no knowledge of art history or theory was required to comprehend it.[12] Harnessing quivering linear structures, palpitating color vibrations, and confounding spatial paradoxes, Op Art paintings became catalysts for extraordinary personal experiences involving the eye and mind, fulfilling their dictum of placing the viewer at the center of the aesthetic equation.

While feting a forward-looking generation, *The Responsive Eye* also acknowledged those senior artists who had seeded the formal principles of geometric and systematic abstraction. Albers, Beckmann, and Bill were included in Seitz's checklist, as they were in many subsequent exhibitions of the movement. Long underappreciated, Albers saw his reputation enhanced by the success of his students, and he became known as the Father of Op.[13] His Bauhaus colleague Hannes Beckmann likewise received renewed attention for his geometric abstractions within the context of the younger perceptual painters. Beckmann shared Albers's fascination with the effects of transparency in painting, often modulating a single hue into overlapping forms to suggest illusions of space and light. The incremental gradations in Beckmann's *Muted Center (Blue Light),* dating from 1965 to 1973 (cat. 22), offers a subtle counterpoint to Albers's elemental *Homage to the Square* series (cat. 23). The analytical rigor of such compositions is matched by Beckmann's almost clinical description of his process as "a spontaneous geometry of vision and a controlled palette based on the reaction of our nervous system to color sensation."[14] He observed the Op Art phenomenon to be "a kind of expression of what is

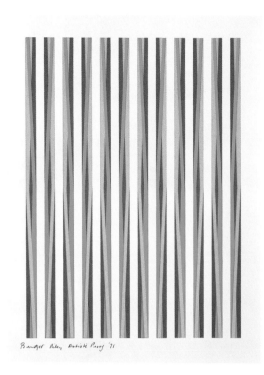

Fig. 3. Bridget Riley, British, born 1931, *Print for Chicago 8,* from the portfolio *CONSPIRACY: The Artist as Witness,* published 1971, screenprint on handmade rag paper, 24 x 18 inches. Gift of David R. Godine, Class of 1966; PR.972.224.9.

going on also in the world of science. It runs parallel to what is going on in the world of mathematics, in physics. That things are not absolute."[15]

Beckmann became increasingly interested in the symbolic potential of abstraction. Adhering less to Op Art's insistence on perceptual purity, he injected symbolism into his abstractions. The infinity sign and yin-yang symbol that began to dominate his compositions in the late 1960s proved attractive for both their symmetrical structures and their conceptual connotations. The pattern that dominates *Aurora* (1967) (cat. 24) displays spiritual concerns that go beyond optical acrobatics. The most innovative artists of the Op Art generation, such as Anuszkiewicz, Stanczak, and Riley, continued to mine the possibilities of perceptual abstraction throughout the 1960s and into the decades beyond, each with an increasingly distinct vocabulary of form and color. Without literal references, their work often parallels, and occasionally exceeds, our experience of the visible world, while making us more acutely aware of our own process of vision. JH

NOTES

1. The fundamental role of the Vorkurs is detailed in Marty Bax, *Bauhaus Lecture Notes 1930–1933* (Amsterdam: Architectura and Natura Press, 1990). Bill taught in Zurich during the war and later returned to Germany to open the Hochschule fur Gestaltung (University of Forms) in Ulm in 1950. The following year, he was featured in the inaugural Sao Paulo Biennial, thus beginning his extended contact with, and influence on, South American artists and architects. Beckmann was interned in a concentration camp in 1944 and immigrated to the United States four years later to head the photographic department at the Guggenheim Museum. He later taught at the Cooper Union in New York (1952 to 1970), was visiting critic at Yale (1970 to 1971), and taught in the Visual Studies Program at Dartmouth (1970 to 1975).

2. Josef Albers, *The Interaction of Color* (New Haven: Yale University Press, 1963, rev. and exp. 1975).

3. Roy R. Behrens, "Rudolph Arnheim: The Little Owl on the Shoulder of Athene," *Leonardo* 31, no. 3 (1998): 231–33.

4. In separate taped interviews with the author in the summer of 2006, Anuszkiewicz and Stanczak remarked upon the influence of Arnhem's publication. Stanczak noted that during his time at Yale he spent months translating the text word for word into his native Polish. Arnheim later returned the favor, writing an illuminating essay for the book *Julian Stanczak: Decades of Light* (Buffalo: University of Buffalo, Poetry and Rare Book Collection, Buffalo, New York, 1990).

5. Rudolf Arnheim, *Art and Visual Perception: A Psychology of the Creative Eye,* 1954, introduction to later edition (Berkeley: University of California Press, 1974), 6.

6. John Gordon, *Geometric Abstraction in America* (New York: Whitney Museum of American Art, 1962), 11.

7. Author unidentified, "Simple Form, Simple Color," *Time* (July 19, 1963): 56.

8. For complete roster of artists involved in the New Tendency exhibitions, which took place in Zagreb, Leverkusen, Paris, and Venice from 1961 to 1973, see Ines Bauer et al., *Die Neuen Tendenzen: Eine europaische Kunstlerbewegung 1961–1973* (Ingolstadt: Museum fur Konkret Kunst, Edition Braus GmbH, 2006), 227–33.

9. Donald Judd, "In the Galleries: Julian Stanczak at Martha Jackson Gallery," *Arts Magazine* (October 1964): 69.

10. Media recognition of the movement and acceptance of the term Op Art had in fact been taking place months prior to the opening of *The Responsive Eye,* as evidenced by Warren R. Young's article "Op Art" in the December 11, 1964, *Life* magazine.

11. Among the more caustic critiques of Op Art are Barbara Rose, "Beyond Vertigo: Optical Art at the Modern," *Artforum International* (April 1965): 30–33, and Sidney Tillim, "Optical Art: Pending or Ending?" *Arts Magazine* (January 1965): 16–23.

12. William C. Seitz, *The Responsive Eye* (New York: The Museum of Modern Art, 1965).

13. Proud of this artistic paternity, he referred to the younger artists as "my babies" at the opening *of The Responsive Eye* (see Brian de Palma, director, *The Responsive Eye,* A Zodiac Associates Production, 1965, 16mm film) and delighted in calling Bridget Riley his "daughter" (see Robert Kudielka, ed., *The Eye's Mind: Bridget Riley, Collected Writings, 1965–1999* [London: Thames and Hudson, Ltd., 1999], 224). For an account of Albers's influence on younger Op Artists, see Sam Hunter, "Josef Albers: Prophet and Presiding Genius of American Op Art," *Vogue* (October 15, 1970): 71–127.

14. Hannes Beckmann, statement in *1+1=3: An Exhibition of Retinal and Perceptual Art* (Austin: University Art Museum of the University of Texas, 1965), 13.

15. Hannes Beckmann, interview by Mike Wallace, *Eye on New York: The Responsive Eye,* Columbia Broadcasting System, New York, 1965.

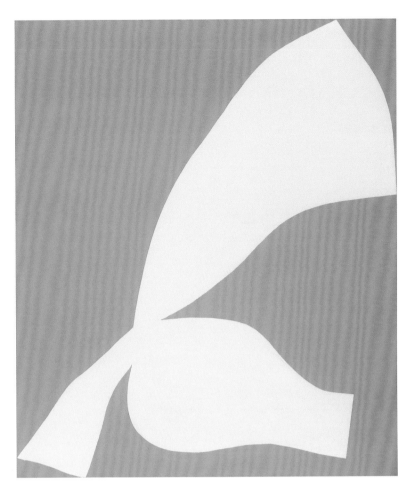

25. Ellsworth Kelly, American, born 1923

Green-White, 1961

Oil on canvas, 69 x 66 inches
Gift of Julian J. and Joachim Jean Aberbach; P.962.44
© Ellsworth Kelly; EK 263

Ellsworth Kelly is loosely associated with a development in 1960s American painting labeled "post-painterly abstraction" by the art critic Clement Greenberg. Reacting against the gestural freedom and emotional content of abstract expressionism, a group of younger artists including Kenneth Noland, Gene Davis, and Frank Stella produced canvases covered with flat, hard-edged expanses of color. While Ellsworth Kelly's *Green-White* belongs to this new mode of abstraction, the organic shape of the white form at its center recalls Kelly's delicate, representational drawings of floral subjects. By giving equal importance to figure and ground, the artist is able to suggest depth in space without painting representational forms. This lyrical use of a simple, flat shape silhouetted upon a brightly colored ground reflects the influence of Jean Arp and of Henri Matisse's late work, which Kelly saw while living in Paris during the late 1940s and early 1950s.

Through abstraction, Kelly sought to reduce the perceived world to a series of minimal, geometric forms and fields of unmodulated, pure color. The work of art, relieved of its descriptive function, expresses values, ideas, and feelings abstractly, so that compositional features—pure line, pure shape, pure color—become its very meaning. This transformation can be seen as well in the brightly colored, hard-edged form in *Untitled (Orange),* 1987–88 (fig. 1), a lithograph that bears a close resemblance to Kelly's sculptures, and to paintings such as *Green-White.* Both works emphasize the concrete nature of color, while the process of printmaking provides Kelly with a further means for exploring his pictorial ideas in the surface and texture of his forms. ESB

Fig. 1. Ellsworth Kelly, *Untitled (Orange),* 1987–88, lithograph on wove paper, 46⅔ x 45⅓ inches. Purchased through a gift from the Cremer Foundation in memory of J. Theodor Cremer and the Miriam and Sidney Stoneman Acquisition Fund; PR.990.6. © Ellsworth Kelly and Gemini G.E.L. Los Angeles; EK AX.237.

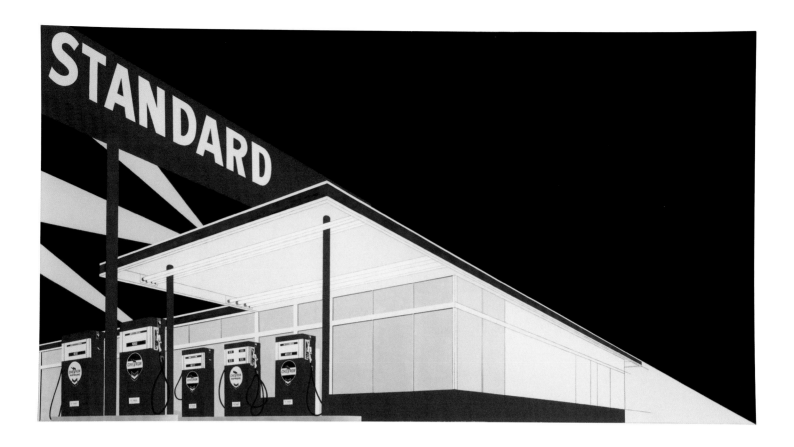

26. Edward Joseph Ruscha, American, born 1937

Standard Station, Amarillo, Texas, 1963

Oil on canvas, 64⅞ x 121¾ inches
Gift of James Meeker, Class of 1958, in memory of Lee English, Class of 1958,
scholar, poet, athlete, and friend to all; P.976.281

During the late 1950s and 1960s, Los Angeles artist Edward Ruscha drove along U.S. Route 66 half a dozen times a year to visit his family in Oklahoma City. The trip inspired both his first book of photographs, *Twenty Six Gasoline Stations,* published in 1963, and this painting of the Standard Station in Amarillo, Texas, produced in the same year. *Standard Station, Amarillo, Texas* is of paramount significance to the Hood Museum of Art's collection for its monumental place not only in Ruscha's oeuvre but also among the works that defined both the modern American landscape and the influential artistic movement that engaged it in the 1960s and beyond: Pop Art.

As in many of Ruscha's works of this period, the service station is depicted with the precision of a technical drawing. Bathed in fluorescent light, its pristine structure zooms forward along the diagonal wedge created by the artist's rendering of the building in forced perspective. Searchlights scan the blue-black night sky, beckoning travelers everywhere to this red-white-and-blue icon of American life in the sixties. As the artist explained, "I don't have any Seine River like Monet. I just have U.S. 66 between Oklahoma and Los Angeles."

The painterly attention to detail found in the precise lines, angles, and lettering (a reference to Ruscha's interest in commercial art, and to the commerciality of the image) contrasts with the lack of authentic representation in the scene, demonstrating the painting to be simultaneously realistic and contrived. Its subject does not, in fact, look like a gas station at all—the lack of people, cars, or any sign of wear and tear makes the structure seem too crisp and shiny to be a working station. It instead could be viewed as a gesture of admiration for the newness of car culture and the highway system that propagated it. Furthermore, it now seems a prophetic statement about American dependence on gasoline oil. The painting has the format of a European Renaissance altarpiece with the pumps standing in for saints and the beam of light sanctifying the lowly gasoline station as secular icon.

Jim Meeker generously gave the painting to his alma mater in memory of his fellow Texan and classmate, Lee English, who died in 1978. [Ruscha 1993: 100 (quotation)]

BK and ESB

27. Allan D'Arcangelo, American, 1930–1998

Hello and Good-bye, 1964

Acrylic on canvas with metal, 20⅛ x 24 inches
Gift of Beverly and Howard Zagor, Class of 1940; P.974.351
Art © Estate of Allen D'Arcangelo/Licensed by VAGA, New York, NY

Allan D'Arcangelo's re-visioning of the contemporary American landscape in the 1960s utilized a significant painterly tradition to redefine the artistic canon. While the rolling vistas and mountain ranges of American landscapes past represented the abundance, promise, and even uncertainty of the new country, D'Arcangelo's flattened vista of outstretched pavement in *Hello and Good-bye* reflects a literal change of view. D'Arcangelo's landscape paintings are at once nostalgic and ironic, and continue to define both the Pop Art movement and a moment in time.

The rearview mirror attached to the top of the canvas is distinctively Pop in its borrowing of common objects and resituating of everyday materials in the museum or gallery setting. The mirror simultaneously references the burgeoning car culture and corresponding highway systems that were the impetus for the major change in the American landscape during the 1960s. The road

is the focus of the painting, represented by a single painted line down black asphalt that disappears at the horizon. Placing the exact reverse view of the painted canvas in the mirror, D'Arcangelo emphasizes the banality and monotony of the modern paved landscape, stating: "So the suggestion is that, with the passage of time, nothing has happened anyway." The painting's title reinforces the notion that the predictability offered by the road makes the direction traveled insignificant. The orange bar at the side of the painting alludes to a highway barrier; a warning symbol intended to keep the driver from straying off the road. According to the artist, it "generates a sense of interrupted view, which is, in fact, what really happens to us. These paintings choke the usual experience of landscape and fill it with interruptions."

Much like Jason Seley's use of automobile bumpers in his work, including *The Boys from Avignon* (cat. 70), the appropriation of the rearview mirror in D'Arcangelo's painting elevates the ordinary and mundane to the status of high art while referencing the mechanization and industrialization implicit in the manufacturing of these objects. [Prokopoff 1971: 8, 11 (quotations)] KMG

28. Gene Davis, American, 1920–1985

Red Burner, 1965

Magna on canvas, 113 x 116 inches
Bequest of Florence C. Davis, in memory of her father, William H. Coulson,
Class of 1918H; P.992.45

Born in Washington, D.C., Gene Davis spent the early years of his career as a sportswriter and White House correspondent. His long-standing interest in the arts led him to begin painting around 1950. Although never formally trained, Davis considered Jacob Kainen his mentor and regarded himself as an abstractionist from the beginning of his artistic career. By the end of the 1950s, Davis had developed the format for which he is best known, using hard-edged stripes in a range of bright colors as the principal means of organizing his compositions. Like many of his contemporaries—most notably "color field" painters Morris Louis and Kenneth Noland, although Davis refused to be identified as part of this movement—Davis rejected the emphasis on gesture that had characterized avant-garde American painting during the late 1940s and early 1950s. He preferred instead to focus on the elaboration of simple pictorial structures and to explore, almost improvisationally, the expressive potential of pure color. Without the aid of preparatory drawings, Davis used the placement and pattern of stripes to create complex rhythms and sequences of colors. He wrote, "Look at the painting in terms of individual colors. In other words, instead of simply glancing at the work, select a specific color such as yellow or a lime green, and take the time to see how it operates across the painting. Approached this way, something happens, I can't explain it. But one must enter the painting through the door of a single color. And then, you can understand what my painting is all about."

Varying the hue and intensity of the bands, Davis considered the vertical stripe as a vehicle for color, enabling the viewer to move beyond the painting's structure to see the color itself. The titles of his paintings were given careful consideration, and they relate both to the forms and hues in the composition as well as to the emotions and narratives they evoke. Indeed, *Red Burner* seems to be ablaze with its defining color. [Davis 1981; Davis 1975 (quotation)]

ESB

29. Dorothea Tanning, American, born 1910

To the Rescue, 1965

Oil on canvas, 80¾ x 58⅜ inches
Purchased through gifts from the Lathrop Fellows;
2006.15

Dorothea Tanning had been living in France since 1949 when she painted *To the Rescue* as part of a series labeled *Insomnias.* Starting around 1955 her "painting compositions began to shift and merge in an ever-intensifying complexity of planes. Color was now a first prerogative," she stated in an interview. "I wanted to lead the eye into spaces that hid, revealed, transformed all at once." Tanning had first discovered surrealism in 1936 at a New York exhibition that engendered what she called "the real explosion, rocking me on my run-over heels. Here is the infinitely faceted world I have been waiting for."

To the Rescue showcases Tanning's focus on color and conjoined forms as part of her desire "to deal with figures that emerge from the canvas." This three-dimensional quality doubles her turn to soft sculpture at the same time: shapes sewn from touchable velvets, satins, and lace—fabrics meant to entice the kind of embrace figured here. Her heightened sensuality emerges in the *Insomnias*

through the incandescent tones typical of her later work, specifically the radiant white of the female nude's back centering the blended forms into which she plunges headfirst. This lightness sparks the opalescent yellow-greens of the merging bodies and the pearly hues of the overhanging clouds. Real and imagined shapes converge: a demonic body grasping the nude's back; a horse's rump; a youthful silhouette whose skin and hair color match the horse. Only Tanning's small dog (a recurrent motif) stares directly at the viewer, grounding the fantastic blur of shapes into a semi-recognizable reality and announcing the surrealist coincidence of waking and dream realities. Similarly, the work's gorgeous luminosity coexists with and simultaneously counteracts what Charles Stuckey calls the "irrational, seemingly multidimensional mind-spaces" in the works that address "the dilemmas of imagination and culture in a new atomic space age." [Tanning 2001: 213–14 (quotation)] KC

30. Xavier Esqueda, Mexican, born 1943

*The Transformation of the Objects
(La Transformacion de Los Objetos)*, 1965

Oil on composition board, 23½ x 19⅝ inches
Gift of the artist; P.965.116

31. Xavier Esqueda

The Relatives of Icarus (Los Parientes de Icaro),
about 1965

Oil and collage on composition board, 14⅝ x 11½ inches
Museum purchase; P.965.105

Xavier Esqueda was only twenty-three when he was invited to participate in Dartmouth College's artist-in-residence program in 1965. Largely self-trained, Esqueda had been exhibiting his work since the age of fourteen and was already represented by the

Galleria de Antonio Souza, one of the most progressive contemporary art galleries in Mexico City. The two works in the Hood Museum of Art's collection reveal immediately the inscrutable fascination of Esqueda's art as well as characteristic elements of his eclectic style. Drawing on the legacy of surrealism as well as contemporary art world trends such as op and Pop Art, Esqueda's work nestles playfully between the rational concerns of geometric abstraction and the deliberately irrational antics of the "panic world," the trajectory taken by postwar Mexican artists who crossed the psychedelic counterculture with esoteric religion and sexual transgression. While Esqueda's works never reach the extremes of Alejandro Jodorowsky's films or the neo-baroque complexity of Pedro Friedeberg's compositions, he shares with these colleagues an allusive exuberance that makes any single work difficult to pin down yet seemingly indebted to everything.

The Transformation of the Objects demonstrates Esqueda's

penchant for arraying accumulations of primary geometric forms within shallow illusionist spaces. Like De Chirico's enigmatic still lifes, this painting at once asserts the inexpressive solidity of its objects—through careful modeling, shading, and the use of cast shadows—and the sense that they are secretly animate. This is particularly the case with the uncanny orange slices, which Esqueda has molded into flattened cubes. By treating natural and abstract forms in the same fashion, Esqueda asks us to ponder art and illusion. And yet the drip of juice that escapes from his still life or *naturaleza muerta* (literally "dead nature" in Spanish) lends the work an air of poignancy. In other works from this period Esqueda painted facial features onto sculpted shapes that could be configured into any number of "identities." Thus it is tempting to read the orange as a weeping proxy for the human eye, a substitution or transference that recalls Rene Magritte's psychosexual explorations of signification and language through *tromp l'oeil* painting.

The Relatives of Icarus further reveals the multimedia nature of Esqueda's work. This collage incorporates elements of Renaissance painting with the avant-garde technique of *papier mâché* to create a virtual shadow box that evokes Joseph Cornell's miniature worlds of wonder. Esqueda invokes the myth of Icarus as the pretense for a meditation on the artist's release from the demands of any single illusionistic system. Esqueda establishes an interior space through a sequence of increasingly smaller squares. However, by placing figures and objects within this "room," he refuses this famous perceptual illusion its ability to vacillate between recession and projection. Furthermore, he cuts an oculus into the "ceiling" of his room through which a figure (Icarus?) takes flight into a blue sky. Much like the cupola in Mantegna's masterful Camera Degli Sposi (1465–74), Esqueda's work is filled with playful references to the art and artifice of illusionism. MKC

55

32. Robert Indiana, American, born 1928

Two, 1966

Acrylic on canvas, 24 x 24 inches
Bequest of Jay R. Wolf, Class of 1951; P.976.174
© 2009 Morgan Art Foundation Ltd./Artists Rights Society (ARS), NY

Robert Indiana famously stated in 1961: "I am an American painter of signs charting the course. I would be a people's painter as well as a painter's painter." Like Indiana's art, this statement says much in seemingly simplistic terms. That he is an "American painter" is evident from his artwork's appropriation of symbols of contemporary American life, including highway motifs, diner culture, and advertising. The social commentary and disciplined artistic sensibility found in his work define Indiana as both "people's" and "painter's" painters respectively. Indiana's borrowing of everyday symbols and signifiers, as well as his creation of works that replicated the look of common signs, collapsed the distance between high and low art and thus aligned him directly with his Pop Art contemporaries. His statement above, in which no distinction is made between the paintings to be produced for people and those for painters, further emphasizes this notion of bridging the gap between high and low culture in art. The crisp lines and stylized font utilized in *Two* are immediately recognizable as evocative of commercially produced imagery, and the bold primary colors enhance the advertising feel. The painting's composition interestingly and ironically references the quickly reproducible (and very Pop) method of screenprinting, which Indiana also frequently uses in his work. Distancing himself from not only the style and subject matter of his painterly predecessors, Indiana's creation of screenprint-worthy images on canvas further blur the line between high and low art and culture.

Numbers appear frequently in Indiana's work, ranging from digits included in compositions with figures or words, to stand-alone signifiers as in *Two*. His stand-alone integers have been produced in paintings, screenprints, and sculpture. *Two* is complemented in the Hood's collection by a screenprinted series of Indiana's numbers, which include textual renderings of the name of each number. [Weinhardt Jr. 1990: 79 (quotation)] KMG

33. Raymond Jennings Saunders, American, born 1934

Lonnie and Marie Lived Together, 1966

Oil on canvas, 71 x 48 inches
Museum purchase; P.969.25

A native of Pittsburgh, Raymond Saunders has lived and worked on the West Coast since graduating in 1961 from the California College of Arts and Crafts in Oakland. In 1964, Saunders won a Prix de Rome, an award for achievement in painting presented by the French Academy that enabled him to study in Rome for two years as well as travel in Europe and Africa. His work from this time combines recurring geometric designs of red, yellow, and blue shapes and patterns that are reminiscent of traditional African textiles.

Lonnie and Marie Lived Together has much in common with other works produced by Saunders during the 1960s and early 1970s: the division of the pictorial field into horizontal sections; the use of emblematic imagery, numbers, and letters; and an articulation of the surface of the canvas by means of an energetic yet lyrical brushstroke. Saunders's imagery is a seamless union of

painting and social commentary: a richness of color and texture is used to depict a watermelon and bottles of hair oil coexisting with bold abstract forms in a strange hierarchy that suggests all-too-false stereotypes of African Americans. This discourse on contemporary society's racial battles is compounded by a title that takes on a life of its own as a vignette from the epic drama of the African American in white America. Interestingly, the artist denies that racial tensions are central to his paintings: "Racial hang-ups are extraneous to art. No artist can afford to let them obscure what runs through all art—the living root and the ever-growing aesthetic record of human spiritual and intellectual experience. Whatever hang-ups here in America, can't we get clear of these degrading limitations, and recognize the wider reality of art, where color is the means and not the end?" [Brackett 1969: 1 (quotation)] ESB

34. George Tooker, American, born 1920

Farewell, 1966

Egg tempera on gessoed Masonite, 24 x 23⅝ inches
Gift of Pennington Haile, Class of 1924; P.967.76

Throughout his career, George Tooker has made gorgeously crafted narrative paintings that combine his lived experience with gestural and iconographical echoes of medieval and Renaissance art. For instance, a preparatory drawing in the Hood Museum's collection made for a painting titled *Men and Women Fighting* includes gestures and facial expressions inspired by figures in Giotto's Arena Chapel frescoes (fig. 1). Tooker was associated early in his career with artist-friends Paul Cadmus and Jared French and like them has painted exclusively with a hand-prepared egg tempera medium since the mid-1940s. Tooker gained fame before the age of thirty with a painting called *Subway* (1950, Whitney Museum of American Art) that still epitomizes the anxious cultural climate of the Cold War for many critics and art historians. For this reason Tooker is often discussed in relation to existentialist writers such as Jean-Paul Sartre but also sociologists such as David Riesman, whose *The Lonely Crowd* (1950) rhymes in spirit with the artist's most melancholic, even paranoid urban scenes. Despite the frightening aspects of Tooker's early work, he displays a consistent commitment toward social justice, equality, and spiritual harmony.

Art historians have generally classified Tooker as a "realist" despite his claim to be "after painting reality impressed on the mind so hard that it returns as a dream." Striving, then, for a heightened experience of the real, Tooker paid close attention to concurrent developments in modernist art even if they were not particularly connected to his work. *Farewell* shows this contextual awareness most directly, as it adopts a dizzying perceptual matrix evocative of Frank Stella's (born 1936) *Hyena Stomp* (1962, Tate Museum of Art) to effect a modernist updating of the Ascent of Souls. Tooker

knew the subject from fifteenth- and sixteenth-century panel painting, including Hieronymous Bosch's *Ascent of the Blessed* (1500–1504, Venice, Palazzo Ducale). *Farewell* was prompted by his mother's death, and Tooker used geometry to conjure his state of mind as well as a way to imagine her own experience: "I was thinking about reversible space, a corridor and boxes coming toward you. It's about a state of shock . . . about how I felt at the time of my mother's death."

While some consider the picture an anomaly in Tooker's career, it in fact synthesizes much of his work—the personal, spiritual, historical, and modern in an image of loss and mourning—and especially his ongoing focus on human experience. [Rodman 1957: 210; Spring 2002: 77 (quotation)] RC

Fig. 1. George Tooker, *Study for Women and Men Fighting,* 1958, graphite on paper, 20 x 20 inches. Purchased through the Contemporary Art Fund; 2006.54.1.

35. Ivan Albright, American, 1897–1983

The Vermonter (If Life Were Life There Would Be No Death), 1966–77

Oil on Masonite, 34¼ x 26½ inches
Gift of Josephine Patterson Albright, Class of 1978HW; P.985.31

Ivan Albright and his twin brother, Malvin (1897–1983), received their first art training during childhood from their father, Adam Emory Albright (1862–1957), who had studied with Thomas Eakins (1844–1916) at the Pennsylvania Academy of the Fine Arts. Alongside extensive formal training, it was Ivan's experience in France during World War I, drawing wounds and their healing process, that most affected his vision. Staunchly independent but well-informed about the international art world, Albright achieved great notoriety for his startling reconfiguration of realism. After maintaining a strong presence in the Chicago art world for over four decades, Albright moved permanently to Vermont in 1965. *The Vermonter,* started immediately after a 1964–65 retrospective, was the first major work made in his new home and represents the culmination of his artistic and spiritual philosophy. From the 1920s onward, Albright described the body as an impermanent material shell that serves as a vessel for the true self—the intangible life force or soul—as it strives to attain higher consciousness and enlightenment.

This painting depicts Albright's neighbor, Kenneth Harper Atwood, as he peers out beyond the picture frame, his eye sockets glowing with faint lavender light. His otherwise rough, leathery face radiates a luminescence that seems cast from within. Albright wrote in a notebook that he wanted to portray Atwood "as spiritual as I can make him but also all flesh." He sought to "study and

comprehend the union of the soul with body. The soul is life—life never dies." Albright represents this "union" of two complementary aspects of being through numerous tiny concentric high-keyed color rings, which appear as chromatic haloes throughout the painting. Many seem to emerge from the folds, sleeves, and openings in Atwood's clothing, while some float around his body. This peculiar depiction of color and light as rising spots emitted by the figure gives visual form to Albright's concept of an intangible life force that can penetrate matter. It is as though we are watching as Atwood's physical body dies and the life force departs as discs of colored energy. The material body's collapse, for Albright, is an essential part of this growth: "In any part of life you find something either growing or disintegrating. All life is strong and powerful, even in the process of dissolution." Albright expanded this vision in an astonishing series of over twenty self-portraits made during the last three years of his life that document his failing health but powerful psychological and spiritual presence (fig. 1). [Cozzolino 2006: 106; Kuh 1960: 23] RC

Fig. 1. Ivan Albright, *Fragment of a Self-Portrait*, 1983, bronze, 12 x 13¼ x 5 inches. Gift of Josephine Patterson Albright, Class of 1978HW; S.984.31.2.

36. Alice Neel, American, 1900–1984

Portrait of Daniel Algis Alkaitis,
Class of 1965, 1967

Oil on canvas, 50 x 34 inches
Gift of Dr. Hartley S. Neel, Class of 1965 AM,
in honor of Churchill P. Lathrop; P.978.155
© Estate of Alice Neel

In the mid-1920s, Alice Neel began to paint the series of portraits for which she would become famous, each one defined by its powerful psychological impact. This "gallery" consisted of paintings of family, friends, neighbors, artists, and business and professional people. A keen observer of personality, Neel would first sketch her subjects in thinned blue paint and then add color and detail.

This portrait depicts Daniel Algis Alkaitis, a Dartmouth classmate of Neel's son Hartley who graduated with him in 1965. This work is one of four or five painted in Alkaitis's Berkeley apartment, where she and Hartley stayed in 1967 during the run of her show at the Maxwell Gallery in San Francisco. *Portrait of Daniel Algis Alkaitis* is closely related in both style and composition to other portraits of her sons and their friends, in particular a painting of

Hartley done two years earlier and a 1969 portrait of Hartley's wife, Ginny.

Alkaitis, his arms firmly perched on his hips and his confrontational gaze trained on the viewer, conveys an almost obstinate teenage self-confidence. Neel is known for this distinctive expressionistic realism, which she articulates through the abstract use of color, the texture of her visible brushstrokes, and the oddly distorted bodies, limbs, and facial features of her subjects. Features that typically recede in the traditional painted portrait—the possible hidden secrets, idiosyncrasies, and vulnerabilities of the sitter—are thereby revealed through the avid (and avidly rendered) expressions of Neel's sitters. ESB

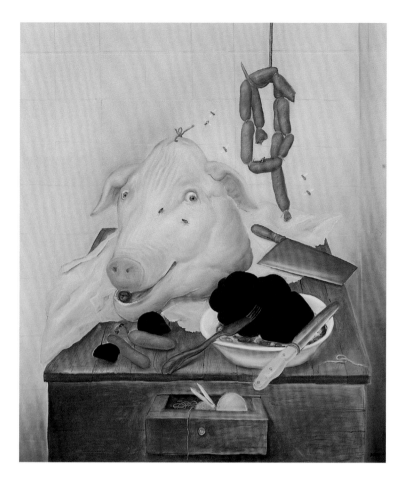

37. Fernando Botero, Colombian, born 1932

*The Butcher Table (La Mesa del Carnicero);
Still Life with Pig's Head,* 1969

Oil on canvas, 71 x 61⅛ inches
Gift of Joachim Jean Aberbach; P.975.72
© Fernando Botero, courtesy of Marlborough Gallery, New York

In *The Butcher Table* Fernando Botero presents us with a still life replete with the implements and offerings of the butcher's trade. A boar's head rests atop some crumpled paper amidst a bowl of crimson organs, knives both small and large, a pair of scissors and ball of twine, and some sausage links dangling from a hook overhead. Flies buzz around the scene, lending it an air of comic realism while showing off the artist's talent at *tromp l'oeil* rendering. The scene evokes daily life in Botero's native Colombia, where cured meats and dissected animal parts are displayed in open-air markets. Executed in his trademark style—referred to by some critics as "Boteromorphic"—the objects are painted in sensuous color with an exaggerated plasticity that gives them a puffed-up appearance. The pig grins at the viewer while gripping a tiny apple between its teeth, the first clue to the satire lurking beneath the ingratiating surfaces of Botero's early paintings.

This still life is one of many dating from the artist's first wave of success while living in New York following a self-imposed apprenticeship with Old Master paintings during a decade spent traveling in Europe. Like the austere Spanish *bodegones* that inspired it, *The Butcher Table* employs illusionism to render the spongy flesh of swine or the glinting surface of a knife blade tangible. Botero attributes his emulation of Old Master subjects and techniques to his provincial upbringing in a country with virtually no public collections of Western art, save for the colonial-era copies of devotional paintings hanging in churches. His quest to understand and master this tradition was motivated by what he describes as a "Third World" artist's desire to define the authenticity of his work while acquiring a "feeling of universality." Yet even as Botero's paintings insist on their relationship to tradition, they bear traces of the artist's commitment to critical modernism and the political satire so characteristic of Latin American figuration.

Like Diego Rivera's murals, *The Butcher Table* subtly integrates avant-garde formal experimentation with a politically inflected but populist realism. Botero's canvas offers us simultaneous views of the table and its contents, employing Cezanne's foreshortened, tipped-up perspective to defy the rationalized systems used by Spanish Golden Age painters such as Velazquez, Zurburan, and Ribera. Likewise, the ceramic tile wall pushes the objects close to the picture plane, creating a shallow sense of space that reinforces the two-dimensional nature of the canvas rather than its fictive depth. The wall vacillates between being read as an object in space (note the corner that suggests recession along the right-hand side of the composition) and as a flat grid. These incongruities suggest that things are not as they initially appear and invite us to question the scene. Might this butcher table be an oblique reference to "La Violencia" and the forms of torture carried out by Colombia's military regime? Just as Botero's humorous portraits of the political family from the same period suggest corruption through symbolic and formal oddities, *The Butcher Table* implies that the still life's classical function as a meditation on death might have new relevance for those living under the daily threat of violence.

MKC

61

38

38. Jack Tworkov, American, 1900–1982

Untitled (R. A. on P. #9), 1972

Acrylic on paper, 30⅞ x 22¼ inches
Purchased through the Julia L. Whittier Fund; P.973.116

39. Jack Tworkov

Untitled (R. A. on P. #10), 1972

Acrylic on paper, 29⅞ x 22¼ inches
Purchased through the Julia L. Whittier Fund; P.973.117

Jack Tworkov once wrote in his journal, "I am torn between the calligraphic and the structural—between the exuberance of movement and the passion of meditation." This duality, and the search for resolution, can be found throughout the artist's lengthy career. Citing as influences Soutine, Cezanne, and his contemporary, Willem De Kooning, Tworkov studied at the National Academy of Design, but suspended his painting during World War II to become a tool designer. He re-emerged in the mid-1940s, becoming a major figure in the development of the New York School of painting and abstract expressionism. During the 1960s, Tworkov became disenchanted with gestural abstraction and its emotional immediacy, seeing in his work a predictability that belied the intended spontaneity of process. In order to regain the freedom to

39

experiment, he needed "some constant I could fasten onto . . . that I could measure and repeat," transforming the remaining variables with every painting. As a result, the artist began to explore the possibilities of geometry and the structural notion of the grid.

Untitled (R. A. on P. #9) and *Untitled (R. A. on P. #10)* show the result of Tworkov's stated desire to reconcile the instinctive impulse of abstract expressionism with the process of intellect. When considering his later work, the artist likened his preparatory sketches to an architect's drawings, precise in their study of proportion and form. It was in the development of color and painterly brushwork that Tworkov found the ability to experiment freely. *Untitled (R. A. on P. #9)* demonstrates Tworkov's masterful understanding of tone. Using blue as the background, Tworkov places orange and pink brushstrokes at regular intervals across the surface to create the rhythm of the organizational grid. The consistency of Tworkov's marks reinforces the sense of pattern. Building layer upon layer, he uses the same types of colors and lines in both the upper and lower sections of the work. However, by shifting value and hue, Tworkov achieves a powerful all-over effect. Due to his manipulation of color, the upper region of the painting seems bathed in light, while in comparison the lower third remains muted by shadow. Through this contrast Tworkov emphasizes his mastery of color and his ability to create a work in which all of the parts are equally important in the generation of the whole. [Ashton 1979: 7 (quotation); Forge 1982: 10 (quotation)] AHW

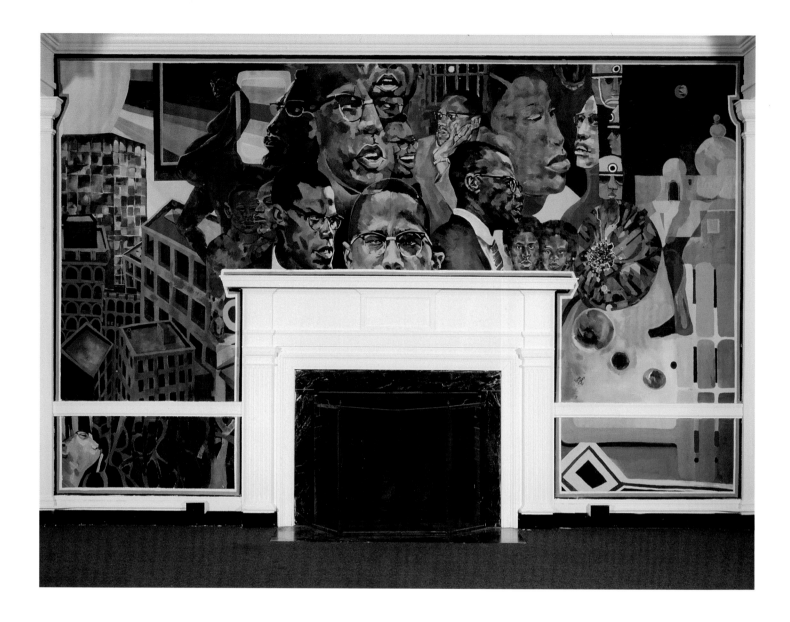

40. Florian Jenkins, American, born 1940

Life of Malcolm X, June 15–October 15, 1972

Acrylic on cotton canvas and linen canvas, eight panels: 7–8 x 12–14 feet
Commissioned by the Afro-American Society, Dartmouth College; P.972.231

In an artistic dialogue with the Black Arts Movement of the 1960s and 1970s, Florian Jenkins here uses a unique combination of figurative and abstract techniques, bold colors, and African design motifs to celebrate African American history. Jenkins's *Life of Malcolm X* murals commemorate the impassioned black leader by evoking the personal circumstances of his life while alluding to his engagement with a global African community. Commissioned by Dartmouth's Afro-American Society in 1972, the murals consist of eight panels that fill the entryway, lounge area, and stairwell of the Cutter/Shabazz Academic Affinity House.

In "Tribes" (fig. 1), one of the entryway murals, a delicate outline renders the continent of Africa, while African masks, patterned textiles, an image of Malcolm X, and the faces of individual students in Dartmouth's Afro-American Society spill from the continent's borders. The overlapping, multicolored faces and masks illuminate the richness and continuity of African and African diasporic cultures. Using a cubist compositional structure, Jenkins eliminates coherent space and depth to suggest a melding of people across time and geographic regions.

The lounge murals contain a central motif of Malcolm X as a powerful orator, which Jenkins flanks with pivotal episodes from his life. On the south wall, a claustrophobic arrangement of

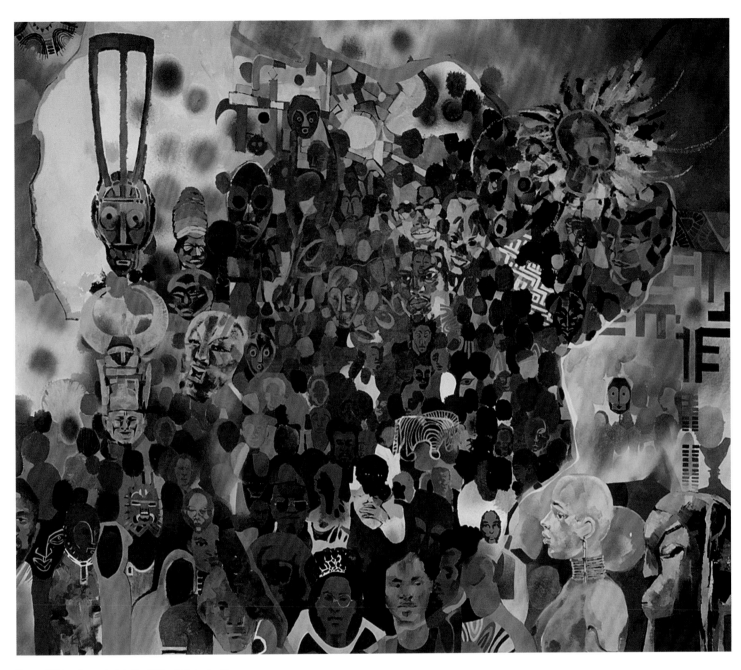

Fig. 1. "Tribes" panel, detail of *Life of Malcolm X*.

skyscrapers denotes his youth in the urban tenements of Lansing, Boston, and New York. On the right of the composition, the bars of a jail cell recall his imprisonment, a key period in his development as an intellectual and a Muslim. Outlines of mosques reference Malcolm X's journey to Mecca and his participation in the hajj, an experience that influenced his momentous break with the Nation of Islam and his embrace of Sunni Islam. Below the murals in the lounge, Bushongo and Yoruba motifs evoke the strong visual traditions of African cultures while underscoring Malcolm X's travels to that continent and his desire to connect with people of African origin throughout the world. By emphasizing self-discov-ery and intellectual maturity in the life and person of his subject, Jenkins speaks to the lives and ambitions of the Dartmouth College students for whom the murals were made and encourages their individual intellectual pursuits. PW

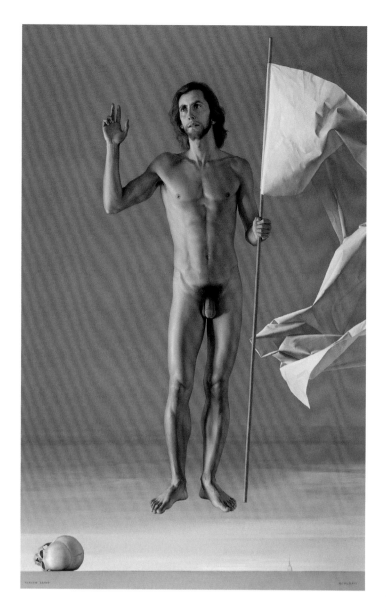

41. Claudio Bravo, Chilean, born 1936

Portrait of a Martyr, 1972

Oil on canvas, 52½ x 33⅜ inches
Gift of Joachim Jean Aberbach; P.974.373
© Claudio Bravo, courtesy of Marlborough Gallery, New York

Claudio Bravo was born and trained in Chile but gained his early reputation as a society portraitist while living in Madrid in the 1960s. In 1972 he relocated permanently to Tangiers, Morocco, and since that time he has become well known for his superrealist paintings of figures, still lifes, and paintings of wrapped packages. While Bravo's mature painting style coincides with the photorealist and neorealist movements in the United States and Spain, his work eschews their reliance on photography and modern subjects—urban vistas, cars, the reflective surfaces of shop windows—in favor of life drawing and themes drawn from the past.

Bravo declares an affinity with the Renaissance and Baroque, citing Velázquez, Vermeer, Michelangelo, Leonardo, and Greco-Roman sculpture as his primary influences. And yet, the erotic charge of his paintings, as well as the machine-like smoothness of their surfaces and strange lack of temporal markers or sense of place, betrays his youthful interest in the surrealism or hyperrealism of Salvador Dali's late work.

In *Portrait of a Martyr,* for example, Bravo, working from a model, offers us a male nude derived from the tradition of Christian martyrs in Italian Renaissance frescos. His perfect body, of course, recalls Greco-Roman canons of ideal beauty, but the image is devoid of the icons or symbols that would identify him as St. Sebastian or St. Anthony. Likewise, the specificity of the unidentified model's face commutes the work from the religious past to the secular present. The overt homoeroticism of the image, while always present in the male nude, even courts sacrilege as it speaks of Bravo's open involvement with contemporary gay culture. Bravo acknowledges the eroticism of his work and welcomes a sexually charged gaze, but he does not view his male figures as gay pin-ups or blasphemous religious icons. He links them instead to his Jesuit education and fascination with mysticism, especially the lives of the saints.

Bravo's martyr stands, almost floating, in a barely delimited space, one hand raised in a benediction while the other grips a white flag. To the left of the figure, Bravo has painted a skull lying on its side, suggesting a *vanitas* theme. All three elements—skull, figure, and flag—balance the composition, lending the work a pleasant harmony and sense of calm. Despite the motion implied by the billowing flag, everything seems to be stilled: the skull no longer wobbles, the figure is arrested in mid-gesture, and the flag even appears frozen and rigid, more like butcher paper than cotton cloth. While this emphasis on tangible reality reminds us of Bravo's love of what he calls the "conceptual realism" of Spanish Baroque *bodegones*, it also suggests a meditation on stilled life, the dialectic of Eros and Thanatos made palpable by the fetishistic beauty of a body that will not age. Taking his cue from the Western artistic tradition, from Greek Kouroi to Catholic martyrs, Bravo suggests that only in death does the eroticized male body become sublime. MKC

66

42. Fritz Scholder, American, 1937–2005

Dartmouth Portrait #17, 1973

Oil on canvas, acrylic background, 80 x 68 inches
Purchased through the William B. Jaffe and
Evelyn A. Jaffe Hall Fund; P.974.11

43. Fritz Scholder

Drunken Indian in Car, 1974

Acrylic on canvas, 30¼ x 40⅛ inches
Gift of Jane and Raphael Bernstein; P.986.77.6

42

Native American painter Fritz Scholder was born in Breckenridge, Minnesota, in 1937. Trained by the Yanktonai Sioux artist Oscar Howe from 1950 to 1954, Scholder later studied painting and art history at California State University, Sacramento, under the tutelage of Wayne Thiebaud, where he was influenced by the broad ideology of Pop Art. Beginning as an abstract colorist, Scholder shifted his focus during the 1960s to an expressionistic exploration of Native American themes.

While artist-in-residence at Dartmouth College in 1973, Scholder began painting a series of numbered portraits, including *Dartmouth Portrait #17*. In this work, the artist appears to make reference to the then-current debate over Dartmouth's intercollegiate athletic teams' unofficial use of an Indian mascot. After a long protest effort by Native American faculty and students, college trustees issued an official statement in 1974 discouraging the mascot's use. This canvas's predominant hue of green (Dartmouth's school color) and monumental and dignified figure in Native American dress offer a counterpoint to more stereotypical renderings of an Indian warrior. Instead of a bow and arrow or hatchet, for instance, Scholder's man carries an eagle-wing feather fan, a symbol of spiritual harmony and prestige.

Scholder's break with the traditional iconography of Native American artists can also be seen in *Drunken Indian in Car*, where

43

the artist again portrays the American Indian in a modern, expressionistic style. Here, Scholder rejects the quintessential Indian as proud warrior, exploiting instead the mundane reality of alcoholism in today's Native American communities. In his own words, the artist wants to depict in his paintings "the complex human situation of the modern Indian, a complex of beauty, dignity, and maddening absurdity." [Scholder 1973: 109–10 (quotation)] ESB

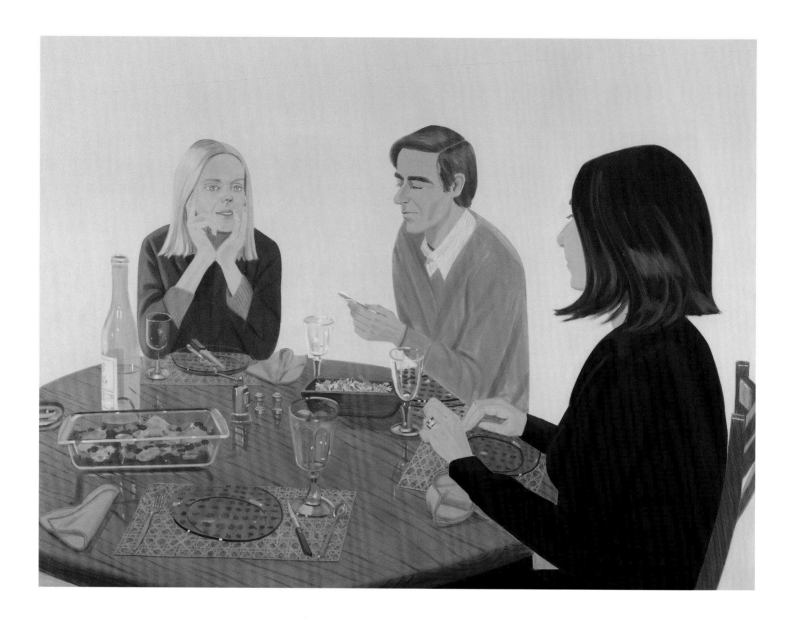

44. Alex Katz, American, born 1927

Supper, 1974

Acrylic on canvas, 72 x 96½ inches
Gift of Joachim Jean Aberbach; P.975.70
Art © Alex Katz/Licensed by VAGA, New York, NY

Portraits by Alex Katz are arresting for their large scale as well as the flat, cool manner in which they are rendered. Working with both painting and printmaking (a number of such prints are also in the Hood's collection), Katz depicts action without drama using a distinctive aesthetic that carefully dictates each mark. His style at once evokes early American naïve portraits, advertising billboards, comic strips, and movie stills.

In *Supper* it appears as if Katz has excused himself from the table and picked up a camera with a wide-angle lens. His wife, Ada (in black), and the couple with whom they are about to eat dinner, Brooke and Carolyn Alexander, seem unaware of the artist, who observes them from a vantage point no farther away than

the table's edge. In 1968, the Alexanders had established the New York contemporary art gallery Brooke Alexander Editions, a commercial gallery that works with artists (including Katz) to publish prints and multiples. Like nearly all of Katz's subjects, they are members of this country's artistic and intellectual elite, engaged in familiar social rituals. The self-conscious simplicity of his style, however, transforms these figures into monumental icons of late-twentieth-century American life.

The three people in the picture are seated off-axis at twelve, two, and five o'clock around a circular table jutting in from the left, an arrangement that activates the image, moving it from a static to dynamic state. Although there is a sense of documentation here, the composition simultaneously feels synthetic and constructed (or reconstructed). Katz suggests narrative but also restrains it, producing a scene that is far from sentimental or emotive.

ESB

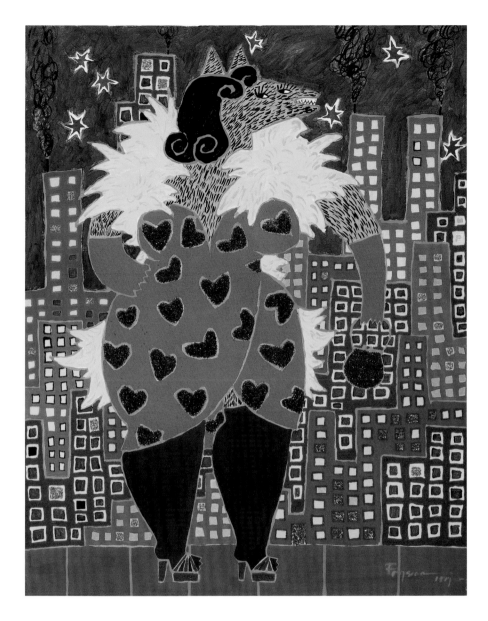

45. Harry Fonseca, American, 1946–2006

Coyote Woman in the City, 1979

Acrylic, glitter, and foil on canvas, 30 x 24 inches
Gift of the Class of 1962; P.989.10
© Harry Fonseca Trust, Santa Fe, NM

Harry Fonseca was born in California of Nisenan Maidu, Hawaiian, and Portuguese heritage. He studied briefly at Sacramento City College with noted Native American (Wintun) artist/poet/teacher/dancer Frank LaPena but rejected formal academic art education in order to pursue his own artistic vision. At first Fonseca relied on a thoroughly contemporary idiom to address issues of Native identity, assimilation, and contemporary life. His Maidu heritage, with its rich use of color and design in dance regalia and basketry, influenced his earliest work. But Fonseca later developed a unique style that created a dialogue between abstract expressionism, Pop Art, and West Coast figurative and abstract landscape painting fused with Native American artistic and narrative traditions, imagery, and experiences.

Initially Fonseca experimented with a number of artistic styles and thematic transformations, but in 1979, his best-known work, the *Coyote* series, began to emerge. In these works, he re-imagined the trickster, Coyote, an anthropomorphized canine commonly found in Native American myths. Fonseca situates his protagonist, Coyote (who is traditionally connected to notions of truth and deception, joy and sadness), in decidedly non-traditional settings, such as San Francisco's Mission District, the Santa Fe opera, or on a Parisian quay. Fonseca's Coyote dresses in zippered black-leather jackets, jeans, and high-tops, epitomizing "cool," while Coyote Woman—his plump and uninhibited girlfriend "Rose"—dons flashy print dresses, a big yellow boa, and red stiletto shoes.

Like the traditional Native trickster, Fonseca's canine furtively confronts the collision of oppositions, particularly between Native and non-Native American cultures and Native identities and mainstream urban life. On the surface, Fonseca's work—such as *Coyote Woman in the City*—evokes a carefree feeling, but just beneath lurks the artist's confrontation of American Indian stereotypes, filtered through his fashion-savvy coyotes, who use irony, comedy, and absurdity to defend themselves against cultural defeat and destruction. BT

69

46. Gregory Amenoff, American, born 1948

Unrest II, 1981

Oil on canvas, 60½ x 52⅜ inches
Gift of Donald S. Dworken M.D., Class of 1951; P.999.65.1

Now living and working in New York City and New Mexico, Gregory Amenoff was born in St. Charles, Illinois, and received a B.A. in history from Beloit College. Grounded in a mystical appreciation for the energy found in life and nature, Amenoff's paintings recall the early-twentieth-century abstractions of such pioneering American modernists as Arthur Dove, Marsden Hartley, and Charles Burchfield.

As in many of Gregory Amenoff's works, the interlocking biomorphic forms of *Unrest II* suggest the vital, regenerative qualities of nature. In his paintings, the artist explores nature's many incarnations, if not their strict representation, explaining:

> The most important elements to me are the nature of light, the emotional atmosphere attached to the light, and the way light plays itself out in terms of color, be it a very muted color, or an extremely vibrant celebratory color. These are the basic visual terms. In terms of actual identifiable form, the paintings have landmasses, horizons, and often a representation of some body of water, such as a river or sea. But it is the contrasting moods and languages that really interest me, much more than the actual images.

Amenoff's paintings of the 1980s, such as *Unrest II* and *Last Look* (fig. 1), have neither narrative structure nor straight representational elements, yet the abstractions are firmly rooted in the landscape, and the artist is a self-proclaimed dedicated naturalist. Heavily abstracted, the organic shapes of *Unrest II* allude to trees, roots, seeds, pods, and quivering sperm-like forms, rendered with thick applications of pigment. Painted improvisationally and without preliminary sketches, Amenoff's visible brushwork and large-scale canvases make for an impressive and imposing surface of vibrant colors. [Balken 2000: 5 (quotation)] ESB

Fig. 1. Gregory Amenoff, *Last Look*, 1980, oil on canvas, 28½ x 32 inches. Gift of Remsen M. Kinne III, Class of 1952; P.990.30.

47. Paul Resika, American, born 1928

Provincetown Pier (Claude), 1984–86

Oil on canvas, 78 x 62 inches
Gift of Susan S. and William A. Small Jr.;
P.994.45.8

Painting in a style at the midpoint between realism and abstraction, Paul Resika works from both outdoor observation and recreated memory. To the artist, his landscapes are "never of something; rather they are something." In his work, everyday forms of reality are transformed into vibrant studies of beauty and light, becoming simple yet sensuous masses meeting on the picture plane.

Studying under Hans Hofmann in the late 1940s, Resika was influenced by Cezanne, Matisse, and teacher Hofmann's emphasis on the fundamental relationship between the canonic history of art and the modern-day development of abstraction. It was during this time that Hofmann introduced Resika to the landscape that would serve as a constant in the artist's work throughout all of the decades that followed: Provincetown and the lower Cape Cod region. Using elements of his daily life as motifs—a particular flowering tree, a grouping of sailboats in the bay—Resika explored the possibilities of color and light, both real and imagined.

In this painting, as in many others, the Provincetown pier acts as the supporting structure, allowing Resika to experiment and play. In the artist's work, color and the use of paint act as both vehicle and subject: the large blocks of color emblazoned across the canvas not only describe the scene and its physical limits but also comprise the formal elements of his particular style of painting. Recalling the expressionist painting of Fauvism, through the seemingly simple pairing of complementary colors, Resika vigorously evokes a depth of human thought and emotion. The brilliant orange sky rushing back into space and the voluptuous broad brushstrokes of the blue outlines along the pier combine to generate a rich understanding of the experience of the place, as well as of the artist at a particular moment in time. [Harvey 1997 (quotation); Harvey 1997] AHW

48

48. Bernard Chaet, American, born 1924

Matthew Wysocki, Chairman, Artist-in-Residence Program, Dartmouth College (1963–), 1986

Oil on canvas, 36 x 24 inches
Purchased through the William S. Rubin Fund; P.986.73.1

49. Bernard Chaet

Churchill P. Lathrop (Director of Dartmouth College Museum and Galleries), 1986

Oil on canvas, 36 x 24 inches
Purchased through the Katharine T. and Merrill G. Beede 1929 Fund; P.992.3

A quintessential New England artist, Bernard Chaet was born in Boston in 1924 and educated at the School of the Museum of Fine Arts, Boston, and Tufts University. Chaet is perhaps best known for his vibrant, expressionistic landscapes, seascapes, and still-life paintings, many of which he painted around Cape Ann and Rockport, Massachusetts, where he lives. Professor emeriti at Yale University School of Art, Chaet painted during a time of contradictory art movements—Pop Art, abstraction, minimalism, and conceptualism—yet he persisted in the traditional techniques and conventional subjects of painting.

49

This does not mean, however, that Chaet was not experimenting. Juxtaposing tradition with improvisation, the artist's paintings possess an extraordinary energy. Each image is built layer upon layer, with an emphasis on the tactility of the paint, as thick painterly brushstrokes unify the whole composition. Within each of Chaet's paintings lies a carefully conceived balance of forms, colors, rhythms, and textures that evoke a myriad of sensations.

The portraits, *Matthew Wysocki, Chairman, Artist-in-Residence Program, Dartmouth College (1963–)* and *Churchill P. Lathrop (Director of Dartmouth College Museum and Galleries),* were both painted and exhibited during Chaet's time at Dartmouth in the fall of 1986. As an artist-in-residence, Chaet would have worked closely with Wysocki and Lathrop, both of whom were instrumental in shaping the face of contemporary art on campus. The emphasis on his subjects' hands recalls an early influence on Chaet—portraits by Oskar Kokoschka—in which the sitter's personality is conveyed as much by hand gesture as by facial features. Through a process of painterly abstraction and a play of color and textures, Chaet finds and conveys the essential nature of these two men in lifelike representations. ESB

50. Jennifer Losch Bartlett, American, born 1941

Fire Table I, 1989

Oil on canvas and enamel on wood, painting: 84 x 60 inches, sculpture: 32⅞ x 35⅞ inches Collection of Sondra Gilman and Celso M. Gonzalez-Falla; EL.P.990.3B, EL.S.990.3A

Jennifer Losch Bartlett first entered the contemporary art scene in the early 1970s with installations of small steel plates coated with white baked enamel. The plates were painted with fastidious configurations of dots and then organized into grids. Over the ensuing two decades, Bartlett's work moved away from the obsessive control so central to these early works toward a free, painterly depiction of nature. Gestural and expressive, her visions of nature are often unfinished narratives that the viewer is left to complete.

In *Fire Table I,* a bright orange fire rages, not consuming but instead energizing the exotic garden and the entire natural world around it. In direct opposition to the raging flames that engulf this garden, Bartlett depicts a simple six-sided table of the same orange tones as the blaze itself. The same hexagonal object also stands in front of the canvas in three-dimensional form, scaled and positioned to correspond to the painted version. This juxtaposition extends the scene into the viewer's space, creating a jarring disjunction between the quiet peacefulness of the gallery that the sculpture inhabits and the apocalyptic vision of a fast-approaching fire contained in the canvas.

Bartlett's clever combination of painting and sculpture creates an elaborate three-dimensional environment. The viewer is left to negotiate the destruction and raw emotion depicted in the painting and the table's distracting matter-of-factness, which tempers the mood of the painting, throwing a cool irony at the heat of its subject. Here the analytical and emotional aspects of Bartlett's art—which had once seemed irreconcilable—are brought together in a dynamic composition of opposites. ESB

51. Nancy Haynes, American, born 1947

Absent Myself, 1989

Oil on panel, 24 x 24 inches
Purchased through a gift from Wynn Kramarsky; P.989.32

Born in Waterbury, Connecticut, in 1947, Nancy Haynes lives and works in Brooklyn, New York. Like many abstract painters of her generation, Nancy Haynes's work reflects emotional states of mind or being. Somber and evocative, Haynes's paintings lie within the tradition of Mark Rothko's late work and represent a return to the expressive, painterly aesthetic of abstract expressionism that flourished in the 1950s.

Absent Myself is a strikingly beautiful example of the artist's monochromatic paintings. The delicate, painstakingly worked surface of *Absent Myself* betrays the artist's delight in the sensuous properties of the painterly materials she employs. In this case, Haynes uses oil on wood; in other paintings, she applies oil and gold leaf to slate, marble, or linen. She has described this emphasis on the expressive properties of materials as central to her work.

The nature of the materials she chooses makes her paintings seem alive and vibrant, deep and mysterious, austere but accessible. Haynes recently described her work as "severely, intentionally non-objective, truly not grounded in anything. My paintings are not abstractions of landscapes, still lifes, figures, or anything we know. They are detached fragments of the unknowable."

Absent Myself is a particularly interesting work due to the disjuncture Haynes creates between the seductively layered surface and the echo of hollowness it evokes (hence the title). Though a vertical black line divides the work at its center, light seems to come from within the panel's surface. This light fog of silvery gray emanating from beneath the layers of oil drifts over the dark shadowy colors of the surface, unifying the composition with its ethereal glow. [Haynes 1992 (quotation)] ESB

52

52. Lois Dodd, American, born 1927

Northern Lights and Stars, Cushing, 1990

Oil on aluminum, 5 x 6⅞ inches
Purchased through a gift from Elinor Bunin Munroe, Class of 1943W;
P.990.46.1

53. Lois Dodd

Blairstown View, 1990

Oil on aluminum, 5 x 6⅞ inches
Purchased through a gift from Elinor Bunin Munroe, Class of 1943W;
P.990.46.2

54. Lois Dodd

Laundry, Sat. Aug. 4, 1990

Oil on aluminum, 5 x 6⅞ inches
Purchased through a gift from Elinor Bunin Munroe, Class of 1943W;
P.990.46.3

Born in Montclair, New Jersey, in 1927, Lois Dodd studied at Cooper Union in New York in the late 1940s. Dodd now lives and works in New York and spends her summers on the coast of Maine, where she does much of her painting. The three paintings seen here were completed during Dodd's tenure as an artist-in-residence at Dartmouth in the fall of 1990. They are representative of the artist's plainspoken yet expressionistic landscapes.

Evocative and poetic depictions of the New England landscape, these paintings were part of a series by Dodd that began in the 1990s, when a carpenter fixing the roof of her house left behind small rectangles of aluminum step flashing, which became a varying new surface on which Dodd could work. Sometimes gessoing the flashing and sometimes painting directly on the bright aluminum, each approach gave the artist a unique version of support for oil paint. In *Northern Lights and Stars, Cushing*, the pale yellow-green northern lights streak across the night sky as stars shine bright with the metallic reflection of the aluminum below.

An atmosphere of intense solitude prevails in Dodd's paintings, as the artist articulates a circumscribed world that resonates with absence. Though it includes some signs of domesticity, the scene in *Laundry, Sat. Aug. 4* is devoid of people. A riot of various greens dotted with red and yellow depict the rich and moist foliage of New England on a warm, sunlit afternoon. While Dodd's paintings rarely feature any figures, through careful attention to composition and the picture plane she is able to shift the role of viewer from passive observer to active participant, allowing them to explore the image unchallenged. *Blairstown View* is such an image, as it pulls the viewer down a road winding into the distance between a wall and a house, while angular shadows play across its surface.

ESB

53

54

55. David Ortins, American, born 1955

Untitled, 1990

Oil and beeswax on panel, 19 x 14 inches
Gift of Susan S. and William A. Small Jr.; P.994.45.6

David Ortins was born in Boston in 1955 and studied at the Massachusetts College of Art. Known for his geometric, monochromatic abstractions, Ortins's paintings are an elegant union of the Op Art and pattern painting traditions. His work reflects this generation of artists' interest in the history of geometric abstraction, particularly that of Kasimir Malevich and the suprematists and of minimalist artists such as Sol LeWitt and Donald Judd. Yet Ortins's paintings differ quite consciously from these models, primarily in the contrast that exists between the implied perfection of the geometric forms that he has adopted and the imperfection and handmade quality of his work.

Untitled was created through a laborious and imprecise process, and the delicate surface—with its scratches and imperfections—serves as a record of this. Sheets of bleached or unbleached beeswax were laid down on linen, and color, in the form of oil paint,

was then applied to the surface and worked into it with a palette knife. The all-over geometric pattern affords a sensation of the sublime, despite the protracted and meticulous process that is evident from the painting's surface.

Ortins crafts a simple array of geometric forms, arranged so that the voids between them also seem geometrical. The result is a kind of implausible flat space, in which forms and voids integrate into a mosaic-like grid, as the appearance of depth continually shifts. A uniform pattern creates an optical illusion of vibrant space that seems to outwit its own decorative quality. The sensuous quality of the materials and the repetitive shapes become hypnotic in their intensity, as a subtle relationship between the transparent beeswax that forms the ground and the opaque paint resting upon it converge into one surface.

ESB

56. Jake Berthot, American, born 1939

Beforehand, 1995

Oil on gessoed paper mounted on aluminum, 21¼ x 17 inches
Purchased through the William S. Rubin Fund, the Claire and Richard P. Morse 1953 Fund, and the Hood Museum of Art Acquisitions Fund; P.996.7

Born in Niagara Falls, New York, Jake Berthot spent his childhood in Pennsylvania before moving to New York City in 1959. Though he studied briefly at the Pratt Institute, Berthot is a self-taught artist who has been very much influenced by the abstract expressionists, Mark Rothko and Milton Resnick in particular, and the subtle nuance of their paintings' surfaces. Berthot emerged as a mature artist in the late 1960s and early 1970s, during a time when there was much discussion about "pure" painting, a dialogue with which his work continues to engage.

Like many of his paintings, *Beforehand* focuses on basic formal problems such as the exploration of movement across canvas and the knitting together of surface and shape. Here, a large red rectangle that is almost as large as the sheet of paper itself is placed symmetrically on the surface and then worked in such a way as to complicate and call into question the relationship between the

two. Berthot's work primarily reveals a dynamic interest in gesture and the transcendent and spiritual possibilities of purely abstract painting (like Rothko).

Berthot's thickly layered abstractions evoke a spectrum of emotions. With a loaded monochromatic red that simultaneously suggests both a rich sensuality and the violence of spilled blood, Berthot employs the language of form, color, and texture to hint at an abstract narrative. And indeed, the artist identifies this narrative, saying that he is trying to "paint silence before it completely disappears." What further stirs this silence are the scarred ridges on the painting's surface where the artist has scraped away pigment, leaving a documentation of his process as well as a surface replete with shadowy meanings. [Betty Cunningham Gallery 2006: 1 (quotation)]

ESB

79

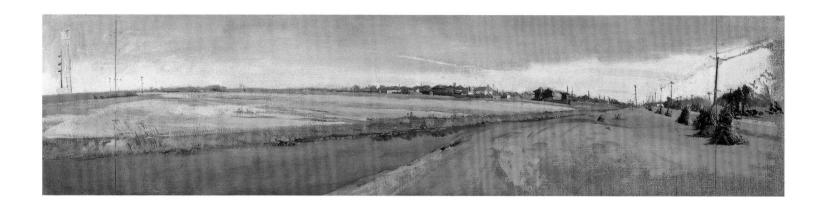

57. Rackstraw Downes, American, born 1939

Drainage Field Off Loop 197, Texas City, 1995

Oil on canvas, 11⅜ x 47⅛ inches
Purchased through the Robert J. Strasenburgh II 1942 Fund; P.997.33.1

British painter Rackstraw Downes studied literature at Cambridge University before receiving his M.F.A. from Yale University in 1964. There he studied under Al Held and Alex Katz and alongside classmates such as Brice Marden, Richard Serra, and Chuck Close. He began his artistic career as an abstract painter but soon came to focus on landscape painting, no doubt due to the influence of Fairfield Porter, whom he met while at Yale. Following Porter's example, he has written perceptively about art throughout his career.

For the last forty years Downes has concentrated on painting landscapes that work as topographical markers of time and place. Working in and around Galveston, Texas, during the winters, and in New York in the summers, Downes most often chooses to depict sites that are on the margin of cities, where the signs of manmade structures and alterations to the landscape stand out against a slightly curved horizon. Observers of Downes's work have often linked it to the growing concern about the destruction of the environment during his lifetime, and, perhaps more to the point, to the visual disorder that results from unregulated and poorly planned

growth. Downes himself, however, states that he is more interested in how disparate parts of the landscape interconnect, such as cows grazing alongside industrial sites and natural elements near radio towers and agricultural fields. He aims to paint objectively, depicting the scenes as they are, explaining:

> I think of industry and engineering as something that has been done to the landscape. I'm neither optimistic nor despairing about it. In fact, I believe that thinking in such polarized terms prevents one from seeing what's there: its complexity, irony, incongruity, robustness, melancholy.

This drawing and painting of a drainage field in Texas demonstrates Downes's development of a sketch into a more finished work. He often does several sketches such as this one, working toward the desired framing of the landscape by shifting elements slightly, here and there, until he reaches the desired composition. These two works offer an essay on how the eye takes in a broad, varied landscape, and how the painter can record both what is there and how it is seen. [Anderson-Spivy 1992: 38 (quotation)]

BK and ESB

Fig. 1. Rackstraw Downes, *Drainage Field Off Loop 197, Texas City,* 1995, graphite on paper, 20 x 68⅞ inches. Purchased through the Robert J. Strasenburgh II 1942 Fund; D.997.33.2.

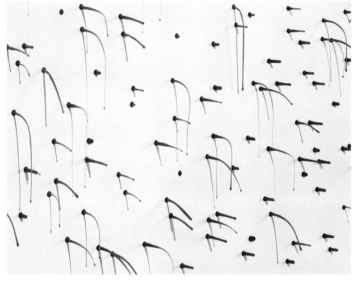

(Detail)

58. Karin Davie, Canadian, born 1965

My Inside Out #1, 1996

Pigment and rubber on paper, 45 x 32⅞ x 3¾ inches
Gift of Hugh J. Freund, Class of 1967; 2005.63

Karin Davie is best known for her large-scale abstract images dominated by bright colored ribbons of paint that twist and swoop across the canvas like a roller coaster. Her graceful creations utilize organic and familiar shapes to explore the performative nature of painting and the use of her own body in the work's creation. Investigating the collision between abstraction and representation, Davie addresses both the physical and psychological character of the body in painting.

Davie's continuing interest in the body is evident in *My Inside Out #1*. Visually simple but deeply poignant, the work is marked by bits of red-tinted rubber that seemingly pierce the creamy surface of white paper. Red trails of pigment stream from the dots and hang frozen in midair. Clearly evoking flesh and blood, it is as if the viewer is observing countless oozing lesions. Are these bodily

fluids seeping from beneath the derma or from dripping puncture wounds? The title, *My Inside Out #1*, further emphasizes the corporeal nature of the work and signifies the presence of Davie; it seems as if we are looking at the artist's own flesh turned inside out.

The use of rubber is a departure from Davie's typical paintings, yet this work echoes the artist's interest in process and its transparency, as well as the insertion of her own body into the final product. The repetition of mark-making inherent in the layers of stripe-upon-stripe of her traditional paintings is mirrored in the field of pigment dots in *My Inside Out #1*. Davie's deliberate and generative gestures are visible within each drip. Although fragile in their petrified state of mid-fall, these dribbles of red rubber also invade the viewer's space, intriguing but repellent in their unnerving corporeality. ESB

81

59. Andrew Forge, British, 1923–2002

Forsythia, 1997

Oil on canvas, 30¼ x 32⅛ inches
Gift of the artist; P.999.59

Born in Hastingleigh, England, in 1923, Andrew Forge moved to the United States in 1972, where as a dean of painting at the Yale School of Art he became equally well known as an artist, critic, and teacher. Forge employed a subtle abstraction in his painting, creating luminous, slowly vibrating expanses of dots. The artist was wholly absorbed by fundamental issues of seeing, and his formal vocabulary was limited to two small, basic units: tiny dots and short, thin dashes of paint that he called sticks. Forge's works defy everyday vision or visual understanding as they examine the artist's perception of the world and how he reconciled this with paint on canvas, as well as the sensory effects of color.

Forge continually plays with spatial complexity as he tests the line between perception and abstraction. He explains:

Each painting starts with a single dot, and it grows as dots accrue over the field of the canvas. During the early stages, the formative principle is simply the vibration of the dots, whether in ordered constellations or randomly dispersed. As the white field of the canvas is covered dot by dot, color reveals itself; the light of the canvas must be rediscovered and reconstructed out of the interaction of the dots. Slowly, ways of reading the painting come up. Areas press forward or drop back. There are alternatives of substance and transparency.

Forsythia, 1997, was purchased from Forge's artist-in-residence exhibition at Dartmouth in 1999. A spatter of glimmering yellow hovers in front of a field of lilac dots, as light emanates from the depths of the painting. This is not a simple allusion to the real, but there can be no doubt that the work references the genus of flowering plants by the same name that produces bright yellow flowers in the early spring. Countless elusive internal rhythms, divisions, and startling structures, all created by unpredictable color shifts, slowly begin to declare themselves. [Wilkin 1999: 4, 1–2 (quotation)]

ESB

60. Y. Z. Kami, Iranian, born 1966

Untitled, 1996–98

Oil on linen, 33 x 20 inches
Gift of Hugh J. Freund, Class of 1967; P.2002.56.1

In this typical portrait from a body of the painter's work done throughout the 1990s, we find a range of suggestive meanings. Painted during the dark years of the AIDS crisis in New York, the plaintive sitter with his furrowed brow and hooded eyes is already the subject of memorial. He is a lamentation, a figure on the road to untimely death. His image is similar to more than twenty depictions by Kami of young men in white tee shirts seen against a background that is blank, holding no clue to location, time of day, or circumstance. In both senses of the phrase, he is out of time, a statistical emblem, one among many in a category of loss. Though the men pictured may not in fact have been stricken with AIDS, their symbolic identification is paramount. The power of the image takes its strength from the aggregate of the doomed crowd, the potency of a single shared identity as the ostracized, the Other, the mark of mortality fixed in their eyes. Yet the blur of the portrait confers progressively larger meanings. Isolated against this featureless background, this young man can easily represent the universal experience of isolation in the cage of existence and the consequent necessity for community against the fundamental solitude of the self. Kami's interest in the idea of communal belonging and a search for wholeness in experience—in contrast to twentieth-century modernism's prominent expression of psychological and social fragmentation—is of decisive importance in understanding the depth of the image and its implications. This painting and its brethren are a poignant key to Kami's later work, which incorporates the spiritual tenets of Sufism and its specific, ecstatic belief in a communal afterlife of oneness with a divine presence.

SHM

61. Sara Sosnowy, American, born 1957

Track 112, 113, 114, 115, 116, 117, 1997

Oil, dry pigment, and canvas, 15⅛ x 15⅛ inches
Gift of Sally and Wynn Kramarsky; 2006.28.7

Born in Texas City, Texas, in 1957, Sara Sosnowy has lived and worked in New York City since receiving an M.F.A. from the Pratt Institute in 1989. Sosnowy's paintings, drawings, and prints share a common characteristic—an all-over pattern of marks in the minimalist tradition. Although primarily abstract, her latest work has begun to feature birds, turtles, and elephants layered on top of brightly striped fields.

Track 112, 113, 114, 115, 116, 117 exemplifies Sosnowy's trademark repetitive surface work. The concentric circles made by small, layered rectangles of yellow pigment call to mind a blooming sunflower or a primitive radiant sun, yet the title points to a more abstract subject, perhaps traces of the artist's hand or paintbrush. Though obsessive in their focused intensity, Sosnowy's paintings are peacefully patient. They are not mechanically ordered or structured, but clearly reveal the hand that painted them.

With strong colors and rich surfaces, Sosnowy's paintings confront the viewer with vistas that are physical in nature but metaphysical in their pull; their presence is palpable. *Untitled Series #23* and *Untitled Series #26* (figs. 1 and 2) are strikingly blood red, yet lush and sensual rather than violent. Her paintings are defined by their bold colors and richly worked surfaces. As the artist explains:

My paintings have evolved over the years from being large minimalist color statements to what I call large maximalist color statements. The once subtle textures lying just below the surface have risen to the top in distinct juxtapositions of color and pattern. My references are multi-cultural, art historical and everyday . . . My work is simple. It takes an extraordinary amount of time and patience to make, but ultimately, it's very simple. It's about beauty. For me as an artist, it's about making something beautiful. Hopefully, every now and then I can accomplish this. [Sosnowy 2006: 1 (quotation)] ESB

Fig. 1. Sara Sosnowy, *Untitled Series #23*, 1993, acrylic and oil stick on heavy wove paper, 10⅛ x 10 inches. Purchased through a gift from an anonymous donor; P.994.8.2.

Fig. 2. Sara Sosnowy, *Untitled Series #26*, 1994, acrylic and oil stick on heavy wove paper, 10¼ x 10¼ inches. Purchased through a gift from an anonymous donor; P.994.8.3.

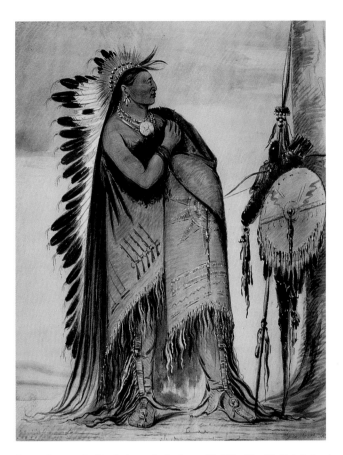

Fig. 1. George Catlin, *Ee-he-a-duck-chee-a (He Who Ties His Hair Before)*, 1836. Gilcrease Museum, Tulsa, Oklahoma.

62. Jaune Quick-to-See Smith, American, born 1940

The Rancher, 2002

Acrylic on canvas, 72¼ x 48 inches
Purchased through the William S. Rubin Fund; 2005.13

One of the foremost Native American artists, Jaune Quick-to-See Smith brings to her canvas a balance between the inspirations of the traditional world and its incarnations into contemporary lifestyles. She was born on the Flathead Reservation in Montana to Flathead Salish, French-Cree, and Shoshone parents. In her art, Quick-to-See Smith recognizes that language is not only a form of communication but also a reflection of cultural values, which she addresses with a touch of humor infused with social commentary, exploring topics such as tribal politics, human rights, and environmental issues. In *The Rancher* she pays tribute to her reservation homeland in Montana (where men were cattle ranchers) but also blends stereotypical imagery of the quintessential "Indian" with modern texts and commercial logos that raise questions about today's consumerist society and its relation to Native identities and histories.

In this work, Quick-to-See Smith appropriates George Catlin's nostalgic portrait of the Crow man *Ee-he-a-duck-chee-a (He Who Ties His Hair Before)* (fig. 1), who Blackfeet elder George G. Kipp III and Quick-to-See Smith believe is the Blackfeet war chief Pe-toh-pe-kiss, or Eagle Ribs. To reject the "Indian" stereotypes that Catlin's imagery perpetuates, Quick-to-See Smith couples logos for products such as Krispy Kreme donuts and Purina with the words "French Fries" (and two hands signing the same words), asserting that Native peoples can be simultaneously traditional and contemporary. The phrase "Hecho en USA" reflects the intermingling of languages, cultures, and subcultures in America. It explores the ever-changing—and at times ironic—communication between and among Native and non-Native peoples as they incorporate new words and concepts into their languages. Juxtaposing history with contemporaneity, Quick-to-See Smith encourages the viewer to acknowledge the contradictions of modern life and the role of Native Americans within it. BT

87

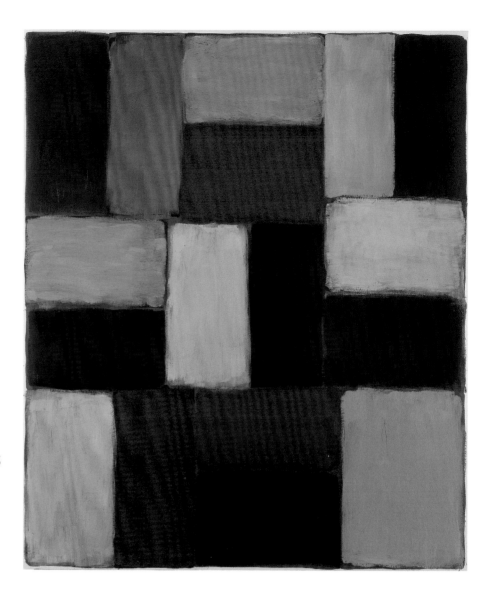

63. Sean Scully, American, born 1945

Wall of Light, Summer, 2005

Oil on canvas, 83⅞ x 71⅝ inches
Purchased through the Miriam and Sidney Stoneman
Acquisitions Fund; 2006.16

Sean Scully's *Wall of Light, Summer* is an exceptional work in a series he has been making since 1998. A profoundly intellectual painter and one of the greatest colorists, Scully has for some time now explored the contradictions inherent in the title of his *Wall of Light* series. The blocks of color in his walls are weighty, but this weight is in turn denied by their color and texture, and by the way they breathe to reveal the surfaces behind them. Scully builds his paintings, and each color block is heavily layered, with many of his original colors ultimately obliterated, incorporated, or infiltrated into the eventual surface colors.

In recent years, Scully's paintings have become looser and more painterly in style, and the edges of his architectonic color-block structures have softened, allowing the colors behind to seep through and provide a more subtle framework for his compositions. *Wall of Light, Summer* is a fabulous ode to joy that Scully himself acknowledges as "rapturous." It was made in the summer of 2005, when Scully felt "wonderful and happy," so the painting has a joy about it that the artist admits is unusual for him. As Scully remarked:

Summer is a very assertive painting. It's so happy to be here, so happy to be in the world, so happy to declare itself. The title, of course— the time when everything grows, when everything comes up, when the sun comes out, when we are warm, when we feel positive . . . I was about to go on a trip and I was feeling exuberant when I painted *Summer*. There's a lot of weight in my paintings, so there's a lot of sorrow. It's not as if I can't paint bright paintings . . . but I have to show the world as I see it. I have to tell the truth as I see it. Paintings like *Summer* tend to be in the minority.

The paint surface of *Wall of Light, Summer* is varied in texture and totally confident and assured. It responds well to the Hood's fine collection of works that tell the story of postwar abstract art, such as Ellsworth Kelly's *Green-White* (cat. 25) and Mark Rothko's *Lilac and Orange over Ivory* (cat. 8), an artist to whom Scully is hugely indebted. [Kennedy 2006: 6 (quotation); Kennedy 2008: 57 (quotation)]

BK

64. Félix de la Concha, American, born 1962

Cuatro Vistas Unificadas Por Dos Pares de Agujas (Four Unified Views through Two Pairs of Train Barriers), 2005

Oil on linen, four panels, each 35⅞ x 29⅟₁₆ inches
Purchased through the Robert J. Stasenburgh II 1942 Fund; 2008.35

Félix de la Concha splits his time working between Spain and New Hampshire. The painter studied at the Facultad de Bellas Artes in Madrid and in 1989 was awarded the prestigious Prix de Rome at the Academia de Bellas Artes. De la Concha is renowned for his monumental display *One a Day: 365 Views of the Cathedral of Learning,* a series of oil paintings that the artist produced at a rate of one per day showing the cathedral from different vantage points throughout the city. It was first exhibited at the Carnegie Museum of Art in 1999.

Cuatro Vistas Unificadas Por Dos Pares de Agujas is part of de la Concha's larger series *New England,* which depicts the urban and rural landscapes of the artist's daily life and everyday environment. Painting in front of his subjects and never from preliminary sketches, de la Concha seeks to capture the particular qualities of light as it is perceived by the senses. The artist's gift for perception crafts a meditation on the spirit of the place, while his super-realist style creates a near-photographic conception of a (locally) familiar spot.

Here, four panels with slightly differing views show a street corner opposite the train station in White River Junction, Vermont. A row of shop fronts in a stately but aging brick building becomes the focal point of the panels, which are divided and marked by shifting lines of railroad tracks and train signals. The landmark company store Vermont Salvage is barely visible in the far left panel. De la Concha's masterful understanding of perspective allows him to manipulate space and depth of field and illustrate a panorama from an array of stationary viewpoints.

ESB

SCULPTURE

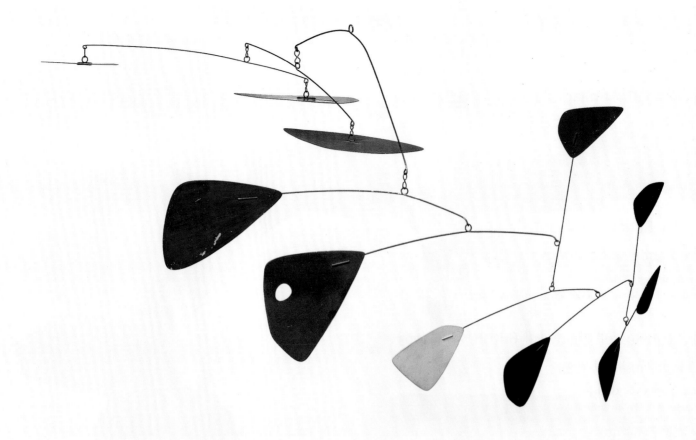

65. Alexander Calder, American, 1898–1976

Mobile, 1953

Painted sheet aluminum and wire, 18 x 36 inches
Partial gift of Nancy and Heinz Valtin in memory of Curt Valentin and partial purchase through the Miriam and Sidney Stoneman Acquisition Fund; S.998.41
© 2009 Calder Foundation, New York/Artists Rights Society (ARS), New York

The American sculptor and painter Alexander Calder is best known for inventing the mobile, a type of hanging sculpture with appendages that float and turn. After receiving an engineering degree in 1919, Calder pursued a career in the visual arts at the Art Students League in New York. In 1926, he moved to Paris, where he built *Cirque Calder,* an impressive array of small-scale circus figures sculpted from wire and other materials. It was through this work that he initiated friendships with other avant-garde artists, including Pablo Picasso, Joan Miró, and Fernand Leger. Influenced by his colleagues, Calder began to make his own work more abstract, while his desire to make paintings that moved resulted in the kinetic forms of the mobile. Over the course of his lifetime, Calder would create more than two thousand of these whimsical sculptures.

The organic shapes of *Mobile* float freely from suspending wires, creating a bold display of primary colors in perpetual motion as the carefully balanced forms are stirred by invisible air currents. A fastidious craftsman, Calder shaped his materials entirely by hand, with the manual emphasis contributing to the sculptures' biomorphic form. Size, color, space, and movement continually recombine in shifting relationships that produce a visual parallel to the harmony and unpredictability of nature.

In 1946, the French philosopher Jean Paul Sartre wrote a perceptive and eloquent essay on the artist's work, exploring the mobile's random make-up and the artist's intentions:

> His mobiles signify nothing, refer to nothing but themselves: they are, that is all; they are absolutes. Chance, "the devil's share," is perhaps more important in them than in any other man's creations. They have too many possibilities and are too complex for the human mind, even their creator's, to predict their combinations. Calder establishes a general destiny of motion for each mobile, then he leaves it on its own. It is the time of day, the sun, the heat, the wind which calls each individual dance. Thus the objects always inhabit a halfway station between the servility of a statue and the independence of nature. One sees the artist's main theme, but the mobile embroiders it with a thousand variations. [Sartre 1946: 2–3 (quotation)]

ESB

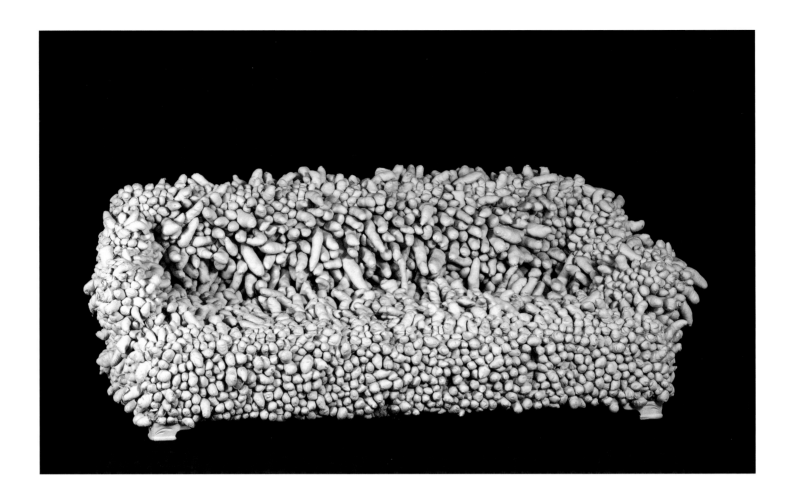

69. Yayoi Kusama, Japanese, born 1929

Accumulation II, 1962

Sewn stuffed fabric, plaster, paint, and sofa frame, 35 x 88 x 40¼ inches
Gift of Mr. and Mrs. Harry L. Tepper; S.974.374

Japanese artist Yayoi Kusama came to New York in 1958, a time when the art world was, as David Joselit described it, "still in the throes of Abstract Expressionism's experimentation with the absorptive scale of all-over compositions and while at the same time feeling the nascent appeal of the everyday object . . . This was also the New York in which artists using seriality were increasingly visible." Each of these formal and conceptual elements is clearly evident in Kusama's *Accumulation II*, where she has employed an all-over technique on a new surface: household furniture rather than a blank canvas.

In *Accumulation II*, Kusama covers a couch with stuffed-fabric phallic projections that she painted monochromatically with plaster and sewed to the surface of the furniture. According to Kusama, adorning *Accumulation II* with shapes resembling phalluses was an exercise in psychic damage control, an attempt to confront subconscious sexual fears by giving them physical shape. There is

also an element of hilarity to this piece, as the bizarre alteration of everyday materials combined with overtly sexual symbolism creates a sense of discomfort verging on embarrassment.

Known for her near-manic applications of polka dots or repeating patterns to every available surface, Kusama's art is in part an expression of her mental illness. Many of her works originate from hallucinations, and it is this obsessive-compulsive disorder that has driven the repetition of form that dominates Kusama's work, keeping her in a Tokyo psychiatric institution for nearly thirty years. Here, she creates art daily, guided by her mantra "Accumulation, repetition, obliteration, infinity." Kusama is also a prolific writer, and continues to work with diverse mediums: drawing, painting, sculpture, installation art, and performance. One documented performance that has been repeatedly reproduced involved *Accumulation II*, on which Kusama posed nude in imitation of a pin-up girl and covered herself in polka dots. This layering of patterns only exaggerated the tactility of *Accumulation II* and its disconcerting sexual overtones. [Joselit 2005: 167 (quotation); Cotter 1998; Martin 2002 (quotation)]. ESB

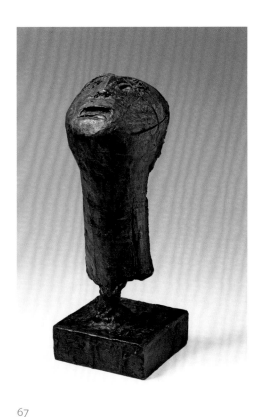

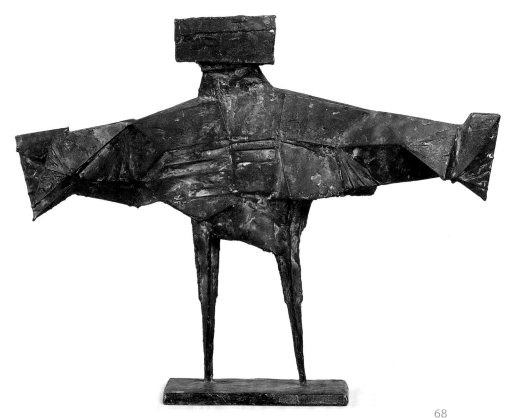

that was mainly concerned with figurative pieces composed of flat surfaces intended to be viewed from the front.

Standing Figure is representative of Armitage's figurative work of this time: spiky, fragmented forms that seem to be half human, half animal. Armitage's approach to the sculptural treatment of the human form can be read as a reaction against the three-dimensional monumentality of Henry Moore. This was a response characteristic of the work produced by a number of British sculptors, including Chadwick and Butler, during the postwar period.

Reg Butler was born in 1913 in Hertfordshire, England, and studied architecture until the war broke out, when he began to formally design and build houses and other structures. Carving wood sculptures from a young age, he began making small lead figures in 1939, and in the early 1950s his work shifted from wrought iron to bronze casting, focusing almost exclusively on the female body. Butler is perhaps best known for designing the winning entry in the competition for a *Monument to the Unknown Political Prisoner* in 1953, a project that was abandoned seven years later.

For the contest—intended to pay tribute to those who had been imprisoned or lost their lives in the cause of human freedom—Butler designed "a monument to those who had died in the concentration camps." At first glance, *Head, Looking Up* seems to refer to the figures of the "watchers" from this unrealized monument. Had it been built, the piece would have stood three hundred to four hundred feet high and combined a rock foundation, three women "in whose minds the unknown prisoner is remembered," and a tower to suggest "the tyranny of persecution."

Lynn Chadwick was born in 1914 in London, where he first worked as a draughtsman in various architectural firms. He soon abandoned his formal architectural training to become a pilot in the Royal Navy. After being stationed in Toronto during World War II, he returned to London, where he specialized as an exhibition designer for the architect Rodney Thomas. Chadwick's first sculptures were mobiles of balsa wood and aluminum wire, built as attractive features for exhibition stands for the architectural office in which he worked. In the 1950s, his sculpture developed a spiky vocabulary of skeletal lines and rough planes organized into generalized images of people or animals that evoked feelings of pain, rage, and fear. He won first prize for sculpture at the 1952 and 1956 Venice Biennales.

Chadwick's *Winged Figure* was a popular subject for the sculptor in the 1950s, as he explored the line between abstract and figurative representation. The sculptures simultaneously suggest movement and yet remain implacably solid and immobile, weighed down by a heavily worked surface. His creatures seem caught between the world of machines and that of nature: organic shapes that have been welded and bent into expressionistic figures far removed from the monumental works of Henry Moore.

This unique group of sculptures entered the Hood Museum of Art collections as a part of a generous bequest by Dartmouth graduate A. Marvin Braverman that included ten works by Butler, Chadwick, Armitage, Malvina Hoffman, and Abbott Pattison.

[Farr and Chadwick 1990: 8 (quotation); The Tate Gallery 1988: 165–67 (quotations)] ESB

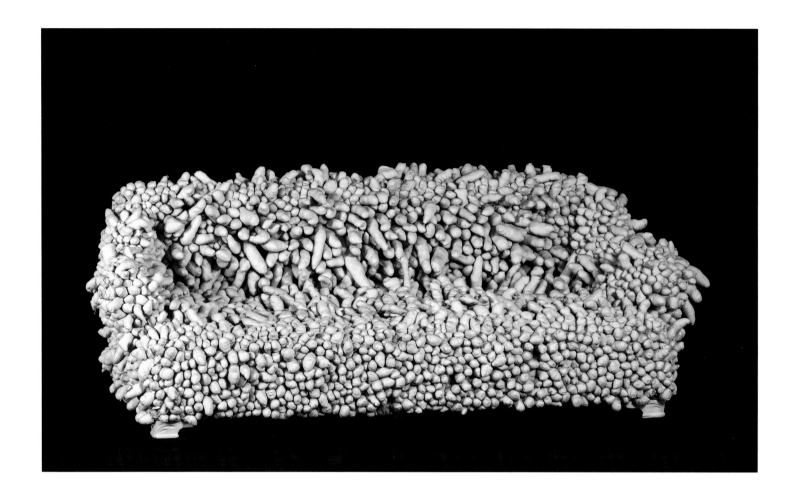

69. Yayoi Kusama, Japanese, born 1929

Accumulation II, 1962

Sewn stuffed fabric, plaster, paint, and sofa frame, 35 x 88 x 40¼ inches
Gift of Mr. and Mrs. Harry L. Tepper; S.974.374

Japanese artist Yayoi Kusama came to New York in 1958, a time when the art world was, as David Joselit described it, "still in the throes of Abstract Expressionism's experimentation with the absorptive scale of all-over compositions and while at the same time feeling the nascent appeal of the everyday object . . . This was also the New York in which artists using seriality were increasingly visible." Each of these formal and conceptual elements is clearly evident in Kusama's *Accumulation II,* where she has employed an all-over technique on a new surface: household furniture rather than a blank canvas.

In *Accumulation II,* Kusama covers a couch with stuffed-fabric phallic projections that she painted monochromatically with plaster and sewed to the surface of the furniture. According to Kusama, adorning *Accumulation II* with shapes resembling phalluses was an exercise in psychic damage control, an attempt to confront subconscious sexual fears by giving them physical shape. There is

also an element of hilarity to this piece, as the bizarre alteration of everyday materials combined with overtly sexual symbolism creates a sense of discomfort verging on embarrassment.

Known for her near-manic applications of polka dots or repeating patterns to every available surface, Kusama's art is in part an expression of her mental illness. Many of her works originate from hallucinations, and it is this obsessive-compulsive disorder that has driven the repetition of form that dominates Kusama's work, keeping her in a Tokyo psychiatric institution for nearly thirty years. Here, she creates art daily, guided by her mantra "Accumulation, repetition, obliteration, infinity." Kusama is also a prolific writer, and continues to work with diverse mediums: drawing, painting, sculpture, installation art, and performance. One documented performance that has been repeatedly reproduced involved *Accumulation II,* on which Kusama posed nude in imitation of a pin-up girl and covered herself in polka dots. This layering of patterns only exaggerated the tactility of *Accumulation II* and its disconcerting sexual overtones. [Joselit 2005: 167 (quotation); Cotter 1998; Martin 2002 (quotation)]. ESB

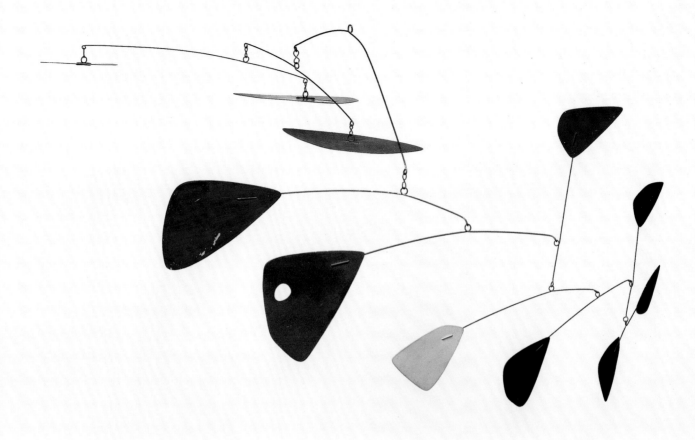

65. Alexander Calder, American, 1898–1976

Mobile, 1953

Painted sheet aluminum and wire, 18 x 36 inches
Partial gift of Nancy and Heinz Valtin in memory of Curt Valentin and
partial purchase through the Miriam and Sidney Stoneman Acquisition
Fund; S.998.41
© 2009 Calder Foundation, New York/Artists Rights Society (ARS), New York

The American sculptor and painter Alexander Calder is best known for inventing the mobile, a type of hanging sculpture with appendages that float and turn. After receiving an engineering degree in 1919, Calder pursued a career in the visual arts at the Art Students League in New York. In 1926, he moved to Paris, where he built *Cirque Calder,* an impressive array of small-scale circus figures sculpted from wire and other materials. It was through this work that he initiated friendships with other avant-garde artists, including Pablo Picasso, Joan Miró, and Fernand Leger. Influenced by his colleagues, Calder began to make his own work more abstract, while his desire to make paintings that moved resulted in the kinetic forms of the mobile. Over the course of his lifetime, Calder would create more than two thousand of these whimsical sculptures.

The organic shapes of *Mobile* float freely from suspending wires, creating a bold display of primary colors in perpetual motion as the carefully balanced forms are stirred by invisible air currents. A fastidious craftsman, Calder shaped his materials entirely by hand, with the manual emphasis contributing to the sculptures' biomorphic form. Size, color, space, and movement continually recombine in shifting relationships that produce a visual parallel to the harmony and unpredictability of nature.

In 1946, the French philosopher Jean Paul Sartre wrote a perceptive and eloquent essay on the artist's work, exploring the mobile's random make-up and the artist's intentions:

> His mobiles signify nothing, refer to nothing but themselves: they are, that is all; they are absolutes. Chance, "the devil's share," is perhaps more important in them than in any other man's creations. They have too many possibilities and are too complex for the human mind, even their creator's, to predict their combinations. Calder establishes a general destiny of motion for each mobile, then he leaves it on its own. It is the time of day, the sun, the heat, the wind which calls each individual dance. Thus the objects always inhabit a halfway station between the servility of a statue and the independence of nature. One sees the artist's main theme, but the mobile embroiders it with a thousand variations. [Sartre 1946: 2–3 (quotation)]

ESB

66. Kenneth Armitage, British, 1916–2002

Standing Figure, 1954

Bronze, 31 x 7 x 4¾ inches
Bequest of A. Marvin Braverman, Class of 1929; S.983.11.7
© The Estate of Kenneth Armitage

67. Reg Butler, British, 1913–1981

Head, Looking Up, about 1954

Bronze, 13½ x 5 x 5 inches
Bequest of A. Marvin Braverman, Class of 1929; S.983.11.5

68. Lynn Russell Chadwick, British, 1914–2003

Winged Figure III, 1959

Bronze, 28¼ x 37 x 8 inches
Bequest of A. Marvin Braverman, Class of 1929; S.983.11.1

In 1952 at the 26th Venice Biennale, an ambitious exhibition titled *New Aspects of British Sculpture* was mounted at the British Pavilion. Outside the pavilion, visitors were greeted with major works by Henry Moore and Reg Butler, and inside by a dramatic installation of the leading young sculptors of the day, including Kenneth Armitage, Lynn Chadwick, Geoffrey Clarke, Eduardo Paolozzi, and William Turnbull. In his introductory essay to this exhibition's catalogue, Herbert Read describes the overwhelming influence of collective social and political experience shaping these artists' work:

> They are individuals participating in a general revival of the art of sculpture, and they are related to each other only by some obscure instinct which has touched them all in life . . . These new images belong to the iconography of despair, or of defiance; and the more innocent the artist, the more effectively he transmits the collective guilt. Here are the images of flight, of ragged claws 'scuttling across the floors of silent seas,' of excoriated flesh, frustrated sex, the geometry of fear. Gone for ever is the serenity, the monumental calm, that Winckelmann had imposed on the formal imagination of Europe; gone, too, the plastic stress of Rodin.

Read recognizes the anxiety-inducing pressures of the contemporary world and identifies an "iconography of despair" developed by these artists sculpting in the aftermath of the horrors of World War II and the beginnings of the Cold War. This group of artists attracted international attention as their sculpture signaled a new, anti-monumental expressionist approach (in contrast to that of Henry Moore), as well as a change in process with the innovative

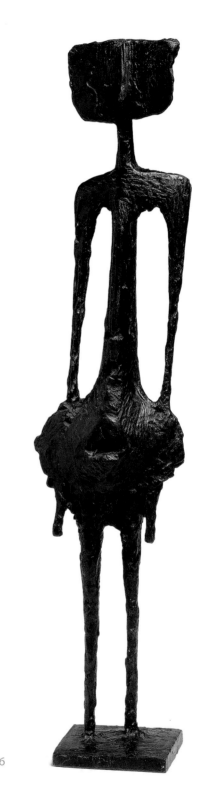

66

use of iron, welded construction, and an emphasis on distressed surface.

Kenneth Armitage was born in 1916 in Leeds, England. In 1934, he was awarded a Gregory Fellowship, an academic scholarship that provided for his education at the Leeds College of Art where Henry Moore, Barbara Hepworth, and Lynn Chadwick had preceded him. After serving in the Army during the war, he taught sculpture at Bath Academy of Art and developed a mature style

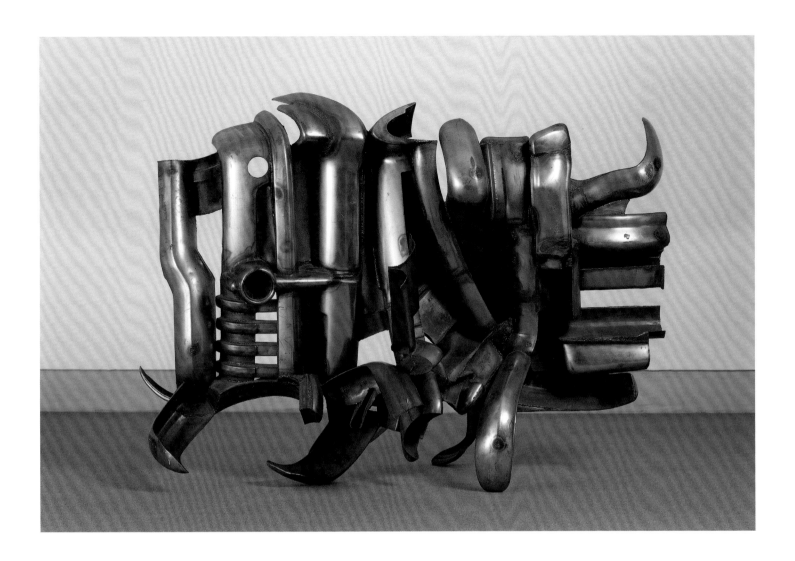

70. Jason Seley, American, 1919–1983

The Boys from Avignon, 1962–63

Chromium-plated steel from a 1949 Buick, 58 x 78 x 47 inches
Purchased with a gift from Evelyn A. Jaffe and William B. Jaffe,
Class of 1964H; S.968.28

Seven years after earning a degree in the history of art from Cornell University, Jason Seley's first solo exhibition came in 1947 at the American-British Art Center in New York. Continuing his sculptural work over the next decade, the seemingly innocuous 1956 roadside discovery of a bumper from a '49 Buick greatly impacted his artistic production. Intrigued by the smooth and stylized molded surface, Seley created the sculpture *Random Walk* using the automobile bumper as his medium in 1958, with the sculpture shown at MoMA in 1959.

Seley's use of automobile bumpers aligns him with contemporaries working in ready-made and found objects, and his choice of material clearly nods to the modern industrial processes through which they are produced. The use of the bumper serves to elevate contemporary materials to the ranks of marble or bronze and, like Allan D'Arcangelo's use of a rearview mirror in *Hello and Good-bye*

(cat. 27), alludes to the pervasiveness of the car in popular culture. While making a departure from sculpture in traditional media, Seley nods to past artistic tradition and the Western canon with his title, *The Boys from Avignon,* a direct allusion to Picasso's 1907 painting *Les Demoislles d'Avignon*. Positioning himself in line with all artists working in the sculptural tradition, Seley stated: "I work, I believe, inspired by the nature of my time and place. To me an automobile bumper is an offering of nature's abundance . . . I do not think of myself as an 'automobile' or 'junk' sculptor, not an 'assembler.' I am a sculptor facing the challenge of the means and materials of my choice, just as my contemporaries and predecessors face, or have faced, that challenge of their own methods and media."

As artist-in-residence at Dartmouth College during the winter of 1968, Seley created *Hanover I,* a sculpture also made out of chromium-plated steel, which resides in the Hood Museum's collection. [Seley 1968: 4 (quotation)] KMG

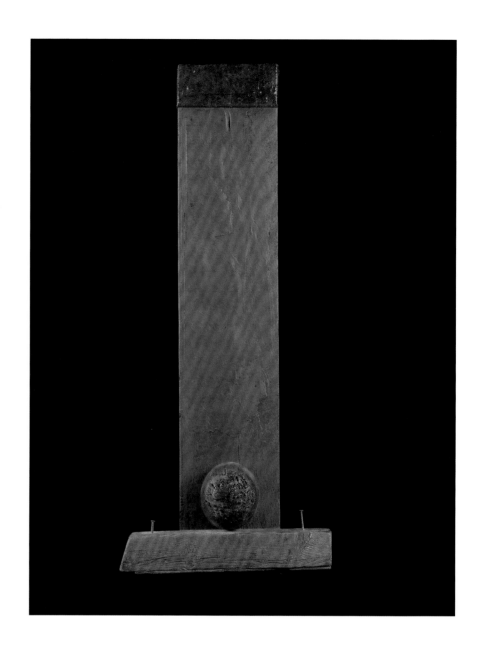

71. Varujan Boghosian, American, born 1926

Homage to Orpheus, 1964

Wood, sculpt metal, steel, 57⅜ x 24⅜ x 7 inches
Gift of Steven Trefonides; 2007.76

Born in New Britain, Connecticut, the son of Armenian immigrants, Varujan Boghosian served in the Navy during World War II and with his GI benefits was able to study at the Vesper George School of Art in Boston. Taking his portfolio of drawings, woodcuts, and watercolors to Josef Albers, then head of the Yale School of Art and Architecture, Boghosian gained admission to the school as well as valuable encouragement from Albers. Boghosian went on to become a professor of studio art at Dartmouth from 1968 to 1996, and continues to live and work in Hanover, New Hampshire, an inspiring mentor to countless young art students.

Central to Boghosian's art is a powerful imagination and a passion for myth, relics, and artifacts. Working in sculpture, collage, and prints, Boghosian has been preoccupied for a quarter-century with the construction of three-dimensional compositions that employ a wide variety of materials. Boghosian's work is inspired by a love for the past; as he has said, "Myth is real to me." His assemblages are guided by his continuing fascination with classical myths, particularly the story of Orpheus and Eurydice. The legendary Orpheus failed to bring his wife, Eurydice, back from the dead, but Boghosian manages to bring discarded objects back to life, and the works themselves become "rescue operations." Boghosian transforms our present consciousness of these old, dead objects by creating works of art that are strange, unique, and completely new.

Working with found materials, Boghosian creates assemblages that are often startling and evocative in the way that poetry is evocative, by juxtaposing unexpected elements. Memory and associations of the past are the essential materials of his art. This early work—the earliest by Boghosian in the Hood's collection—is totemic. The weathered quality of the wood and intensity of the nails piercing the circle that anchors the piece give *Homage to Orpheus* a gravitas and weight in keeping with its subject, the ancient Greek musician and poet who traveled to the underworld to retrieve his lost and beloved Eurydice.

BK and ESB

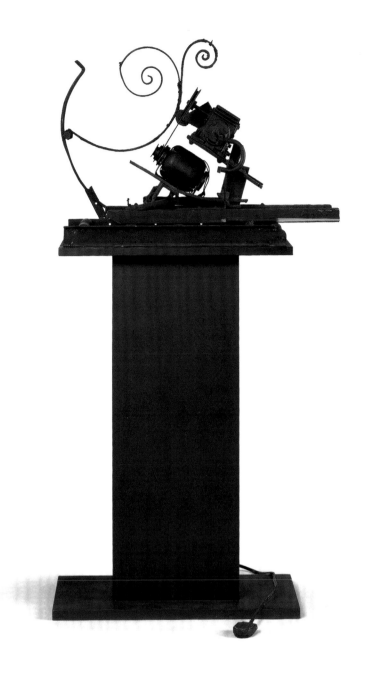

72. Jean Tinguely, Swiss, 1925–1991

Iwo Jima, 1965

Welded steel, electric motor, rollers, wood pedestal, and
foot-operated switch, height: 66½ inches
Purchased through the Julia L. Whittier Fund and gifts from
Dr. and Mrs. F. H. Hirschland and Jay R. Wolfe, Class of 1951,
by exchange; S.977.22
© 2009 Artists Rights Society (ARS), New York/ADAGP, Paris

A pioneer of kinetic sculpture, Jean Tinguely grew up in Basel, Switzerland, and studied there at the School of Arts and Crafts. In 1952, the artist left Switzerland for Paris, where he became a part of the Parisian avant-garde in the 1950s and 1960s, living next door to sculptor Constantin Brancusi and showing in the same gallery as Yves Klein. The artist's fascination with motion, sound, and disorder began with a childhood pastime of constructing elaborate water-powered mechanisms that whirled frantically, hammered on tin cans at odd intervals, and gradually worked themselves to pieces. The artist observed, "People have always tried to fix things into permanence . . . but in reality, the only stable thing is movement. Our only chance is to make things move from beginning to end, to allow them to eternally transform themselves."

Starting in the mid-1940s, Tinguely devoted himself to serious play with the same "mechanics of chance," producing "meta-mechanicals"—automated reliefs and motorized collages of machine parts like this one—as well as enormous constructions of scrap metal and other debris that deliver hilarious, chaotic performances ending in self-destruction amid fits of dynamite, fireworks, and flames. An important turning point in Tinguely's work occurred in 1963, when he began painting his sculptures a uniform black, thereby emphasizing their formal, plastic-sculptural qualities.

In *Iwo Jima,* a spiral element is raised and lowered by an electric motor that whirs and shuttles back and forth in response to the viewer activating its foot pedal. As a kinetic sculpture, Tinguely's work must be in motion to be fully appreciated, but the formal elements, in combination with the sculpture's title, communicate a narrative even when it is stationary. Produced just twenty years after the American invasion of Iwo Jima during World War II, the piece recalls this fierce battle and its celebrated flag-raising with the ironic undertone that pervades Tinguely's work. [Seckler 1963: 62 (quotation)] ESB

97

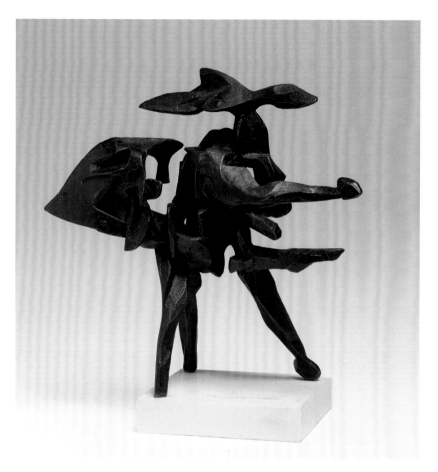

73. Dimitri Hadzi, American, 1921–2006

Thermopylae (JFK Model), 1965–66

Bronze, height: 15 inches
Purchased through the Guernsey Center Moore 1904 Memorial
Fund and gifts from Mrs. Hersey Egginton in memory of her
son, Everett Egginton, Class of 1921, by exchange; S.969.38

Born in Greenwich Village, New York, Dimitri Hadzi studied at
Cooper Union, the Brooklyn Museum, the Polytechneion Athens,
and the Museo Artistico Industriale in Rome. Hadzi was a professor of visual and environmental studies at Harvard for many years,
teaching both sculpture and printmaking. Abstract, expressionist,
and decidedly modern in character, the traditional remains central
to Hadzi's work, not only in material (bronze, stone, pen and ink)
but also in subject matter (epics and myths). The artist's semi-abstract sculptures in bronze and stone often reference mythology
and classical antiquity and suggest the forms of figures but stop
short of evoking straightforward narratives.

Thermopylae (JFK Model) is a cast of the original wax model
for the commissioned sixteen-foot *Thermopylae (JFK)* erected in
front of the John Fitzgerald Kennedy Federal Building in Boston,
Massachusetts, in June of 1969. The title refers to the ancient and
epic Greek conflict of 480 BC when an alliance of Greek city-states fought the invading Persian Empire at the pass of Thermopylae in central Greece. Explaining his choice of subject for the
commission the artist said, "The theme of the *Thermopylae* piece
is courage, based on Kennedy's *Profiles in Courage*. And, being
of Greek extraction, I thought, why not take battles where great
courage was displayed?" Imposing even as a maquette, the irregular, faceted surfaces and biomorphic elements of Hadzi's bronze
sculpture demonstrate the transitional nature of his oeuvre from
figuration to abstraction.

In addition to this bronze, a number of the artist's sculpture
studies (fig. 1) were acquired during Hadzi's summer artist-in-residence exhibition at Dartmouth in 1969. Vigorous pen and ink
jottings of muscular, stocky forms closely resemble some of the
artist's monumental public bronzes, including *Thermopylae (JFK)*.
[Brown 1981: (quotation)] ESB

Fig. 1. Dimitri Hadzi, *Sculpture Studies,* 1969, pen and ink with white opaque
watercolor corrections on wove paper: 10¹⁄₁₆ x 14¹⁵⁄₁₆ inches. Gift of the artist;
D. 969.34.

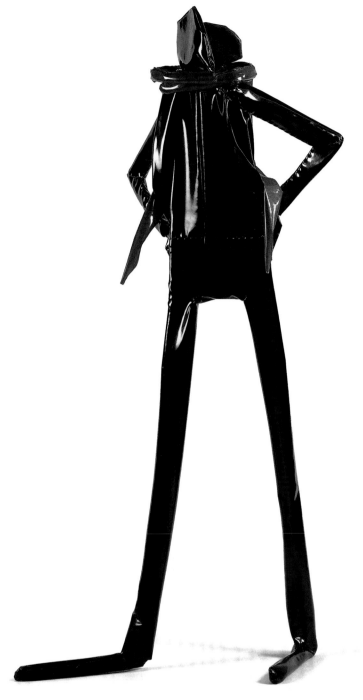

74. William Dickey King, American, born 1925

"Daddy," 1966

Vinyl and plastic, height: 96 inches
Gift of the artist; S.968.33

William Dickey King was born in Jacksonville, Florida, in 1925 and studied at the University of Florida, Cooper Union Art School, Brooklyn Museum Art School, Academia dei Belli Arte Rome, and the Central School, London. Known for his lanky, caricature-like figures in wood, clay, and vinyl, King is a sculptor of the comic gesture. Full of unexpected combinations of images and materials, King's work reverberates with American folk art traditions.

King's choice of materials distinguishes his sculptures from other twentieth-century sculptors' work. Greatly influenced by the Polish American artist Elie Nadelmann, King's ungainly figures stand upon spindly legs that clearly echo the stature of Nadelmann's typical subjects. Yet no other sculptor has moved from the traditional uses of bronze and wood to newer "soft" materials with so little change in the spirit of his work. By 1959, the artist had begun making sculpture with these materials on a regular basis—first burlap, then Naugahyde and Mylar. Many of his earlier works have since been lost.

Both the title *"Daddy"* and the two intertwined bodies suggest a narrative that is incomplete. An awkwardly tall figure (presumably the "daddy" of the title) carries a smaller, bright red figure on

his back. Here, the intimate and casual embrace between father and child has a somewhat intimidating character caused by the height of the sculpture (which stands nearly eight feet tall), the exaggeration of the limbs, and the faceless, vinyl heads that add a disconcerting and slightly comical element to the work. However, knowing King was a father himself adds a strong autobiographical element to the work as well. It is clear that King's figures are particular individuals caught at a precise moment, yet we are left to wonder exactly who they are. ESB

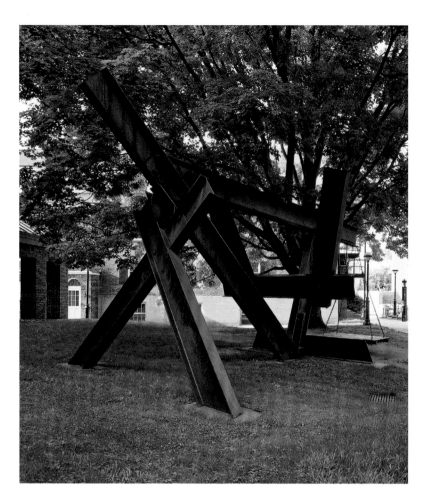

75. Mark di Suvero, American, born 1933

X-Delta, 1970

Iron, steel, wood, 132 x 216 x 120 inches
Gift of Hedy and Kent M. Klineman, Class of 1954; S.976.72

X-Delta arrived at the College shortly after Mark di Suvero's triumphant exhibition at New York's Whitney Museum of American Art. That mid-career survey, during which large-scale sculptures were placed in each of New York City's five boroughs, marked the artist's return to this country after a self-imposed exile to the village of Chalon sur Saone, France. The artist moved his base of operations and refused exhibitions in the United States as a protest against the country's involvement in the Vietnam War.

X-Delta is among the first of di Suvero's architecturally scaled steel beam works. It was created the same year as *Are Years What? (For Marianne Moore),* now on the Mall in Washington, D.C. He had begun working with a crane in the Brooklyn Navy Yard the previous year, when the elements of his work came together: the use of the crane, which the artist has referred to as "my paintbrush" (di Suvero is a member of the crane operators' union), and the structural steel whose positioning the crane makes possible. The great advance in size and scale, which began here, would culminate in works exceeding heights of one hundred feet.

The Greek characters hinted at in the title are suggested by the linear arrangements of the beams. The basic structure relates to the workaday improvisation of the sawhorse. The distinctive cantilever, from which the wooden platform (bed) hangs, breaks through the frame into the openness of space.[1] In doing so, it dramatizes the balance of the piece. The sculptor speaks of how the center of gravity of individual beams and entire sculptures reveals itself

through the balance struck when the weight is lifted by crane. The center of gravity is actual and metaphoric.[2]

Di Suvero studied philosophy at the University of Southern California. He was living a beatnik life in a tree house when a touring exhibition of abstract expressionist paintings at the Berkeley Museum revealed to him the possibilities of form and invention in advanced art. From his tree house, he could experience a vertiginous viewpoint similar to that of Pollock striding around his canvases, flinging paint to the surface while looking down at the horizontal plane. *X-Delta* is unusual for a work from this stage of the sculptor's development in that it allows access to the wooden "bed," where students can recapture the excitement of this type of viewing while lying to face the earth, or perhaps experience the sublimity of Rothko's light by looking up at the heavens. [Rose 1973: 160–62, 202–3 (quotation)] MD

1. The concept of "spatial sculpture" was set out in di Suvero's remarks in the symposium for the Jewish Museum, New York, exhibition *Primary Structures* (May 2, 1966). Transcript at the Archives of American Art.

2. Mark di Suvero in Dirk Van Dall, *Storm King* (Dreamtime Productions, 1987, 22-minute videotape): "Center of gravity is an invisible point in any beam. Ballet dancers can pull their centers of gravity outside their bodies by doing certain motions, [but] a crane never lies. When it picks up an object, the center of gravity swings underneath the point of suspension, and that always happens." Transcription by Monroe Denton. See Carl Von Clausewitz and J. J. Graham, *On War* (New York: Taylor & Francis, 2004), 106.

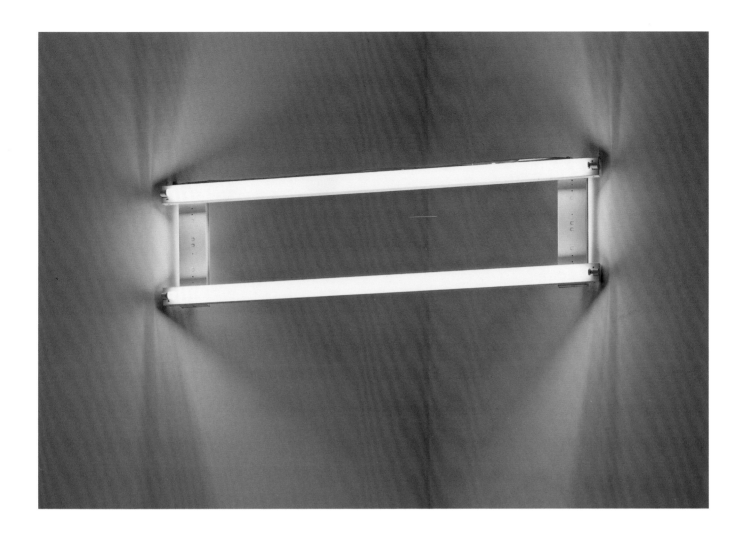

76. Dan Flavin, American, 1933–1996

untitled (to Elita and her baby, Cintra), 1970

Red, blue, and pink fluorescent light, 25 x 96 x 8 inches
Gift of Leo Castelli; S.975.71
© 2009 Stephen Flavin/Artists Rights Society (ARS), New York

Thirty-five years after the General Electric Company made the fluorescent light bulb a commonly used and available piece of technology, Dan Flavin produced his first fluorescent light sculpture: *the diagonal of personal ecstasy (the diagonal of May 25, 1963)*. The impact of Flavin's work on perceptions of art, progress, and space is based in large part on the ubiquitous nature of fluorescents in the contemporary West and the subsequent invisibility of the fixtures and their corresponding technologies.

By calling attention to light and treating it as both subject and art, Flavin's work subverts the traditionally accepted understanding of gallery and museum space, as well as the role of viewers within these venues. Light in these arenas is typically used to enhance or illuminate, not serve as, a work of art. The very act of viewing is overturned by Flavin, as one can only look as his bright fluorescent lights for a certain amount of time without experiencing discomfort to the eyes. Unlike a painting hung on a wall, the light is not confined to the space to which it is affixed, but fills the room, casts shadows, and can (depending on placement) bathe its viewers in a glow. It is also kinetic, and though without obviously moving parts, the pulsing and flowing electricity inside the bulb is often perceptible. This flow can also produce a faint hum, which can change in frequency and tone as the bulb ages, involving viewers audibly.

It is fascinating to note that while subverting so many of the preconceived notions of art and the use of museum and gallery space, some of Flavin's sculptures, including *untitled (to Elita and her baby, Cintra),* mimic the typical pictorial plane by the placement of bulbs. With two horizontal bulbs of the same length situated parallel to each other and connected vertically by their metal supports, *untitled (to Elita and her baby, Cintra)* reveals an inherent understanding of the perceived boundaries of space presented by a traditional canvas, and Flavin's acknowledgment of this as he consciously sets himself apart from this previous limitation of art history. KMG

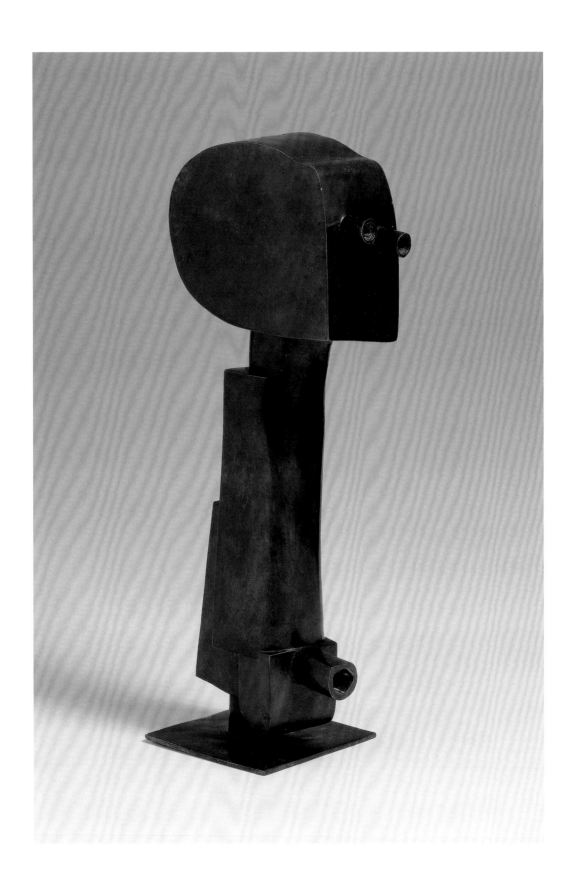

77. Amir Nour, Sudanese, born 1939

Dismuke, 1972

Bronze, 17⅜ x 4⅞ x 6½ inches
Purchased through the Robert J. Strasenburgh II 1942 Fund, the Phyllis and
Bertram Geller 1937 Memorial Fund, the William B. Jaffe and Evelyn A. Jaffe
Hall Fund, and the William B. and Evelyn F. Jaffe (58, 60, & 63) Fund; 2005.15

One of the first African "modernists" to move to the United States
in the 1960s, Amir Nour was trained and taught at the School of
Applied and Fine Art in Khartoum, Sudan, which promoted the
European modernist language. He continued his studies at the
Slade School of Fine Art and the Royal College of Art in London
and then at Yale University, earning a B.A. and M.A. in fine arts
before moving to Chicago in the late 1960s.

Nour acknowledges the impact that Western artistic training,
technology, and media—steel, cement, plaster, and molded plas-
tic—have had on his aesthetic formulations, which draw equally
from African art and architecture. For example, the geometric ren-
dering of the facial features of his bronze sculpture *Dismuke,* with
its conical eyes and mouth, recalls the style of the European cubis-
tic (fig. 1) but also traditional African sculpture, such as this *Kagle*
mask by an unknown Guéré-Krahn artist from Côte d'Ivoire (fig.
2). For the narrative component of his art, Nour draws directly
from Sudan's regional history and environment and from personal
experiences and memories of his Nubian cultural legacy, his Afro-
Islamic background, and his hometown in Shendi. Nour calls these
Sudanese experiences his "fingerprints."

In 1970, Nour returned briefly to Sudan, where he was shocked
to see starving children in his homeland. A boy named Dismuke,
a victim of the famine caused by drought and governmental
mismanagement, especially moved him. The image of the child's
bulging eyes, protruding umbilicus, and horrifyingly thin body
haunted the artist, who created this sculpture a year later "from the
heart" as a "symbolism of the suffering" of the hungry Sudanese
children. Today, the work is a stark reminder of the continued dev-
astation and genocide in Sudan, where decades of drought, famine,
and political conflicts have wiped out entire generations. [personal
communication, 2005 (quotation)] BT

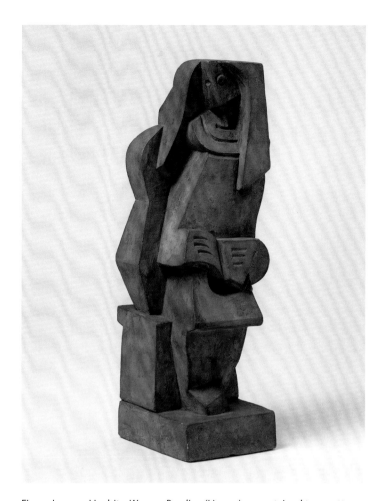

Fig. 1. Jacques Lipchitz, *Woman Reading (Liseuse),* 1919, stained terracotta,
height: 15¼ inches. Purchased through the Evelyn A. and William B. Jaffe
Fund; S.965.13. © Estate of Jacques Lipchitz.

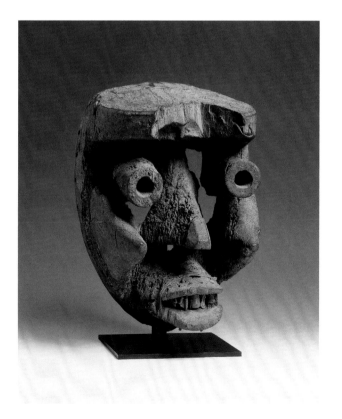

Fig. 2. Artist unknown, Ngere (Kran) peoples, Guéré-Krahn, Côte d'Ivoire,
Kagle, mask associated with aggression, early 20th century, wood. Gift of
Evelyn A. Jaffe Hall; S.973.319.

103

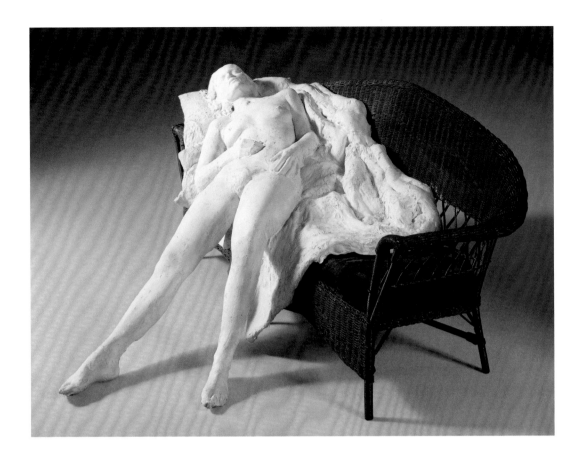

78. George Segal, American, 1924–2000

Girl on Red Wicker Couch, 1973

Plaster, wicker couch, 35 x 80 x 58 inches
Purchased with a gift from Joachim Jean Aberbach and a matching grant
from the National Endowment for the Arts; S.975.7
Art © The George and Helen Segal Foundation/Licensed by VAGA,
New York, NY

> I count heavily on the human ability to spot metaphor. The urge to
> read poetry into things is universal.
>
> — George Segal

An aspiring painter, a student of Hans Hofmann, and an associate of the
Hansa Gallery—an artists' cooperative famous for launching careers—
George Segal inherited his teacher's respect for European modernism
but was in awe of Franz Kline's muscularity and Willem de Kooning's
treatment of the figure. Less often mentioned was the inspiration Segal
drew from Jewish tradition and from reading the Bible. A breakthrough
occurred in 1958 at the Hansa Gallery: a large painting of *Lot and his
Daughters* morphed into a combine that, in addition to the canvas,
contained, posed in front of it, three human forms, clumsily modeled in
plaster over chickenwire. First formulated here was Segal's belief that a
sculpture gains definition not just in terms of itself but also through its
relationship to another consciously presented reality.

As the artist gained greater command over his materials, plaster effi-
gies replaced the painted ones. In their stead, accoutrements of every-
day life, neither new nor fancy, became the foils for single or grouped
figures whose narrative was either imposed by the artist or left up to
the viewer.

By the mid-1970s, Segal had changed his method from covering his
subject's body with medical plaster-impregnated fabric, cutting it off
when hardened, and reassembling the pieces, to making an interior cast
of the plaster hull in order to better capture a naked body's nuances.
Girl on a Red Wicker Couch offers more detail and is thus more provoca-
tive than earlier nudes. The sprawl of the body mimics the spread of the
towel. Delighted by the sensuality of his models, Segal, on occasion,
would compare himself to King David beholding Bathsheba on the ter-
race below. [van der Marck 1979: 15 (quotation)] JVDM

Throughout George Segal's career, his most constant subject was
the female nude. Segal offered three explanations for this: his hu-
man instincts, the overwhelming prevalence of female models in
art classes, and the lengthy Western tradition of the genre. In 1961,
Segal developed his signature technique of creating casts of his
models by dipping Johnson & Johnson bandages in plaster and
wrapping their bodies with the strips. During the lengthy drying
process he worked and reworked the malleable bandages to obtain
the desired effect. In the finished work the artist included everyday
objects for which he scavenged his urban surroundings—in this
case a couch—creating what he called "assembled environments."
While Segal has been linked to Pop artists, in particular sculptor
Claes Oldenburg, his work avoided the popular culture references
proliferating in art at that time. While his figures are realistic, they
are ultimately also unsettling. The woman sprawled across the
familiar piece of furniture is too still and too white to be entirely
provocative or sensual. [Friedman and Beal 1979: 18; Smith 2000]

AHW

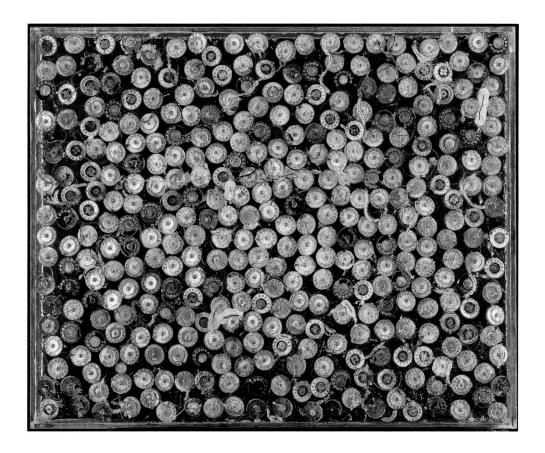

79. Arman, American, 1928–2005

Untitled (Accumulation of Telephone Dials), about 1974

Telephone dials in polyester, 63½ x 79 inches
Gift of Thomas G. Newman; S.977.165
© 2009 Artists Rights Society (ARS), New York/ADAGP, Paris

When I assumed directorship of the Dartmouth College Museum and Galleries in 1974, thoughtful colleagues had arranged for Yves Klein's *Blue Monochrome Sponge Relief* (cat. 17) to hang in my office. No one appreciated it more than I did, but I quickly realized that within the collection, this colossal masterpiece was an orphan and also, for many, the epitome of art's errant ways. So, how better for students and faculty to make sense of Klein than to show, with contextual acquisitions, that he had likeminded cohorts united by a manifesto, active in Paris and Nice (and soon New York), calling themselves "Nouveaux Realistes." Klein was inseparable from Arman, so I featured that artist in a 1975 exhibition and obtained the gift of an important example from a mutual friend. When John and Kimiko Powers decided to concentrate on American art, I snatched their Tinguely, *Iwo Jima* (cat. 72), for the College. Yayoi Kusama's phallic couch (cat. 69) serendipitously arrived on our doorstep long before she became famous. Even the title gives her away as the Arman-groupie she was in New York in 1962.

The son of what the French call a "brocanteur," a dealer in minor antiques, Arman was a natural collector who identified the pathetic quality of objects that had served their purpose and the particular fascination of a great many of the same objects immobilized together within a case or frame. "Accumulation" was the strategy of his invention and but one of many that made his reputation. Objects taken out of circulation and entombed evoke the irreversibility of life, time, and human endeavor. Does anyone of iPhone age even remember rotary dials?

Arman has said, "Even in my volumetric compositions my aim is always pictorial rather than sculptural; I want to see my proposals understood as involving the optics of a surface rather than a realization in three dimensions." Did Arman imitate Andy Warhol or vice-versa? Of course not. They were friends, mega-collectors both, and respected each other. One accumulates with no claim to sameness, the other repeats; one uses objects, the other uses images; one is bound by scale or reality, the other enlarges his images at will. Do they touch the same snare in us? [van der Marck 1984: 12 (quotation)] JVDM

Arman's accumulations of found objects—huge yet fragmentary masses of stuff—act to make explicit the conflicting realities of the surrounding world. Adding object upon object, Arman exposes the consumerism and materialism of everyday life, critiquing needless accretion through sheer quantity. Yet, by taking these objects apart, the artist also shows their inner workings and allows the viewer to see them in a new light. There is a degree of fascination in this sort of investigation and analysis that cannot help but be imparted to his audience. *Untitled,* an abstract pattern of rotary telephone dials, reveals the effects of what he learned from local artists beginning to work in plastics during a teaching stint in California. Here he began to coat his objects with layers of polyester resin, creating glossy masses that merged sculpture, painting, and the everyday. [van der Marck 1973: 92] AHW

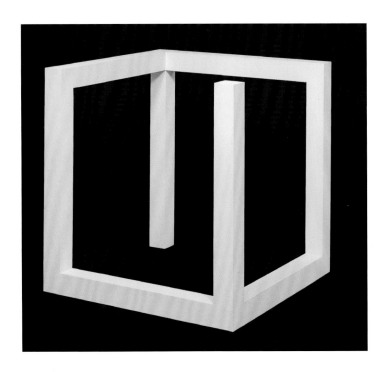

80. Sol LeWitt, American, 1928–2007

Incomplete Open Cube 8-14, 1974, 1974

Enameled aluminum, 42 x 42 x 42 inches
Purchased with a gift from Joachim Jean Aberbach and a matching grant
from the National Endowment for the Arts; S.975.8
© 2009 The LeWitt Estate/Artists Rights Society (ARS), New York

At the forefront of conceptualism, Sol LeWitt explored the possibilities of systems and series, both mathematical and aesthetic. Working in both two- and three-dimensional media, LeWitt reduced his artistic vocabulary to the most elemental components. Using simple polygons and primary colors, he set for himself programs to complete and directions to follow. Among his many influences are the mechanistic qualities of constructivism and the frame-by-frame photo sequences of Eadweard Muybridge, as well as the paintings of contemporaries Frank Stella and Jasper Johns. *Incomplete Cube 8-14, 1974* examines the fundamental qualities of sculpture. Thinking of a cube as an open form comprised by twelve edges, LeWitt sought to find every way he could suggest a cube without using all of its edges, with the requirements that the edges connect, it exist in three dimensions, and that it have a unique configuration and orientation. In the end he discovered—and made—122 different sculptures. While LeWitt believed in the primacy of the idea over the object, he also maintained that it was crucial that his concepts actually be created, stating, "I don't mean the idea of a cube, I mean a physical object . . . The word part is only an adjunct to the physical part."

It was important to LeWitt that his ideas be realized, but it was not important that he be the one to carry them out. This is evidenced by his wall drawings, including *Wall Drawing #655* (fig. 1), currently on view at the Hood Museum. Having spent time working in an architect's office, LeWitt noted that while the architect does not pour the cement, he is still the artist; the composer does not play the instrument, but the music is his creation. In his studio, craftsmanship was unprivileged, with no praise lavished on the application of paint or rendering of line. Having created guidelines for a particular wall drawing, LeWitt gave his ideas over to assistants to complete. Underscoring the uniqueness of his approach, LeWitt said of his assistants, "I count on the rebelliousness they have . . . as long as they stick to the plan . . . I want them to express themselves." *Wall Drawing #655* was created with the following instructions: "A wall divided into three vertical sections / the left and right sections divided into 15 horizontal bands of equal width / the middle section divided into 12 vertical bands of equal width / each band received a combination of 3 of 4 possible colors / the colors being yellow, red, blue, and grey."

Like the systematic removal of edges in LeWitt's *Incomplete Cube* series, *Wall Drawing #655* treats color as a variable that can be added or removed. He sharply restricts his palette, but the thinness of each wash of ink and the blending nature of color ensure that each section of the wall is unique in appearance. [Kent 2007: 69 (quotations)]

AHW

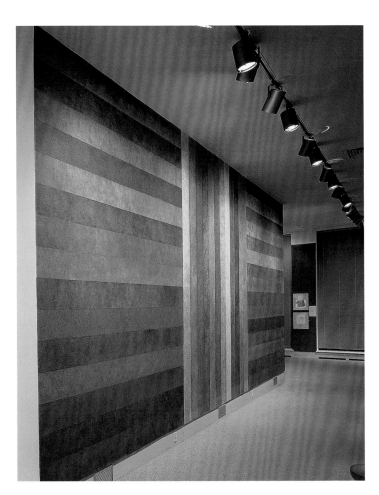

Fig. 1. Sol LeWitt, *Wall Drawing #655*, October 1990, colored India ink wash, 152 x 368 inches. Collection of the artist; EL.D.990.39. © 2009 The LeWitt Estate/Artists Rights Society (ARS), New York.

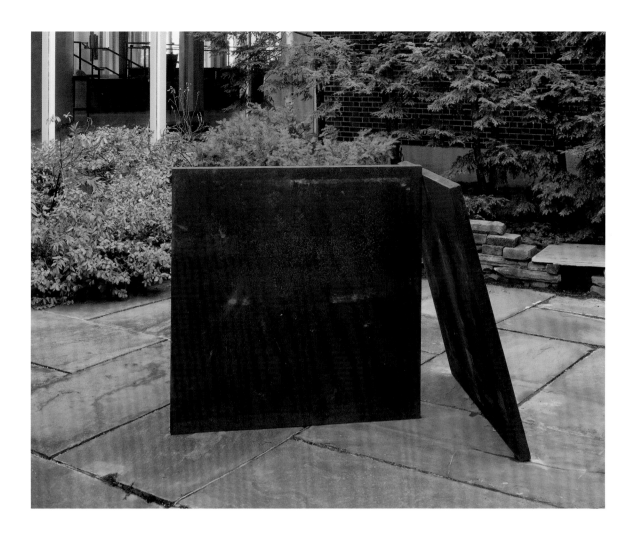

81. Richard Serra, American, born 1939

Two-Plate Prop, fabricated 1975–76
(original lead version 1969)

Cor-Ten steel, 48 x 48 x 64 inches
Gift of Dorothy and Roy Lichtenstein; S.975.97
© 2009 Richard Serra/Artists Rights Society (ARS), New York

Richard Serra is known for his huge-scale structures of manipulated sheet metal. Highly educated, he cites as influences fellow sculptor Alberto Giacometti, land artist Robert Smithson, writer Herman Melville, and Corbusier's modernist church at Ronchamp, France. His abstract work focuses on the inherent nature of his constructive process as well as the innate qualities of his materials. Describing his method, the artist said, "For me process has always taken precedence over results if only because without the how there is no what." Early in his career, Serra went so far as to create a lengthy list of active verbs he wished to carry out and enact upon his work, eventually trying them all in the studio.

As with *Two-Plate Prop* many of his sculptures are self-supporting, emphasizing the extreme weight and solidity of steel, as well as the force of gravity. Serra's work is powerful and elemental, often dwarfing its site or acting as an immovable barrier to the viewer.

Frequently called a minimalist, Serra braces against this label, reinforcing the fact that his sculptures are concerned above all with time and the relation of the body to the environment. Often working in the public sphere, Serra insists upon the viewer's active relationship with his massive sculptures, designing his work according to the specific spatial context of the site. As he said repeatedly during the controversy surrounding the removal of the wall-like *Tilted Arc* (1981) from the Federal Plaza, "To remove the work is to destroy it."

Two-Plate Prop, an early work of Serra's, is a non-narrative exploration of the very basic vocabulary of sculpture: geometric forms that emphasize spatial relationships to the exclusion of all else. It is composed of two pieces of Cor-Ten Steel with a combined weight of 2,600 pounds. Set perpendicular, each plate acts as the other's support, allowing the force of gravity to transfer down through the steel and spread evenly into the ground. To Serra, it was always "important that whatever was finally made reveal its making." In this work, the weight and compression of the steel is clear through the seemingly precarious yet actually stable balance of the two plates. Like the Earth's tectonic plates, Serra's *Two-Plate Prop* stands in equilibrium, yet suggests its potential power and force through sheer mass. [Serra 2008 (quotation); Serra 1989: 34 (quotation); Serra, in McShine et al. 2007 (quotation)] AHW

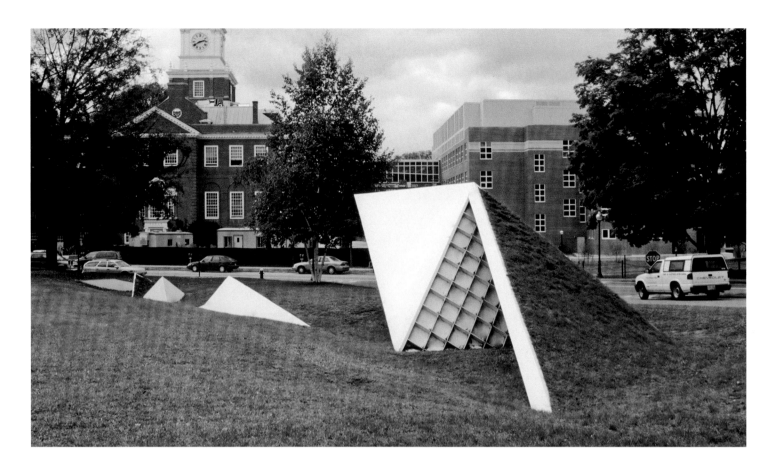

82. Beverly Pepper, American, born 1924

Thel, 1975–77

Painted Cor-Ten steel and grass, 11 x 135 x 18 feet
Purchased through a gift from the Sherman Fairchild Foundation with a
matching grant from the National Endowment for the Arts; S.977.144

Minimalist art eschewed poetic titles, but, historically, Pepper's *Thel*
represents late minimalism and a form of "land art" that, in our time,
can be said to have originated in 1955 with Herbert Bayer's Aspen "earth
mound" and may have reached its acme in Michael Heizer's ongoing
Complex of City in the Nevada desert. Site-specificity as definition and
dictate for outdoor sculpture came into usage at the same time. What
this means is that *Thel*—created with its present site in mind—would
lose its physical and spiritual context if disassembled and moved from
the Dartmouth campus to another location. Sculptures and buildings
are notoriously vulnerable to time and fashion. Whatever is ordained
for *Thel* (one can never tell the future of a site-specific sculpture), it will
remain lodged in the impressionable minds of generations of students
and preserved in countless recorded images.

"Placing art on our campuses will strengthen the visual literacy of
the future," Joan Mondale, wife of Vice President Walter Mondale and
an artist and force for art in her own right, asserted at *Thel's* 1978 official
dedication. Since then the sculpture has severely tested that notion and
elicited more than its share of negative criticism. Its formal configura-
tion was never at issue, nor was its color, which blends in with clapboard
buildings and churches. Location was the bugaboo and so, to some ex-
tent, was its non-traditional character. Were students robbed or incon-
venienced? I have seen them milling about or lounging on *Thel's* flanks.

Pepper invites that kind of interaction. At the Museum of Contemporary
Art, Chicago, in 1969, her sculptures came alive and gained additional
meaning when Meredith Monk and her dancers in white overalls used
them as props for a performance that made avant garde history.

JVDM

Thel epitomizes the particularity of site-specific sculpture. Beverly
Pepper visited Dartmouth College several times during the de-
velopment of her idea, and as she gained greater insight into the
character of the campus, her original plan for a 39-foot-long sculp-
ture expanded outward to a length of 135 feet. Comprising four
similarly pyramidal structures telescoping downward in scale, the
steel sculpture was painted white to respond to the nearby archi-
tecture and snowy New Hampshire weather. In this work Pepper
chose to leave the interior undersides exposed, displaying the grid-
like supporting structure. The grass coating several surfaces brings
the sculpture further into balance with the site, and it seamlessly
becomes a part of the ground. The site and sculpture change with
the season, emphasizing the importance of time in Pepper's work.
Describing monumental sculpture, the artist explained, "The only
inescapable need is to relate and create an interaction between
man and aesthetic experience . . . The use of nature within *Thel*
is not only to project but also to link it to process and change in
man's life and society." [Pepper 1977: 251 (quotation)] AHW

83. George Warren Rickey,
American, 1907–2002

*Two Lines Oblique Down,
Variation VI,* 1976

Stainless steel, height: 132 inches
Gift of the artist and gifts of anonymous donors,
by exchange; S.977.186
Art © Estate of George Rickey/Licensed by
VAGA, New York, NY

Born in South Bend, Indiana, in 1907, George Warren Rickey was raised in Scotland and studied in Paris with André Lhote, Fernand Leger, and Amédée Ozenfant. After returning to the United States in 1934, Rickey continued painting in New York in a social realist style. As a gunnery instructor for the Army Air Corps during World War II, Rickey had access to a machine shop where he created his first sculptures—small mobiles reminiscent of Alexander Calder's work.

After hearing a lecture by Nuam Gabo at the Institute of Design, Chicago, Rickey developed a keen interest in constructivist theories and began translating the aesthetic principles of Gabo and Antoine Pevsner into kinetic sculpture. Rickey's mature style emerged in the late 1950s when he reduced his forms to simple geometric shapes, limited his medium to stainless steel, eliminated

color, and increased the scale of his work. His sculptures are distinguished by a commitment to non-motorized yet complex and spontaneous movement. The thin blades he prefers to use are configured vertically or horizontally and may be either freestanding or suspended.

Two Lines Oblique Down, Variation VI, is typical of Rickey's later style and his continued concern with exploring the movement of reflective surfaces. Though the sculpture appears delicate, it is strong enough to withstand the wind, and its two arms swing gracefully according to the changing currents of its environment. As Rickey explained, "I have worked for several years with the simple movement of straight lines, as they cut each other, slice the intervening space, and divide time, responding to the greatest air currents." [Baigell 1979: 301 (quotation)] ESB

84. Richard Nonas, American, born 1936

Telemark Shortline, 1976

Georgia oak, 16 x 12 x 880 inches
Gift of Holly and Horace Solomon; S.976.1

Born in New York in 1936, Richard Nonas was educated as an anthropologist, a concentration that continues to influence his sculptural work. A number of critics have noted that the forms and sites that Nonas favors call to mind the totems and ceremonial enclosures of indigenous cultures, frequently evolving from markers and gathering places. Often inspired by traditional partitioning of the land or boundary markers, Nonas's sculptures employ basic shapes and constitute the simplest definitions of space.

Telemark Shortline was designed by the artist for a specific site between the Hopkins Center and Wilson Hall on Dartmouth's campus. At the time of the construction of the Hood Museum of Art in 1982, this work was deinstalled. It was then reconstituted for installation in the fall of 2009 on a new site. The first part of the title comes from the sculpture's form, which resembles a deep-snow turn made with a pair of Nordic skis. "Shortline" refers to both the railroad company name (the sculpture's composition brings to mind railroad tracks) and the artist's term for the bevel-cut ends of his beams.

Installing the work in the dead of winter, Nonas placed two squared, bevel-cut thirty-four-foot beams of Georgia oak into the snow. The sculpture itself is a broken line, formed by aligning the beams end-to-end with a seven-foot gap between them. It is a simple object that changes as you approach it, appearing at first as one continuous line, then revealing itself as separate beams as one draws nearer. Through its very presence *Telemark Shortline* subtly changes the surrounding area, activating a traditionally vacant space, and—on a practical level—denotes the shortest crossing from one corner of campus to the Lebanon Street parking lots.

Although its unconventional spareness made the sculpture a challenging work for many, as former director Jan van der Marck noted, "Spontaneous use is often the most eloquent sign of approval for outdoor sculpture." He observed, "No sooner had the snow melted than students and faculty began to use Nonas's *Telemark Shortline* as a convenient bench to hold open air seminars, eat brown-bag lunches, or play the guitar." [van der Marck 1978: 249 (quotation)] ESB

85. Richard Peter Stankiewicz,
American, 1922–1983

Untitled, 1979

Steel, 24¾ x 22 x 15 inches
Gift of the artist; S.979.137

The American artist Richard Stankiewicz was celebrated in the 1950s and early 1960s for his so-called "junk sculptures," agglomerations of seemingly worthless detritus salvaged from broken down, discarded machinery. Using unpromising and at times unclassifiable bits and pieces of refrigerators, stoves, automotive assemblies, and plumbing accessories—among many other items rescued from junkyards—he created both figurative and rigorously abstract formal constructions. A student of Ossip Zadkine in Paris, and Hans Hofmann in New York, he adopted the modernist doctrine that all materials touched by the artist should be infused with the spirit of life. Before the term "assemblage" was first used to describe three-dimensional collages juxtaposing ostensibly unrelated objects, Stankiewicz was creating such works. While his sculptures demonstrated great compositional sophistication, through their base material properties and sardonic wit they also obliquely parodied the notion of art as a precious, privileged commodity.

By the time this work was made, Stankiewicz had learned advanced welding techniques and, working in a modern steel foundry, had created large-scale compositions with freshly milled steel elements including cylinders, pipes, and I-beams. His formal vocabulary was affected by minimalism and the taste for simplified, unfussy geometric order. He had learned to bend steel to his own specifications, and rather than constructing work through additive improvisation as he had in the past, he now composed it from industrial materials made deliberately for his purposes.

The easel series, to which this piece belongs, reflects the artist's indebtedness to his teacher Hans Hofmann, who inculcated in his students the doctrine of "push-pull," urging them to create a dynamic illusion of depth on a flat surface. A demonstration of the tensions that define a plane—with vigorous projections both before and behind it—this sculpture is a paradigm in steel of modernist economy and integrity. ED

86. Mel Kendrick, American, born 1949

Red, Yellow and Blue Poplar, 1986

Japan color, wood, resorcinol resin and thermal glue, 36¼ x 18 x 12 inches
Purchased through the Robert J. Strasenburgh II 1942 Fund; S.997.9

A sculptor who began his career during the minimalist period of
the 1970s, Mel Kendrick has an unerring sense of sculptural form.
Working without preparatory drawings or preconceived ideas
about how a sculpture should look, Kendrick responds to each
piece as it evolves, remaining open to accident and visual possibil-
ity. Often the mark of his pencil or fingertips remain on the surface
of the wood, lending even a large and complex work the appear-
ance of having just been created and the sense that the viewer has
participated in the moment of creation. The open-ended quality of
Kendrick's process contrasts with his clear and disciplined vision
of his sculpture's evolution as a series of variations on a succession
of themes. He sets the parameters for creating a series in much the
same way a mathematician might set up an equation with one or
more independent variables.

In making *Red, Yellow and Blue Poplar,* Kendrick started with
a six-by-six-inch block of poplar and marked the sides with red,
yellow, and blue. He then made pencil marks on the sides and
proceeded to use a power saw to carve it and then reshape and
reassemble it into a dynamic spiraling form that fully exploits both
positive and negative space. The visual complexity of his work
links it with a sculptural tradition that dates back to the Renais-
sance—a person circumnavigating an object can experience chang-
ing profiles, textures, and the play of light and shadow. *Red, Yellow*

and Blue Poplar is stunningly varied from all viewpoints; to be
understood as an object the sculpture must be seen in three dimen-
sions. The colored washes, now divided and appearing in different
planes, allow the viewer to meditate upon and reconstruct how it
was made. Through the transparency of his process, the artist inte-
grates an experience of time that is fully present in the work. Since
Kendrick is also concerned with how the work will be experienced
after it leaves his studio, for many of his smaller sculptures he cre-
ates pedestals that are integral to their presentation.

KWH

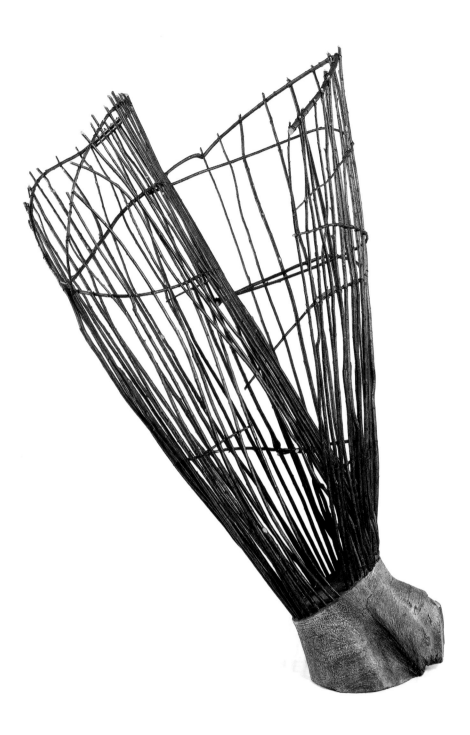

87. Carol Hepper, American, born 1953

Tropus, 1987

Copper beech, willow, wire and pigment, 79 x 47 x 47 inches
Gift of Shelly Kolton; S.2002.5

Now living and working in New York City and upstate New York, sculptor Carol Hepper was born in 1953 in McLaughlin, South Dakota, on the Standing Rock Sioux Reservation. Her personal history with the West is often invoked in descriptions of her work, which in both materials and subject matter revolves around the natural world. Hepper is widely known for her use of non-traditional materials to produce sinuous sculptures; her earliest works were made from branches and stretched animal hides. Primarily a self-taught artist, Hepper received a B.S. from South Dakota State University. She has taught at colleges and universities across the country and was a Dartmouth artist-in-residence in the summer of 2000.

Tropus is a construction of copper beech trunk from which

willow branches emanate into abstract, basket-like curvilinear shapes. The spiral silhouette of the work recalls the funnel clouds of a tornado, while the twisted branches seem to suggest an animal snare. Yet Hepper's works are not about anxiety or danger. Rather, the artist's sophisticated use of natural and nontraditional materials, her feeling for craft, and the transparency of her process create an exquisite object that evokes reverence. Although *Tropus* stands more than six feet tall, the multiple points of view it affords and the loops and circles of the woven branches make the sculpture seem delicate and finely made. Meticulously gathered, cut, scraped, and bundled, the branches reveal the artist's process, and the acts of gathering, cutting, bending, and tying become part of the organic content of the final work. ESB

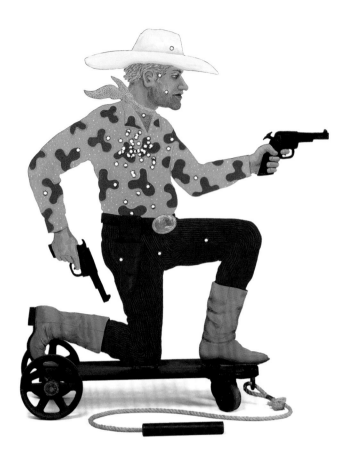

88. Bob Haozous, American, born 1943

Apache Pull-Toy, 1988

Painted steel, 54 x 48 x 16 inches
Purchased through the Joseph B. Obering '56 Fund; S.989.17

Bob Haozous was born in Los Angeles in 1943 to Allan Houser (Chiricahua Apache/English) and Anna Marie Gallegos (Navajo/Spanish). He grew up in California, Oklahoma, and northern Utah, and attended Utah State University before serving four years in the U.S. Navy. He received a B.F.A. from California College of Arts and Crafts in Oakland, California, in 1971. In 1999 and 2001 he helped organize the first Native American Pavilions at the Venice Biennale—a groundbreaking effort to inspire Indigenous artists to create a more meaningful contemporary statement of identity. *Indigenous Dialogue,* a retrospective of Haozous's work, opened in 2004 at the Institute of American Indian Arts Museum in Santa Fe, New Mexico. This exhibition was followed two years later with *Relations: indigenous dialogue,* an exhibition that involved a dozen artists discussing contemporary Indigenous arts, artistic cultural responsibility, and the issue of relinquishing individual focus for community issues. The conversations that took place over a year were transcribed and published with additional essays by scholars and critics to create the *Relations* catalogue. The resulting exhibition was a collaborative effort by all participants. The following quote by Bob Haozous reflects the tone of an exhibition that challenged existing attitudes of artists, curators, and museums in their presentation of contemporary indigenous arts:

> Many of us believe there was and still exists a profound philosophical foundation supporting tribal identity, knowledge and purpose. The weakened contemporary identity we now share is based on a well maintained historically focused, romantic, and superficial portrayal that is unable to adapt to change while maintaining

fundamental cultural values. We have lost the true meaning of being sovereign and Indigenous.

Apache Pull Toy, 1988, is a reverse cultural stereotype fabricated from half-inch cut steel, created in flat form like a paper doll on wheels, in which a cowboy target is shot full of holes. The heavy metal, welded-steel construction gives the work a sense of presence and permanence. The work presents a rare opposing viewpoint to the Saturday morning matinees of the 1950s and 1960s that portray cowboys killing scores of Indians with Colt six shooters. Haozous's artistic statement is satirical, humorous, and intellectually challenging, all in one shot. Haozous brings to focus the idea that Native Americans did not disappear with the advent of colonial oppression, but still exist, with a heavy load of cultural trauma. This backward, simple, angry, and potentially violent toy is a reminder of the lingering stereotypes that still exist in the understanding of the Native experience in the twenty-first century.

Haozous is an artist intent on bringing forth an honest depiction of the contemporary realities, politics, and understandings that exist within the Native community. In so doing, he challenges the perception that there are parallels shared between western art and Indigenous art. In the pursuit of a more meaningful "Indian" statement, Haozous states that Western art history and aesthetics are no more meaningful a tool than current technology: "A true cultural statement must originate from the real cultural experience of the artist and must be founded on an Indigenous philosophical basis to have true meaning and purpose." [Sanchez and Grimes 2006: 8 (quotation); personal communication 2008 (quotation)] JS

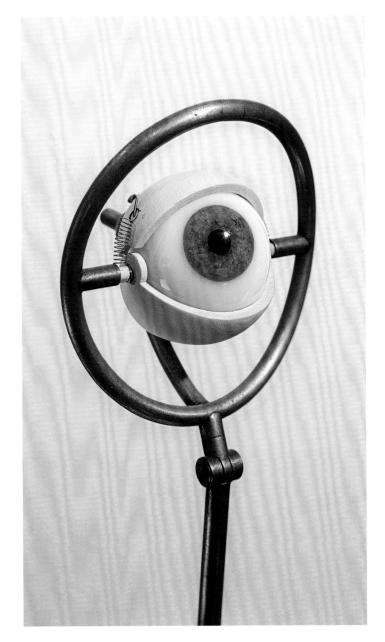

89. Elizabeth King, American, born 1950

Idea for a Mechanical Eye, 1988–90

Cast acrylic, wood, brass, 10½ x 2¼ x 2¼ inches (with stand); eyeball:
⅞ inch in diameter
Purchased through the Virginia and Preston T. Kelsey '58 Fund; 2008.37

Richmond-based artist Elizabeth King received B.F.A. and M.F.A. degrees in sculpture from the San Francisco Art Institute and currently serves as School of the Arts Research Professor in the Department of Sculpture + Extended Media at Virginia Commonwealth University. For the past thirty years, King has created puppets in her own image and in the images of her mother and grandmother, and her work now combines sculpture, film, and installation. King crafts meticulously wrought figurative sculptures and sets them in motion with stop-frame film animation, presenting object and film together and challenging the boundary between actual and virtual space.

The life-sized eyeball of *Idea for a Mechanical Eye* is unusual, as King usually plays with a discrepancy in scale between her sculptures, their human models, and their documentary photographs, initiating a fascinating dialogue. Intimate in scale and distinguished by a level of craft that solicits close viewing, her work reflects her interests in early clockwork automata, the history of the mannequin and the puppet, and literature in which inanimate figures come to life. King's creations capture the artifice of emotion and are dominated by a powerful and almost fantastic sense of longing, sadness, and isolation.

Through her highly articulated automatons King invites us to consider how consciousness arises from physical being. Portraying her mechanical models as convincingly self aware, the viewer is left to ponder, where exactly does the self reside? The artist writes: "We are always caught thinking of a person as a thing one minute (made of blood, organs, joints), and a being the next (a personality, with memories, plans). We can never quite put these two definitions of ourselves together. What happens in the finished work of art from forcing one form of representation to collide with another?"

Here, the eye—often considered the portal to the soul, a true communicator of emotions, and a mediator for direct experience—becomes the site for exploring this sense of self as well as the process of modeling and machine operations. [King 2008: 5 (quotation)] ESB

115

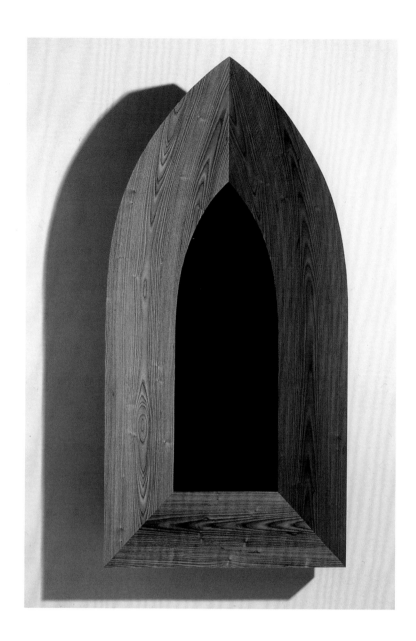

90. Richard Ernst Artschwager, American, born 1923

Arch, 1989

Wood and laminate, 72 x 35¼ x 14⅜ inches
Gift of AXA Art Insurance Ltd.; 2005.36

Many artists do not make their living making art—especially during the early part of their careers—and that was the case with the sculptor Richard Artschwager. After studying with French cubist painter Amédée Ozenfant from 1949 to 1950, he made furniture as a way to keep his bills paid. When the contents of his wood workshop were destroyed by fire in the late 1950s, leaving him without the tools of his trade for an extended period, he began creating art again by painting landscapes. He made the transition to actively presenting himself as an artist in the early 1960s, when he made—perhaps inspired by the newly emerging Pop Art aesthetic of Jasper Johns and Claes Oldenburg—furniture-like forms painted with a false-grain pattern that imitated a wood surface. Soon he began to apply a laminate veneer instead, making use of a commercial product called Formica. In a 1965 interview he stated, "It was Formica which touched it off. Formica, the great ugly material, the horror of the age, which I came to like suddenly because I was sick of looking at all of this beautiful wood." This early work, with easily recognizable furniture forms and cheap imitation surfaces,

presented an aggressive physicality that partook of the pared down aesthetic of minimalism as well as the idea-based framework of conceptual art, both of which were getting their start as art movements in the early 1960s.

Arch is clearly a descendent of these early works by the artist. A wall piece and also a sculpture, its form evokes a Gothic-style arch, but when viewed from the side it reveals the curved surface and jutting prow of a boat. Its Formica-laminated frame is crisp, clean, and regular, but vastly rich in its repeated patterns of line, especially when compared to the flat black surface of its center. It mimics the "mirrors" that Artschwager intermittently created throughout his career—sculptures whose even, unreflective surfaces resist the expectations of those who stand in front of them and do not see their own reversed images. The sense of recognition that *Arch* and other Artschwager sculptures stir is promptly negated by their obdurate refusal to fulfill the initial anticipation that their form inspires. KWH

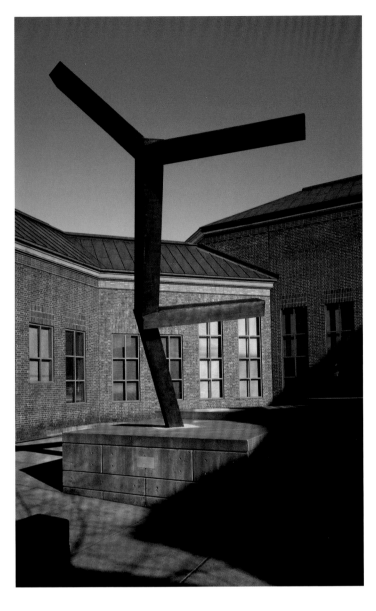

91. Joel Shapiro, American, born 1941

untitled (Hood Museum of Art), 1989–90

Bronze
Purchased through gifts from Kirsten and Peter Bedford, Class of 1989P; Sondra and Celso Gonzalez-Falla; Daryl and Steven Roth, Class of 1962; and an anonymous donor; The Lathrop Fellows, including Kirsten and Peter Bedford, Class of 1989P; Mr. and Mrs. Walter Burke, Class of 1944; Mr. and Mrs. Mark Gates, Class of 1959; Jerome Goldstein, Class of 1954; Mr. and Mrs. W. Patrick Gramm, Class of 1952; Mrs. Frank L. Harrington, Class of 1924W; Melville Straus, Class of 1960; Frederick Henry, Class of 1967; Mrs. Preston T. Kelsey, Class of 1958W; Mrs. Richard Lombard, Class of 1953W; and an anonymous friend; purchased through the Miriam and Sidney Stoneman Acquisition Fund and the Claire and Richard P. Morse 1953 Fund; Evelyn A. and William B. Jaffe, Class of 1964H, by exchange; S.990.40
© Joel Shapiro/Artists Rights Society (ARS), New York

Shortly after the Hood Museum of Art opened in 1985, Kit Bedford, a member of its Board of Overseers, challenged the museum to commission a sculpture for its courtyard. Four years later, Joel Shapiro was selected to complete the commission. To that date, Shapiro had been known principally for his small-scale near abstractions in wood and bronze. Suggestive of elemental forms—houses, tables, chairs—his work triggered thoughts of childhood, dreams and memories, loss and displacement. In the 1980s, Shapiro explored larger, even life-size forms of the human body, at once reminiscent of classical Indian and Greek sculpture and of early modernist works by Degas and Brancusi.

Almost all of these works were made for and exhibited in museums and galleries. An elegant, large untitled bronze work of 1985–86 was an exception. Acquired by the Louisiana Museum for Moderne Kunst and placed outside against the stark backdrop of the northern inner waters between Denmark and Sweden, the sculpture's quiet grace and rigorous geometry read as an elegant and powerful abstraction of human strength. Over the next few years Shapiro expanded his formal repertoire, creating pieces that

suggested the human form dancing, crouching, slipping, and falling, continually exploring the dynamics of balance, cantilever, projection, and compression. And increasingly he exhibited his sculptures outdoors.

The challenge at the Hood—among Shapiro's earliest large outdoor commissions—was to engage the museum's exterior entrance ramp and energize the courtyard space without allowing the work to overpower or be diminished by the scale of the museum to one side and the Hopkins Center to the other. Shapiro's solution was to make an elegant, attenuated form leaning back over the walkway that crosses the courtyard between the Hanover Green and Lebanon Street, while kicking up the ramp as it unwinds toward the museum entrance. The near-falling figure energizes the space, its articulated limbs echoing the fractured, unwinding façade of the museum itself. And the courtyard becomes a kind of stage set, which, although unintended, seems now so appropriate for a work that joins the College's center for the performing arts with its visual arts museum.

Untitled (Hood Museum of Art) played an important role in the development of Shapiro's art. Since its commission, he has become one of our nation's most important public sculptors, with major works in most American cities. And yet he has never turned away from the rigorous experimentation inspired by the more intimate setting of the workshop studio. His regular exhibitions at Pace-Wildenstein gallery in New York reveal a searching artist who is always exploring the physical and dramatic possibilities of expression through the deceptively simplest of means. For these reasons he was the perfect choice for the artist to meet Kit Bedford's early, transformative challenge to the Hood Museum: to make a work that defined the College's commitment to excellence and experimentation and inspires students as they walk through one of its most beautiful public spaces. JC

92, 93

92. Sana Musasama, American, born 1957

Yellowbird Bark, Slippery Rock, Pennsylvania, 1990

Ceramic (low-fire), mixed media, dimensions variable
Purchased through the Virginia and Preston T. Kelsey 1958 Fund and the Kira Fournier and Benjamin Schore Contemporary Sculpture Fund; 2007.54.1

93. Sana Musasama

My Hand, May Heart, Den Bosch, Holland, 1992

Ceramic (stoneware), mixed media, dimensions variable
Purchased through the Virginia and Preston T. Kelsey 1958 Fund and the Kira Fournier and Benjamin Schore Contemporary Sculpture Fund; 2007.54.2

94. Sana Musasama

Outer Beauty, Inner Anguish, 2001

Ceramic, 16¼ x 6 x 5½ inches
Purchased through the Virginia and Preston T. Kelsey 1958 Fund and the Kira Fournier and Benjamin Schore Contemporary Sculpture Fund; 2007.54.3

Sana Musasama's experiences as a world traveler for the past twenty-five years drive much of her work. As an artist, she challenges systems that deny women the right to free expression and full ownership of their bodies and their lives. Opening a dialogue not only between her art and the viewer, Musasama raises concerns about issues affecting women the world over—female genital mutilation, foot binding, dowry burning, and domestic violence.

Outer Beauty, Inner Anguish is the first piece in a series that addresses the issue of female circumcision, a practice she saw first-hand throughout her travels in Africa. Although deeply troubled

94

by the bloody custom, she respects the value of its larger ritual context, and works like *Outer Beauty, Inner Anguish* are meant to raise awareness within a cultural context while trying to protect young women who may be forced to undergo the procedure in the future. The only work in the series that includes the fallopian tubes, *Outer Beauty, Inner Anguish* is distinct also for its representations of the intact eggs, ovaries, and clitoris. These isolated vaginal forms stare back at us in stunning silence, but they are not mute. Instead, the beautifully crafted and delicate forms speak volumes of the pain, pride, beauty, and shame surrounding issues affecting women, such as female circumcision.

Yellowbird Bark, Slippery Rock, Pennsylvania and *My Hand, May Heart, Den Bosch, Holland* are part of a series of sculptures honoring the Maple Tree Movement, a largely unknown nineteenth-century social movement. When Europeans first arrived in North America, Native Americans showed the settlers how to harvest the sap of the maple tree. Cane sugar, maple sugar's

competitor, was a commodity made available by the enslavement and labor of thousands of Africans. Therefore, for early American abolitionists, domestically produced maple sugar could serve the goal of eliminating slavery. It is this notion of the maple tree as a symbol of liberation that has propelled Musasama to explore variations on the tree form over several years, creating colorful low-fired ceramic installations that pay tribute not only to the Maple Tree Movement, but to countless histories that remain untold.

ESB

95. Allan C. Houser, American, 1914–1994

Peaceful Serenity, 1992

Bronze-plated steel, 74 x 36 x 17 inches
Purchased through a gift from Mary Alice Kean Raynolds and
David R. W. Raynolds, Class of 1949; 2007.56

Allan C. Houser (born to Sam and Blossom Haozous) was the first Chiricahua Apache child in his family born out of captivity in the twentieth century, twenty-seven years after the surrender of their leader Geronimo to the U.S. Army in 1886. Today, Houser is regarded as one of the century's most important Native American artists who played a pivotal role in the development of Native American modern and contemporary art. Following a thirteen-year teaching career at the Institute of American Indian Arts in Santa Fe, Houser came to Dartmouth College as artist-in-residence in 1979. In the subsequent two decades, he produced almost one thousand realistic and abstract sculptures. He became a major international figure in contemporary sculpture, known as a master of marble, limestone, slate, wood, cast bronze, and fabricated metals.

Houser's early drawings and paintings displayed the figurative and naturalistic style of the Indian art movement taught at the Santa Fe School and the University of Oklahoma in the early twentieth century. However, he soon developed a signature style that digressed from what was expected of "Indian" artists at that time, fusing Native American narrative themes with a streamlined modernist and often abstract sensibility. His open style of sketching and modeling explored the possibilities of pure form in evoking action, emotion, and relationship, more suggestive of three-dimensional art. These two-dimensional works—and the work of sculptors Brancusi, Arp, Lipschitz, and Henry Moore in their play with positive and negative space—inspired his later transition to sculpture. *Peaceful Serenity* captures the calm beauty of a mother and child figure. Both stand firm and proud, protective of the precious life cradled in their arms—a narrative motif evident in all phases of Houser's artistic career. BT

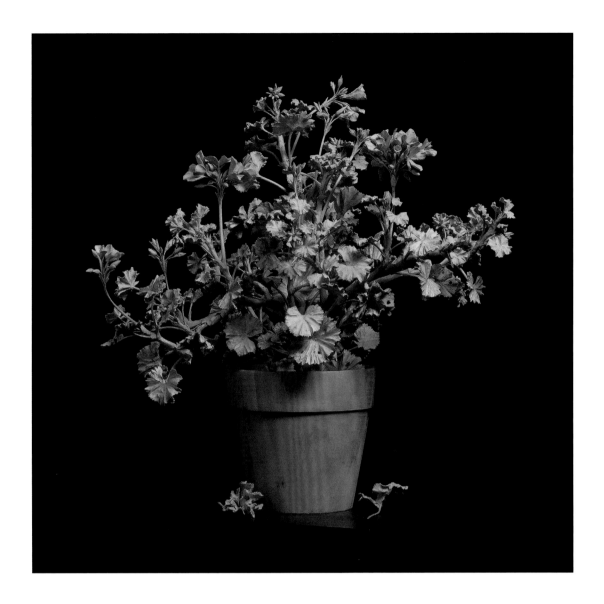

96. Fumio Yoshimura, American, 1926–2002

Geraniums, 1997

Lindenwood, 32½ x 28¼ x 28¾ inches
Purchased through the Virginia and Preston T. Kelsey 1958 Fund; the Guern-
sey Center Moore 1904 Memorial Fund; the Phyllis and Bertram Geller 1937
Memorial Fund; the Katharine T. and Merrill G. Beede 1929 Fund; a gift from
Adele Baron Marks in memory of David N. Marks, Class of 1930, with love;
and a grant from the Richard Florsheim Art Fund; S.999.12

Fumio Yoshimura immigrated to the United States from Japan
in 1962 after studying painting at the Tokyo University of Fine
Arts and Music. Once in New York, Yoshimura taught himself to
sculpt wood using a variety of tools and soon left painting behind.
The artist came to Dartmouth as an artist-in-residence in 1981 and
stayed at the college until 1993, teaching sculpture in the Studio
Art Department.

Geraniums is typical of Yoshimura's work in that it is a meticu-
lously carved wooden reproduction of a seemingly mundane ob-
ject. In the artist's hands, everyday objects were transformed into
elegant, intricately carved aesthetic and technical wonders. The
artist spent thousands of hours painstakingly carving these objects,
creating wooden tomato plants, motorcycles, a hot dog stand, fish
skeletons, and most famously, bicycles. Yoshimura described his
work as creating the "ghost" of an object, and the white, unfin-
ished lindenwood he used gives his sculptures a decidedly ghostly
pallor.

Although Yoshimura has often been named a part of the super-
realist movement, his sculptures were not painted to resemble
their original items, nor did he use other trompe l'oeil techniques,
as in the work of other artists who work in this style. Instead, the
delicate and naturally wood-colored petals, stems, and leaves of
the geranium seem to capture the soul of the particular plant that
inspired them. Astounding technical virtuosity aside, the artist
transcended both craft and process, creating sculptures driven en-
tirely by the need to divine and preserve the essential spirit of the
everyday objects around us. [Marcus 1993: 4 (quotation)]

ESB

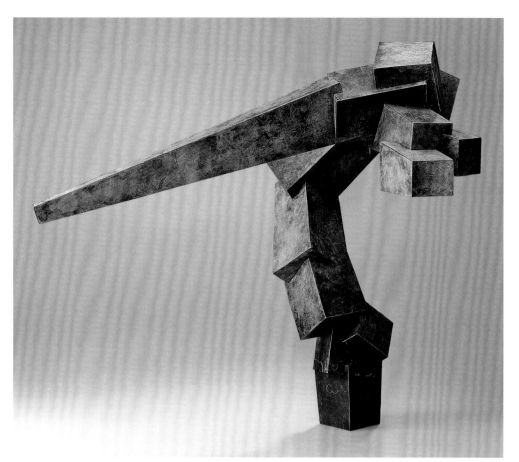

97. Bruce Beasley, American, born 1939

Partisan II, 1997

Patinated cast bronze, 52 x 56 x 40 inches
Gift of Liliane and Edward Schneider,
Class of 1968; 2007.46.5

Bruce Beasley's obsession with working in metal began at an early age. Born and raised in Los Angeles, California, Beasley took a required shop class in the eighth grade and discovered a natural talent for metalworking, both in welding and casting. He further honed his skills as a student at Dartmouth College and University of California, Berkeley, growing interested in assemblage and the use of discarded materials, and exploring a variety of processes.

Initially working in a number of cast metals, in the late 1960s Beasley developed a revolutionary process that cast clear acrylic sculpture on a monumental scale. Works such as *Titiopoli's Lighthouse* (fig. 1) defied conventional perceptions on an aesthetic level and were groundbreaking on a technical level. As the artist explains:

> I started imagining sculptures where the eye would not know where to stop. Normally, the eye stops on the surface of a sculpture. The idea was of the eye being drawn into, through, and past the sculpture so that you would see things that are behind the sculpture, in the sculpture, not as reflections but seeing them in it. I wanted them to act as lenses, where you would see through to whatever was behind but distorted and changed, bringing color and light into the sculpture.

Beasley continues to practice in a modernist vein, creating art for art's sake that is driven by a focus on the "pure form"—form as content. He cautions, "What I want to do is evoke feelings, not evoke images. It is not about resemblance. Resemblance is just

the skin of the truth." With a delicate patina and elegant posture, *Partisan II* seems to suggest a bird with a wing outstretched, yet the motivation for this work remains material and structure. Simmering with energy, Beasley's cohesive arrangements of shapes and volumes explore the modernist aesthetic anew. [Oakland Museum of Art 2005: 52 (quotation); Oakland Museum of Art 2005: 10 (quotation)]

ESB

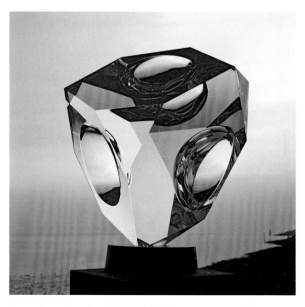

Fig. 1. Bruce Beasley, *Titiopoli's Lighthouse*, 1970, acrylic, 32 x 29 x 15 inches. Gift of Mr. and Mrs. James Compton Wicker, Class of 1921; S.978.178.

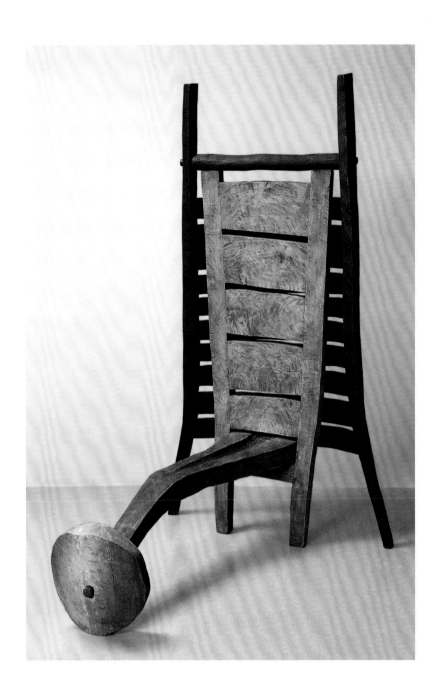

98. Lawrence Fane, American, 1933–2008

Mill Piece, 1998

Polychrome wood, 73 x 42 x 60 inches
Purchased through the Miriam and Sidney Stoneman
Acquisitions Fund; 2007.80

Born in Kansas City in 1933, Lawrence Fane lived and worked in New York City and summered in rural Vermont. Fane studied at Harvard University and the Boston Museum School. Early in his career, he served as an apprentice to sculptor George Demetrios, with whom he worked at a bronze foundry in Florence. In 1960, Fane was awarded the Rome Prize, traveling throughout Europe while living and working at the American Academy in Rome. While teaching at Queens College in New York, Fane became fascinated by the drawings of Mariano Taccola, an Italian Renaissance artist and engineer. Fane himself had an amateur interest in engineering that began in art school and was present throughout his life's work.

Although Fane never made sculpture that strictly followed the images of Taccola's notebooks, there is a clear relationship between the Italian artist's mechanical drawings and Fane's own works, including *Mill Piece.* In fact, at times Fane signed his work M.T./L.F.

to acknowledge the ongoing connection he felt with this artist. Yet it is material that was most important to Fane. Using lumberyard wood as well as branches and logs he found in the woods, Fane attempted to transform his materials so that fabricated parts might appear found and found parts appear made. The artist explained:

I think of shapes, sizes, proportions, use of the materials I chose, and how they go together. I consider technical problems and how they contribute to the formal arrangements. It is a decidedly non-verbal process. I cannot imagine making art without the impetus and pleasure of manipulating materials with my hands. It would be disingenuous, however, to claim that I am not also considering ideas and references that the work reflects, though these thoughts can be vague and ambiguous. In fact, I sometimes feel more like a critical observer than a maker. [Fane 2006: 47 (quotation)]

ESB

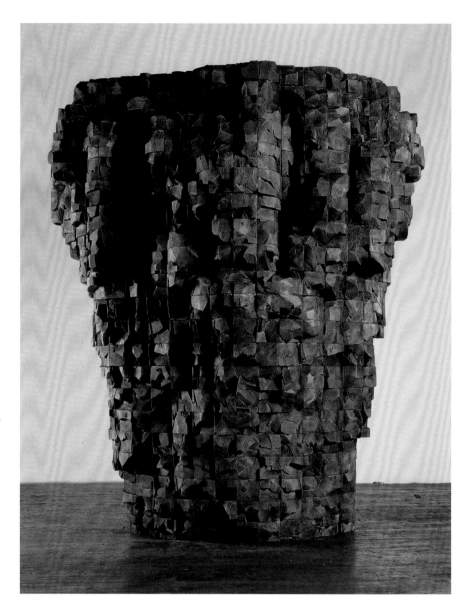

99. Ursula von Rydingsvard, American, born 1942

Bowl with Pleats, 1999

Cedar toned with graphite, 74 x 64 x 74 inches
Purchased through the William S. Rubin Fund, the Julia
L. Whittier Fund, the Claire and Richard P. Morse 1953
Fund, the Hood Museum of Art Acquisitions Fund, and
the Anonymous Fund #144; S.999.14

Like many artists who came to maturity in the 1970s, Ursula von Rydingsvard responded to the spare geometries and emotional austerity of Minimal Art by creating works that were both rich in personal content and fully exploited the expressive potential of different sculptural materials and techniques. In von Rydingsvard's case, the inspiration for many of her most powerful and eloquent pieces comes from memories of her childhood home in Poland and the displacement she and her family suffered during and after World War II.

Among the forms that recur frequently in her work is the bowl. The title is something of a misnomer, because von Rydingsvard's bowls are neither functional nor small in scale. To the contrary, they are monumental in size and character, often towering over the viewer like the rough-hewn objects that we, as children, might have imagined furnishing the houses of giants. They have an air of familiarity, but at the same time they are of a different order and belong equally to the realm of the imaginary.

Bowl with Pleats belongs to a series of sculptures produced by the artist during the past two decades. Typically constructed of four-by-four-inch cedar beams, they were stacked and then shaped at their ends with cuts made with a circular saw. As such they provide ample evidence of von Rydingsvard's graphic talents—she is a superb draftsman—and of her taste for inflecting the surface of these works with rhythmic gestures that recall, among other things, the folds and flowing shapes of drapery.

The stark beauty and expressive power of *Bowl with Pleats* derives not only from the complex textures and chromatic richness of its surface but also, and more fundamentally, from von Rydingsvard's gift for creating an evocative language of form that explores the uncertain boundary between abstraction and figuration. This has proven to be a rich field of inquiry and has inspired her to create a body of work that ranks among the finest and most eloquent of any artist of her generation. T R

100. Terry Adkins, American, born 1953

Still, 2000

Steel, wood, glass, and whiskey, height: 17 inches, diameter: 33 inches
Purchased through the Guernsey Center Moore 1904 Fund; S.2003.39

Born in Washington, D.C., in 1953, Terry Adkins received his M.F.A. from the University of Kentucky and initiated his artistic career as a musician. Later inspired to become a visual artist, he began creating sculptures from discarded objects. Adkins explains, "My quest has been to find a way to make music as physical as sculpture might be, and sculpture as ethereal as music is. It's kind of challenging to make both of those pursuits do what they are normally not able to do." In his work, Adkins brings to light underappreciated historical figures' contributions to society, frequently referencing the cultural tradition of the African American South, including crafts, folklore, and, most importantly, music. The artist continues, "My quest is to use abstract means, to educate the public about these figures through ways that are not image based or narrative based but to challenge them to think abstractly in relating to the stories of the lives of the people concerned."

Still is composed of a circular wooden mold crowned by a perforated and cupped steel disc (which could be a nod to the shape of phonograph records). Upon it rests a blown, nippled glass globe half-filled with amber-colored whiskey. This work is a part of a series made during a residency in San Antonio, Texas, and exhibited during Adkins's artist-in-residence exhibition at Dartmouth in 2003. The artist was inspired by the remnants of Finesilver Manufacturing Company, a uniform-manufacturing operation across from the Gunter Hotel in San Antonio, where a number of blues artists such as Blind Willie Johnson, Leadbelly, and Blind Lemon Jefferson first recorded their music. The multiple meanings of the title—its suggestions of time, a physical state of being, and the apparatus for distilling alcohol—combined with the resilience of the found objects and ethereal effect they produce, intertwine to suggest the disorientation that alcohol induces as the real and imagined merge. Bridging the past and present in astonishing ways, a chorus of anonymous and timeless voices emanates from *Still*.

[Roc 2006: 1 (quotations)] ESB

101. Joe Fig, American, born 1968

Maker of Dreams (Ivan Albright 1949), 2000

Mixed media, 15½ x 21½ x 12½ inches
Gift of Monroe A. Denton Jr., Class of 1968, in Honor of Friends at the
Hood Museum of Art; S.2004.70

In the late 1990s, painter Joe Fig was living in a small apartment in Brooklyn, New York, and using his living room for studio space. Coveting the spacious, light-filled studios of other painters, Fig embarked on a lengthy project spurred by envy, making miniature models of their studios as a commentary on his own situation. The series grew into a mix of celebrity journalism, historical documentation, and anthropological study that plays off the cult of the artist while simultaneously rejecting the notion that what an artist does is inherently fascinating. Instead, Fig, in revealing a world inaccessible to the average art lover, places the emphasis on the day-to-day mundane tasks of making art. Fig pays homage to the painter's practice but dismisses the romantic persona of the heroic artist. At the same time, Fig challenges his own artistic skills against the masters he adeptly recreates.

Maker of Dreams (Ivan Albright 1949) depicts the working space of Ivan Albright, creator of the Hood Museum of Art's painting *The Vermonter* (cat. 35). Working nearly twenty years after the artist's death, Fig used photographs and documentary footage to recreate as accurately as possible Albright's working space on a one inch to one-foot scale. Paused in the midst of a preparatory drawing, Albright sits back and intently studies the elaborate window scene before him. He is surrounded by a neat array of pigments and brushes, while the paint-splattered floor and abandoned staging attests to a long history of creation in this space.

Part craftsman, humorist, and historian, Fig skillfully fashioned an intricate and realistic setting, treating the space itself as a form of portraiture. There is an aura of veneration or reverence for the artist in replicating Albright's studio so faithfully. Yet within the elements of the studio's clutter and relative cleanliness, Fig also reveals the artist's working style, daily habits, and artistic practice, as the everyday details of the artist's world become representative of his personality. By providing a God's-eye perspective similar to that of a dollhouse, Fig allows us to safely peer into the artist's miniaturized life on stage, as it plays out in a world separate yet parallel to our own. ESB

102. Juan Muñoz, Spanish, 1953–2001

Hombre Colgado Pie (Figure Hanging from One Foot), 2001

Bronze and galvanized steel, 63 x 31½ x 19⅝ inches
Purchased through a gift from Peter and Kirsten Bedford, Class of 1989P, and the Virginia and Preston T. Kelsey 1958 Fund; S.2002.27

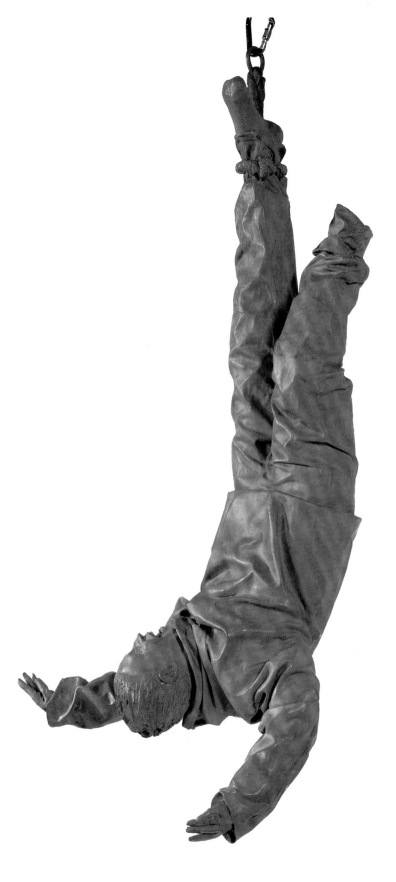

Juan Muñoz was born into a large family in Madrid. He traveled widely throughout his too-short life, training as a lithographer in London at the Central School of Art and Design and then at the Croydon School of Art, where he eventually met his wife, Christina Iglesias. In 1981, Muñoz received a Fulbright Fellowship that enabled him to work for a year in New York City. There, he continued printmaking studies at the Pratt Graphic Center and met the sculptor, Richard Serra, who became a lifelong friend. The earliest of Muñoz's many solo exhibitions took place in 1984, in Madrid, and featured miniature staircases and iron balconies placed ambiguously high on the gallery's walls. Subsequent installations throughout Europe included vast, illusionistic floor treatments and featureless mannequin set in surreal situations. Enigmatic relationships between subjects and their surroundings were lasting concerns of the artist. "Among scientists and philosophers space is generally thought to be continuous and homogenous," he once explained. "The task of sculpture appears to be the healthy intention of proving the contrary."

Hombre Colgado Pie (Figure Hanging from One Foot) was the artist's final public work. The Hood's sculpture was introduced at his first major U.S. retrospective at the Hirshhorn Museum and Sculpture Garden in late 2001. It received a highly theatrical display in Washington, suspended high above the museum's central courtyard space. *Hombre Colgado Pie* disturbed some visitors who felt that it unsympathetically recalled the victims of terror who leaped from the World Trade Center buildings on September 11. Muñoz died in Ibiza on August 28 and could not have intended any reference to that disaster. *Hombre Colgado Pie* relates closely to a group of sculptures from this phase of his career. The empty trouser leg, monochromatic costume, glove-like fingers, and open-mouthed grimace/smile appear repeatedly in works from 1997 to 2001. The artist reused figures, implying connections between otherwise discrete objects in his oeuvre. Recently, Manuela Mena has argued that *Hombre Colgado Pie* and *Hanging Figures* (1997) have a common source in the late etchings of Goya, specifically *Los Disparates,* where piteous figures undergo a variety of torments. Because Muñoz keenly valued art historical references, it seems possible that he might have intended viewers to note a relationship to his Spanish forebears. Floating disconcertingly above Charles

Moore's grand stairway, this sculpture today animates the contemporary museum experience in a way that would have pleased the artist as it does so many visitors to the Hood. [Benezra and Viso 2001: 59 (quotation); Wagstaff 2008: 125] DRC

127

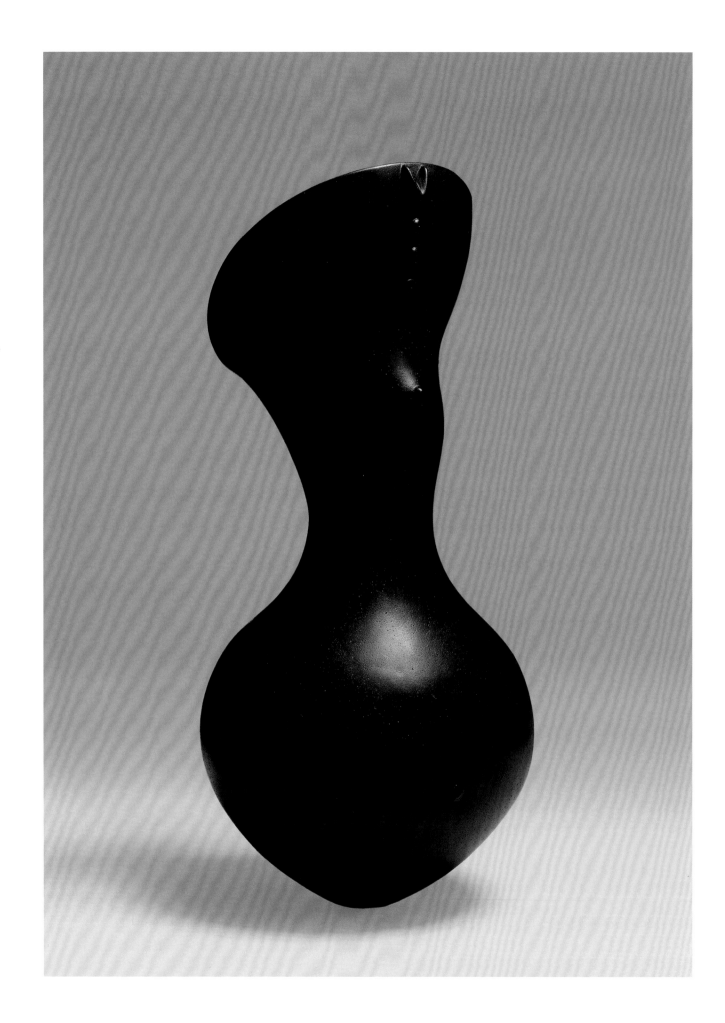

Fig. 1. Magdalene Odundo, *Tear Drop*, 1996, burnished, oxidized, and reduced terracotta, 19½ x 11 inches. Purchased through the Miriam and Sidney Stoneman Acquisition Fund; 2008.74.1.

EXPÉDITION CITROEN - CENTRE AFRIQUE
Deuxième Mission Haardt-Audouin Dubreuil

LA CROISIÈRE NOIRE
Femme d'un chef Mangbetu (Congo belge)

Fig. 2. Léon Poirier, French, 1884–1968, and Georges Specht, French, active 1909–1931, *Wife of Mangbetu Chief (Belgian Congo)* (Nobosodrou, wife of Mangbetu King Touba), 1925, halftone print, postcard, publisher unidentified. Christraud M. Geary Collection.

103. Magdalene Odundo, Kenyan, lives in England, born 1950

Untitled, 2001

Blackened terracotta, 23 x 9¾ x 9¾ inches
Purchased through the William B. Jaffe and Evelyn A. Jaffe Hall Fund and the Claire and Richard P. Morse 1953 Fund; C.2003.50

Although she began her career as a graphic artist in Kenya, Magdalene Odundo turned to ceramics while completing her M.A. at the Royal College of Art in London. Using the coiling technique of handbuilding found in pottery traditions around the world, Odundo creates thin-walled vessels that defy rational symmetry, pushing the limits of gravity while maintaining beauty, balance, and form (fig. 1). First burnished, then slipped and burnished again, the surfaces of her vessels turn bright red-orange or glimmering jet black, depending on whether they are fired in a gas kiln with an oxygen-rich or oxygen-deprived atmosphere.

Odundo always casts a keen eye toward the movement and form of the female body in her examinations of female beauty and how it is (re)defined and (re)shaped over time according to specific cultural ideologies. By abstracting the female form into a sensuous dialogue between positive and negative space, her vessels become metaphors of the changing tenets of female beauty. In the anthropomorphized vessel *Untitled*, Odundo reinterprets colonial era depictions of the "classic" African beauty: the Mangbetu woman (fig. 2). Celebrated for their regal splendor accentuated by an elongated head and haloed coiffure, the Mangbetu woman of the colonial era inspired both European and African artistic representations of idealized African beauty.

However, Odundo's ceramic vessels embody also important cultural references to the symbolic connection between the pot and the womb or the female body as a carrier of life as portrayed in African stories of genesis. Odundo's subtle placement of nodule-patterns on this vessel's surface serves not only as a tribute to the enduring beauty of African women, but also as a reference to African traditions of body scarification that publicly declare a woman's passage through key moments in her life: the onset of menstruation, conception, childbirth, nursing, and motherhood.

BT

129

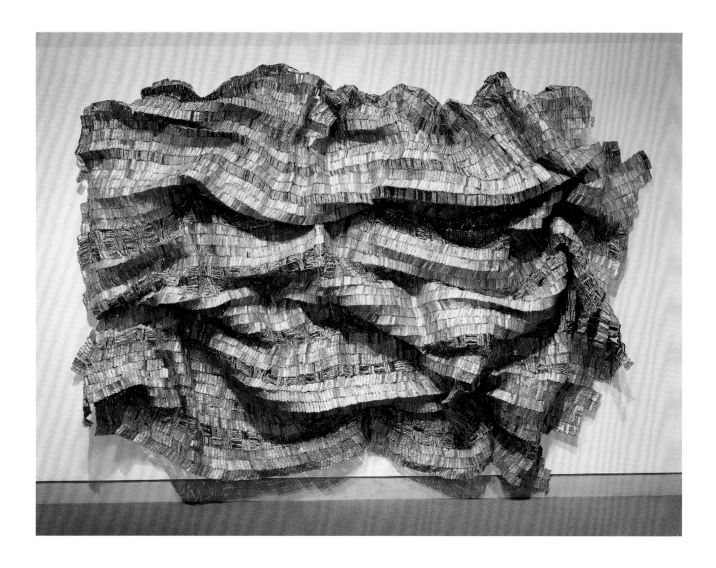

104. El Anatsui, Ghanaian, lives in Nigeria, born 1944

Hovor, 2003

Aluminum bottle tops and copper wire, 240 x 216 inches
Purchased through gifts from the Lathrop Fellows; 2005.42

El Anatsui earned a B.A. in sculpture and a postgraduate diploma in art education from the University of Science and Technology in Kumasi, Ghana. In 1975, he left Ghana to become professor of sculpture at the University of Nigeria, Nsukka, where he still teaches as one of Africa's most influential contemporary artists.

This majestic and monumental sculpture pays tribute to the textile traditions of West Africa. Loosely draped on the wall like a shimmering tapestry of silver and gold, *Hovor* appears to be fluid and supple. Yet, on closer inspection it becomes apparent that this massive "cloth" is made from thousands of very small, flattened pieces of aluminum liquor bottle caps held together by copper wire. In his "tapestries," Anatsui intends to subvert the stereotype of metal as a stiff, rigid medium and rather reveal it as a soft, pliable, almost sensuous material capable of attaining immense dimensions and being adapted to specific spaces.

Hovor's colors, patterns, and designs mimic traditional Ghanaian textiles, particularly strip woven *kente* cloth, which was first developed in the twelfth century as sacred regalia worn by Ashante and Ewe royalty. Today, *kente* cloth has become a global icon of African cultural heritage, its symbolic patterns migrating into contemporary everyday fashions in Africa and around the world.

Hovor incorporates elements of the past with contemporary times not only through its visual reference to African textile traditions but also through the artist's purposeful use of transformed and recycled materials. Beyond *Hovor*'s resplendent visual impact, this work imparts a poignant message about the post-colonial heritage, especially the impact of globalization and the excesses of mass consumption, alcoholism, exploitation, and waste on the cultural, spiritual, and physical landscape of Africa. [Anatsui 2005]

BT

105. Alison Saar, American, born 1956

Caché, 2006

Wood, ceiling tin and wire, 28 x 26 x 90 inches
Purchased through the Virginia and Preston T. Kelsey 1958 Fund; 2006.32

Combining woodcarving with found objects and industrial ma-
terials, Alison Saar constructs enigmatic large-scale figures whose
origins seem rooted in folklore or legend rather than everyday real-
ity. Despite the mythological nature of *Caché,* however, through
subtle gestures and symbolic attributes the sculpture conveys the
weight of lived experience and an individual consciousness.

Caché consists of a nude reclining woman whose mass of balled
hair extends along the floor in front of her. Sheets of rusted and
irregularly marked ceiling tin serve as the figure's exposed brown
flesh; lined and imperfect, the tin suggests scars, wrinkles, and
other signs of aging, while also evoking African scarification ritu-
als. Having both African and European ancestry, Saar often depicts
figures of mixed heritage in order to contemplate the complex-
ity and social and historical connotations of racial identity. Her
figure's thick accumulation of hair, represented by a sprawling ball
of wire, has been straightened, a practice common to many African

American women. The bundle of hair speaks not only to racial and
cultural identity but also to the passage of time and the accumu-
lated memories and experiences that this woman carries with her.
Saar suggests that the woman's profound yet burdensome heritage
signified by this mass of hair is not easily eluded.

Iconic in the history of art, the nude woman often denotes vul-
nerability, ideal beauty, and sexual availability. Saar's figure, how-
ever, conveys decidedly different meanings. The woman's extended
arm shields her body as she pushes down with her hand, poised
to lift herself from the ground. This subtle gesture, along with her
tough exterior of tin and nails, conveys strength and self-posses-
sion. Reclining on the ground in an active state of contemplation,
her posture, aged skin, and long mound of hair communicate the
profound knowledge that comes with lived experiences and matu-
ration. The woman's nudity frees her from the specific cultural
attributes conveyed by clothing, and thus Saar arrives at a more
universal figure of womanhood. The title of the work refers to that
which is hidden; the artist insinuates the hidden heritage, hidden
thoughts, and hidden desires that this mysterious figure conceals.

PW

106. Joyce J. Scott, American, born 1948

Mammy Under Undue Influence, 2007

Blown, cast and lampworked glass, beadwork (peyote stitch),
27½ x 9 x 7¾ inches
Purchased through the Virginia and Preston T. Kelsey 1958 Fund; 2007.51

Born into a family of quilt makers and artisans from the Carolinas, Joyce Scott grew up with the understanding that art is a part of everyday life. By creating a body of sculpture using ordinary materials such as beads, fabric, and glass, Scott aligned herself with the burgeoning feminist art movement of the early 1970s that elevated low, "feminine" materials to the status of high art. Quirky and unsettling, *Mammy Under Undue Influence* communicates the ways in which Western culture stereotypes and devalues black womanhood. Scott uses humor to communicate this serious message; her eccentric figure undermines the mammy stereotype in part by rendering her absurd and funny.

Scott embraces the great abolitionist and statesman Frederick Douglass's call to "agitate," by creating satirical and often unsettling images of African Americans. The artist began her "mammy" sculptures in the mid-1980s. These sculptures reference the infamous stereotype of maternal black womanhood, yet portray the mammy as deeper and more conflicted than her typical embodiment. While referencing this stereotype, Scott also alludes to the personal history of her mother, Elizabeth Talford Scott, who worked as a nanny for white children and witnessed the children's developing awareness of racial privilege and discrimination as they reached adolescence.

In *Mammy Under Undue Influence,* Scott adopts the familiar hands-on-hip posture of the mammy, yet by elongating the figure's head, distorting her facial features, and composing a beaded layer that functions simultaneously as bare skin and an article of clothing, the artist delves into the surrealistic and uncanny. Beneath the mammy's unfastened skin Scott places an "ideal" classical glass nude. Scott imagines the mammy "under undue influence" because the figure seeks to replace her own attributes with "white" features deemed more desirable by Western culture. By destroying the complacent façade of the stereotypical mammy, Scott reveals a tortured psyche underneath. The artist thus pushes the viewer to contemplate the centrality of race to Western conceptions of beauty and its damaging implications for African American women. Instead of creating a pleasing object on display for veneration, Scott distorts and literally dismantles the black female body to complicate and disrupt the typical articulation of this figure within Western art and visual culture. PW

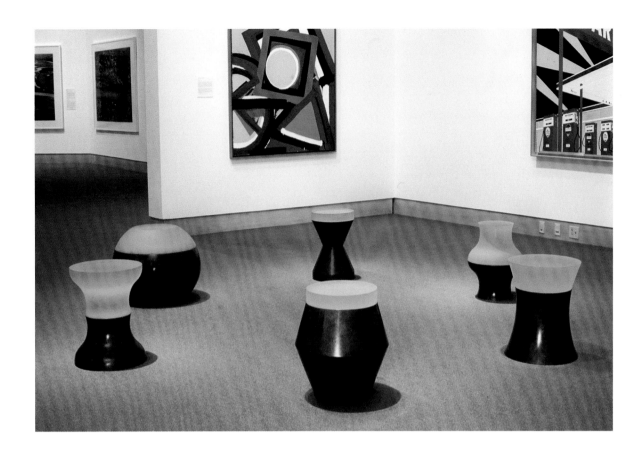

107. Howard Ben Tré, American, born 1949

Kira's Benches, 2007

Bronze and glass, height: 20⅜ inches, diameter irregular
Commissioned by the Hood Museum of Art through the Kira Fournier and
Benjamin Schore Sculpture Fund; 2007.30.1–6

Trained at Portland State University and the Rhode Island School of Design in the late 1970s, Howard Ben Tré is a sculptor who works with cast glass, frequently in combination with bronze or stone. Throughout his long career, Ben Tré has been conscious of the glass medium's status as decorative craft, and in this work he demonstrates its beauty as sculpture. Ben Tré is drawn to the slow, ritualistic process of creation and to the light-filled translucency of the final product. The density of the cast glass in which he works captures the transitory effects of sunlight. Over time, he has worked increasingly in the public sphere, designing urban plazas, outdoor installations, and a variety of bench groupings, particularly for museums. Made for the public and highly participatory, he views these works as transformative, hoping to bring viewers to a heightened understanding of their environment. He works to give pieces like his benches what he calls "a kind of heroic nobility," bringing the spiritual and universal into a human scale.

Named in honor of the late Kira Fournier, a sculptor who worked extensively in bronze, glass, and ceramics, *Kira's Benches* is made up of six objects. Tactile and inviting, each bench is a fusion of cast glass and bronze with a filmy green patina. In addition to the opposition found in the differing surfaces, each bench is associated with another of the set, opposite in shape and configuration. This use of complements is a manifestation of Ben Tré's exploration of the feminine and the masculine, a constant theme in his work. Within a single body of work, he seeks to integrate the genders, creating a more powerful whole. Through this conscious pairing, Ben Tré's work brings about a sense of equilibrium, both physical and spiritual. [Streitfeld 2002 (quotation)]

AHW

135

MIXED MEDIA

108. Jean Dubuffet, French, 1901–1985

Topography with a Nest of Stones (Topographie au nid de pierres), 1958

Oil and collage on canvas, 38½ x 60 inches
Gift of Joachim Jean Aberbach; P.975.99
© 2009 Artists Rights Society (ARS), New York/ADAGP, Paris

The son of a successful wine merchant, Jean Dubuffet was born in Le Havre, France, in 1901. He studied art in Paris for several years and entered the family wine business, leaving it in 1942 to devote himself to painting on a full-time basis. Despite his knowledge of historic French painting, the artist claimed that previous artistic conventions were of little value. Striving to create art that was new and unconventional, he coined the term *art brut*—art made without concern for traditional aesthetic principles—which included works by untrained artists.

A radical statement of anti-art in postwar France, Dubuffet's *Topography with a Nest of Stones* demonstrates the artist's innovative use of materials and choice of subject matter for which he was known. This large collage is part of Jean Dubuffet's *Topographies* series of 1957–59, which was made by applying sheets of variously textured materials, such as oilcloth or paper, to freshly painted surfaces and then peeling the material away. The artist's attention remained continually attracted to the phenomena of the earth—primarily flowers, stones, and soil—and the attempt to translate its texture into graphic equivalents. He explained: "What seduced me right from the start was the idea of composing pictures by the simple means of juxtaposition of textures in which no delimited object or contour appears and which recreates the impression one gets from contemplating the soil of a vast expanse that can be extended indefinitely."

Dubuffet was far more interested in the abstract development of ideas than in the presentation of concrete thought. For this reason, he left this painting compositionally open and excluded any objective figuration or traditional iconographic content. The richly sensuous surface of *Topography with a Nest of Stones* becomes a fascinating field for discoveries, as viewers are impelled to connect what they see here with their own associations of what a stony ground or landscape viewed from a distance can—or should—look like. [Dubuffet 1967: 127 (quotation)] ESB

137

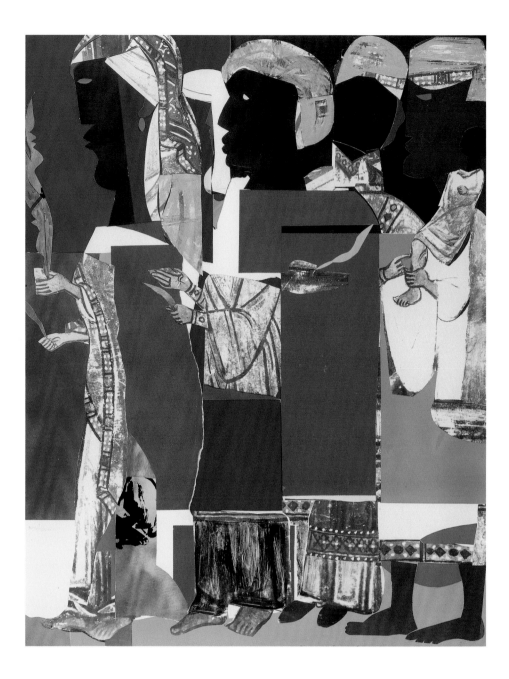

109. Romare Howard Bearden, American, 1911–1988

Palm Sunday Procession, 1967–68

Collage of paper and synthetic polymer paint on composition board, 56 x 44 inches
Gift of Jane and Raphael Bernstein; P.986.77.4
Art © Romare Bearden Foundation/Licensed by VAGA, New York, NY

Romare Bearden was in his early fifties when he achieved fame and recognition for his first series of collages whose subjects centered on African American culture and his own memories. For the next twenty-five years Bearden continued to create these assemblages of paper and photographs, becoming, along with Kurt Schwitters and Henri Matisse, one of the acknowledged twentieth-century masters of collage. Bearden's subject in this collage is the celebratory procession that accompanied Christ's entry into Jerusalem on the Sunday before his crucifixion. The artist places this scene in historical context by dressing the participants in long robes and turbans, but simultaneously suggests a reenactment of the Palm Sunday procession by African American parishioners. The figures and their robes are partially defined by pieces collaged from photographs of a medieval wall painting or manuscript illumination and by flat vibrant areas of torn and cut colored paper. The tiny hands and sections of robe, cut from photographic reproductions,

merge with the flat bright colors of the paper to form a fusion of past and present, of remembered and living forms of ritual. Bearden's practice of drawing on diverse influences such as biblical texts, older paintings, and music allowed him to forge an art with universal themes, in keeping with his belief that art spoke in a language that was not specific to race. However, the major subject of his work involved his own experience as an African American. He saw the need to "redefine the image of man in terms of the Negro experience I know best. I felt that the Negro was becoming too much of an abstraction rather than the reality that art can give a subject." Bearden's choice of various brown color papers for the faces and feet of the processional figures underscores that this image tells a story about people of African heritage, which Bearden brought to the forefront through the practice of his art. [Williams 1972: 9 (quotation)] KWH

Fluxus

110. George Maciunas, American, 1931–1978

Gift Box for John Cage: Spell Your Name with These Objects, about 1972

Closed box with twelve removable parts, 4⅛ x 9⅜ x 2⅛ inches
Gift of John Cage; GM.978.204.2

111. Ben Vautier, Swiss, born 1935

Propositions Pour l'Art, ed. 1955, 1966 original, modified 1970

Metal desk painted black with white enamel lettering and dictionary, "Larouse Elementaire," ed. 1955, 58 x 35 x 22½ inches
Gift of Jan and Ingeborg van der Marck; GM.980.290

112. Mieko (Chieko) Shiomi, Japanese, born 1938

Spatial Poem No. 1/Word Event, 1965

World map on white board, map drawn with black marker or pen, small printed flags, and straight pins, 13 x 18 inches
Purchased through the Hood Museum of Art Acquisitions Fund; GM.989.12.4A

113. Nam June Paik, American, 1932–2006

Zen for TV, 1963/1978

Altered television set, 21 x 15½ x 12¼ inches
Gift of the artist; GM.978.211

114. Geoffrey Hendricks, American, born 1931

Sky Laundry (Sheet) #3, 1966–72

Acrylic on cotton with rope and wooden clothespins, 45 x 77 inches
Gift of Jean Brown; GM.978.207

115. Milan Knížák, Czechoslovakian, born 1940

Killed Book, 1972

Book, 8 x 5½ inches
Gift of Dr. Abraham M. Friedman; GM.986.80.149

> I don't mind to be "an artist" or "a composer"
> I mind to be <u>human</u> and all I do is just simple (and complicated)
> searching of life. Teaching myself and others how to live.
> To live otherwise. To live better.
> — Milan Knížák, around 1972[1]

Globalism, unity of art and life, intermedia, experimentalism, chance, playfulness, simplicity and parsimony, specificity, presence in time—these are some of the criteria one participant used to describe Fluxus, which resists characterization as an art movement, collective, or group.[2] Dada and surrealism were international art movements, involving artists from both Europe and the United States. Other postwar art movements and groups—Cobra, Letterism, International Situationism, Nouveau Réalisme, Group ZERO, Gutai, and Neo Dada Organizer—shared the iconoclastic spirit of Fluxus but retained the imprint of their respective countries of origin. In contrast, the artists, composers, poets, and performers who were at one time or another participants in Lithuanian émigré George Maciunas's Fluxus programs and projects came together all over the world from all over the world—Korea, Japan, Germany, France, Czechoslovakia, Denmark, and the United States. The first truly global art phenomenon, Fluxus found an institutional home at Dartmouth College early on, thanks to the efforts of previous Hood Museum of Art director Jan van der Marck, who founded the George Maciunas Memorial Collection following Maciunas's death in 1978, and Fluxus artist Ken Friedman, who through his father generously contributed many of the objects he had gathered as the Maciunas-appointed head of "fluxus west."

Fluxus emerged in the early 1960s from developments in avant-garde music. (Two of the most well-known Fluxus artists, Yoko Ono (fig. 1) and Nam June Paik, were originally musicians; others, like La Monte Young, continue to compose and perform.) Imprinted by the thinking of composer John Cage (1912–1992) and his mentor Marcel Duchamp (1887–1968), Fluxus shared their goal of eliminating the boundary between art and life. Duchamp based a lifelong practice on his conception of the artist as a "mediumistic being" who distills experience into forms that are fully realized only in the mind of the viewer. He subversively promoted the perspective that everything is worthy of our attention and the understanding that this—our attention—is the creative act.[3] John Cage put it this way: "Art is everywhere; it's only seeing which stops now and then."[4] Cage's "Experimental Composition" classes at the New School for Social Research in the late 1950s were formative for future Fluxus artists George Brecht, Al Hansen, Dick Higgens, and Jackson Mac Low, and others who attended his classes unofficially, such as George Maciunas.

Maciunas believed that the end goal of art is the end of art itself—marked by its absorption into the practice of living. His statement that "Fluxus objectives are social (not aesthetic)"[5] demonstrates his intent to circumvent both the critical and the commercial art world and empower people to engage with essential issues via the Fluxus approach to life as connection and flow. "Fluxus," Maciunas wrote, "is definitely against art-object as non-functional commodity . . . It could temporarily have the pedagogical function of teaching people the needlessness of art including the eventual needlessness of itself."[6] His point is clear: art, to cite the title of pragmatist philosopher John Dewey's well-known

110

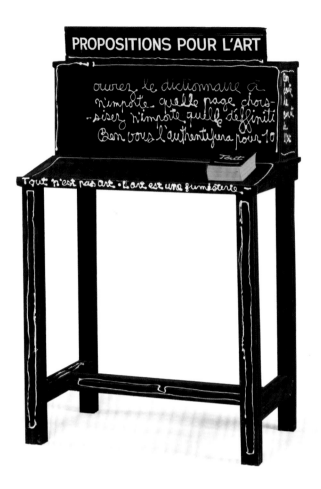

PROPOSITIONS POUR L'ART

111

book, is experience. The pedagogical function of Fluxus artworks is to help us experience life; what we "learn" from Fluxus is how to be ourselves.

One of the characteristics that distinguishes Fluxus is the self-evident nature of its productions. Extensive explanations are not only beside the point, they can actually hinder understanding. However, for those not able to experience in person the examples shown here, some commentary is in order.

George Maciunas, *Gift Box for John Cage* (cat. 110). Fluxus impresario George Maciunas loved to assemble boxes and issued numerous Fluxus editions of different artists' works in boxed format. His own *Gift Box for John Cage: Spell Your Name with These Objects* was made around 1972 using an old U.S. Army medical kit. The items in this box include objects that, with a bit of mental exploration, can be used to spell Cage's name, such as a pine cone, acorn, glass bottle stopper, and egg. This game is quite appropriate for a name box: according to social psychologist George Herbert Mead, games are how individuals achieve selfhood. After Maciunas's death from cancer at the age of forty-seven, Cage contributed his gift box to the Maciunas Memorial Collection at Dartmouth College.

Ben Vautier, *Propositions Pour l'Art* (cat. 111). The desk entitled *Propositions Pour l'Art* is a paradigm of the pedagogical nature of Fluxus. Ben Vautier typically signs only his first name—to everything he chooses to claim as his art. What at first might seem a self-aggrandizing gesture can also be read as a statement about art. Here, Ben has painted a metal desk black, written on it with white enamel paint, and affixed to it an edition of the French encyclopedic dictionary, *Larousse Elementaire*—also painted black and labeled in white: *tout*, "everything." The inscription on the top part of the desk instructs the viewer to "Open the dictionary at any page and choose any definition. Ben will authenticate it for you for 100 francs." On the front of the desk he adds: "Art does not exist, art is a smokescreen," and on the side: "Ben doubts Ben and art." If the reality of both art and Ben is in doubt, what is the implication for you, the viewer?

Mieko ("Chieko") Shiomi, *Spatial Poem No. 1* (cat. 112). In 1965 Japanese artist Mieko ("Chieko") Shiomi sent instructions for *Spatial Poem No. 1,* a "word event," to friends all over the world: "Write a word or words on the enclosed card and place it somewhere." After hearing back from her participants, she mapped the results, and maps with pinned responses were issued as a Fluxus edition. Responses included, from Nam June Paik: "sweet salt / nowhere"— nowhere, because there is no such thing (except on Shiomi's map).

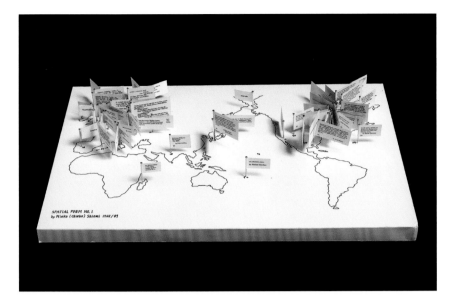

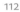

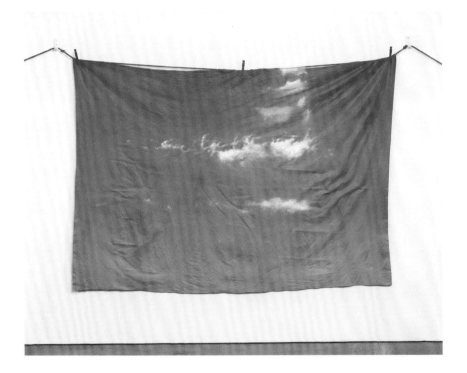

Nam June Paik, *Zen for TV* (cat. 113). "I am proud to be able to say that all thirteen sets actually changed their inner circuits," Nam June Paik joked about the exhibition in which *Zen for TV* first appeared, his *Exposition of Experimental Television* (1963).[7] For this piece, Paik reduced the image on the screen to a horizontal line of light, which he made vertical by turning the set on its side. The title, *Zen for TV,* implies that the television set is both an aid to meditation and is itself in a meditative state. "Anyway," Paik concluded a long, contrarian essay in the Fluxus newspaper, *V TRE,* "if you see my TV, please, see it more than 30 minutes."[8] His plea would seem to apply to art as well as to Zen meditation.

Geoffrey Hendricks, *Sky Laundry (Sheet) #3* (cat. 114). Geoffrey Hendricks became part of Fluxus in the mid-1960s. In addition to performance and intermedia pieces that tend to focus on nature and issues of identity, Hendricks is known for his paintings that portray the ever-changing sky. *Sky Laundry (Sheet) #3*—a canvas depicting a blue sky dotted with white clouds attached to a clothesline with wooden clothespins—evokes the movement of clouds on a bright summer day.

Milan Knížák, *Killed Book* (cat. 115). Thanks to Ken Friedman's many international contacts, Dartmouth's Fluxus collection includes a significant representation of work by Eastern European

115

Fig. 1. Yoko Ono, American, born 1933, *A Box of Smile*, original 1971, ReFlux Editions 1984, plastic, mirror, and embossed gold print, 2 x 2 x 2 inches. Purchased through the Hood Museum of Art Acquisitions Fund; GM.989.12.5.

artists. Milan Knížák's *Killed Book* is pierced by what appear to be bullet holes, generating a combination of shock and humor. The book's subtitle, "O Zivote Mladych Komunistu, Ktery Padli V Boji Za Vlast," means "of the lives of young communists who fell in battle for homeland." The name of the publisher—Mlada Fronta, an official state organ during the Communist Period—translates as "Youth Front." The book was published in 1954, the height of the Stalinist period in Czechoslovakia. In retrospect, *Killed Book* feels like a premonition of Czechoslovakia's 1989 "Velvet Revolution," which ended over forty years of Communist rule without killing one person.

Author of the epigraph that opens this essay, Milan Knížák is today director of the National Gallery in Prague. Now part of the art establishment, Knížák seems to regard his work not that much differently than he did thirty-five years ago. Asked by *The Prague Tribune* whether it was hard to go from being an unconventional artist to being a state official, he responded that it was not hard at all: "I can easily imagine being in command of a submarine, or running a comb factory. I don't see any great difference between the three."[9] It might be said that Fluxus followed a similar path: from under-the-radar international phenomenon to an increasingly recognized forerunner of today's art that defies boundaries and pervades public life. JB

NOTES

1. *"M.K.,"* ink on paper, Hood Museum of Art, George Maciunas Memorial Collection. Gift of Dr. Abraham M. Friedman; GM.986.80.150.

2. Ken Friedman, *The Fluxus Reader* (West Sussex: Academy Editions, 1998), ix.

3. Marcel Duchamp, "The Creative Act," talk given to the American Federation of Arts in 1957, first published in *Marcel Duchamp*, Robert Lebel (New York: Paragraphic Books, 1959), 78.

4. Constance Lewallen, "Cage and the Structure of Chance," in *Writings through John Cage's Music, Poetry, and Art,* eds. David W. Bernstein and Christopher Hatch (Chicago: University of Chicago Press, 2001), 234.

5. From a 1963 letter to Tomas Schmit quoted in Clive Phillpot and Jon Hendricks, *Fluxus: Selections from the Gilbert and Lila Silverman Collection* (New York: Museum of Modern Art, 1988), 24.

6. Ibid.

7. From Nam June Paik, "Afterlude to the Exposition of Experimental Television," *cc fiVe ThReE,* June 1964. "Exposition of Experimental Television" (Paik's title signals his transition from music to the electronic image) was held in March 1963 at the Galerie Parnass in Wuppertal, Germany. The first *Zen for TV* disappeared in 1967; Paik made several replicas, including this one for Dartmouth's George Maciunas Memorial Collection.

8. Ibid.

9. See http://www.prague-tribune.cz/2004/1/12.htm (accessed August 11, 2008).

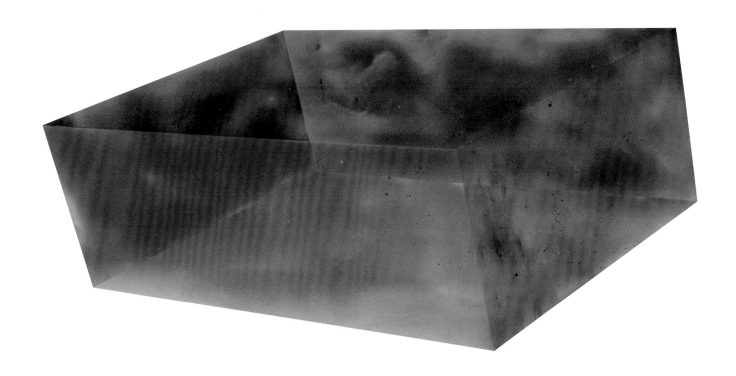

116. Ronald Davis, American, born 1937

Three Box-G, 1968–70

Polyester resin and fiberglass, 63½ x 115¼ inches
Gift of Leo Castelli; P.977.200

Citing influences as diverse as Frank Stella and Piero della Frances-ca, California native Ron Davis created his own method of paint-ing, focusing on brilliant color and clean edges. While closely tied to the movement in 1960s art away from the gestural quality and emotional intensity of abstract expressionism and toward smooth surfaces, pure geometry, and shaped canvases, Davis also subverted the literal and pictorial flatness that was pervasive in the art of his contemporaries, exploring how the conventions of illusionism and two-point perspective could be applied to new materials and new techniques. Like many artists working in Los Angeles at the time, such as Robert Irwin and John McCracken, Davis began to delve into the possibilities inherent in nontraditional materials. Heav-ily influenced by the area's surfing culture, he used the develop-ing surfboard technology to create a paint-like medium that was smooth, hard, and highly reflective.

The stunning result is found in *Three Box-G.* Guided by a book on fiberglass for use in motorcycles, cars, and surfboards, Davis combined polyester resin with strong color toners. He poured layer upon layer into a mold and then added fiberglass matting, literally building his painting. As the mixture hardened it became almost transparent. Seeming to hover on the wall, its layered depths and high-gloss surface catching the light, Davis's paint-ing both revives the forgotten tradition of illusionism and breaks from it, creating his own compelling version. *Three Box-G* asks the viewer to trace the actual contours of the external parallelogram and the imaginary three-dimensional box. It is both an illusion of a beautiful object and a carefully crafted beautiful object in its own right. AHW

143

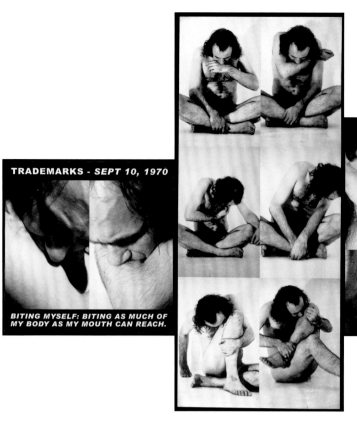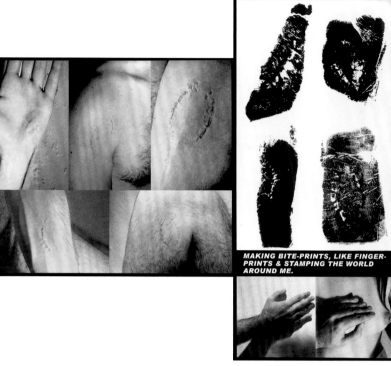

117. Vito Acconci, American, born 1940

Trademarks, 1970/2004

Black and white photo-montage, part 1 of 4: 21½ x 21⅞ inches, part 2 of 4: 51 x 21⅞ inches, part 3 of 4: 27¾ x 32⅞ inches, part 4 of 4: 48⅝ x 21¾ inches
Purchased through the Virginia and Preston T. Kelsey 1958 Fund; 2005.16

Vito Acconci made his mark in the early 1970s with a series of performance works that often applied the scientific method of inquiry to a series of actions. A hallmark of this art is its personal edginess, sometimes involving bodily manipulation, fluids, or excretions. Its subject is ostensibly himself, exposed to such a degree that he creates discomfort and unease among his observers. At his most impersonal, a work like *Step Piece* (1970) documents how many steps onto an eighteen-inch-high stool the artist can make without tiring in a certain amount of time. He records this action through photographs and a numerical record, making himself a Muybridge-like subject of a suspect experiment. At his most personal, a work like *Untitled Project for Pier 17* (1971) has the artist revealing embarrassing facts about himself to visitors to an abandoned warehouse, whereas *Seedbed* (1972) finds him muttering autoerotic fantasies while hidden from sight (but audible) to those who walk over him on a minimalist corner sculpture.

Acconci's work straddles the line between the public and private, very much part of the human condition in post-1960s culture. In *Trademarks,* a 1970 performance work that is documented by this particular reissued group of photographic images and text, he sets up its parameters by biting himself all over his body wherever he "can reach." These bite marks make impressions of his teeth and leave traces of saliva on his skin; he then not only photographed the marks but made prints of them as well. He also extends the metaphor of impression upon flesh by conferring the same meaning on his touch of a woman's breast. In order to do this work, he exposes his naked body, once again exposing his vulnerability to a masochistic activity and becoming both the object of an investigation/action as well as the subject who performs the piece. *Trademarks* became a classic of performance art based on the body, simple in its execution but complex in its wealth of issues involving replicability and the imprint of personal will on the flesh (and, by extension, the world). KWH

118. Sonia Landy Sheridan, American, born 1925

Sonia through Time (Verticle), 1972

3M VRC on paper, 11 x 8⁹⁄₁₆ inches
Gift of the artist; MIS.2004.84.286

119. Sonia Landy Sheridan

Sonia through Sonia in Time, number 18 from a series of 18, 1974

3M VQC on paper [double-sided], 8½ x 14 inches
Gift of the artist; MIS.2004.84.324.19

Twentieth-century avant garde artists often privileged ideas and actions that by their nature fell outside more traditional definitions of art. One influential but lesser-known experimental art maker of the last fifty years is Sonia Landy Sheridan. Her interest in science, technology, and art led her to work with image-making machines that were being developed during the 1960s and 1970s, apparatus that presaged the digital revolution of the last two decades. In this period artist/industry collaborations were not uncommon, but tended to be one-time endeavors, such as those commissioned by the Los Angeles Country Museum of Art between 1967 and 1971. Sheridan, who was centrally engaged in issues involving cross-fertilization between art and industry, was artist in residence at 3M-Company from 1969 through the mid-1970s. This collaboration resulted, in part, from her expressed interest in working with machines while a professor at the School of the Art Institute of Chicago, where she taught from 1960 to 1980.

In 1970, Sheridan established a program for her students at the School called Generative Systems. The program, which drew on her ideas about creative practice, emphasized scientific inquiry combined with social and cultural questions more germane to artists' concerns. During the decade she directed the program, students studied new image-making systems and eventually worked on an early computer graphic system with the help of Sheridan's former student and teaching assistant John Dunn. Sheridan nurtured the creativity and free expression of the students under her tutelage with an openness and open-ended approach that stressed process and creativity over end product.

These two works, chosen from the Hood's comprehensive holdings of her work from the 1940s through the present, are self-portraits. *Sonia through Time* was made on a 3M VRC or Variable Remote Copier, a machine that transmitted sounds through the machine to make images. Sonia used two techniques to create this work, a common practice in her experimentation with different image-making machines: She took a self-portrait she had created with Haloid Xerox and used it as the source image. She sent this image to the telecopier, altering the image by manipulating the

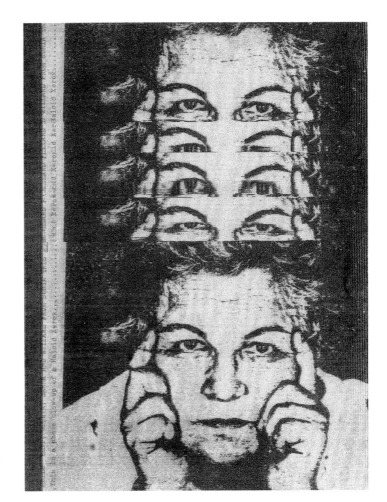

118

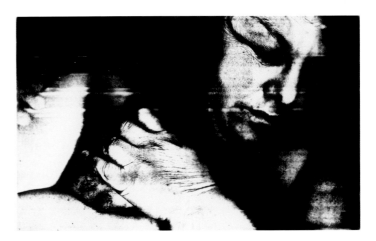

119

needle, interrupting and resuming the transmission. The second image, one of a series of eighteen, was made on a Versatile Quality Copier I (she affectionately titled it Very Queer Copier), which she acquired from 3M the same year that this work was made. The Hood collection contains close to one hundred VQC works by the artist. Sheridan has stated that she was drawn to the dark velvety quality of the images produced by this machine, created using silver oxide powder on paper treated with a zinc oxide formula.

KWH

145

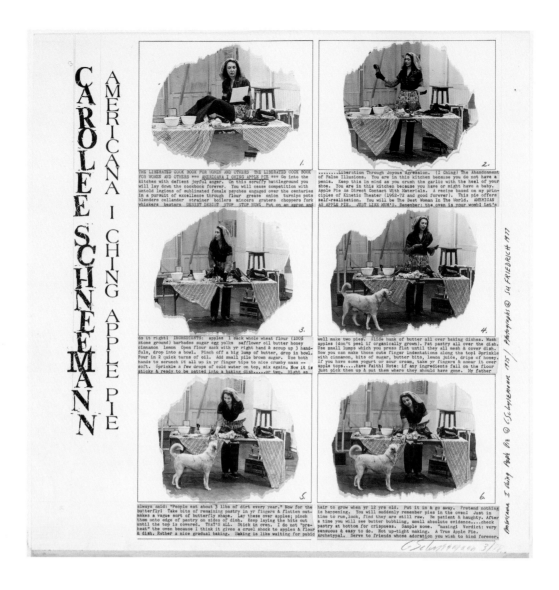

120. Carolee Schneemann, American, born 1939

Documentation of the Performance "Americana I Ching Apple Pie," performance: 1975, photographs: 1977

Photographs and typewriting on paper, 19⅞ x 19¾ inches
Gift of Monroe A. Denton Jr., Class of 1968; 2006.100.2

The performance artist and filmmaker Carolee Schneemann was a key figure in the late 1960s and 1970s in the feminist art movement. In *Americana I Ching Apple Pie,* Schneemann documents with six photographs a performance from May 1977, in which she took items from a jumble or garage sale and sold them as if they were baked goods. By enacting a parody of a type of charity fund-raising event and bake sale typical of fairs and church socials, Schneemann takes a critical stance with regard to the traditional domestic roles and activities of women. This work was created at a time when the women's movement had just begun to achieve some of its goals, including the employment of more women in non-traditional careers, and Schneemann's work should be seen in the context of this struggle to redefine women's place in the work-

force and at home. In the text that accompanies the photographs, Schneemann states, "Go into the kitchen with defient [*sic*] joyful anger. On this scruffy battle ground you can lay down the cook-book forever. You will cease competition with untold legions of sublimated female psyches engaged over the centuries in a pursuit of excellence through flour grease onion turnips." The text also gives loose instructions on how to make an apple pie and alludes to the mystical ancient Chinese text of the I Ching, which became popular in the United States during this period as part of a growing fascination with Asian religions. In *Looseleaf* (1964), a related work performed at the Judson Dance Theater in New York, an apron-wearing Schneemann sets a table on stage as two men appear from the audience to sit at it. She serves them cake and water, emphasizing the domestic role of women and the expectation that they serve men. Both this performance and *Americana I Ching Apple Pie* emerge from a very specific era in American cultural and social history that had largely disappeared by the late 1980s. The documentation itself is typical of the period, with black-and-white photography collaged onto paper with handwritten or typed annotations. KWH

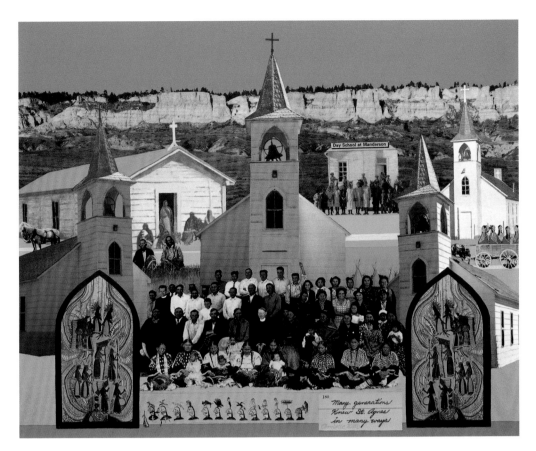

121. Arthur Amiotte,
American, born 1942

*"Saint Agnes" Manderson,
S.D. Pine Ridge Rez,* 2001

Acrylic and collage on canvas,
24 x 30 inches
Purchased through the Phyllis and Bertram
Geller 1937 Memorial Fund; MIS.2004.36

Arthur Amiotte was born on the Pine Ridge Reservation in South Dakota. He is the great-grandson of Chief Standing Bear (1859–1933), who fought at Little Big Horn and whose ledger art illustrated the well-known book *Black Elk Speaks.* Amiotte's early art was executed in the flat-planed style of renowned Lakota modernist, Oscar Howe, with whom he had taken a workshop in college in 1961 (fig. 1). However, in 1988, Amiotte took off in a new direction, creating autobiographical and over-painted collages that explored Lakota history and art from the reservation period. As the artist explains, "I purposefully decided to treat Sioux life from the periods of approximately 1880 to 1930, a period when culture change and adaptation were drastically taking place in the areas of technology; printed media and language; fashion; social and sacred traditions; education; and for Sioux people, an entirely different world view."

In his collages, Amiotte combines real and imagined voices with visual snapshots from the Lakota past, taken from family photographs; texts and advertisements from antique books and magazines; and reproductions of ledger drawings by Standing Bear. In *"Saint Agnes" Manderson, S.D. Pine Ridge Rez,* Amiotte addresses the impact of Christianity on his Pine Ridge ancestors, who experienced assimilation, conversion, and transformation through mission schools, the church, and the government. Amiotte reproduces various manifestations of Saint Agnes church to represent the process of assimilation. This particularly speaks to the generations of Oglala Sioux forced into Christianity by poverty when the American government withheld annuities of food

and clothing or treaty payments from Pine Ridge families who prevented their members from attending mission schools or church activities. The different generations of Oglala Sioux represented here expose a chronology of responses to conversion and Americanization, which, as Amiotte points out, was marked as much by pride and contentment as by bitterness and rejection. [Amiotte 2001: 5 (quotation)] BT

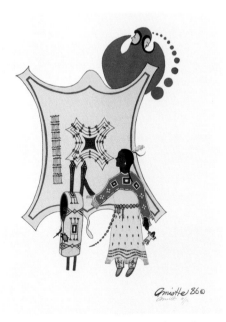

Fig. 1. Arthur Amiotte, *Lakota Girl,* 1986, photomechanical reproduction, 23⅛ x 17½ inches. Gift of the artist; 2005.39.2.

147

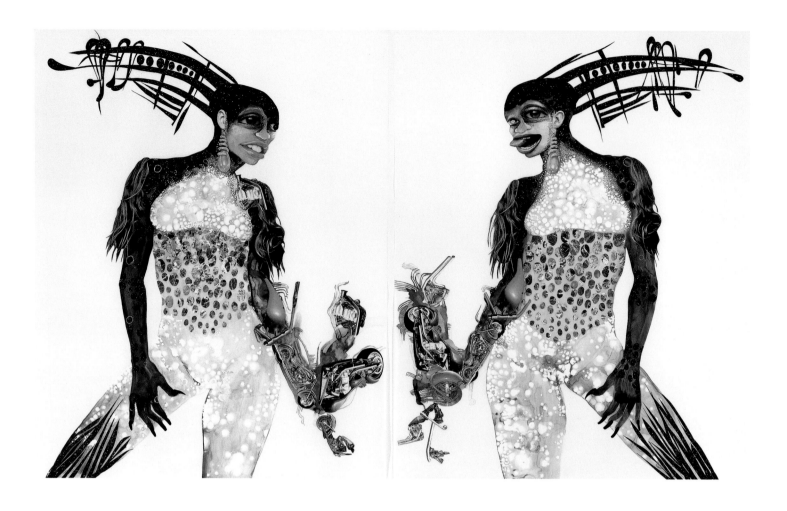

122. Wangechi Mutu, Kenyan, lives in New York, born 1972

Double Fuse, 2003

Ink and collage on Mylar, panel 1 of 2: 45 x 36⅛ inches; panel 2 of 2: 44¾ x 36⅛ inches
Purchased through the Charles F. Venrick 1936 Fund; MIS.2003.38

In her collages, photomontages, and watercolor paintings, the Kenyan-born artist Wangechi Mutu creates images of exotic and native women that usurp stereotypical assumptions about race, gender, post-colonialism, geography, history, and beauty. Initially, Mutu's women appear to be powerful and sensual, but upon closer inspection, the incongruity of shapes, sizes, textures, materials, and colors reveals these women as hybrids—part human, part beast, part machine. Their missing or distorted features remind us of captured and mutilated prey, bionic creatures, and cloned miscon-structions that reveal themes of "loss, desire, morbid fantasy, and the injured body," as the artist explains.

Drawing from the African vernacular, modernist European collage styles, and American mass culture for the diptych *Double Fuse,* Mutu superimposes cut-out fragments from fashion and motorcycle magazines onto ink-soaked fields of color that form idealized female figures. Yet the menacing features and gestures of these alluring, goddess-like twins tease out the boundaries be-tween balance and disproportion, beauty and deformation, attrac-tion and repulsion, and biology and artificiality to parody Western representations of submissive, marginalized, or native women portrayed in Condé Nast publications, the porn industry, and *National Geographic*. As such she directly tackles the problem of how images of women's bodies are objectified, fragmented, and recycled in popular culture and the mass media.

Armed with appendages made up of machine parts from motorcycles, for example, Mutu's women are neither submissive nor victims. "They're the survivor of all these moments in his-tory that we've been through as a race," the artist explains. "All of their history is written upon their bodies and in their hair. It's very clear where they've been. Some of them are missing parts, or have gained a new a part, be it an animal part or a machine part, as they've gone along. These are images of triumph and transgression. They're very contemporary even though they have archaic artifacts attached to them too and a vision of what can happen if we sur-vive." [Mutu 2003 (quotation); Tate 2007 (quotation)] BT

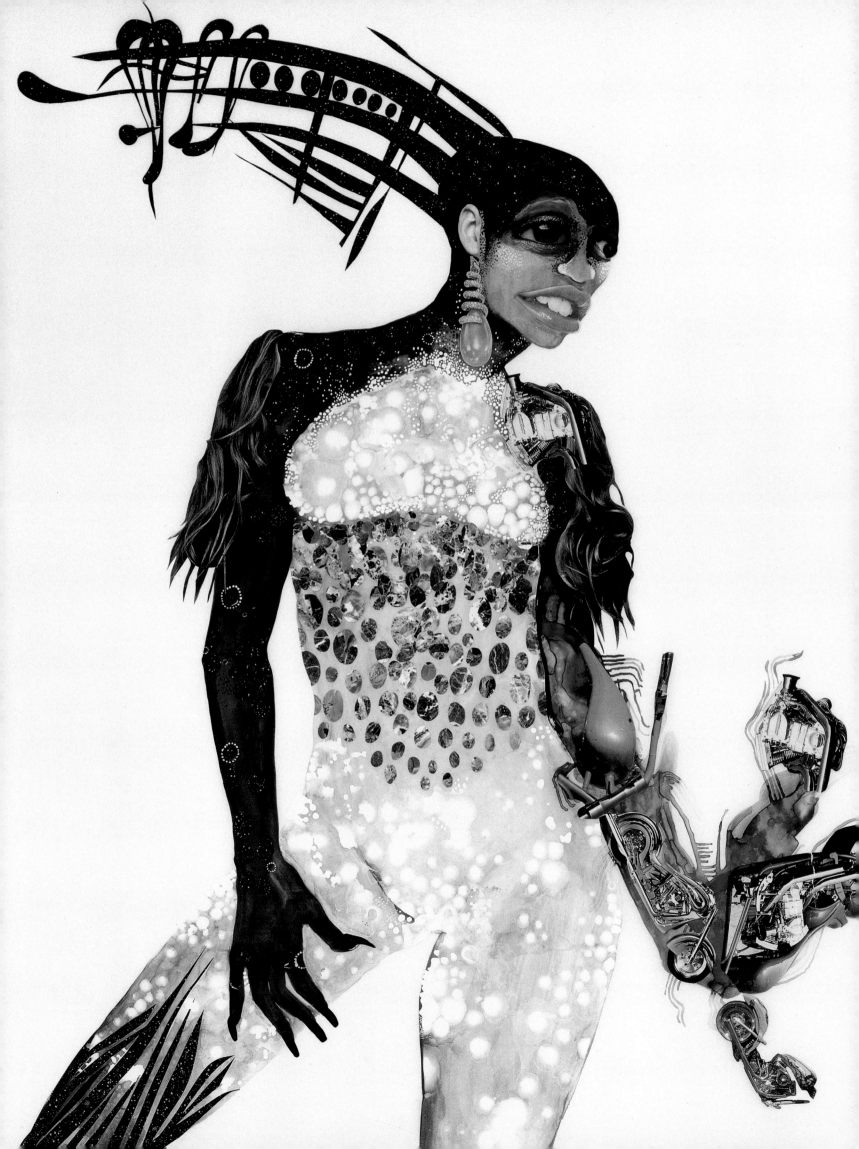

NEW MEDIA

123. Alfredo Jaar, Chilean, born 1956

The Eyes of Gutete Emerita, 1996

Two Quadvision light boxes and eight transparencies, 26 x 48 x 6 inches
Purchased through the William S. Rubin Fund, the Contemporary Art Fund,
the Guernsey Center Moore 1904 Memorial Fund, and the Anonymous
Fund #144; 2006.17

War and violence have been a constant presence from one era
to another in all parts of the world, and artists have often been
witnesses to these conflicts. *The Eyes of Gutete Emerita* by film-
maker, photographer, and conceptual/installation artist Alfredo
Jaar grew out of his visit to Rwanda a few months after the 1994
genocide. The impact of Jaar's visit to Rwanda was deep and pow-
erful. He worked for almost ten years on projects related to the
genocide, and this installation became one of the Rwanda series'
signature pieces. Like many of Jaar's works, *The Eyes of Gutete
Emerita* combines text and image. It focuses on the suffering of
one woman who lost her husband and two sons in the mass kill-
ing of Tutsis during a Sunday mass at a church forty miles south
of the Rwandan capital, Kigali. When Jaar visited the site in late
August, he met Gutete Emerita, who told him about seeing her
family murdered as she escaped with her daughter. Jaar chose not
to photograph the remains of bodies still lying on the ground at

the massacre site and instead directs our attention to one survivor's
story. The last lines, each on one of the double light boxes, state,
"I remember her eyes. I remember the eyes of Gutete Emerita."
Jaar purposefully names the survivor, her daughter, and her dead
husband and sons in his work—they are not anonymous victims,
but individuals who have suffered personal tragedies of horrific
proportions.

In the final two transparencies of *Gutete Emerita,* Jaar shows
the eyes for only a fraction of a second, denying the viewer the
experience of prolonged contact with her gaze. The fleeting ap-
pearance of her eyes mirrors the elusive quality of memory as well
as the quick but lasting impact of a violent act, the extinguishing
of a life through the sharp movement of a knife or a machete. By
concentrating on the survivor as witness, Jaar echoes the theme of
seeing as a devastating legacy for both artist and subject. His work
leads us to question not only the photographic image's capacity
to convey the reality of an experience, but also to compare the ef-
ficacy of words, versus images, to represent that reality. He under-
scores the way in which word and image interact to create meaning
outside the constraints of their different expressive languages.

KWH

151

124. Bill Viola, American, born 1951

The Quintet of the Silent, 2000

Single channel video on wall-mounted plasma screen, 24¾ x 40½ x 7 inches
Purchased through gifts from the Lathrop Fellows; MIS.2002.7

The Quintet of the Silent is one in a series of four single-channel video works in which Bill Viola explores the Passions. The series was inspired by Viola's study of late Medieval and early Renaissance Christian paintings—in particular Hieronymus Bosch's *Christ Mocked (The Crowning with Thorns),* about 1490–1500—while a scholar-in-residence at the Getty Institute in 1998. Revealing the artist's interest in new media, spirituality, and the "invisible" or "those experiences below the threshold of expression," *The Quintet of the Silent* presents five men performing joy, rapture, anger, fear, and sorrow within a shallow and indeterminate space. Viola employed actors capable of noiselessly emoting on command and filmed them in high-speed digital video for ninety seconds. He then slowed down the video, stretching those ninety seconds into a seventeen-minute screen image that seems to evolve without moving. By modifying the duration and speed of the video, Viola estranges the physical rhetoric of emotion, a set of performative clichés rooted in the iconographic conventions of allegorical painting but routinized through repetition within the dramatic arts of our mass-mediated age. In the resultant work, the minute changes in facial expression or bodily affect that would normally escape notice take visual prominence, and yet the precise identity of any single passion is obscured, as a figure seems at first to exude anger, only to conjure joy moments later. If Bosch froze emotional experience in gesture and singular facial expressions, and film mobilized it through the edited sequencing of human action, Viola reveals the indeterminate physiological state that produces discreet passions.

Viola argues that this technical capacity of video helps to reveal what we experience perceptually but cannot process cognitively. For him, the electronic medium is no mere vehicle for image making, but rather a kind of being itself, an ontological fact that he likens to the parasympathetic systems of the human body. From his earliest work as a pioneer in video art, Viola has explored the visceral dimensions of the medium through the creation of elaborate installations that embed viewers within multi-sensory environments and shape their experience. However, in the early 1990s he shifted his focus from technical intervention to the narrative tradition in Old Master paintings. *The Quintet of the Silent* represents this dialogue with painting. Not only are the gestures and facial expressions derived from painterly convention, but also Viola has carefully calibrated the light and highly saturated color in these works to suggest Caravaggio's dramatic chiaroscuro or Pantormo's vibrant palette. In short, these plasma screen works become altarpieces for the twenty-first century. Viewers stand before them in a state of awed silence, witnesses once more to the miraculous capacities of figurative art and its technological devices to capture and communicate something essential but hitherto unnoted about the subjective and embodied experience of being human.

MKC

152

125. Lorna Simpson, American, born 1960

Corridor, 2003

Color HD video transferred to DVD, dimensions variable
Purchased through the Julia L. Whittier Fund; MIS.2004.50
© Lorna Simpson

Filmmaker and photographer Lorna Simpson frequently tackles issues of identity and the gender and racial exclusivity of Western visual discourse by depicting characters and situations typically absent from visual culture. Much of her work includes linear, if often incomplete, narratives through which the audience experiences the artist's own thought process by following sequential images or disjunctive film series.

In *Corridor,* Lorna Simpson uses period-specific buildings, lighting, costumes, and everyday objects to bring the viewer's sense of politics, race, and history into question. Through these artifacts of daily life, Simpson evokes two different points in time: one in colonial America and the other in the mid-twentieth century. The double projection shows the interior of two homes, each inhabited by a black woman: the seventeenth-century Coffin house (located in Newbury, Massachusetts) on the left and the 1938 Walter Gropius house (in Lincoln, Massachusetts) on the right. Both houses are part of the collection of historic homes of the Society for the Preservation of New England Antiquities (now Historic New England), which commissioned *Corridor* for an exhibition at MASS MoCA in 2003.

The questions of who these women are and what social classes they represent are in part triggered by their race and their gender—a trajectory of thought Simpson intentionally sets for the viewer. As the two figures navigate their unique environments, they are accompanied by music by nineteenth-century musical savant Blind Tom and twentieth-century American jazz composer Albert Ayler. At first, the two themes play separately, each apparently corresponding to one of the two scenes, but they later weave into one, joining the two worlds across time and space. With *Corridor,* Simpson exposes the manner in which images inform our making of meaning and the extent to which that meaning draws on assumptions based on gender and race.

ESB

126

126. Luis Gispert, American, born 1972

Untitled (Dinner Girls), 2002

Cibachrome mounted on aluminum, 36 x 80 inches
Purchased through the Harry Shafer Fisher 1966 Memorial Fund; PH.2003.34

127. Luis Gispert

Foxy Xerox, 2003

Two channel DVD projection, stereo, color, dimensions variable
Purchased through the Anonymous Fund #144; MIS.2004.19

Luis Gispert was raised in a close-knit Cuban American family in Miami. By his own account, he passed his childhood in front of electronic equipment, transfixed by mass-media presentations of film violence, and listening to popular music. Gispert received his primary artistic training first at Miami-Dade Community College, then at the Art Institute of Chicago and, finally, at Yale University where he was awarded an M.F.A. in 2001. From his student days up to the present, the artist has mined popular culture's celebration of youth, focusing on its dissonance with mainstream sensibility. After years of inclusion in numerous Florida-based group shows, where his work championed car culture, juvenile pranks, and local hip-hop music, Gispert received international attention at the 2002 Whitney Biennial. There he filled a gallery with large-scale,

highly saturated, elaborately staged color photographs. Many of these works featured cheerleaders posed against bright green backgrounds—a knowing nod to cinematic techniques whereby scenes filmed on a studio set receive backgrounds at a separate moment in their production. The ethnically diverse cheerleaders in these works floated in indeterminate spaces, enacting familiar scenes from the history of art: annunciations, resurrections, ecstatic prayers, or battles between the gods. In the *Cheerleader Series* Gispert cited artists from renaissance masters to the contemporary canon—Antonio Pollaiuolo to Bruce Nauman—reflecting his referential breadth and divergent art historical tastes.

Untitled (Dinner Girls) is an outstanding example of Gispert's photo-based practice. The large, glossy work dates from immediately after his Whitney display. Like many of the artist's most memorable images from this time period, *Untitled (Dinner Girls)* features members of his immediate family. His sister and two of her friends are gathered around a large, highly polished dinner table. Their tattooed arms, elaborate hairstyles, and bright manicures suggest a contrast with their middle-class surroundings, and perhaps also with their traditional cheerleading garb, while their distinctive hand gestures seem to be repeated in the more baroque elements of the surrounding interior. The three women appear somnolent and are engaged in a form of séance, or some other

127

private ritual. The heavy gold jewelry that they wear around their necks floats improbably, an illusion the artist produced by attaching monofilament line to the ends of each of their fingers (traces of which he later eliminated through digital means). The Hood's photograph thus points toward a set of concerns for the artist: a passion for youthful transgression mixed with reverence for the family unit, and a fundamental interest in Latin-American mysticism. While he was raised in an observant Christian household, Gispert recalls being aware of Santeria and other Afro-Cuban religious practices that were commonplace in his neighborhood. *Untitled (Dinner Girls)* thus combines the supernatural and the everyday, reflecting both Gipsert's average American upbringing and his more complex appreciation of baroque wonder.

Foxy Xerox was one of the first digital artworks to be purchased by the Hood Museum of Art. Its acquisition coincided with a major traveling retrospective of the young artist's work—*Luis Gispert/Loud Image*—organized by Dartmouth College in 2004. *Foxy Xerox* consists of a carefully synchronized two-channel projection. The first image to appear in the time-based work features a young blonde woman in a turquoise velour tracksuit. She is the painter, Kristin Baker, who often served as a model in Gispert's works from this period. Baker stalks the camera and gestures menacingly toward the viewer, all the while lip-synching to a sampled

guttural rap lyric. In the next projection, the same model appears wigged, in a bright pink sleeveless jumpsuit, continuing the song in a comparably exaggerated manner. Like her alter ego in the projection that has just cut from view, this woman wears the chunky gold jewelry that is sometimes associated with hip-hop celebrities in contemporary culture. In this sequence of staccato appearances, however, the model appears in blackface, with painted black arms. The overt reference to minstrelsy in *Foxy Xerox* is as deliberate as it is alarming. Gispert raises questions about authenticity and ownership of sub-cultural forms. The work proceeds dialogically, with one performance interrupting the other, the twin projections volleying back and forth at a rapid pace, like television coverage of a highly competitive tennis match. It culminates with both performers unified momentarily in a single projection, levitating in space as an opera-like aria brings the sequence to an abrupt close. By creating a shocking "rap-off" between two kinds of over-the-top performers, *Foxy Xerox* raises tough questions about race, cultural authority, and the appropriation of countercultural forms in contemporary life. These are enduring themes in Gispert's work, as seen in his recent, more lush filmic projects, such as *Stereomongrel* (2005) and *Smother* (2008). [Tejada 2004: 22 (quotation)]

DRC

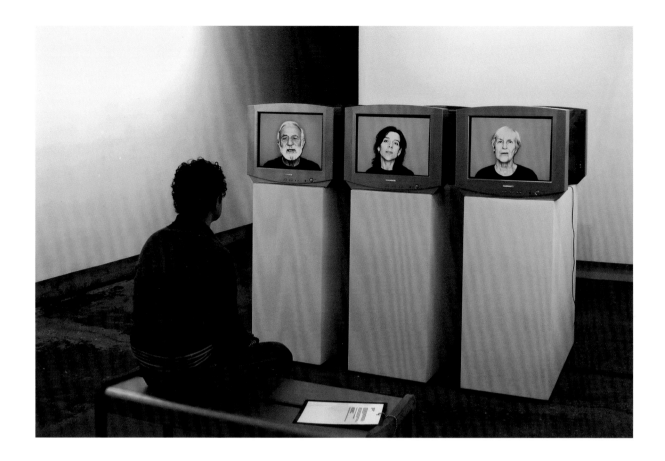

128. Nina Katchadourian, American, born 1968

Accent Elimination, 2005

Six televisions, three pedestals, six-channel video (three synchronized programs and three loops), headphones and benches; dimensions variable
Purchased through gifts from the Lathrop Fellows; 2008.36

Nina Katchadourian was born in Stanford, California, in 1968, and grew up spending summers on a small island in the Finnish archipelago, where she still spends part of each year. Her work exists in a wide variety of media, including photography, sculpture, video, and audio, and often addresses issues of cultural heritage, language and translation, and her own relationship with the natural world.

In her video installation *Accent Elimination,* Katchadourian stages a witty tug-of-war between family history and the all-American goal of assimilation. Katchadourian's work traces the story of her parents' lineage and personal history by studying and emulating their speech patterns. The artist describes the evolution of her video:

> My foreign-born parents who have lived in the United States for over forty years both have distinctive but hard-to-place accents that I have never been able to imitate correctly (and have not inherited). Inspired by posters advertising courses in "accent elimination," I worked with my parents and professional speech improvement

coach Sam Chwat intensively for several weeks in order to "neutralize" my parents' accents and then teach each of them to me. The very existence of these courses points to the complexities of assimilation and self-image, and the tricky maneuvering between the desire to preserve the distinctive marks of one's culture, on one hand, and to decrease them in order to seem less foreign, on the other. In the video, my parents and I struggle to hear and imitate what is so close at hand and yet so difficult to access. The accent is treated very literally, like an heirloom, and the project illustrates the very awkward attempt to concretely transfer this elusive, and ultimately culturally determined, attribute.

Accent Elimination is a six-channel piece, with each television screen showing a different video. The front "talking head" monitors show a synchronized conversation, scripted by Katchadourian's parents, which plays out first in their natural accents, and at the end in their "reversed" accents. The middle section, which consists of outtakes from their practice sessions in Katchadourian's studio, was edited to play with the patterning and repetition of various words. Though *Accent Elimination* is humorous at times, frustration and desperation are evident as the artist and her parents try to adopt or lose auditory markers of identity, ethnicity, and familial heritage. [Katchadourian 2005 (quotation)]

ESB

WORKS ON PAPER

129. Jacob Lawrence, American, 1917–2000

Soldiers and Students, 1962

Opaque watercolor over graphite on wove (Arches) paper,
22½ x 30⅛ inches
Bequest of Jay R. Wolf, Class of 1951; W.976.187
© 2009 The Jacob and Gwendolyn Lawrence Foundation, Seattle/
Artists Rights Society (ARS), New York

Adopting an innovative modernist style to impart socially conscious themes, Jacob Lawrence served as an indispensable artist, historian, and observer of black life in the United States throughout his more than sixty-year career. In the 1960s, the civil rights movement became an overriding concern for Lawrence. As one of several compositions by the artist to focus on the demonstrations and violence of the period, *Soldiers and Students* responds to the controversy surrounding school desegregation in the southern United States.

In *Soldiers and Students,* three armed guards and several protesters block a group of African American students from entering a schoolhouse. By condensing space, defining figures through bold patches of color and rough outlines, and simplifying facial features, Lawrence accentuates the emotion and intensity of the event. With determined yet anxious expressions, the students grip their books and hold their ground, while the demonstrators declare their resistance to integration through mockery and threats of violence. The grimaces and downturned eyes of the soldiers convey their ambivalence even as they dutifully fulfill their task. The artist positions the viewer on the side of the students, encouraging us to identify with their frustrations and fear.

Although Lawrence creates generic character types rather than individuals, the image readily recalls the controversies surrounding the integration of Little Rock Central High School in 1957. In order to prevent nine African American students from attending the school, Arkansas Governor Orval Faubus summoned the state's National Guard to bar their entry. While Lawrence's *Soldiers and Students* may respond to the event in Little Rock, his efficient use of line and color conveys the essence, rather than the details of the conflict, and thus suggests the more universal subject of struggle and dispute. As the artist explained, "Although my themes may deal with the Negro I would like to think of it as dealing with all people, the struggle of man to always better his condition and to move forward." [Lawrence 1968: (quotation)] PW

130. Christo, American, born 1935

Running Fence: Project for Sonoma and Marin Counties, California

Drawing in two parts, 1976
Pencil, charcoal, pastel, engineering data, map, masking tape, wax crayon,
part 1 of 2: 15 x 96 inches, part 2 of 2: 42 x 96 inches
Gift of Thomas G. Newman; D.977.149.1–2
© Christo 1976

There is no road back to Cezanne. — Christo[1]

All of Christo and Jeanne-Claude's large-scale projects have been preceded by a hundred or more preparatory drawings in various formats, some accompanied by a set of framed specifications. They are done by Christo, whose considerable talent was honed at the Sofia Academy, as visionary approximations with the aid of scale models and site photographs. Like an architect making a presentation, he supplies technical data and individual credits as appropriate. Once the project is realized, the artist ceases to produce drawings of that particular project. Drawings are sold to collectors, dealers, and museums as the sole means of financing feasibility and environmental impact studies, the rental of land, fabrication of hardware, purchase of materials, labor, constructions, security, and removal. Christo and Jeanne-Claude have never accepted, in a collaboration that began in 1961, grants or sponsorships.

Their art is neither in the drawings, nor entirely in the finished product, which is temporary in nature. It includes the process—from obtaining permits and lobbying the authorities to novel engineering solutions and material innovations.

The idea for *Running Fence* was born in 1972, when on a drive through Independence Pass—the summer route between Aspen and Denver—the artists observed the snow fence marking the watershed line between the eastern and western slopes. Having just finished *Valley Curtain, Running Fence* became their next undertaking. It took four years of work before the 24.5-mile-long, 18-foot-high white nylon fence was unfurled across 2,050 steel poles. Held up by guy wires, *Running Fence* meandered through ranch and pastureland between Highway 101 and the Pacific Ocean at Bodega Bay in September 1976. Running a food and water relay to keep the workers supplied, I would come across another visitor in a rented Toyota doing the same. Tom Newman had bought

Fig. 1. Christo and Jeanne-Claude, *Running Fence, Sonoma and Marin Counties, California*, 1972–76. © Christo 1976. Photo by Jeanne-Claude.

several of Christo's drawings and was willing to part with a large one of my choosing. JVDM

Expanding the definition of art, Christo and Jeanne-Claude's works project out into life, offering an experience that goes beyond that of a traditional museum exhibition. They include the 2005 construction of 7,503 vinyl gates draped with saffron nylon fabric panels in New York City's Central Park, as well as the 1985 wrapping of Paris' Pont Neuf in fabric and rope. A sprawling ribbon of white nylon, *Running Fence* meandered across the California landscape following forty-two months of planning, which included eighteen public hearings, three days spent at the Superior Courts of California, and a 450-page environmental impact report, not to mention the participation of countless workers. For the fourteen days of its existence, *Running Fence* could be viewed day and night, its twenty-four-and-a-half-mile length traced by forty miles of roads and visible to the ranchers and livestock whose properties it crisscrossed (fig. 1). As agreed, the work was removed and the materials given to the fifty-nine ranchers on whose land the fence was built. Impermanence and mutability are hallmarks of the artists' unique art. AHW

1. Jan van der Marck, "Christo: The Making of an Artist" in *CHRISTO*, La Jolla Museum of Contemporary Art, 1981, p. 48.

131. Alice Aycock, American, born 1946

Solar Wind Project for Roanoke, 1982

Graphite on Mylar, 47⅝ x 54⅛ inches
Gift of Sally and Wynn Kramarsky; D.991.18.1

Born in Harrisburg, Pennsylvania, in 1946, Alice Aycock received her B.A. from Douglass College and her M.F.A. from Hunter College, where she worked with minimalist sculptor Robert Morris. Aycock's early sculptures were site-specific and largely made from wood and stone. As her work moved quickly through the theories of minimalism to those of the prevailing earthwork and built structure movements of the 1970s, many of Aycock's sculptures began to involve viewers who, through their own participation and reactions in wandering through the structures, made the installation complete. Her large semi-architectural projects deal with the interaction of structure, site, and materials, and intend to evoke deliberate psychophysical responses in the viewer—for example, claustrophobia and vertigo.

More than simple sketches for projects, Aycock's drawings are works of art in their own right. These are meticulous plans and elevations that resemble real blueprints, most likely due to the influence of her father, who owned a construction company and studied both architecture and engineering. However, the majority of Aycock's drawings are schemes for the unbuildable, structures that could never stand, and many were never intended to be realized.

Solar Wind Project for Roanoke is a study drawing for *The Solar Wind* (1983), a thirty-one-foot-high static blade sculpture that derives its form from cosmic diagrams of heavenly bodies made by the English Renaissance mystic Robert Fludd. The artist explains: "In designing this piece, I was thinking of all the potential power we have right now, and it dawned on me, what if there was this force that was neither bad nor good, but mindless, a kind of raw source of power, much like the sun, and as it moved it created all sorts of things?"

With one foot anchored in reality and the other in a fantasy world, Aycock explores both existences with precise diagrams and the potential for infinite possibilities. [Poirier 1986: 85 (quotation)]

ESB

132. Rupert Garcia, American, born 1941

Roots (Raices), 1984

Pastel on paper, 30 x 84 inches
Purchased through the Claire and Richard P. Morse 1953 Fund; D.2002.11

A pioneer in the Chicano arts movement, Rupert Garcia has been at the forefront of the practice of politically and socially engaged art for most of the past four decades. Born in French Camp, California, in 1941, Garcia received degrees in painting, print making, and art history from San Francisco State University and the University of California, Berkeley. As an artist, Garcia has been committed to creating artwork not only as a means of achieving aesthetic ends but also as a viable way of addressing social and political concerns.

Works like *Roots (Raices)* mark a transition in Garcia's style from posters and single-figure paintings to a monumental multi-panel format. Often done in vivid pastel, they combine disparate images to challenge the viewer to make new connections between the subjects represented. *Roots (Raices)* juxtaposes a close-up of an Olmec head, an example of monolithic sculpture from one of Mexico's earliest civilizations, with a slightly blurred image of the birthplace of the revolutionary figure Emiliano Zapata. Bridging nearly three millennia of Mexican history, *Roots (Raices)* represents another Orozco-like epic of American civilization, raising issues of permanence versus destruction, icons and their auras, and indigenous versus colonial histories. *Roots (Raices)* also reflects how Garcia, like many Chicano artists, explored his ancestry in pre-Columbian culture in order to cultivate an alternative national identity for Mexican Americans.

Similarly, the image *Orozco* (fig. 1) demonstrates the profound influence of the Mexican muralists on Chicano artists. It reinterprets José Clemente Orozco's *Self-Portrait* in the vibrant graphic style that Garcia developed for posters to promote the various causes of La Raza during the Chicano Civil Rights Movement. In much of Garcia's work, art historical images mingle with images drawn from contemporary culture as well as abstract elements to create compelling pieces that reflect the artist's ongoing engagement with social and aesthetic dilemmas. ESB

Fig. 1. Rupert Garcia, *Orozco,* 1972, re-edition 2002, inkjet print on rag paper, 29½ x 30⅛ inches. Purchased through the Hood Museum of Art Acquisitions Fund; PR.2002.20.

133. Allan McCollum, American, born 1944

Numbers One through Fifteen, from *Collection of Fifteen Drawings,* 1988–90

Graphite on archival board, dimensions variable
Purchased through the Contemporary Art Fund; D.998.45.1–15

The repetitive imagery of Allan McCollum's drawings is central to their meaning. From 1988 to 1990, McCollum executed more than two thousand of these drawings with the help of twenty-five assistants. To make the series he designed two hundred templates, which he combined according to a simple numerical system so that no picture would be identical to another. This process contains enormous potential: it is theoretically possible to create billions of unique drawings in this vein. The stenciled graphite images can be installed on the wall in large numbers or, as in this case, in groups of as few as fifteen.

The dark shapes of McCollum's *Drawings* call to mind a Rorschach inkblot test—a psychological test of personality in which the subjects' interpretations of ten standard abstract designs are analyzed to reveal their emotional and intellectual level of function. Yet when conventionally mounted in glass and frame and carefully arranged on a gallery wall, rather than a projective blank slate for the viewer, the *Drawings* become a revealing documentation of the artist's own process.

The framed, silhouette-like drawings covering the walls and ceilings call to mind some super-warehouse and the unsettling homogeneity of objects created for mass consumption. However, each of McCollum's drawings is a singularly unique object, and as viewers we are led to recognize the wonderful individuality that occurs within multiplicity. Making these black shapes interchangeable, so that they can be displayed in a variety of arrangements, the artist calls attention both to their similarities and the differences between them. This contradiction between difference and repetition is essential to the serial mode of production itself—a mode that proceeds from the mass production of commodities. As Mc-Collum has explained, "Modern industrial production has always been more than just a making of things; it has always also been a highly orchestrated expression, a sort of epic dramatization of a wish, a wish we all share, a wish that we might be able to be as productive as nature." [Shottenkirk 1990: 165 (quotation)] ESB

134. Ouattara Watts, Côte d'Ivoirian, born 1957

The Ten Initials No. 1, 1992

Pastel and collage with mirror on paper, 90½ x 44½ inches
Gift of Larry Sanitsky; 2007.87

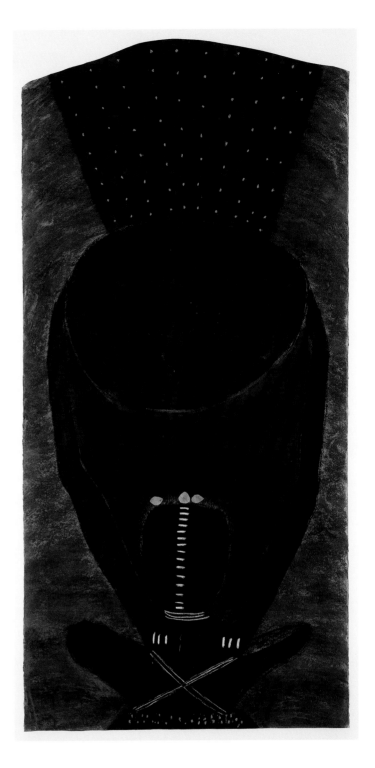

Ouattara Watts divides his time between the urban environment of Abidjan, Côte d'Ivoire, the traditional setting of his hometown Korhogo in northern Côte d'Ivoire, and the international art worlds of Paris and New York. Quietly reflecting upon his African upbringing, spiritual sensibilities, and cultural heritage, Watts's work reveals his personal response to the transnational experience.

In 1977, Watts left Côte d'Ivoire to study art at L'Ecole des Beaux Artes in Paris, where in 1988 he met the internationally acclaimed African American artist Jean-Michel Basquiat, who was immediately captivated by the spirituality and energy of Watts's paintings. Basquiat convinced Watts to move to New York, where they could pursue their shared goals of creating a visual language that blurred the boundaries between their diverse but interrelated art worlds. Under Basquiat's aegis and the legacy of their brief but intense friendship, Watts came of age in New York City as the first African artist to enter the elite ranks of the contemporary art world.

Watts's color sensibilities, use of found objects, and close relationship with the materiality of his art are closely aligned to abstract expressionism and the pivotal influences of Jackson Pollock, Cy Twombly, and Joseph Beuys during his formal training. However, Watt's use of recycled objects and natural pigments mixed with organic materials also connected his art to his Côte d'Ivoirian predecessors, who developed the Vohou-Vohou movement at L'Ecole des Beaux Arts d'Abidjan in Côte d'Ivoire between 1968 and the 1980s. The imagery in this and other examples of his earlier work allude directly to the esoteric knowledge of West African cosmologies, especially of his own Senufo culture and the Dogon peoples of Mali. Both the symbolism and rich earth tones point to Watt's own firsthand knowledge of African rituals of divination, healing, and initiation rites, which have had a lasting impact on his philosophical outlook in life. BT

165

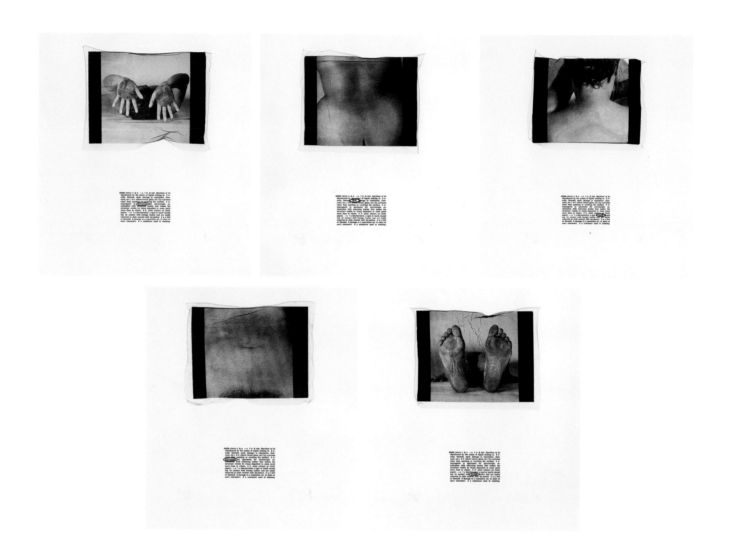

135. Berni Searle, South African, born 1964

Stain, from the *Discolored* series, five prints, 2000

Digital print with text, five sheets, each sheet: 19⅔ x 17⅔ inches
Purchased through the William B. Jaffe and Evelyn F. Jaffe (58, 60, & 63) Fund;
PR.2002.67.1–5

One of South Africa's leading contemporary artists, Berni Searle studied at the Michaelis School of Fine Art at the University of Cape Town, where she completed her undergraduate degree in 1987 and an M.F.A in 1995. Searle uses photo-based media, installation, and video to encourage viewers to think about the politics of race and gender, bringing into question the arbitrary measurement and taxonomies of ethnicity, race, and nationalism used in African and Western politics. Searle's *Discolored* series provides the artist's personal journey into issues of race in South Africa.

In *Stain,* a portfolio of five prints, Searle couples fragmented images of her own nude body with strategically circled definitions of the word "stain." Searle's combination of text and image evokes the ideological and physical violence against black South African

women during the brutally oppressive apartheid regime. Caught up in the midst of the political conflict, women in war zones paid for the actions of their absent husbands, brothers, and fathers through rape and sexual torture.

Searle recalls this tragic history by magnifying those hidden parts of the body most commonly associated with tenderness and intimacy: the palms of the hands, the small of the back, the nape of the neck, the soles of the feet, and the belly. However, she breaks the promise of seduction or tenderness through the disturbing presence of purplish stains—smears of Egyptian henna on Searle's body, which she presses up against a glass pane. The appearance of swelling, distortion, and discoloration heightens the sense of violence to the black female body. Yet, Searle also pays tribute here to black South African women who, like women elsewhere in the world, have used their bodies to protest aggression, violence, and oppression, as in 1990, when a group of women stopped the destruction of their homes in Soweto by publicly stripping and parading themselves naked in the streets in front of an army of policemen and bulldozers. BT

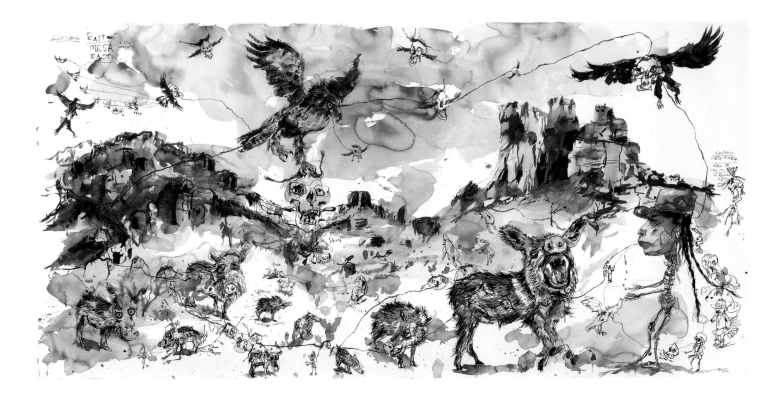

136. Brad Kahlhamer, American, born 1956

East of Mesa East, A 55 Plus Community, 2002

Ink and watercolor on paper, 44½ x 91¾ inches
Purchased through the Stephen and Constance Spahn '63 Acquisition Fund;
W.2003.40

Born of Native descent in Tucson, Arizona, Brad Kahlhamer was adopted as an infant into a German American family who moved to the Midwest, where he grew up without knowledge of his tribal affiliation. Kahlhamer earned a B.A. from the University of Wisconsin-Oshkosh, worked as a road musician, and then as a graphic artist for Tops Chewing gum. While his Native American identity undoubtedly motivates his work, his stylistic influences are often traced to the German Expressionist artist Emile Nolde, 1940s American cartoons, and the African American artist Jean-Michel Basquiat.

Kahlhamer's work focuses on feelings of displacement, a search for belonging, and the renegotiation of hybrid identities. Filtered through the lenses of his Christian upbringing, American popular music and culture, and an imagined Native American past, Kahlhamer's paintings present a recurring cast of characters—the prairie dog, the eagle, the prickly, pig-snouted Javelina, the artist's self-caricature, malleable yellow smiley faces, upside-down American flags (the symbol of the American Indian Movement), and skulls—as symbols of himself, people from his inner circle, and his real and imagined life.

Kahlhamer's characters populate an intercultural narrative like Kahlhamer's own life using Plains conventions akin to ledger art and its precursors—including pictographic name glyphs—that

blend subjective experiences with broader Native American history. As in early Plains ledger art (fig. 1), Kahlhamer pays little regard to scale, perspective, or spatial realism. Like the Plains warrior-artist of the nineteenth century, Kahlhamer floats his figures within an expansive, expressionistic, and almost mystical southwestern landscape that serves as a platform from which he can fuse the imagined world of his unknown ancestors with his lived urban American experience. BT

Fig. 1. Chief Killer, Cheyenne, 1849–1922, *Untitled (Arapahos after a Ute village)*, about 1875–77, drawing media on ledger paper, 8 x 11 inches. Partial gift of Mark Lansburgh, Class of 1949; and partial purchase through the Mrs. Harvey P. Hood W'18 Fund, and the Offices of the President and Provost of Dartmouth College; 2007.65.21.

137. Linda Haukaas, American, born 1957

Return from War Dance, 2003

Colored pencil, graphite, ink on ledger book paper, 17⅝ x 22¹³⁄₁₆ inches
Purchased through the Alvin and Mary Bert Gutman 1940 Acquisition Fund
and the Hood Museum of Art Acquisitions Fund; D.2004.23

Linda Haukaas recreates historical Plains ledger art within a modernized context, often addressing nontraditional themes such as the life and perspectives of Native women. Haukaas breaks new ground as a female ledger artist who defies tradition in this male-dominated genre. Using the same drawing media as her ancestors, which she executes on historical ledger paper collected from antique stores and flea markets, she creates depictions of the ceremonial lives of women and children while interjecting humorous, political, or ironic twists that critique social issues pertaining to Native American populations in the past and present.

In *Return from War Dance,* Haukaas depicts five Native American women posed with their backs to the viewer. As in Black Hawk's rendition of a similar scene from the "Dream Visions" ledger (fig. 1), the figures wear ceremonial dress and carry staffs specific to their personal, societal, and tribal identities. The clothing is highly decorative, with traditional motifs offset by ornamentation that alludes not just to the history of ledger art but also to Native/non-Native relations. Nationalistic symbols, flags, and visual vignettes recall critical moments of conflict and reconciliation. As Haukaas

explains, "*Return from War Dance* is the dance where women dress in men's clothing and war accoutrements to honor the returning warriors. It is a moving piece . . . this honorific dance should never be forgotten. It is particularly important given the incredible numbers of Natives who are presently in the military, and the death of Lori Piestewa (Hopi) in Iraq." [Personal communication with Barbara Thompson, 2004] BT

Fig. 1. Black Hawk, Sans Arc Lakota, about 1832–1890, *Untitled (plate #4)*, "Dream Visions" ledger, about 1880–81, ink and colored pencil on paper. Thaw Collection, Fenimore Art Museum, Cooperstown, New York. Gift of Eugene V. and Clare E. Thaw.

DRAWINGS

The Hood Museum of Art's modern and contemporary drawings collection has been substantially enhanced in the last ten years by a series of gifts of minimalist and post-minimalist works by Sally and Wynn Kramarsky and a recent gift of fifty works by Dorothy and Herbert Vogel through a program instituted by the National Gallery of Art, titled *The Dorothy and Herbert Vogel Collection: Fifty Works for Fifty States.* The Kramarskys, who are parents of a Dartmouth alumna (Wynn Kramarsky also served on the museum's Board of Overseers in the late 1980s and early 1990s), were equally dedicated collectors and supporters of contemporary artists. They have given over one hundred works to the Hood Museum of Art, of which almost seventy are drawings, such as sculptor Jene Highstein's monumental work *Barge,* 1993 (cat. 156), which contains a large black dense totemic form on an expanse of white paper. The Vogel gift (which was made possible by grants from the National Endowment for the Arts and the Institute for Library and Museum Services) was part of a larger program in which one institution in each state was selected to receive fifty works collected by this remarkable New York City couple. The Vogels acquired primarily avant-garde minimalist and conceptual work from the 1960s until the middle of this decade with funds provided through her work as a librarian and his as a postal worker. Their remarkable story is an inspiration to those who believe that only the rich have access to collecting art. The gift to the Hood is primarily drawings by such artists as Richard Tuttle, Edda Renouf, and Michelle Stuart (cat. 149).

An energetic drawing by sculptor David Smith from 1952 (cat. 138) is a highlight of the museum's holdings and reveals his use of the graphic medium to explore potential forms for his bronze sculptures. Its three tiers of dynamic jagged silhouetted black forms that emerge in a linear flow across the white brushed paper are almost pictographic in their shapes. Drawings by sculptors Pietro Consagra (cat. 139), Dimitri Hadzi (cat. 73, fig. 1), James Rosati (cat. 143), and Lee Bontecou (cat. 147) are all strong examples of their respective work. The two drawings by Bontecou from 1964 are vivid demonstrations of her working process, showing her morphing forms from nature, such as a lobster claw or a fish form, alongside the organic abstractions that relate to her wall sculpture. Pop artist Larry Rivers's *Double Money Drawing* (cat. 145) is a change of pace, with its appropriation of French paper currency with the imprimatur of Napoleon's portrait.

Other notable drawings in the collection stemmed from purchases made in preparation for an exhibition of the museum's American drawings, *Marks of Distinction: Two Hundred Years of American Drawings and Watercolors from the Hood Museum of Art* (2004–05), which was funded in part by the Henry Luce Foundation. One of these works, an important untitled drawing by Eva Hesse from 1964 (cat. 146), was bought by former director Derrick Cartwright in 2004 with funds provided through the museum's Lathrop Fellows. This work, made with a variety of media including felt-tip markers, was created during 1964 and 1965, while Hesse was in Germany with her husband, Tom Doyle. The off-kilter stacked colored squares and rectangles lend the work a jittery energy, partnering the idea of stable building blocks with irregular forms that teeter on top of one another. In the upper right, empty square forms outlined in black and brown placed on top of one another presage the sculptural work that emerged during the latter part of her stay in Europe. Echoing the serial numbers tattooed on the arms of concentration camp inmates, the numbers that occupy a horizontal series of boxes may refer to her own early childhood as a refugee from Nazi Germany, where her family's relatives perished in the Holocaust. Two other works that were purchased for the *Marks of Distinction* exhibition were drawings by Joan Mitchell (cat. 140) and Agnes Martin (cat. 148).

The museum's modern and contemporary drawings collection will undoubtedly continue to grow as the Hood Museum of Art moves forward past its first quarter century. Drawing has always been a key medium for understanding the creative process of artists and will never cease to be an integral part of our work within the curriculum.

KWH

138

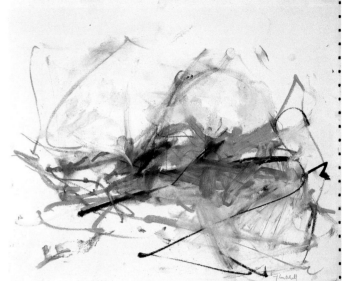

140

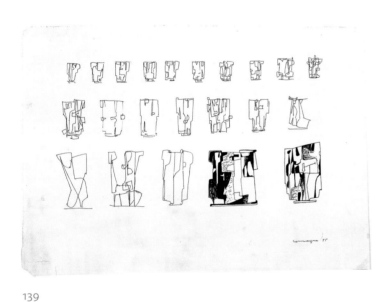

139

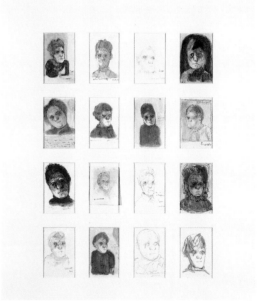

141

138. David Smith, American, 1906–1965

3/20/52, 1952

Brush and egg ink and opaque watercolor on wove paper, 18⅜ x 23⅝ inches
Purchased through the Miriam and Sidney Stoneman Acquisition Fund;
P.997.42
Art © Estate of David Smith/Licensed by VAGA, New York, NY

139. Pietro Consagra, Italian, 1920–2005

Studies for Sculpture, 1955

Pen, black ink, 13¾ x 19⅞ inches
Purchased through the Phyllis and Bertram Geller 1937 Memorial Fund;
D.963.47

140. Joan Mitchell, American, 1925–1992

Untitled, about 1959

Oil pastel and oil paint on wove paper, 13¾ x 16¾ inches
Purchased through the Julia L. Whittier Fund; D.2002.28
© The Estate of Joan Mitchell

141. José Luis Cuevas, Mexican, born 1934

Self-Portraits, 1960–61

Pen and ink, graphite, and watercolor, 5½ x 3¾ inches
Bequest of Jay R. Wolf, Class of 1951; W.976.169
© 2009 Artists Rights Society (ARS), New York/SOMAAP, Mexico City

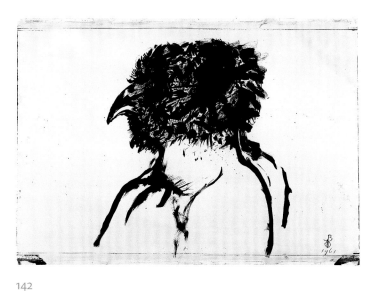

142

144

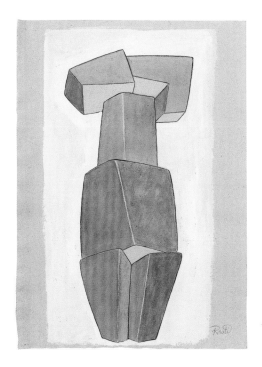

143

145

142. Leonard Baskin, American, 1922–2000

Untitled (possibly study for The Iliad), 1961

Ink and crayon on paper, 25½ x 36⅛ inches
Gift of Virginia Kelsey, Class of 1958W; 2006.9.5
© Estate of Leonard Baskin, courtesy Galerie St. Etienne, New York

143. James Rosati, American, 1911–1988

Untitled, April 1962

Transparent and opaque watercolor and pen and ink over graphite on
wove paper, 15½ x 11¼ inches
Museum purchase; D.963.99.1

144. Walter Tandy Murch, American, 1907–1967

Study #18, 1962

Transparent and opaque watercolor and charcoal on very thick wove paper,
23 x 17½ inches
Gift of Mr. and Mrs. Thomas R. George, Class of 1940; D.995.61

145. Larry Rivers, American, 1923–2002

Double Money Drawing, 1962

Crayon and graphite on wove paper, 12 x 12⅜ inches
Bequest of Jay R. Wolf, Class of 1951; D.976.194
Art © Estate of Larry Rivers/Licensed by VAGA, New York, NY

146

148

147

149

146. Eva Hesse, American, 1936–1970

Untitled, 1964

Opaque and transparent watercolor, pen and black ink, felt-tip marker, and crayon on wove paper, 22⅜ x 28½ inches
Purchased through gifts from the Lathrop Fellows; W.2004.1

147. Lee Bontecou, American, born 1931

Untitled, 1964

Graphite on wove graph paper, 16½ x 21⅝ inches
Bequest of Jay R. Wolf, Class of 1951; D.976.217.2

148. Agnes Martin, American, 1912–2004

Untitled, 1967

Pen and red and gray ink and gray wash on wove paper, 11⅞ x 11⅔ inches
Purchased through the William S. Rubin Fund and the Contemporary Art Fund; D.2003.51
© 2009 Agnes Martin/Artists Rights Society (ARS), New York

149. Michelle Stuart, American, born 1938

July, New Hampshire, 1974

Microfine graphite (rubbed), silver paint, with indentations (pounded with rock) on heavyweight canvas paper, 9¹³⁄₁₆ x 6½ inches
Gift of the Dorothy and Herbert Vogel Collection: Fifty Works for Fifty States, a joint initiative of the Trustees of the Dorothy and Herbert Vogel Collection and the National Gallery of Art, with generous support from the National Endowment for the Arts and the Institute for Museum and Library Services; 2008.83.1

150

152

151

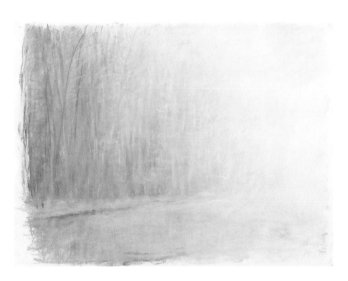

153

150. Edda Renouf, American, born 1943

Mitila, 1975

Chalk on paper with incised marks, 13⅝ x 13½ inches
Gift of Hugh J. Freund, Class of 1967; D.2001.50

151. Thomas George, American, born 1918

Crawford Notch, from *The White Mountain Suite,* 1979

Ink on paper, 20 x 26⅛ inches
Gift of Mr. and Mrs. Thomas R. George, Class of 1940; D.998.24.10

152. Matt Mullican, American, born 1951

Untitled (Hell), 1982

Lead paint on wove paper, 22⅛ x 30⅛ inches
Gift of Hugh J. Freund, Class of 1967; P.996.49.9

153. Wolf Kahn, American, born 1927

Untitled (Landscape), 1984

Pastel, 20 x 30 inches
Gift of Varujan Boghosian; D.985.19.2

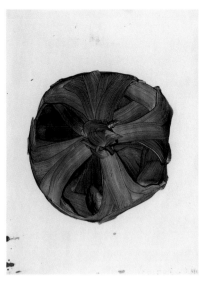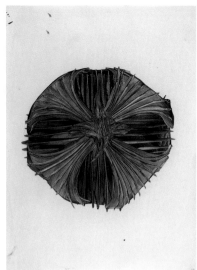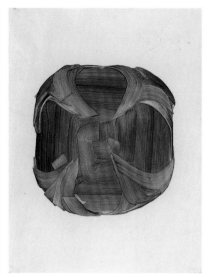

154

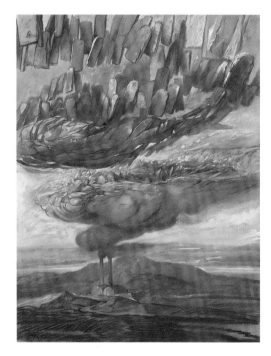

155

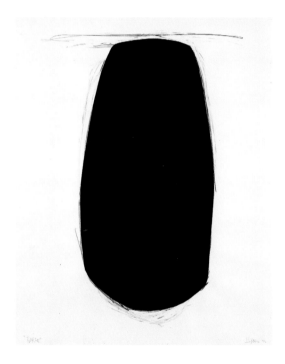

156

154. James Nares, American, born 1953

To Release Four Hands, 1986

Oil on paper, three of each: 16 x 12 inches
Gift of Sally and Wynn Kramarsky; P.2004.15.7.1–3

155. Samuel Bak, American, born 1933

Study for Smoke I, 1992

Mixed media on paper, 25⅝ x 19⅝ inches
Gift of Bernard H. and Suzanne Pucker in honor of Judy and Charles Hood
with feelings of great friendship; D.996.46

156. Jene Highstein, American, born 1942

Barge, 1993

Bone black pigment and graphite on paper, 72⅛ x 60³⁄₁₆ inches
Purchased through gifts from Wynn Kramarsky and McKinsey and
Company; D.997.23

157

159

158

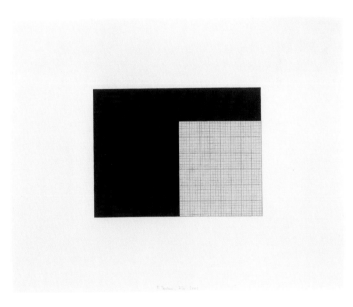

160

157. Luca Buvoli, Italian, born 1963

Page 7 from "Not-a-Superhero" #8: Transformed!,
1995

Mixed media on wove paper, 10⅛ x 7 inches
Museum purchase; MIS.996.15

158. Morgan O'Hara, American, born 1941

*Form and Content: The Shape of Discourse #11
Corrado Costa, Artist, lawyer, poet, Milano, Italia /
October 1990,* 1995

Sumi ink on paper, 19 x 26 inches
Gift of Sally and Wynn Kramarsky; D.2003.42.1

159. Liza Phillips, American

Overton, 1999

Acrylic on paper, 12⅝ x 23¾ inches
Gift of Sally and Wynn Kramarsky; 2005.67.42

160. Frank Badur, German, born 1944

Fin, 2001

Graphite and gouache on paper, 10¹⁄₁₆ x 12⁹⁄₁₆ inches
Gift of Sally and Wynn Kramarsky; 2005.67.8

PRINTS

Prints make up one of the largest collections in the museum's modern and contemporary holdings, with a wide-ranging selection of lithographs, silkscreens, etchings, aquatints, and mixed media. From the 1960s to the present, curators and directors of the Hood, as well as generous donors, have acquired and given prints, from those inspired by an abstract expressionist ethos, such as Dorothy Dehner's etching *Ancestors,* 1954 (cat. 161) and Lee Krasner's lithograph *Pink Stone,* 1969 (cat. 166) to the post-modernist comic book fragments assembled in the color aquatint *Luna,* 2005 by Aaron Noble (cat. 205). The 1960s and 1970s are well represented by a number of works by Robert Rauschenberg, such as *Core,* 1965 (cat. 163) with its images of Kennedy, freeways, and a space capsule, as well as other quintessential Pop Art prints such as Roy Lichtenstein's iconic *Crying Girl,* 1963 (cat. 162) and a set of ten silkscreens of Warhol's *Mao,* 1972 (cat. 169) in various color iterations. Other practitioners from these exuberant and vibrantly experimental decades represented here include Richard Lindner, Lester Johnson, William Wiley, and Malcolm Morley. Ronald B. Kitaj, who was an artist-in-residence at Dartmouth in 1978, is well represented by a witty modernist appropriation print *Matisse with a Tattoo,* 1978 (cat. 175) and a conceptual series of screenprint reproductions of book covers that drew directly on tomes from his personal library. Other 1970s works include the large color lithograph *Inez,* 1979 (cat. 176) by Robert Kushner, which was inspired by decorative pattern painting, and a cast paper relief by Louise Nevelson (cat. 174), which emulates the white-and-black assembled constructions of her sculptures.

The museum is particularly rich in works of master printmaker, painter, and assemblage artist Jim Dine. Dine, who was an artist-in-residence at Dartmouth in the fall of 1974 and lived for many years in Putney, Vermont, was aided while he was here by Dartmouth student and artist Mitchell Friedman.

Highlights from the 1980s include prints by Ellsworth Kelly and Frank Stella, such as the latter's *Swan Engraving* (cat. 180); both men had print retrospectives at the museum in 1990 and 1991, respectively. The museum also owns Dorothea Rockburne's cool minimalist folded-multiple *Melancholia* (cat. 177) and a monumental aquatint by Donald Sultan depicting his trademark black lemons (cat. 178). Sally and Wynn Kramarsky donated not only drawings but also prints by such figures as Richard Serra, Agnes Denes, Jasper Johns, and Carole Seborovski, such as her *Three Black Bars,* 1986 (cat. 182).

The 1980s and 1990s collection benefited from former director Timothy Rub's serious interest in the print medium. He was responsible for acquisitions of master prints by Joe Andoe, Lucien Freud, Chuck Close, Brice Marden, Tony Cragg, Glenn Ligon, Terry Winters, Christopher Brown, Robert Therrien, Lesley Dill, and Terry Allen. These works are not only superb examples of their respective techniques but also excellent representatives of each artist's practice. Brice Marden's *After Botticelli I,* 1993 (cat. 191) series is an assured and fluid demonstration of the artist's mastery of line, even within the confines of the demanding process-oriented media of etching and aquatint. Chuck Close's self-portrait is constructed of gridded splotches of spit-bite aquatint whose intensely controlled placement belies the disheveled image of its creator. In Lesley Dill's use of word and image in *Front (The Soul Has Bandaged Moments),* 1994 (cat. 194), she inscribes the words of a poem by Emily Dickinson on the body of a woman, which is also marked by voids at the head, breasts, and loins that merge with the dark background surrounding her. Stitching along the upper edge emphasizes a traditional craft that is usually the province of women and echoes Dill's other work of this period.

In recent years, curators and directors have often acquired prints with social/political content to help round out the collection's conceptual and abstract offerings. Enrique Chagoya's accordion print *Utopian Cannibal.Org,* 2000 (cat. 199) appropriates and skews images of Mexican and American cartoon characters and cultural icons such as James Dean and Barbie in a whimsical and ironic post-colonial amalgam. John Wilson's powerful etching and aquatint *Martin Luther King* (cat. 201) is an elegiac and majestic image of the Civil Rights leader, created when the artist was in his eightieth year. A series of drypoint portraits depicting former prisoners of Abu Ghraib prison by Dartmouth graduate Daniel Heyman includes transcriptions of their respective depositions for United States lawyers who had traveled to Amman, Jordan, in an effort to record their voices for potential legal action (cat. 206). Heyman, who also witnessed their testimony, transcribed their words and their portraits in real time, lending the images an intense immediacy. Another print by Inka Essenhigh titled *War* (cat. 204) mixes a surrealist malleability of image making with a landscape that brilliantly maps a morphed space as it rapidly recedes into the background. The mix of the illustrative, such as the fallen solider in the foreground, with the cartoonish, computer game–like vista makes this a work of art that draws on imagery that is particular to this decade.

Students taking printmaking courses at Dartmouth are among the most assiduous users of the collection, often visiting the Bernstein Study-Storage Center classroom five or six times during a single term. This is in part due to the wealth of this collection, which continues to fascinate those who spend time looking closely at the intricate methods used by many of these artists. Also, with works representing a diverse array of publishers and print studios, such as U.L.A.E, Gemini, Tamarind, Crown Point, Center Street Studio, and Wingate Studio, as well as prints made by individual artists, students have ample material with which to study the methodologies, predilections, and patronage of one of the most democratic modes of art making of past or present. KWH

161

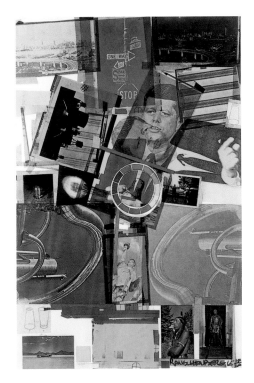

163

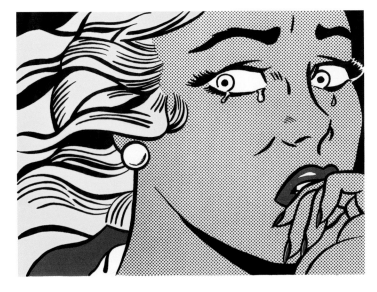

162

164

161. Dorothy Dehner, American, 1901–1994

Ancestors, 1954

Color etching on laid paper, 4⅜ x 10 inches
Purchased through the Claire and Richard Morse 1953 Fund and the
Phyllis and Bertram Geller 1937 Memorial Fund; PR.993.21.2

162. Roy Lichtenstein, American, 1923–1997

Crying Girl, 1963

Offset lithograph on wove paper, 18 x 24 inches
Gift of Professor John Wilmerding; PR.967.3
© Estate of Roy Lichtenstein

163. Robert Rauschenberg, American, 1925–2008

Core, 1965

Color screenprint, 36⅛ x 24½ inches
Bequest of Lawrence Richmond, Class of 1930; PR.978.170
Art © Estate of Robert Rauschenberg/Licensed by VAGA, New York, NY

164. Ben Shahn, American, 1898–1969

Farewell to New York—All That is Beautiful, 1965

Serigraph in colors with hand-coloring on wove [Rives BFK] paper,
26 x 38¾ inches
Gift of Margaret F. Edwards, in memory of her father, Atlanta architect
H. Griffith Edwards, F.A.I.A. F.C.S.I. (1907–1972); 2007.77
Art © Estate of Ben Shahn/Licensed by VAGA, New York, NY

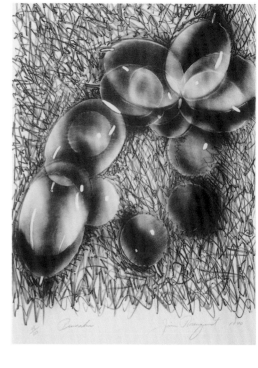

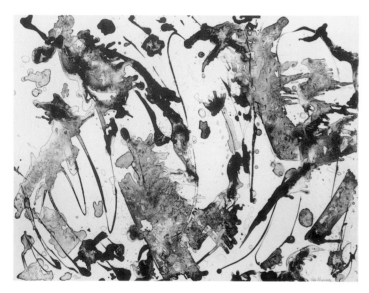

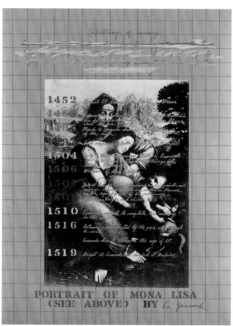

165. Richard Lindner, American, 1901–1978

Untitled (Two Figures), 1967

Lithograph, 30 x 24 inches
Gift of Joan S. Sonnabend; PR.977.194

166. Lee Krasner, American, 1908–1984

Pink Stone, 1969

Lithograph, 23¼ x 29¹⁵⁄₁₆ inches
Gift of John H. Plunkett, Class of 1957; PR.979.154.3
© 2009 The Pollock-Krasner Foundation/Artists Rights Society (ARS),
New York

167. James Albert Rosenquist, American,
born 1933

Bunraku, 1970

Lithograph on wove paper, 32 x 23¼ inches
Purchased through the Julia L. Whittier Fund; PR.973.381
Art © Estate of James Rosenquist/Licensed by VAGA, New York, NY

168. Shusaku Arakawa, Japanese, born 1936

Splitting of Meaning, 1970–71

Screenprint, 44 x 34 inches
Purchased through the Adelbert Ames Jr. 1919 Fund; PR.977.7

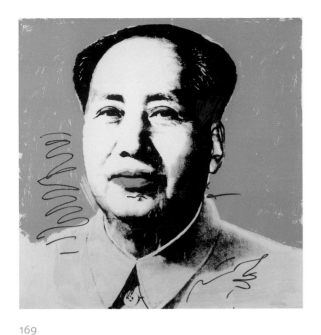

169

171

170

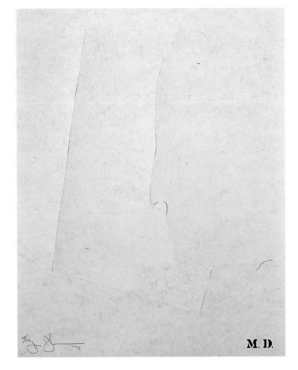

M. D.

172

169. Andy Warhol, American, 1928–1987

Mao, 1972

Screenprint on Lenox Museum Board, 36 x 36 inches
Purchased through the Hood Museum of Art Acquisitions Fund; PR.977.10
© 2009 The Andy Warhol Foundation for the Visual Arts/(ARS), New York

170. Lester F. Johnson, American, born 1919

Midtown I, 1973

Lithograph, 25¼ x 35 inches
Museum purchase; PR.974.167

171. William T. Wiley, American, born 1937

Little Hide, 1973

Lithograph on chamois hide, 21½ x 29 inches
Museum purchase; PR.975.9

172. Jasper Johns, American, born 1930

M.D., 1974

Die-cut stencil board, 22⅛ x 18 inches
Gift of Sally and Wynn Kramarsky; MIS.2000.30
Art © Estate of Jasper Johns/Licensed by VAGA, New York, NY

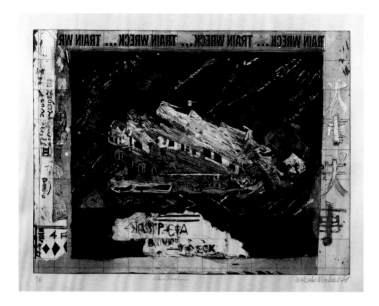

173

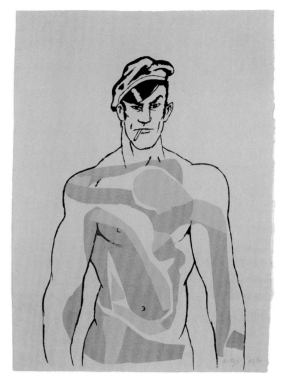

175

174

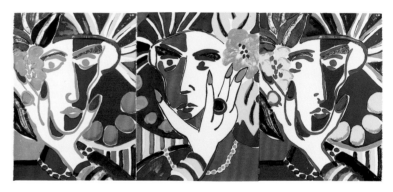

176

173. Malcolm Morley, British, born 1931

Train Wreck, 1975

Etching, 38¼ x 49⅛ inches
Purchased through the Guernsey Center Moore 1904 Memorial Fund;
PR.976.67

174. Louise Nevelson, American, 1899–1988

Dawn's Presence, 1976

Cast paper relief, 32¼ x 21½ inches
Gift of Sally and Wynn Kramarsky; PR.996.34.4
© 2009 Estate of Louise Nevelson/Artists Rights Society (ARS), New York

175. Ronald B. Kitaj, American, 1932–2007

Man with Matisse Tattoo, 1978

Four-color screenprint on buff mould made paper, 30¾ x 22¾ inches
Purchased through the Hood Museum of Art Acquisitions Fund; PR.978.176

176. Robert Kushner, American, born 1949

Inez, 1979

Three-part color lithograph, 30 x 22½ inches
Purchased through the William S. Rubin Fund; PR.979.127

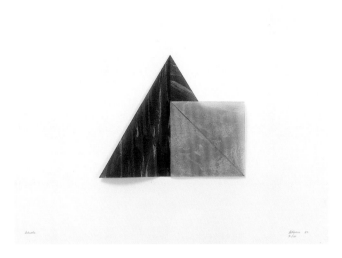

177

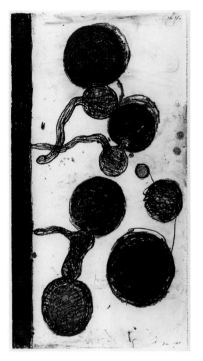

179

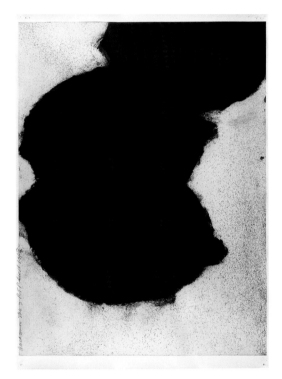

178

180

177. Dorothea Rockburne, Canadian, born 1934

Melencolia, 1982

Six-color lithograph on Transpagra, printed on both sides, 31¾ x 39 inches
Purchased through the Miriam and Sidney Stoneman Acquisition Fund;
PR.987.10
© 2009 Dorothea Rockburne/Artists Rights Society (ARS), New York

178. Donald Sultan, American, born 1951

Black Lemon, Dec. 14, 1984, 1984

Aquatint on wove paper, 65½ x 48¼ inches
Gift of Hugh J. Freund, Class of 1967; PR.996.49.12

179. Terry Winters, American, born 1949

Double Standard, 1984

Lithograph printed in twenty-two colors on Arches paper, 78 x 45½ inches
Gift of George T. M. Shackelford, Class of 1977, in honor of Sue and Duke
Shackelford; 2005.11

180. Frank Stella, American, born 1936

Swan Engraving V, 1982–85

Etching on handmade paper, 59⁹⁄₁₆ x 49¹³⁄₁₆ inches
Purchased through the William S. Rubin Fund; PR.985.25.1
© 2009 Frank Stella/Artists Rights Society (ARS), New York

183

182

184

181. David Salle, American, born 1952

Grandiose Synonym for Church, 1985

Aquatint, 60½ x 48¼ inches
Gift of Hugh J. Freund, Class of 1967; PR.996.49.7
Art © David Salle/Licensed by VAGA, New York, NY

182. Carole Seborovski, American, born 1960

Three Black Bars, number 5 from a suite of five prints, 1986

Aquatint-gravure etching, 16 x 32¼ inches
Gift of Sally and Wynn Kramarsky; PR.2001.23.3

183. Judy Pfaff, American, born 1946

Melone, 1987

Woodcut and silkscreen collage, 60⅜ x 68⅜ inches
Gift of Susan R. Malloy in memory of her husband, Edwin A. Malloy;
PR.2001.12.1
Art © Judy Pfaff/Licensed by VAGA, New York, NY

184. Sandy Walker, American, born 1942

Tree Ghost, 1987

Woodblock print on Suzuki, 53 x 27 inches
Gift of Robert Dance, Class of 1977; 2005.8.1

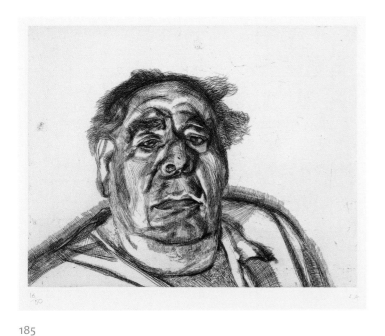

185

187

186

188

185. Lucian Freud, British, born 1922

Lord Goodman in His Yellow Pajamas, 1987

Etching and watercolor on wove paper, 19⅛ x 22 inches
Gift of Hugh J. Freund, Class of 1967; PR.996.49.8

186. Tony Cragg, British, born 1949

Six Bottles, Large, State 1, 1988

Aquatint on wove paper, 30½ x 38⅞ inches
Purchased through the Claire and Richard P. Morse 1953 Fund; PR.993.28.1

187. Robert Longo, American, born 1953

Men in the Cities IV, 1990

Lithograph, 40 x 25¹⁵⁄₁₆ inches
Purchased through the Claire and Richard P. Morse 1953 Fund; 2006.48.1

188. Richard Ryan, American, born 1950

House of Mysteries, 1990

Etching, electric engraver, 22⅓ x 29¾ inches
Purchased through the Claire and Richard P. Morse 1953 Fund; PR.990.28.3

189

191

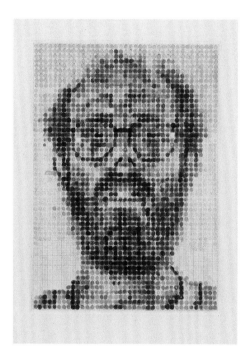

190

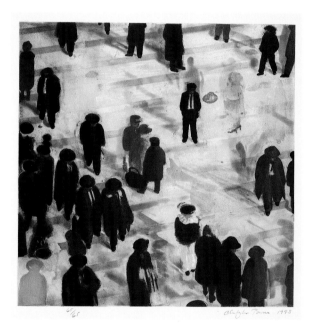

192

189. Joe Andoe, American, born 1955

Untitled (Flying Swan), September 27, 1991

Aquatint on wove paper, 17½ x 17½ inches
Purchased through the William S. Rubin Fund; PR.993.27.1

190. Chuck Close, American, born 1940

Self-Portrait, 1992

Spitbite aquatint and soft-ground etching, 19⅝ x 15⅝ inches
Purchased through the Phyllis and Bertram Geller 1937 Memorial Fund
and the Anonymous Fund #144; PR.993.27.2

191. Brice Marden, American, born 1938

After Botticelli 1, from a series of 5, 1993

Etching and aquatint on heavy wove paper, 27¹⁄₁₆ x 21¹³⁄₁₆ inches
Purchased through the William S. Rubin Fund; PR.994.25.1
© 2009 Brice Marden/Artists Rights Society (ARS), New York

192. Christopher Brown, American, born 1951

Station, 1993

Aquatint on wove paper, 30⅝ x 30 inches
Purchased through a gift from Elinor Bunin Munroe, Class of 1943W;
PR.993.28.2

193

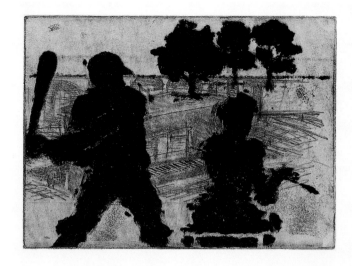

195

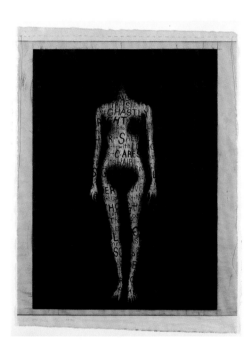

194

196

193. Robert Therrien, American, born 1947

Untitled, 1993

Aquatint on wove paper, 26½ x 20 inches
Purchased through a gift from Elinor Bunin Munroe, Class of 1943W, and
through the Phyllis and Bertram Geller 1937 Memorial Fund; PR.993.29.3
© 2009 Robert Therrien/Artists Rights Society (ARS), New York

194. Lesley Dill, American, born 1950

Front (The Soul Has Bandaged Moments);
from the suite *A Word Made Flesh*, 1994

Photolithograph, etching, and aquatint on Mulberry paper, hand sewn onto
Arches buff paper, 28¼ x 21⅜ inches
Purchased through the Hood Museum of Art Acquisitions Fund; PR.995.7.3

195. Terry Allen, American, born 1943

Hitter, 1994–95, published 1996

Soft-ground and sugarlift aquatint etching, 17¹/₁₆ x 11⅞ inches
Purchased through the Miriam and Sidney Stoneman Acquisition Fund;
PR.997.25.3

196. Glenn Ligon, American, born 1960

White #1, 1995

Etching and aquatint on wove paper, 19⅝ x 14½ inches
Purchased through the Phyllis and Bertram Geller 1937 Memorial Fund;
PR.996.6

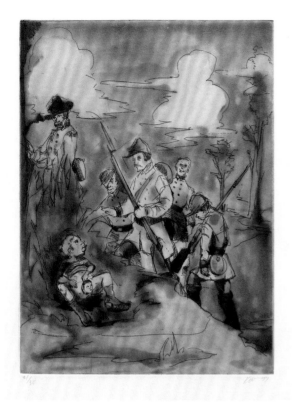

197

199

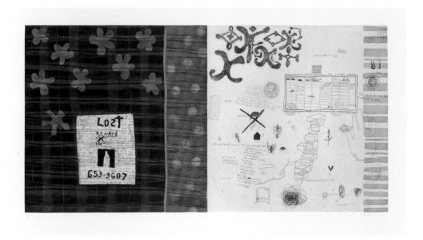

198

197. Kara Elizabeth Walker, American, born 1969

Li'l Patch of Woods, 1997

Etching and aquatint on chine colle on medium-weight white wove paper,
18 x 15 inches
Purchased through a gift from Melville Straus, Class of 1960; PR.2003.37

198. Squeak Carnwath, American, born 1947

Every Creature Found, 1999

Color sugarlift and soap-ground aquatint, hard-ground and soft-ground
etching on Rives BFK paper, 34½ x 61⅜ inches
Purchased through gifts from David B. Payne, Class of 1958, Elisabeth Bowan
and Joseph Kagle, Class of 1955; PR.2002.16

199. Enrique Chagoya, Mexican, born 1953

Utopian Cannibal.Org, 2000

Thirteen-color lithograph and woodcut with chine colle and collage,
7⅝ x 11⅝ x ³⁄₁₆ inches
Purchased through a gift from Jan Seidler Ramirez, Class of 1973; PR.2002.2

200

202

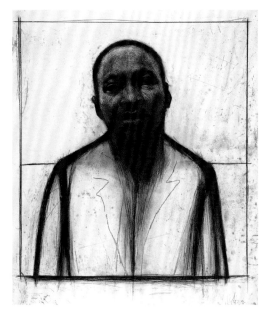

201

203

200. John Walker, British, born 1939

Passing Bells V, 2000

Color etching and aquatint, 31⁷⁄₁₆ x 36¾ inches
Purchased through the Claire and Richard P. Morse 1953 Fund; 2006.3.13

201. John Wilson, American, born 1922

Martin Luther King, Jr., 2002

Etching and aquatint with chine colle, 35⅝ x 29⅞ inches
Purchased through the Olivia H. Parker and John O. Parker 1958
Acquisition Fund; PR.2002.17.2

202. Fred Wilson, American, born 1954

Arise!, 2004

Spitbite aquatint with direct gravure, 30¾ x 34 inches
Purchased through the Sondra and Charles Gilman Jr. Foundation Fund;
PR.2004.26

203. Markus Linnenbrink, German, born 1961

Me Thinks You Right, No Problem, 2004

Monotype, 47¾ x 35⅛ inches
Purchased through the Claire and Richard P. Morse 1953 Fund; 2006.3.11

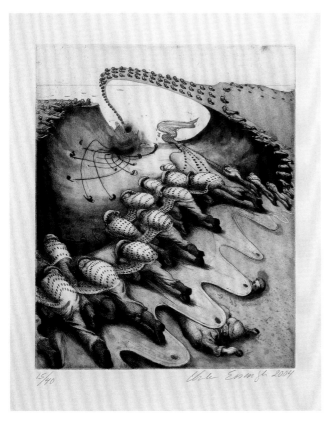

204

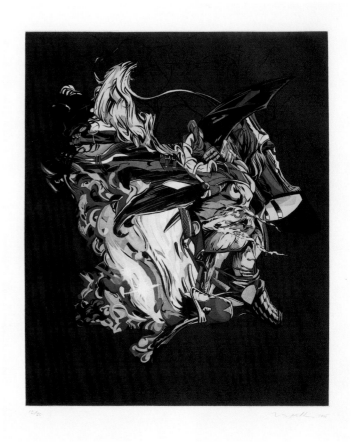

205

204. Inka Essenhigh, American, born 1969

War, 2004

Aquatint and spitbite etching with drypoint, 16½ x 13¼ inches
Gift of Hugh J. Freund, Class of 1967; PR.2004.75.8

205. Aaron Noble, American, born 1961

Luna, 2005

Hardground, aquatint, spitbite aquatint, sugarlift, white ground, drypoint, and roulette, 30⅛ x 22⅝ inches
Purchased through the Claire and Richard P. Morse 1953 Fund; 2006.43

206. Daniel A. Heyman, American, born 1963

He Could Feel the Dog's Breath, from the *Amman* series of *The Abu Ghraib Project,* March 2006

Drypoint on Rives BFK paper, 27¹⁄₁₆ x 22½ inches
Purchased through the Anonymous Fund #144; 2007.66.1

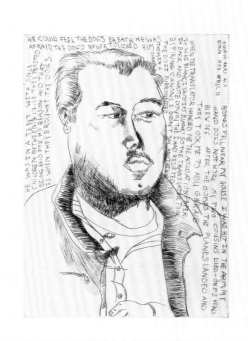

206

PRINT PORTFOLIOS

The portfolio is a convenient way for an artist to present a series of prints and photographs for collectors or museums. Prints presented as an unbound boxed set can either show examples from a suite of new work or take a retrospective look at material from diverse periods in an artist's oeuvre. The portfolio often also serves as compendium of prints by an affiliated group of artists, banded together because of their shared participation in a workshop project (as in the *Provincetown* portfolio [cat. 218]) or a social and political agenda (*Guerilla Girls' Most Wanted: 1985–2006* [cat. 216]). Other portfolios place the work of poets side by side with that of artists. The Hood's collection includes almost one thousand prints contained within portfolios that represent all of these types. Those pictured here range from Dorothea Tanning's surrealist series of lithographs *The 7 Spectral Perils* (cat. 207), which are paired with short prose poems by André Pieyre de Mandiargues, to Dennis Oppenheim's *Projects* (cat. 209), which documents ten works created during a performance/installation-oriented period of his career from 1968 to 1972.

One of the most influential printmakers of the mid-twentieth century, Stanley William Hayter worked with a wide range of artists that included Picasso, Alexander Calder, and Joan Miró in his Paris printmaking workshop *Atelier 17* (he was also based in New York during and after World War II). Hayter produced technically complex color intaglio prints that ranged from surrealist-inspired abstraction to more lyrical and narrative imagery in his later career. His prints for *The Death of Hektor*, 1979 (cat. 210), which accompanies Brian Coffey's poem about the ill-fated Trojan prince, draw on archaic imagery, experimental technique, and expressive line to convey this story of gods and ancient conflict. Another portfolio that matches poetry and image is *Her Story* (cat. 215), which represents the combined efforts of poet Anne Waldman and painter and printmaker Elizabeth Murray. The lighthearted spirit of Murray's organic and whimsical imagery belies her intricate interweaving of the intaglio and lithographic processes.

The 1960s and 1970s are well represented in the museum's collection with the exuberant amalgam of text and image in *1¢ Life*, 1964, as well as *Ten Works by Ten Painters* from the same year, *CONSPIRACY: The Artist as Witness*, 1971, an anti-war effort by artists with diverse styles and methods, *Yippie Portfolio*, 1972 (cat. 208), and *Works by Artists in the New York Collection for Stockholm*, 1973. These portfolios, which contain work by well-known artists such as Ellsworth Kelly, Roy Lichtenstein, Frank Stella, and Sol LeWitt, are telling snapshots of a very particular point in time in American art and culture.

In the early 1990s the Hood produced an exhibition of Jonathan Borofsky's graphic work from 1982 through 1991 that traveled extensively to other museums and galleries. Borofsky's 1982 portfo-

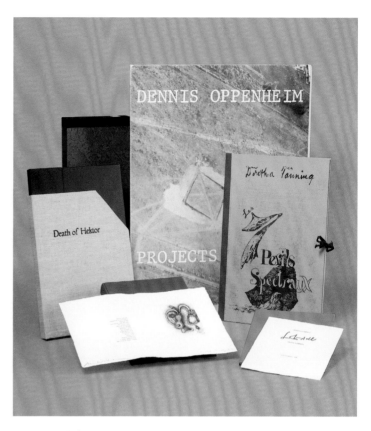

Fig. 1. From left to right: Stanley William Hayter, *Death of Hektor* (cat. 210) ©2009 Artists Rights Society (ARS), New York/ADAGP, Paris; Peter Feldstein, *Agios* (cat. 217); Dennis Oppenheim, *Projects* (cat. 209); Dorothea Tanning, *The 7 Spectral Perils (Les 7 Perils Spectraux)* (cat. 207). Foreground, open with sheets displayed: Elizabeth Murray, *Her Story: A book of thirteen original graphics by Elizabeth Murray for thirteen poems by Anne Waldman* (cat. 215) and Frank Lobdell, *Seven Etchings* (cat. 214).

lio *2740475* (cat. 212) entered the collection as the exhibition was being planned by James Cuno and Ruth Fine. Other portfolios that came to the museum in the 1980s and early 1990s included the *Art and Sports* portfolio (cat. 213), produced in conjunction with the 1984 Winter Olympics in Sarajevo, Richard Estes's *Urban Landscapes* (cat. 211), and a compilation of small intaglio prints by Frank Lobdell (cat. 214). The museum continues to collect portfolios, such as the aforementioned Guerilla Girls collection; *Artist as Catalyst*, 1992, a collection of prints by artists such as Luis Jimenez, Lorna Simpson, and Ida Applebroog; a series of abstract aquatint and drypoint prints by printmaker and publisher James Stroud; Homer-inspired woodblock prints by Seattle artist and Dartmouth artist-in-residence Michael Spafford; and prints by Ellen Gallagher, whose mixed-media work explores issues of race and identity with a uniquely oblique approach to image making.

KWH

189

207

209

208

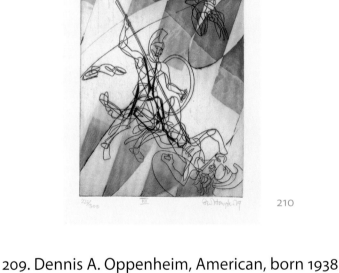

210

207. Dorothea Tanning, American, born 1910

First Peril (Premier peril), from the portfolio
The 7 Spectral Perils (Les 7 Périls Spectraux), 1950

Color lithograph, 20⅛ x 13⅛ inches
Purchased through the Julia L. Whittier Fund; PR.951.7.1

208. Robert Whitman, American, born 1935

Untitled, from the *Yippie Portfolio,* 1972

Screenprint, 29⅝ x 39⅞ inches
Purchased through the Hood Museum of Art Acquisitions Fund; PR.977.1

209. Dennis A. Oppenheim, American, born 1938

Rocked Circle—Fear, number 7 of 10 from *Projects
by Dennis Oppenheim: A Portfolio of 10 Original
Lithographs Documenting Projects Executed
between 1968 and 1972,* 1970, printed 1973

Photolithograph in black and blue on Arches Cover White paper,
22 x 30 inches
Purchased through the Adelbert Ames Jr. 1919 Fund; PR.975.10.7

210. Stanley William Hayter, British, 1901–1988

Death of Hektor, from the portfolio *Death of
Hektor,* 1979

Engraving and soft-ground etching on handmade paper, 15½ x 11¼ inches
Hood Museum of Art, Dartmouth College; PR.980.253.7
© 2009 Artists Rights Society (ARS), New York/ADAGP, Paris

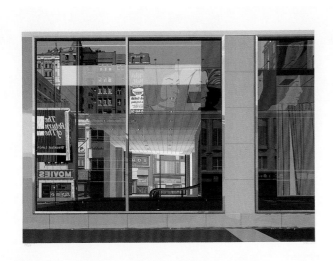

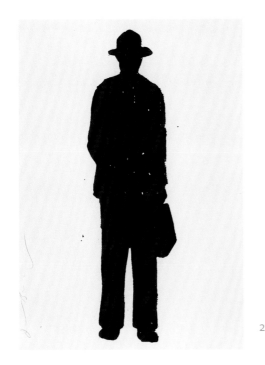

211. Richard Estes, American, born 1932

Movies, from the portfolio *Urban Landscapes No. 3,* 1981

Screenprint on wove paper, 14 x 20 inches
Gift of Judith and Eugene H. Kohn, Class of 1960; PR.982.63.2

212. Jonathan Borofsky, American, born 1942

Untitled, number 1 of 13 from the portfolio *2740475,* 1982

Screenprint, 30 x 22 inches
Purchased through the Miriam and Sidney Stoneman Acquisition Fund; PR.989.44.1.1

213. Friedensreich Hundertwasser, Austrian, 1928–2000

The End of the Road, from the portfolio *Art and Sports,* 1983

Screenprint, 33⅟₁₆ x 24⅛ inches
Gift of Barbara and Jay Rosenfield, Class of 1949; PR.986.87.12

214. Frank Lobdell, American, born 1921

5.8.87, number 3 of 7 from the portfolio *Seven Etchings,* 1987, published in 1988

Etching and aquatint on wove paper, 8¹³⁄₁₆ x 10³⁄₁₆ inches
Purchased through a gift from Elizabeth and Mark T. Gates Jr., Class of 1959; PR.992.15.3

217

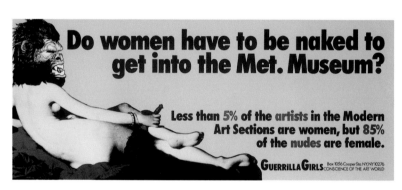

215

216

218

215. Elizabeth Murray, American, 1940–2007

Untitled, number 10 of 13 from *Her Story: A book of 13 original graphics by Elizabeth Murray for thirteen poems written by Anne Waldman,* 1988–90

Letterpress, lithograph, etching, and aquatint on custom-made paper, 11³⁄₁₆ x 17¹¹⁄₁₆ inches
Purchased through the Anonymous Fund #144; PR.2000.28.10
© Elizabeth Murray, courtesy PaceWildenstein, New York

216. Guerrilla Girls, American, 20th century

Do Women Have to Be Naked?, from the portfolio *Guerilla Girls' Most Wanted: 1985–2006,* 1989

Offset lithograph, 11⅛ x 27⅛ inches
Purchased through the Anonymous Fund #144; 2006.83.7

217. Peter Feldstein, American, born 1942

Agios, 1990

Twelve cliché-verre prints, 7⅞ x 20⅝ x 1½ inches
Purchased through the Hood Museum of Art Acquisitions Fund; MIS.992.5

218. Sylvia Plimack Mangold, American, born 1938

Provincetown Tree, from *The New Provincetown Print Project Portfolio 1991,* 1991

Monoprint, lift-ground etching on Rives BFK paper, 30⅛ x 22½ inches
Purchased through the William S. Rubin Fund; PR.992.34.2

219

221

220

222

219. Ellen Gallagher, American, born 1965

Untitled, Number IV, from *Portfolio of 10 Prints,* 2000

Silkscreen and drypoint etching on Kizuki paper, 22⁹⁄₁₆ x 18¹⁄₁₆ inches
Gift of Hugh J. Freund, Class of 1967; 2005.80.5

220. Michael Spafford, American, born 1935

IV, number 4 of 24 from the portfolio *The Iliad,*
2004

Woodcut, 19⅞ x 26 inches
Purchased through the Virginia and Preston T. Kelsey 1958 Fund; 2006.12.4

221. James Stroud, American, born 1958

I, number 1 of 9, from the portfolio *Stations II,* 2005

Aquatint and drypoint with chine colle and coated with beeswax on
Rives BFK paper, 23 x 21 inches
Purchased through the Claire and Richard P. Morse 1953 Fund; 2006.3.1

222. Jennifer Anderson, American, born 1967

Essence, from *Portfolio 2006,* 2006

Stone lithograph on chine colle, 15⅛ x 11¼ inches
Purchased through the Class of 1935 Memorial Fund; 2007.41.1

PHOTOGRAPHS

Addressing the issue of acquisitions in photography in 1979, Dartmouth Galleries director Jan van der Marck wrote:

Photography as a fine art has established itself in the museum-goer's awareness with such force that no program is complete without photography exhibitions and no institution can any longer make light of increasing pressures to collect representative examples of that rapidly gaining art. For lack of requisite expertise and funds, we have not addressed ourselves to this medium in a major way. The days in which our predecessors acquired photographs by Julia Margaret Cameron, Mathew Brady, Stieglitz, Atget and Walker Evans are long gone and we have not been able, with the means available to us, to quite match their accomplishments [van der Marck 1979: 22 (quotation)].

As van der Marck makes clear, photography was not collected in a deliberate manner before the 1970s. Thirty years later, the photography collection at the Hood Museum of Art has grown substantially, particularly in post-1950 works. Several factors have helped in developing various aspects of this collection beyond the generosity of our individual donors, particularly the artist-in-residence program and Dartmouth's Museum Collecting 101 class, initiated in 2001 by Hood Director Derrick Cartwright and Curator of Academic Programming Katherine Hart.

In 1972, Walker Evans became the first artist-in-residence in photography at Dartmouth College. Evans began his residency by traveling throughout the Upper Valley with Dartmouth professor of studio art Varujan Boghosian and director of visual studies Matthew Wysocki and creating works such as *Trinity Church, Cornish New Hampshire* (cat. 237). Reacting to the artifice of Pictorialism that was in vogue in American photography of the 1920s, Evans developed a straightforward, documentary style early in his celebrated career as a photographer. His carefully framed images offer both a meditative reflection on the everyday and a revealing slice of Americana that appeal to a range of audiences and have proven to be a key part of our collection.

Evans set a high standard for photographers at Dartmouth, and other artists-in-residence in photography have followed suit, providing opportunities for the acquisition of significant works by William Christenberry, Maria Cosindas, Ralph Steiner, Joel Sternfeld, Olivia Parker, Peter Feldstein, Steven Trefonides, Andrew Moore, and Jane Hammond, among others. Having artists of this stature on campus not only allows for important additions to the permanent collection that have a material connection to the community, but also raises the profile of photography as a fine art and encourages further engagement and appreciation of the medium. Photography has been considered a "modern" medium almost from its inception, and its ability to engage with diverse audiences

cannot be denied. Technological advances have provided new forums for experimentation in subject and process while also making the medium more accessible as it became an everyday hobby for many of its viewers. Modernist and post-modernist subject matter such as a focus on the body, self-identity, or issues such as racism and sexism provide continual opportunities for initiating dialogue. Connecting with a comprehensive group of contemporary photographers, the Hood is able to address the evolving issues of our own time through a format that is familiar to its audiences.

Museum Collecting 101, a non-credit course offered to Dartmouth undergraduates, seeks to introduce students to the process of acquiring works through purchase. Each year, areas of the collection that need further development are identified by Hood staff members, and participating students research possible works and select one for acquisition. The result has been the addition of an array of phenomenal photographs, including Daniela Rossell's *Untitled (Janita Harem Room, Villa Arabesque, Acapulco, Mexico)* from the series *Ricas y Famosas* (cat. 261), Loretta Lux's *The Drummer* (cat. 270), Ogle Winston Link's *Hawksbill Creek Swimming Hole, Luray NW1126* (cat. 228), Nobuyoshi Araki's *Untitled "Bondage (Kinbaku),"* Sebastião Salgado's *Brasil (Hand, Serra Pelada)* (cat. 251), and Mario Cravo Neto's *Christian with Bird*.

Exhibitions featuring photography have played a key role in bringing important works into the permanent collection. In 2006, the Hood Museum organized *Protest in Paris: Photographs by Serge Hambourg*, an exhibition featuring the work of the French photojournalist taken in 1968 while he was working for the Parisian weekly magazine *Le Nouvel Observateur*. *Protest in Paris* resulted in a gift from the artist of thirty works from this series, adding to an already noteworthy collection of works in the photojournalist tradition by Dick Durrance, James Nachtwey, and W. Eugene Smith. Similarly, a 1991 solo show of Carrie Mae Weems's photographs resulted in the purchase of *Untitled (Make-up with Daughter)*, from the *Kitchen Table Series* (cat. 253). Most recently, *Black Womanhood: Images, Icons, and Ideologies of the African Female Body*, a major traveling exhibition organized by the Hood Museum, provided the opportunity to acquire photographer's Renée Cox's iconic self-portrait, *Baby Back* (cat. 264), which joined *Atlas*, another significant image by the artist previously donated by Hugh J. Freund, Class of 1967.

Several key portfolios augment the photography collection, particularly in the aesthetic styles popular throughout the 1950s, 1960s, and 1970s, including street photography, a focus on the urban landscape, documenting everyday life in the spirit of Henri Cartier-Bresson's "decisive moment," and the use of the camera as a social witness. Garry Winogrand's influential style of street

photography is exemplified in both *Women are Beautiful* and *Garry Winogrand, A Portfolio of 15 Gelatin Silver Prints* (cat. 238), while Serge Hambourg's *Mills and Factories of New England* epitomizes the classic New England urban landscape. Noteworthy series by Elliott Erwitt, Ralph Eugene Meatyard, Lotte Jacobi, and Robert Doisneau further complement our holdings.

The majority of acquisitions in the area of modern and contemporary photography have been accomplished by purchases made possible through the Sondra and Charles Gilman Jr. Foundation Fund, (including works by Jane Hammond, James Nachtwey, Sally Mann, Lotte Jacobi, Rineke Dijkstra, and Hiroshi Sugimoto), and the Olivia H. Parker and John O. Parker 1958 Acquisition Fund (including works by Justine Kurland, Abelardo Morrell, Malick Sidibé, Olivia Parker, and Carrie Mae Weems). An unprecedented donation made by the Andy Warhol Photographic Legacy Program has allowed the Hood Museum to enrich its wonderful collection of works by Andy Warhol, adding 153 photographs (both Polaroids and black-and-white prints) taken from 1973 to 1985 of various subjects including Olympic skater Dorothy Hamill (cat. 245), art collector Steve Rubel, musician John Denver, fashion designer Carolina Herrara, and celebrity Candy Spelling.

However, it is the generosity of individual donors, both artists and passionate collectors, many of whom are Dartmouth alumni, that cannot be overstated. Former artist-in-residence Joel Sternfeld, Dartmouth Class of 1965, gifted one of his iconic works *McLean, Virginia (Pumpkins)* (cat. 247). Andrew Lewin, Class of 1981, supplied the funding to purchase two images by Japanese photographer Hiroh Kikai. Individual gifts, such as Carol Vaughan Bemis gift of Jean-Luc Mylayne's *No. 28 June, July, August 1981 (No. 28 Juin, Juillet, Aout 1981)* (cat. 248), Barbara and Robert Levine's collection of works by Stephen Shore, and Jane and Raphael Bernstein's donation of George Tice's *Petit's Mobil Station, Cherry Hill, New Jersey, 1974* (cat. 243), have proven to be key pieces in the collection.

A significant effort has been made in the last ten years to diversify the collection, particularly in geographic terms, adding works such as Fiona Foley's *HHH #1(2004)* (cat. 271) and Subhankar Banerjee's *Caribou Migration I* (cat. 268). Yet clearly there are areas of the photography collection that require further development, and gaps remaining range from the work of important early twentieth-century photographers to contemporary photographers of today. Perhaps most imperative is continuing the effort to fully represent the global cultural exchange that characterizes today's art world by collecting the work of artists from diverse backgrounds.

ESB

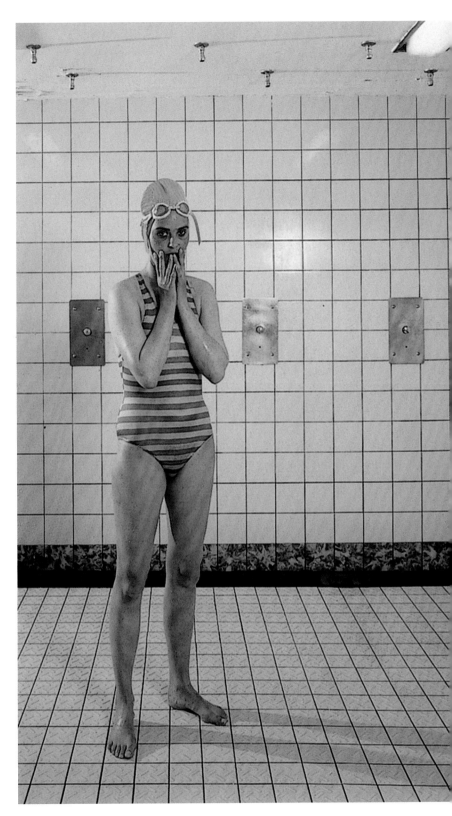

Rineke Dijkstra, *Self Portrait, Marnixbad,* Amsterdam, 1991 (cat. 255, detail).

223

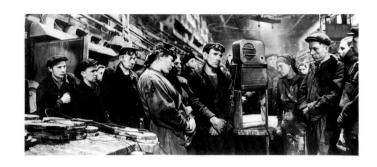

225

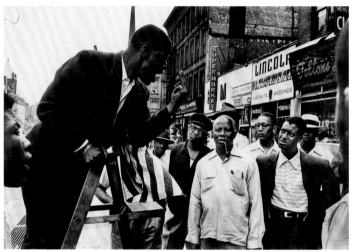

224

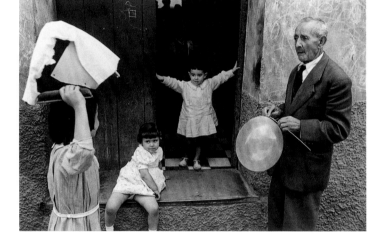

226

223. Lotte Jacobi, American, 1896–1990

Landscape, number two from the portfolio *Lotte Jacobi Portfolio 3,* 1946–55, published 1981

Photogenics, 10 x 12 inches
Purchased through the Sondra and Charles Gilman Jr. Foundation Fund;
2007.25.24

224. Gordon Parks, American, 1912–2006

Untitled (Man Preaching to Crowd with Four Fingers Up), about 1952

Vintage gelatin silver print, 9¼ x 13⅝ inches
Purchased through the Sondra and Charles Gilman Jr. Foundation Fund;
PH.2000.13

225. Dmitri Baltermants, Russian, 1912–1990

Announcement of the Death of Stalin, Dynamo Factory, Moscow (composite photo), negative March 6, 1953, print 2003

Gelatin silver print, 16 x 20 inches
Purchased through a gift from Harley and Stephen C. Osman, Class of 1956,
Tuck 1957; PH.2003.56.644

226. Edouard Boubat, French, 1923–1999

Rue de Grenade, Espagne, 1954, number 9 of 15 from the portfolio *Edouard Boubat, 1954,* published 1981

Gelatin silver print, 14⅛ x 9⅜ inches
Gift of Kenneth G. Futter; PH.982.30.9

227

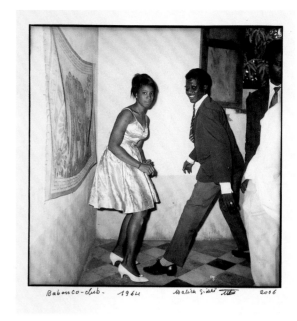

229

228

230

Ameer, Class of 2004, Maggie Lind, Class of 2002, Phil Mone, Class of 2002, Mirte Mallory, Class of 2002, Christopher Moore, Class of 2002, Debra Truman, Vicki Walsh, and Ian Williams; PH.2002.10

227. W. Eugene Smith, American, 1918–1978

Untitled (Pittsburgh Steel Worker), 1955

Gelatin silver print, 12¹¹⁄₁₆ x 9⅞ inches
Gift of Franklin Davidson M.D., Class of 1955; PH.2004.74.5
© 1955, 2009 The Heirs of W. Eugene Smith

228. Ogle Winston Link, American, 1914–2001

Hawksbill Creek Swimming Hole, Luray NW1126,
negative 1958, print 1996

Gelatin silver print, 19⅞ x 16 inches
Purchased through the Charles F. Venrick 1936 Fund, and a gift from David V. Picker, Class of 1953. Selected by participants in the Winter 2002 Miniversity Class at the Hood Museum of Art: Alexandra Arad, Class of 2002, Amanda

229. Malick Sidibé, Malian, born 1936

Babanco Club, negative 1960s, print 2006

Gelatin silver print, 11⅝ x 9½ inches
Purchased through the William B. and Evelyn F. Jaffe (58, 60, & 63) Fund and the Hood Museum of Art Acquisitions Fund; 2006.82.1

230. Elliott Erwitt, American, born 1928

Confessional/ Czestochowa, Poland, 1964,
from the portfolio *Photographs: Elliott Erwitt,*
negative 1964, published 1977

Gelatin silver print, 8 x 10 inches
Gift of Mr. and Mrs. James Hunter; PH.978.28.6

231

233

232

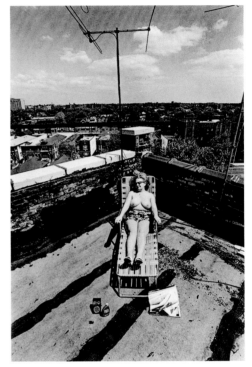

234

231. Ralph Eugene Meatyard, American, 1925–1972

Romance of Ambrose Bierce #3, number 4 of 10 from *Portfolio Three*, 1964

Gelatin silver print, 6¾ x 6⅞ inches
Purchased through the Harry Shafer Fisher 1966 Memorial Fund; PH.974.131.4
© The Estate of Ralph Eugene Meatyard, courtesy Fraenkel Gallery, San Francisco

232. Diane Arbus, American, 1923–1971

Loser at a Diaper Derby, 1967

Gelatin silver print, 15½ x 14¹⁵⁄₁₆ inches
Purchased through a gift from the Cremer Foundation in memory of J. Theodor Cremer; PH.986.49
© 1972 The Estate of Diane Arbus

233. Dick Durrance, American, born 1942

Crewman, CH-47A (Chinook) helicopter on mission over Mekong Delta, August 1967, 1967

Gelatin silver print, 15⅞ x 19⅞ inches
Gift of Jeffrey Hinman, Class of 1968, in memory of William Smoyer, Class of 1967, and J. Robert Peacock, Class of 1968; PH.2004.45.1

234. Leslie Robert Krims, American, born 1942

Mother Sunbathing, 1969

Silver print on Kodalith paper, 8 x 5⅓ inches
Purchased through the Harry Shafer Fisher 1966 Memorial Fund; PH.978.149

235

237

236

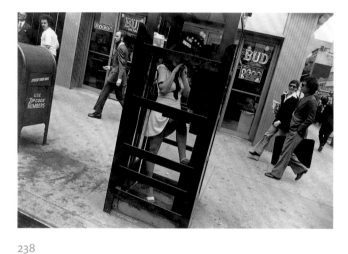

238

235. Ralph Steiner, American, 1899–1986

Clouds IV, about 1970

Gelatin silver print, 5½ x 5½ inches
Gift of Willard van Dyke; PH.975.51

236. William Christenberry, American, born 1936

Post Office, Sprott, Alabama, 1971, negative 1971, print 1988

Polaroid, 3⅛ x 4⅞ inches
Gift of Marc Efron, Class of 1965, and Barbara Bares; PH.2001.44.1

237. Walker Evans, American, 1903–1975

Trinity Church, Cornish, New Hampshire, 1972

Gelatin silver print, 10 x 8 inches
Gift of the Class of 1935; PH.973.9
© Walker Evans Archive, The Metropolitan Museum of Art

238. Garry Winogrand, American, 1928–1984

New York City, 1972, number 11 of 15 from *Garry Winogrand, a Portfolio of 15 Silver Prints,* 1972, published 1978

Gelatin silver print, 11 x 14 inches
Gift of Lynn Hecht Schafran; PH.979.9.11
© The Estate of Garry Winogrand, courtesy Fraenkel Gallery, San Francisco

239

240

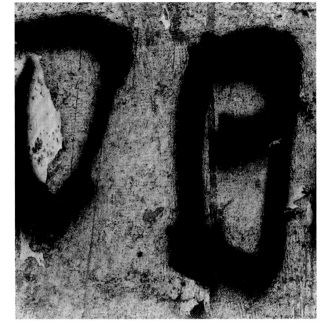

241

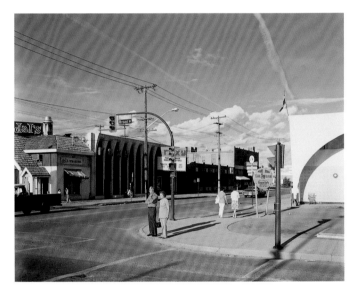

242

239. Ralph Gibson, American, born 1939

1972 (Man with Classical Statue), number 1 of 15 from the portfolio *Chiaroscuro,* 1982

Gelatin silver print, 13⅘ x 10⁹⁄₁₀ inches
Gift of Gerald D. Levine, Tuck Class of 1963; PH.989.48.1.1

240. Thomas Francis Barrow, American, born 1938

Stockbridge Shadow, from the series *Pink Stuff,* 1972

Pink-toned gelatin silver print, 5½ x 13⅞ inches
Gift of Bart Osman, Class of 1990, Tuck 1996; PH.2003.70.4

241. Aaron Siskind, American, 1903–1991

Rome 33, 1973, from *Homage to Franz Kline,* 1973

Gelatin silver print, 13⅞ x 11 inches
Gift of Suzanne B. and Waldo L. Fielding M.D., Class of 1943; PH.989.49.3

242. Stephen Shore, American, born 1947

Broad Street, Regina, Saskatchewan, 1974

Type C print, 16 x 20 inches
Gift of Barbara and Robert Levine, Class of 1954, Tuck 1955; PH.2000.1.2

243

245

244

246

243. George A. Tice, American, born 1938

Petit's Mobil Station, Cherry Hill, New Jersey, 1974,
1974

Gelatin silver print, 20 x 24 inches
Gift of Jane and Raphael Bernstein; PH.986.77.17

244. Helmut Newton, German, 1920–2004

Chez Karl Lagerfeld, Paris 1974, number 5 of 15 from
the portfolio *Helmut Newton 15 Photographs,* 1974

Gelatin silver print, 11 x 14 inches
Gift of Constance and Stephen H. Spahn, Class of 1963, Blake Spahn and
Kirk Spahn, Class of 1999; PH.2001.39.5

245. Andy Warhol, American, 1928–1987

Dorothy Hamill, 1977

Polacolor Type 108, 3½ x 4¼ inches
Gift of the Andy Warhol Foundation for the Visual Arts; 2008.3.2
© 2009 The Andy Warhol Foundation for the Visual Arts/(ARS), New York

246. Olivia Parker, American, born 1941

An Orderly Mind, number 8 of 10 from the
portfolio *Ephemera,* 1977

Split-toned photograph, 8 x 10 inches
Gift in memory of John H. and Jennie D. Hinman, Class of 1908; PH.990.22.8

247

248

250

247. Joel Sternfeld, American, born 1944

McLean, Virginia (Pumpkins), December 1978

Dye transfer print, 15⅞ x 19⅞ inches
Gift of Joel Sternfeld, Class of 1965, and Neil Grossman, Class of 1965,
in memory of John Pickells, Class of 1965; PH.986.24

248. Jean-Luc Mylayne, French, born 1946

No. 28 June, July, August 1981 (No. 28 Juin, Juillet, Aout 1981), 1981

C-print, 23¼ x 23⅜ inches
Gift of Carol Vaughan Bemis, Class of 1976; 2006.25

249. Serge Hambourg, French, born 1936

Scovill Manufacturing Company, Waterbury, Connecticut, negative 1982–85, print 1987

Chromogenic-development (Ektacolor) print, 14⅓ x 18 inches
Purchased through a gift from the Bernstein Development Foundation,
courtesy of Jane and Raphael Bernstein; PH.988.2.81

250. Lois Conner, American, born 1951

Huang Shan, Anhui, China, 1985

Platinum print, 18¾ x 7⅝ inches
Purchased through a gift from the Prospero Foundation,
and a gift from Peter A. Vogt, Class of 1947; PH.998.30.1

251

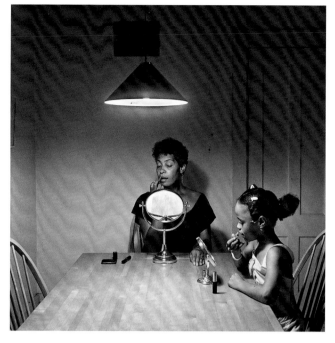

253

252

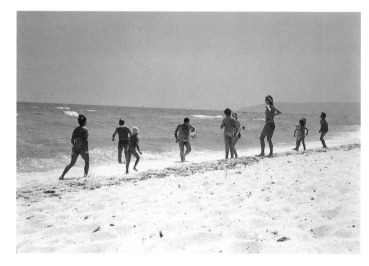

254

251. Sebastião Salgado, Brazilian, born 1944
Brasil (Hand, Serra Pelada), 1986

Gelatin silver print, 16 x 20 inches
Purchased through the Fund for Contemporary Photography. Selected by
participants in the Fall 2002 Hood Museum of Art Seminar: Betty Baez-Melo,
Class of 2005, Gabriela Jaramillo, Class of 2004, Marilyn Nyanteh, Class of
2005, Lia Rothstein, Holly Shaffer, Class of 2003, and Yin Zhao, Class of 2006;
PH.2002.59
© Sebastião Salgado/Amazonas Images/Contact Press Images

252. Gary Schneider, American, born 1954
Mirriam, 1989

Selenium toned gelatin silver print, 35½ x 29⅜ inches
Purchased through the Hood Museum of Art Acquisitions Fund; PH.997.41.1

253. Carrie Mae Weems, American, born 1953
Untitled (Make-up with Daughter), from the *Kitchen Table Series,* 1990

Gelatin silver print, 29 x 29 inches
Purchased through the Harry Shafer Fisher 1966 Memorial Fund; PH.991.46

254. Eric Fischl, American, born 1948
Untitled (Ten people standing along shoreline), number 6 of 16 from the portfolio *St. Tropez,* 1990

Dye transfer print, 16 x 20 inches
Gift of Helaine and Paul S. Cantor, Class of 1960; PH.995.67.6

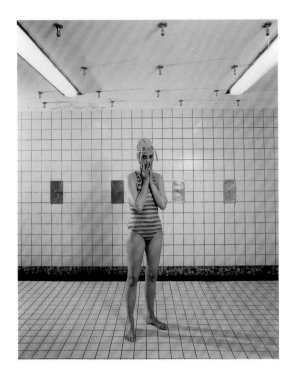

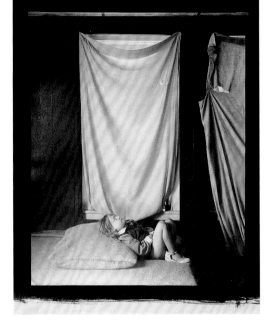

255

257

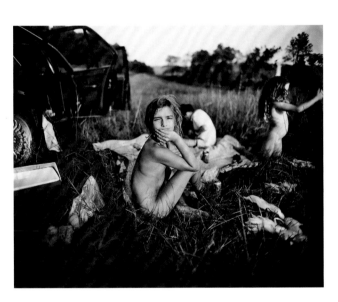

256

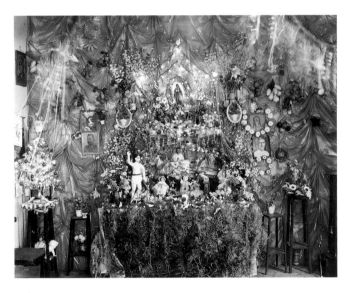

258

255. Rineke Dijkstra, Dutch, born 1959

Self Portrait, Marnixbad, Amsterdam, 1991

C-print, 14 x 11⅛ inches
Purchased through the Sondra and Charles Gilman Jr. Foundation Fund and
the Contemporary Art Fund in honor of Derrick R. Cartwright, Director of
the Hood Museum of Art, 2000–2004; PH.2004.52

256. Sally Mann, American, born 1951

Luncheon in the Grasses, negative 1991, print 1996

Gelatin silver print, 19⅞ x 24 inches
Purchased through the Sondra and Charles Gilman Jr. Foundation Fund;
PH.997.10
© Sally Mann

257. Andrea Modica, American, born 1960

Treadwell, New York, 1993, 1993

Platinum palladium contact print, 11¾ x 8⅞ inches
Purchased through gifts from Robert A. Levinson, Class of 1946, Eleanor Platt
Caldwell, and Fredrick Goldstein in honor of Joseph Millimet and Ruth Cserr,
Class of 1988; PH.997.24

258. Dana Salvo, American, born 1952

Mendoza Household Shrine-Chiapas, about 1995

Type C print, 16 x 20 inches
Gift of Varujan Boghosian; PH.998.47

204

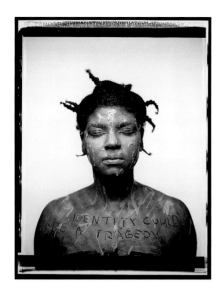

259

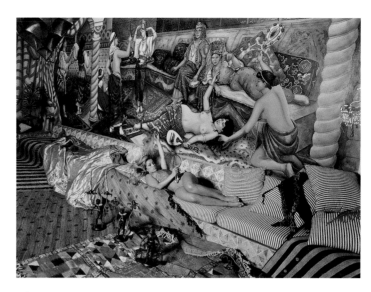

261

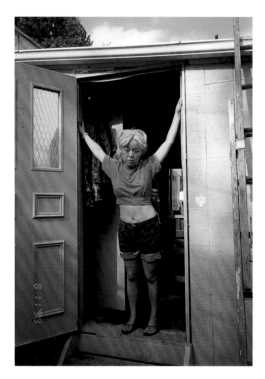

260

259. Maria Magadalena Campos-Pons, Cuban, born 1959

When I Am Not Here / Estoy Allá, 1996

Polaroid, 24 x 20 inches
Purchased in honor of Hugh Freund, Class of 1967, Class of 2008P; 2008.7

260. Nikki S. Lee, American, born 1970

The Ohio Project (8), 1999

Fujiflex print, 40 x 30 inches
Purchased through the Elizabeth and David C. Lowenstein '67 Fund; 2007.59

261. Daniela Rossell, Mexican, born 1973

Untitled (Janita Harem Room, Villa Arabesque, Acapulco, Mexico), from the series *Ricas y Famosas,* 2001

C-print, 30 x 40 inches
Purchased through gifts from Charles W. Gaillard, Class of 1962, Kenneth I. Reich, Class of 1960, James and Susan Wright, Lee and Marguerite Berlin, Karen Berlin, Class of 1989, Elizabeth E. Craig, Class of 1944W, Jan Seidler Ramirez, Class of 1973, and the Class of 1952. Selected by participants in the Winter 2004 Hood Museum of Art Seminar: Sarah Bohlman, Class of 2004, Jeffrey Cooperman, Class of 2006, Joanne Kim, Class of 2005, Amy Kurtz, Class of 2006, Sarah Murray, Class of 2004, Rolaine Ossman, Class of 2004, Arielle Ring, Class of 2007, Catherine Roberts, Class of 2005, Emily Salas, Class of 2006, Liz Seru, Class of 2004, Eleanor Smith, Class of 2004, Miell Y. Yi, Class of 2002; PH.2004.18
Courtesy of the artist and Greene Naftali, New York

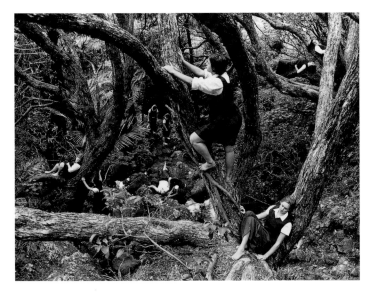

262

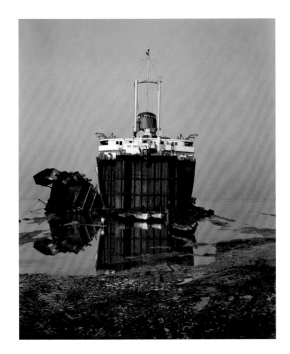

263

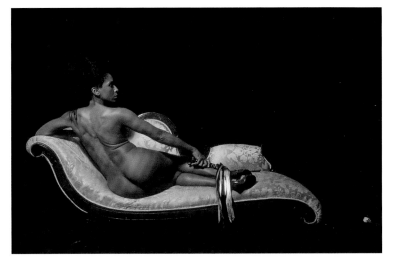

264

262. Justine Kurland, American, born 1969

Jungle Gym (Jungle Gym Jungle), 2001

C-print laminated on ⅛-inch Sintra panel, 30 x 40 inches
Purchased through the Olivia H. Parker and John O. Parker 1958
Acquisition Fund; PH.2003.57

263. Edward Burtynsky, Canadian, born 1955

Shipbreaking #31, Chittagong, Bangladesh, 2001

Dye-coupler print, 34 x 27 inches
Gift of Jane and Raphael Bernstein; 2005.20
© Edward Burtynsky

264. Renée Cox, American, born 1960

Baby Back, 2001

Archival digital "C" print mounted on aluminum, 100 x 144 inches
Purchased through the Sondra and Charles Gilman Jr. Foundation Fund and
the Fund for Contemporary Photography; 2008.31

265

267

266

268

265. James Nachtwey, American, born 1948

World Trade Center, 2001

Fuji Crystal Archive Print, 16 x 20 inches
Purchased through a gift from Hugh Freund, Class of 1967, in memory of the Dartmouth alumni who perished on September 11, 2001; PH.2004.21

266. Hiroh Kikai, Japanese, born 1945

An Old Man with a Penetrating Gaze (wearing a face mask), 2001

Gelatin silver print, 19¹⁵⁄₁₆ x 16 inches
Purchased through a gift from Andrew E. Lewin, Class of 1981; 2008.2.2

267. Abelardo Morell, American, born 1948

Camera Obscura Image of La Giraldilla de la Habana in Room under Construction (Camera Obscura Image of La Giraldilla de la Habana in Room with Broken Wall), 2002

Gelatin silver print (mounted on aluminum support), 31⅜ x 39¾ inches
Purchased through the Olivia H. Parker and John O. Parker 1958 Acquisition Fund, the Contemporary Art Fund, the William S. Rubin Fund, and the Fund for Contemporary Photography; PH.2003.71

268. Subhankar Banerjee, Indian, born 1967

Caribou Migration I, 2002

UltraChrome print, 39¾ x 29¾ inches
Purchased through the Charles F. Venrick 1936 Fund; 2006.61

269

271

270

272

269. Andrew Moore, American, born 1957

Gypsy Camp, Sarajevo, 2002

Chromogenic print, 46 x 56 inches
Purchased through the Sondra and Charles Gilman Jr. Foundation Fund;
2007.2

270. Loretta Lux, German, born 1969

The Drummer, 2004

Ilfochrome print, 13⅜ x 11¾ inches
Purchased through the Fund for Contemporary Photography. Selected by
Dartmouth College students who participated in the Hood Museum of Art
Seminar Museum Collecting 101: Brittany M. Beth, Class of 2006, Jillian F.
Rork, Class of 2006, Bradley G. Wolcott, Class of 2006, Mukund Bhaskar, Class
of 2006, Jaime L. Padgett, Class of 2007, Jessica I. Hodin, Class of 2007, Rose
M. McClendon, Class of 2006, Sophia C. D. Hutson, Class of 2006, Kelly E.
Baker, Class of 2006, Teresa M. Lattanzio, Class of 2009, Selena Hadzibabic,
Class of 2006, Erin R. Rumsey, Class of 2006; 2006.34

271. Fiona Foley, Australian, born 1964

HHH #1 (2004), 2004

Ultrachrome print on paper, 30¹⁄₁₆ x 40¹⁄₁₆ inches
Purchased through the Harry Shafer Fisher 1966 Fund; 2007.60
© 2009 Artists Rights Society (ARS), New York/VISCOPY, Australia

272. Jane Hammond, American, born 1950

Bee-Line Trucking, 2005

Selenium toned silver gelatin print, 13⅞ x 11 inches
Purchased through the Sondra and Charles Gilman Jr. Foundation Fund;
2006.33.1

273

275

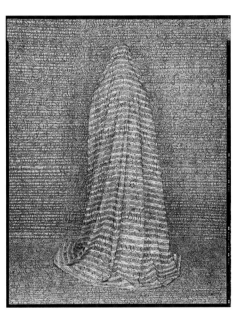

274

273. Matthew Pillsbury, American, born 1973

George Spencer, Seducing the Babysitter, Tuesday, April 1, 2003, 11–12 am, 2003

Pigment ink print, 38 x 44⅛ inches
Gift of Maggie Hunt, Class of 1978; 2005.10

274. Lalla Essaydi, Moroccan, born 1965

The Women of Morocco #23 (Femmes du Maroc #23), 2006

C41 print mounted on aluminum, three panels, each 60 x 48 inches
Purchased through the Robert J. Strasenburgh II 1942 Fund; 2006.76.1–3

275. Senzeni Marasela, South African, born 1977

Baby Doll, 2006

Digital print on matte archival paper, 23¼ x 16½ inches
Purchased through the Charles F. Vernick 1936 Fund; 2008.8

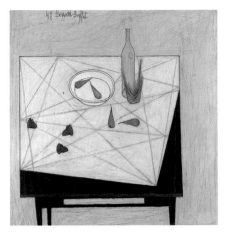

276

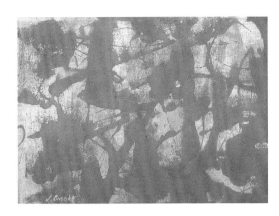

278

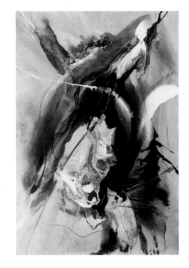

280

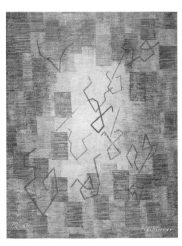

277

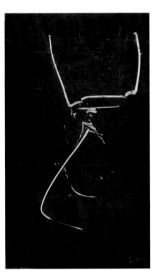

279

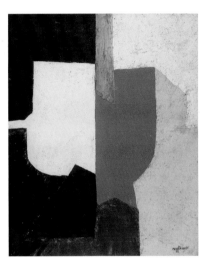

281

PAINTING

276. Bernard Buffet, French, 1928–1999

Geometry, 1949

Oil on canvas, 51¾ x 49⅜ inches
Gift of Julian J. and Joachim Jean Aberbach; P.962.47
© 2009 Artists Rights Society (ARS), New York/ADAGP, Paris

277. Oskar Fischinger, German, 1900–1967

Untitled, 1950

Oil on board, 11¾ x 9¼ inches
Gift of the Estate of Fannie and Alan Leslie M.D., Class of 1930, Medical School 1931; 2006.104

278. James Brooks, American, 1906–1992

V, 1951

Oil on canvas, 16⅝ x 23 inches
Gift of Jeffrey R. Brown, Class of 1961; P.996.39
Art © Estate of James Brooks/Licensed by VAGA, New York, NY

279. Georges Mathieu, French, born 1921

Vepres Siciliennes, 1953

Oil on canvas, 64½ x 38½ inches
Gift of Mr. and Mrs. Samuel M. Kootz; P.962.152
© 2009 Artists Rights Society (ARS), New York/ADAGP, Paris

280. Paul Jenkins, American, born 1923

Untitled Abstraction, 1954

Oil on canvas, 63 x 44⅞ inches
Gift of William S. Rubin; P.964.89
© 2009 Artists Rights Society (ARS), New York/ADAGP, Paris

281. Serge Poliakoff, Russian, 1906–1969

Composition, 1954

Oil on canvas, 39⅝ x 32⅜ inches
Gift of Evelyn A. and William B. Jaffe, Class of 1964H; P.959.137.5
© 2009 Artists Rights Society (ARS), New York/ADAGP, Paris

282

284

286

283

285

282. Aaron Bohrod, American, 1907–1992

Infinity, 1955

Oil on gessoed Masonite, 5½ x 9 inches
Bequest of Lawrence Richmond, Class of 1930;
P.978.168
Art © Estate of Aaron Bohrod/Licensed by VAGA,
New York, NY

283. Ernst Wilhelm Nay, German, 1902–1968

In Blazing Yellow (In Strahlendem Geld), 1959

Oil on canvas, 39½ x 32 inches
Gift of Wallace K. Harrison, Class of 1950H; P.967.21

284. Baclomb Greene, American, 1904–1990

Mountains and the Sea, 1961

Oil on canvas, 54⅛ x 46⅛ inches
Gift of Susan S. and William A. Small Jr.; P.994.45.2

285. William Christopher, American, 1924–1973

The Mammon Altarpiece, 1963

Oil on board, 45 x 84½ inches
Gift of Tatiana de Fidler in memory of her mother,
Marie Morosoff de Fidler; P.966.126

286. William Christopher, American, 1924–1973

Contemplation of the Mask, 1963

Oil on panel, 42 x 40 inches
Gift of the artist, in honor of Charles M. Adams,
Class of 1937; P.965.16

287

289

291

288

290

287. Jack Youngerman, American, born 1926

White Palma, Study, 1964

Acrylic on canvas, 23 x 28 inches
Bequest of Jay R. Wolf, Class of 1951; P.976.177

288. Lowell Nesbitt, American, 1933–1993

The Chair, 1966

Acrylic on canvas, 36 x 36 inches
Bequest of Jay R. Wolf, Class of 1951; P.976.142

289. Horst Antes, German, born 1936

Head, 1977/1978

Acrylic on C. M. Fabriano 100 percent rag paper, 27½ x 20½ inches
Gift of Jane and Raphael Bernstein; P.986.77.1
© 2009 Artists Rights Society (ARS), New York/
VG Bild-Kunst, Bonn

290. Bernar Venet, French, born 1941

Position of Two Arcs of 167.5 Degrees and 184.3 Degrees, 1978

Acrylic on canvas, diameter: 96 inches
Partial gift of the artist and partial purchase through the Hood Museum of Art Acquisitions Fund;
P.978.42A–B
© 2009 Artists Rights Society (ARS), New York/
ADAGP, Paris

291. Alan Uglow, British, born 1941

Green Painting #3, 1978

Oil on canvas, 85⅛ x 73⅛ inches
Gift of Hugh J. Freund, Class of 1967; P.996.49.10

292

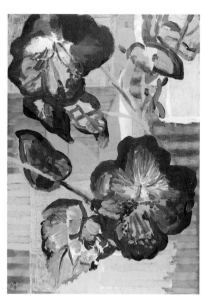

295

293

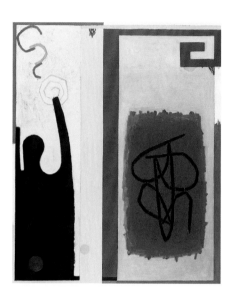

294

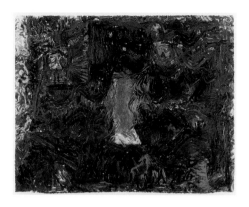

296

292. Robert S. Neuman, American, born 1926

Lame Deer Triptych, 1979

Oil on Belgian linen, three panels, each 76 x 76 inches
Gift of Gabriella Plimpton Ressler and
Dr. Herbert W. Plimpton Jr; P.983.49A–C

293. Robert Cottingham, American, born 1935

Pool Tables, 1979

Acrylic silkscreened on paper, from a photoscreen,
17 x 17 inches
Gift of the American Academy and Institute of Arts
and Letters, Hassam and Speicher Purchase Funds;
P.980.73

294. Frank Lobdell, American, born 1921

Winter '86, 1986

Oil on canvas, 72¼ x 60¼ inches
Gift of Susan S. and William A. Small Jr.; P.994.45.4

295. Carol Haerer, American, 1933–2002

Dark Chamber, 1986

Acrylic on canvas, 38 x 48½ inches
Gift of Philip Wofford; P.2003.23.1

296. Roberto Juarez, American, born 1952

Vine Wind, 1987

Acrylic, pastel, collage, and linen, 84 x 60 inches
Gift of Susan S. and William A. Small Jr.; P.994.45.3

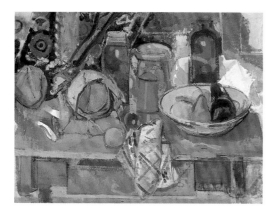

297

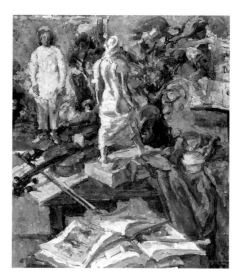

299

301

298

300

302

297. Ruth Miller, American, born 1930

Blue Table Still Life, about 1993–98

Oil on canvas, 30 x 40⅛ inches
Purchased under the auspices of the Henry Ward
Ranger Fund; EL.P.2001.37

298. Joe Zucker, American, born 1941

Canoe, 1994

Acrylic on pegboard and plywood, 24 x 48 inches
Gift of Hugh J. Freund, Class of 1967; P.2004.75.10

299. Rosemarie Beck, American,
1923–2003

House of Venus, 1994

Oil on linen, 58⅜ x 52¼ inches
Partial gift from the Rosemarie Beck Foundation and
partial purchase through the Claire and Richard P.
Morse 1953 Fund; P.2004.29

300. Charles Clough, American,
born 1951

Ecliptic, 1996

Enamel on Masonite, 48⅛ x 36 inches
Gift of Mr. and Mrs. Peter A. Vogt, Class of 1947, in
memory of Richard H. Morgan, Class of 1944 and
Rodney A. Morgan, Class of 1944, Tuck 1945, Thayer
1945; P.997.50

301. James Bohary, American,
born 1940

Hand Ball, 1998

Acrylic on paper, 30⅓ x 22⅝ inches
Purchased through a gift from Peter Vogt, Class of
1947, in honor of his 50th Reunion; P.998.17

302. Damian Loeb, American,
born 1970

D-IBADTGEDB, 2000–2001

Oil on linen, 20 x 20¼ inches
Gift of Hugh J. Freund, Class of 1967; 2005.74

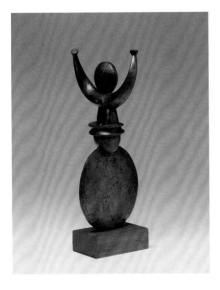

303

305

307

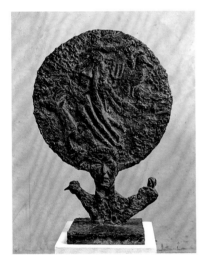

304

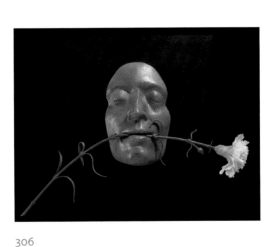

306

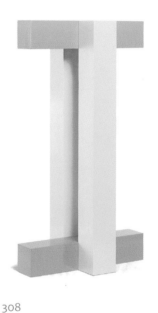

308

SCULPTURE

303. Jack Leslie Squier, American, born 1927

Small Disk Figure, not dated

Bronze, 11 x 5 inches
Purchased through a gift from Bess and M. H.
Brodkey, Class of 1965P, for the Joel P. Benezet,
Class of 1966, Memorial Collection; BR.S.964.218

304. Chaim Gross, American, 1904–1991

Homage to Chagall, 1961

Bronze, 34⅔ x 24⅓ x 11 inches
Bequest of Lawrence Richmond, Class of 1930;
S.978.172
© 2009 Artists Rights Society (ARS), New York

305. Robert Morris, American, born 1931

Model, 1967

Vacuum formed plastic, 20 x 23⅜ inches
The Herbert G. Swarzman, Class of 1958, Collection;
S.968.2

306. Marisol, American, born 1930

White Dreams, 1968

Plastic and wood, 9½ x 10¼ x 2⅔ inches
Bequest of Jay R. Wolf, Class of 1951; S.976.175
Art © Marisol Escobar/Licensed by VAGA,
New York, NY

307. Donald Judd, American, 1928–1994

Multiple, 1968

Stainless steel, 20⅛ x 24 x 2½ inches
The Herbert G. Swarzman, Class of 1958, Collection;
S.970.79
Art © Judd Foundation. Licensed by VAGA,
New York, NY

308. Lyman Kipp, American, born 1929

Bartar, 1968

Steel, 36 x 12 x 20 inches
Gift of Joan S. Sonnabend; S.977.195

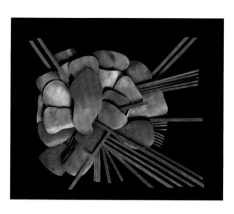

309

311

310

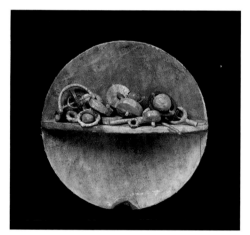

312

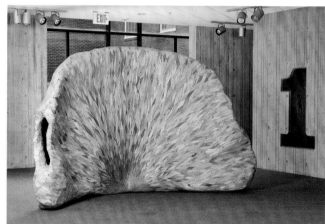

313

309. Mary Callery, American, 1903–1977

Untitled (Wall Sculpture), not dated

Brass and iron, 29 x 26 x 5½ inches
Bequest of Mary Callery; S.981.124

310. Barbara Hepworth, British, 1903–1975

Gemini, 1970

Lead crystal and walnut, 14 x 11¾ x 18 inches
The Carborundum Company Sculpture Award given
to the Tuck School of Business and the Thayer School
of Engineering, Dartmouth College; S. 973.250
© Bowness, Hepworth Estate

311. Charles O. Perry, American, born 1929

D sub-two D, 1973–75

Bronze, height: 120 inches
Purchased through the Fairchild Foundation; S.975.74

312. Paul Bowen, British, born 1951

Navigator, 1980

Mixed media, diameter: 28½ inches, height: 8 inches
Gift of the Estate of Robyn S. Watson; 2005.35

313. Thomas S. Beale, American, born 1978

Harlequin, 2002

Found wood, 132 x 84 x 36 inches
Purchased through anonymous funds; 2005.66

314

316

317

315

318

314. John Kemp Lee, American, born 1956

Ghostwriter, 2005

Copper, lead, bronze, steel, encaustic,
46 x 56 x 5 inches
Purchased through a gift from Donald L. Drakeman,
Class of 1975, on the occasion of his 30th reunion;
2005.60

MIXED MEDIA

315. Al Hansen, American, 1927–1995

Homage to the Girl of Our Dreams, 1966

Paper collage and wood, 7½ x 6½ x ⅔ inches
Gift of Corice and Armand P. Arman; GM.978.203.2

316. Leo Manso, American, 1914–1993

The Last Voyage of Clemens VIII, 1984

Cloth and paper collage, 35¾ x 27⅞ inches
Purchased through the William S. Rubin Fund;
P.985.12

317. Esme Thompson, American, born 1946

Blue Divide, 2005

49 piece installation; acrylic on tin (concave
galvanized maple sugar bucket lids), each panel
12 x 12 x 3 inches
Purchased through the William S. Rubin Fund; 2008.11

NEW MEDIA

318. MANUAL (Ed Hill and Suzanne Bloom), American, 20th century

Archive Fever, 2005

Computer-programmed digital animation on DVD,
dimensions variable
Purchased through the Virginia and Preston T. Kelsey
1958 Fund; 2005.44.1

The Studio Art Department's Artist-in-Residence Program

The Artist-in-Residence Program at Dartmouth College has a most interesting history, one that began more than eighty years ago following projects by Carlos Sanchez and José Clemente Orozco. In 1983, Churchill Lathrop, Professor of Art and Director of the Art Galleries, described the program's origins:

During the entire decade of the 1930's we were experimenting with the artist-in-residence idea: all kinds of artists from ultra-conservative to avant-garde; all types of artistic personality; all sorts of media and craft. The only artists we tried to avoid were the jokers, the fakers, the hanger's on and the bandwagon riders, the ones without personal integrity.

In our experience with serious artists, we found that many would come to Hanover for a short visit but very few would leave their home bases for an extended stay. We had, therefore, a long string of architects, artists and craftsmen, who came for a few days, or at most, a few weeks. Among that group I can recall, Alvar Aalto, Joseph Albers, Thomas Benton, Stuart Davis, Buckminster Fuller, Walter Gropius, George Howe, Reginald Marsh, Lewis Mumford, Elliot O'Hara, Carrels Woodbury and Mahonri Young.

For longer stays, measured in years rather than days, we had Adelbert Ames (artist and scientist), Curt Behrendt (city planner), Lawren Harris (painter), Jens Frederick Larson (architect), Ray Nash (printer and graphic designer), Virgil Poling (craftsman), Sanford Ross (painter), Paul Sample (painter) and Carl Schaeffer (painter). Messrs. Behrendt, Larson, Nash and Sample received academic appointments and had faculty status as teachers.

In the late 1930's, the long-held barriers to academic credit for work in the art studios began to crumble. Paul Sample, Class of 1920, a distinguished American artist whose paintings were in the collection of many major museums, was given a lifetime appointment as artist-in-residence with the rank of full Professor. Art majors who had demonstrated special talent in drawing and painting were permitted to receive course credit as "Honors Work" under the professional guidance of Paul Sample. Exhibitions of such work were convincing proof of the quality and integrity of both the teaching and the learning activity.

The teaching artists in the late 1940's and 1950's were Winslow Eaves, Peter Michael Gish, Edgar H. Hunter, Jr., Charles Morey, Ray Nash, Virgil Poling, Paul Sample and Richard Wagner.

We also continued, of course, the briefer visits of role model visiting artists. In fact, there were a great many of them and among those I personally remember were Ivan Albright, Leonard Baskin, Russell Cowles, Stuart Eldredge, David Fredenthal, Thomas George, Wallace Harrison, Un-Ichi Haratsuka, Hans Hofmann, Will Hollingsworth, Rockwell Kent, Irving Marantz, Shiko Munakata, Alice Neel, Peir Luigi Nervi, Abraham Rattner, Ben Shahn, John Sloan, Byron Thomas, George Tooker and Eugene Witten.

With the completion of the Hopkins Center in 1962, we had, among many other good things, a fine series of art studio facilities and the opportunity for a first class visual studies program. We also had a special studio for an artist-in-residence and the chance to adapt its use to the four-term plan that was being proposed for Dartmouth. We adopted a standard plan of having one carefully chosen artist-in-residence in Hanover and at work in the Hopkins Center studio during each and every Dartmouth term. It turned out, quite happily, that the ten-week Dartmouth term was just right for the artists. The period was long enough for them to have a real change of pace in a new and pleasant environment and it was not too long a time for them to be away from their professional sources and the art market places.

Our students, too, have found the ten-week term an adequate period for getting to know an artist. There is enough time to observe him or her at the daily routine of work and there can be many opportunities to speak with the artist, both formally in a classroom, studio or gallery and informally in a snack bar, a movie theater or almost anywhere on campus. For a few very lucky and very talented students there has been an experience similar to the Renaissance tradition of apprenticeship with a master in the master's atelier.

In summary, Dartmouth was a pioneer in the practice called "Artists in Residence." The art department developed this practice as a worthy supplement to the conventional structured teaching of the visual arts. There have been approximately 200 artists-in-residence at Dartmouth and perhaps they were a sort of ghost or spirit faculty. They might be considered once-and-future Emeriti. They might also be thought of as unofficial Alumni. Since a great many of them have expressed their respect, affection and loyalty for Dartmouth, I believe that, no matter how brief their residency, they did gain some measure of that deep and mysterious love for the College that so distinguishes all other groups of the Dartmouth Family.

Today the program continues to accommodate and reflect contemporary artistic practice by inviting artists in new media, multimedia, and performance while retaining its commitment to the media of sculpture, painting, drawing, architecture, printmaking, and photography. The Studio Art Department's Artist-in-Residence Program acknowledges the importance of artists in our culture and provides students and the community with an appreciation of contemporary art.

Carlos Sanchez, Painter, 1931–33
José Clemente Orozco, Painter, 1932–34
Paul Sample, Painter, 1940–62
Friedl Dzubas, Painter, Fall 1962
Robert Rauschenberg, Painter, Winter 1963
James Rosati, Sculptor, Spring 1963
Frank Stella, Painter, Summer 1963
T. B. Huxley-Jones, Sculptor, Fall 1963
Paul Georges, Painter, Winter 1964
Max Bernd-Cohen, Painter, Spring 1964
David Porter, Painter, Fall 1964
Lyman Kipp, Sculptor, Winter 1965
Yu Fujiwara, Ceramist, Spring 1965
Xavier Esqueda, Painter, Fall 1965
George Rickey, Sculptor, Winter 1966
Joseph Hirsch, Painter, Spring 1966
Donald Judd, Sculptor, Summer 1966
Walter Murch, Painter, Fall 1966

Jacques Hurtbise, Painter, Winter 1967

Sorel Etrog, Sculptor, Spring 1967

Richard Anuszkiewicz, Painter, Fall 1967

Jason Seley, Sculptor, Winter 1968

T. B. Huxley-Jones, Sculptor, Spring 1968

Varujan Boghosian, Sculptor, Summer 1968

Julian Stanczak, Painter, Fall 1968

Larry Zox, Painter, Winter 1969

Will Carter, Typographer/Designer, Spring 1969

Dimitri Hadzi, Sculptor, Summer 1969

Nicholas Krushenick, Painter, Fall 1969

Elbert Weinberg, Sculptor, Winter 1970

Hannes Beckmann, Painter, Spring 1970

Jack Zajac, Sculptor, Summer 1970

Leroy Lamis, Sculptor, Fall 1970

Dennis Kowal, Sculptor, Fall 1970

A. B. Jackson, Painter, Spring 1971

Richard Claude Zieman, Painter, Summer 1971

Robert Sowers, Stained-Glass Designer, Fall 1971

Philip Grausman, Sculptor, Winter 1972

Paul Resika, Sculptor, Spring 1972

Edward Giobbi, Painter, Summer 1972

Walker Evans, Photographer, Fall 1972

Jack Tworkov, Painter, Winter 1973

Paul Suttman, Sculptor, Spring 1973

Charles Perry, Sculptor, Summer 1973

Fritz Scholder, Painter, Fall 1973

Ashley Bryan, Painter, Winter 1974

Laura Ziegler, Sculptor, Summer 1974

Luise and Morton Kaish, Sculptor and Painter, Summer 1974

Jim Dine, Printmaker, Fall 1974

Donald Aquilino, Sculptor/Painter, Winter 1975

Gilbert Franklin, Sculptor, Spring 1975

T. C. Cannon, Painter, Summer 1975

Jack Youngerman, Painter, Fall 1975

Erwin Hauer, Sculptor, Winter 1976

Robert Reed, Painter, Spring 1976

James Wines, Sculptor, Summer 1976

Maria Cosindas, Photographer, Fall 1976

William Majors, Printmaker, Winter 1977

John Willenbecher, Painter, Spring 1977

Gyorgy Kepes, Painter/Photographer, Fall 1977

Walter Feldman, Painter, Winter 1978

R. B. Kitaj, Painter, Spring 1978

Costantino Novola, Sculptor, Fall 1978

Ralph Steiner, Photographer, Winter 1979

Allan C. Houser, Sculptor, Spring 1979

Richard Stankiewicz, Sculptor, Summer 1979

Thomas George, Painter, Fall 1979

Charles Simonds, Sculptor, Spring 1980

Tom Blackwell, Painter, Fall 1980

Katherine Porter, Painter, Winter 1981

Fumio Yoshimura, Sculptor, Spring 1981

John Alcorn, Graphic Designer, Fall 1981

Don Nice, Painter, Winter 1982

Leonardo Lasansky, Printmaker, Spring 1982

John Udvardy, Sculptor, Fall 1982

Peter Milton, Printmaker, Winter 1963

Philip Morsberger, Painter, Spring 1983

Irving Petlin, Painter, Fall 1983

Wolf Kahn, Pastel Drawer/Painter, Winter 1984

Antoni Frasconi, Woodcut Printmaker, Spring 1984

Leo Manso, Painter, Winter 1985

Frederick Brosen, Painter, Winter 1985

Richard Britell, Fresco Painter, Summer 1985

Joel Sternfeld, Photographer, Fall 1985

Richard Lytle, Painter, Spring 1986

Bernard Chaet, Painter, Fall 1986

Robert Vickery, Painter, Spring 1987

Gabor Peterdi, Painter/Printmaker, Fall 1987

Olivia Parker, Photographer, Winter 1988

John Lueders-Booth, Photographer, Spring 1989

Bob Haozous, Sculptor, Summer 1989

Dean Chamberlain, Photographer, Fall 1989

Sebastian, Sculptor, Spring 1990

Lois Dodd, Painter, Fall 1990

Lynn Curtis, Painter, Winter 1991

Jane Wilson, Painter, Spring 1991

James Lechay, Painter, Fall 1991

Hugh Townly, Sculptor, Fall 1991

Peter Feldstein, Photographer, Winter 1992

Rosemarie Beck, Painter, Spring 1992

Byron Burford, Painter, Fall 1992

David Bumbeck, Sculptor/Printmaker, Winter 1993

James McGarrell, Painter, Spring 1993

Don Weygandt/Ben Summerford, Painters, Fall 1933

Pat Adams, Painter, Winter 1994

Steven Trefonides, Photographer, Fall 1994

Charles Burwell, Painter, Winter 1995

Louis Finkelstein, Painter, Spring 1995

Jake Berthot, Painter, Fall 1995

Michael Singer, Sculptor, Spring 1996

Charles Cajori, Painter, Fall 1996

Pablo Delano, Photographer, Winter 1997

Reeva Potoff, Sculptor, Spring 1997

Ed Smith, Sculptor, Fall 1997

James Bohary, Painter, Winter 1998

Wlodek Ksiazek, Painter, Spring 1998

Susanna Coffey, Painter, Fall 1998

Jin Soo Kim, Sculptor, Winter 1999

Robert Birmelin, Painter, Spring 1999

Andrew Forge, Painter, Fall 1999

Ruth Miller, Painter, Fall 1999

Don Hanlon, Architect, Winter 2000

Judy Pfaff, Installation, Spring 2000

Carol Hepper, Sculptor, Summer 2000

Gillian Pederson-Krag, Painter, Winter 2001

Stanley Lewis, Painter, Spring 2001

Thomas Butter, Sculptor, Fall 2001

Charles Spurrier, Painter, Winter 2002

Barbara Grossman, Painter, Spring 2002

Amy Sillman, Painter, Fall 2002

William Chistenberry, Sculptor/Photographer, Winter 2003

Alison Saar, Sculptor, Spring 2003

Terry Adkins, Sculptor, Summer 2003

Peter Garfield, Photographer, Fall 2003

James Cutler, Architect, Spring 2004

Toon Verhoef, Painter, Fall 2004

Paul Bowen, Sculptor, Winter 2005

Frances Barth, Painter, Summer 2005

Michael Spafford, Painter/Printmaker, Fall 2005

Jane Hammond, Painter/Photographer/Multimedia, Spring 2006

Andrew Moore, Photographer, Fall 2006

Sana Musasama, Sculptor, Winter 2007

Louise Fishman, Painter, Spring 2007

Christopher Cozier, Multimedia, Fall 2007

Vincent Desiderio, Painter, Winter 2008

Elizabeth King, Multimedia, Spring 2008

Magdalene Odundo, Ceramics, Fall 2008

Subhankar Banerjee, Photographer, Winter 2009

Marjetica Potrc, Architect, Spring 2009

Selected Bibliography

Albers, Josef. *The Interaction of Color*. New Haven: Yale University Press, 1963, rev. and exp. 1975.

Alexandrian, Sarane. *Surrealist Art*. London: Thames and Hudson, 1969.

Alloway, Lawrence, and Mary Davis MacNaughton. *Adolph Gottlieb: A Retrospective*. New York: The Arts Publisher, Inc., in association with the Adolph and Esther Gottlieb Foundation, Inc., 1981.

Amiotte, Arthur. "Artist's Statement." *Arthur Amiotte Retrospective Exhibition: Continuity and Diversity*. Pine Ridge, S.D.: The Heritage Center, Inc., Red Cloud Indian School, 2002.

Anatsui, El. "Artist's Statement." In *In the Making: Materials and Process*, ed. Sophie Perryer. Cape Town: Michael Stevenson, 2005.

Anderson-Spivy, Alexandra. "Local Knowledge: Rackstraw Downes Paints Things as They Are." *Arts Magazine* (March 1992): 38–41.

Anfam, David. *Mark Rothko: The Works on Canvas; Catalogue Raisonné*. New Haven: Yale University Press, 1998.

Arnason, H. H. *Robert Motherwell*. New York: Harry N. Abrams, Inc., 1982.

Arnheim, Rudolf. *Art and Visual Perception: A Psychology of the Creative Eye*, 1954, introduction to later edition. Berkeley, Calif.: University of California Press, 1974.

Ashton, Dore. "Art: Soulages Paintings." *New York Times,* November 15, 1957, Arts Section.

———. "Jack Tworkov and the Passion of Meditation." In *Jack Tworkov: Paintings 1950–1978*, ed. Bridget Brown and Christopher Carrell. Glasgow, Scotland: Third Eye Centre, 1979.

Baas, Jacquelynn. *Treasures of the Hood Museum of Art, Dartmouth College*. Hanover, N.H.: Hood Museum of Art, Dartmouth College, 1985.

———. "'The Epic of American Civilization': The Mural at Dartmouth College." In *José Clemente Orozco in the United States, 1927–1934*, eds. Renato González Mello and Diane Miliotes, 142–85. Hanover, N.H.: Hood Museum of Art, Dartmouth College, in association with W. W. Norton and Company, 2002.

Baigell, Matthew. "George Warren Rickey." In *Dictionary of American Art,* 301. New York: Harper & Row, Icon Editions, 1979.

Bailly, Jean-Christophe, ed. *Dorothea Tanning*. New York: George Braziller, 1995.

Baker, Susan Jane. "George Tooker and the Modern Tradition." Ph.D. diss., University of Kansas, 1994.

Balken, Debra. "Interview with Gregory Amenoff." New York: Salander O'Reilly Galleries, LLC, 2000.

Bauer, Ines, et al. *Die Neuen Tendenzen: Eine europaische Kunstlerbewegung 1961–1973*. Ingolstadt, Germany: Museum fur Konkret Kunst, Edition Braus GmbH, 2006.

Bax, Marty. *Bauhaus Lecture Notes 1930–1933*. Amsterdam, The Netherlands: Architectura and Natura Press, 1990.

Beal, Graham W. J., and Martin Friedman. *George Segal, Sculptures*. Minneapolis, Minn.: Walker Art Center, 1978.

Beckmann, Hannes. *1+1=3: An Exhibition of Retinal and Perceptual Art*. Austin: University Art Museum of the University of Texas, 1965.

Behrens, Roy R. "Rudolph Arnheim: The Little Owl on the Shoulder of Athene." *Leonardo* 31, no. 3 (1998): 231–33.

Benezra, Neal, and Olga M. Viso. *Juan Muñoz*. Chicago: University of Chicago Press, 2001.

Berman, Greta, and Jeffrey Wechsler. *Realism and Realities: The Other Side of American Painting, 1940–1960*. Rutgers, N.J.: Rutgers University, 1981.

Berry-Hill Galleries, Inc. *Esteban Vicente Then & Now: Work from the 1950s and 1990s*. New York: Berry Hill Galleries, Inc., 1998.

Betty Cunningham Gallery. *Jake Berthot: Recent Paintings and Drawings*. Betty Cunningham Gallery, 2006.

Bianco, Juliette, David Cateforis, Eleanor Heartney, Allen Hockley, and Brian P. Kennedy. *Wenda Gu at Dartmouth: The Art of Installation*. Hanover, N.H.: Hood Museum of Art, Dartmouth College, in association with the University Press of New England, 2008.

Blumenthal, Arthur R. "Art at the College: 50 Years of Art at Dartmouth." *The Dartmouth,* November 3, 1978.

Bosquet, Alain. *Dorothea Tanning, peintures récentes*. Paris: Galerie Mouradian et Valloton, 1962.

Bowen, W. Wedgwood. *A Pioneer in the Wilderness*. Hanover, N.H.: The Dartmouth College Museum, 1958.

Brackett Jr., Truman H. *Ray Saunders*. Hanover, N.H.: Hopkins Center Art Galleries, Dartmouth College, 1969.

Braverman, A. Marvin "Letter from A. Marvin Braverman to Richard Teitz." April 5, 1982.

Brettell, Richard R., and Phylis Floyd. *Ivan Albright: The Late Self-Portraits*. Hanover, N.H.: Hood Museum of Art, Dartmouth College, 1986.

Brown, Robert. "Interview with Dimitri Hadzi." Smithsonian Archives of American Art, 1981.

Burke, Emily. Interview with Jan van der Marck, May 8, 2008.

———. Interview with Derrick Cartwright, May 12, 2008.

———. Interview with James Cuno, May 16, 2008.

———. Interview with Jacquelynn Baas, May 19, 2008.

———. Interview with Timothy Rub, July 16, 2008.

———. Interview with Peter Smith, July 22, 2008.

———. Interview with George Shackelford, September 23, 2008.

Calas, Nicolas. *Matta: A Totemic World*. New York: Andrew Crispo Gallery, 1975.

Cathcart, Linda L. *Milton Resnick Paintings 1945–1985*. Houston: Contemporary Arts Museum, 1985.

Centro Galego de Arte Contemporánea. *Compostela: Lorna Simpson*. Santiago de Compostela, Spain: Xunta de Galicia, 2004.

Chadwick, Whitney. *Women Artists and the Surrealist Movement*. London: Thames and Hudson, 1985.

Chuang, Joshua, Brian P. Kennedy, Bruce Herman, Jeffrey Lewis, and Gregory Wolfe. *Immanence and Revelation: The Art of Ben Frank Moss.* Hanover, N.H.: Hood Museum of Art, Dartmouth College, 2008.

Coggswell, John F. "Bitter War over Dartmouth's Murals." *Boston Sunday Post,* April 22, 1934.

Conley, Katharine. "Les Révolutions de Dorothea Tanning." *Pleine Marge* 36 (December 2002): 146–75.

Cooke, Lynne. *Juan Muñoz.* New York: Dia Center for the Arts, 1999.

Cooper, Harry. "Starting with Oedipus: Originality and Influence in Gottlieb's Pictographs." In *Adolph Gottlieb: Pictographs, 1941–1951.* New York: PaceWildenstein, 2004.

Corbett, William. *Sara Sosnowy Drawings.* Chicago: Zolla/Lieberman Gallery, 1999.

Cotter, Holland. "An Innovator Battling Demons of Society and Her Mind." *New York Times,* July 10, 1998, Arts Section.

Cozzolino, Robert. "Every Picture Should Be a Prayer: The Art of Ivan Albright." Ph.D. diss., University of Wisconsin-Madison, 2006.

Cozzolino, Robert, Marshall N. Price, and M. Melissa Wolfe. *George Tooker.* London: Merrell, 2008.

Croydon, Michael. *Ivan Albright.* New York: Abbeville Press, 1978.

Cummings, Paul. "Oral History Interview with Al Held by Paul Cummings." November 19; December 12, 19, 30, 1975; January 8, 1976.

Dartmouth Arts Council. *The Protean Century, 1870–1970.* New York: M. Knoedler & Co., Inc., and Dartmouth Arts Council, 1970.

Davis, Gene. "Gene Davis in an Interview with Donald Wall." In *Gene Davis,* ed. Donald Wall. New York: Praeger Publishers, 1975.

———. Interview by Buck Pennington. April 23, 1981. Washington, D.C.

De Palma, Brian. *The Responsive Eye.* Zodiac Associates Productions, 1965, 16mm film.

Donadio, Emmie. *Miracle in the Scrap Heap: The Sculpture of Richard Stankiewicz.* Andover, Mass.: The Addison Gallery of American Art, 2003.

Dubuffet, Jean. *Jean Dubuffet Prospectus et tous écrits suivants.* Vol. 2. Paris: Éditions Gallimand, 1967.

Duchamp, Marcel. "The Creative Act," talk given to the American Federation of Arts in 1957. First published in Robert Lebel, *Marcel Duchamp.* New York: Paragraphic Books, 1959.

Durozoi, Gérard. *History of the Surrealist Movement.* Trans. Alison Anderson. Chicago: University of Chicago Press, 2002.

Fane, Lawrence. "M.T./L.F.: A Sculptor's Dialogue with Mariano Taccola, Fifteenth-Century Italian Artist-Engineer." Lake Placid, N.Y.: Pont La Vue Press, 2006.

Farr, D., and E. Chadwick. *Lynn Chadwick, Sculptor, with a Complete Illustrated Catalogue 1947–88.* Oxford: Clarendon Press, 1990; reprinted Stroud: Lypiatt Studio, 1997 and 2001.

Feinstein, R. *Luis Gispert: Cheerleader Series, 2001–2002.* Miami: Kendall Campus Art Gallery, Miami-Dade University, 2003.

Finch, Elizabeth. *Sara Sosnowy Paintings 2000–2006.* New York: Lesley Heller Gallery, 2006.

Forge, Andrew. "The Knight and the Barrier." In *Jack Tworkov: Fifteen Years of Painting,* 10–16. New York: Solomon R. Guggenheim Museum, 1982.

Frank, Elizabeth. *Esteban Vicente.* Chronology and appendices by Ellen Russotto. New York: Hudson Hills Press, 1995.

Freund, Hugh. Letter from Hugh Freund to Richard Teitz. September 29, 1981.

Friedman, Ken. *The Fluxus Reader.* West Sussex: Academy Editions, 1998.

Froment, J. L., and Juan Muñoz. *Juan Muñoz: Sculptures de 1985–1987.* Bourdeaux: Musée d'art contemporain de Bourdeaux, 1987.

Galeria Leandro Navarro. *Félix de la Concha: Nueva Inglaterra.* Madrid: Galeria Leandro Navarro, 2008.

Galerie Buchman Basel. *David Ortins.* Basel, Switzerland: Galerie Buchman Basel, 1993.

Garcia, Miki, and Shamim M. Momin. *Stereomongrel: Luis Gispert and Jeffrey Reed.* Santa Barbara, Calif.: Santa Barbara Contemporary Arts Forum, 2005.

Garlake, Margaret. *The Sculpture of Reg Butler.* Hertfordshire, England: The Henry Moore Foundation, in association with Lund Humphries, 2006.

Garver, Thomas H. *George Tooker.* San Francisco: Pomegranate, rev. ed. 2002.

Goizueta, Elizabeth. *Matta: Making the Invisible Visible.* Boston: McMullen Museum of Art, 2004.

Gordon, John. *Geometric Abstraction in America.* New York: Whitney Museum of American Art, 1962.

Gottlieb, Adolph. "The Ides of Art: The Attitudes of Ten Artists on Their Art and Contemporaneousness." *The Tiger's Eye* 1, no. 2 (December 1947): 43.

Grachos, Louis, Barry Schwabsky, and Lynne Tillman. *Karin Davie.* New York: Rizzoli International Publications, 2006.

Greene, Alison de Lima. *Kenneth Noland: The Nature of Color.* Houston: The Museum of Fine Arts, Houston, 2004.

Harvey, Steven. "Architecture and Painting: The Provincetown Paintings of Paul Resika." In *Light, Air and Color: Provincetown Paintings.* Provincetown, Mass.: Provincetown Art Association and Museum, 1997.

Hauser, Katherine. "George Tooker, Surveillance, and Cold War Sexual Politics." *GLQ* 11 (2005): 391–425.

Haynes, Nancy. *Parameters: Nancy Haynes.* Norfolk, Va.: Chrysler Museum, 1992.

Heffernan, Ildiko. *George Tooker: Working Drawings.* Burlington, Vt.: Robert Hull Fleming Museum, 1987.

Held, Al. "Oral History Interviews." November 19, 1975–January 8, 1976. Archives of American Art, Smithsonian Institution, Washington, D.C.

Heon, Laura Steward. *Yankee Remix: Artists Take on New England.* North Adams, Mass.: MASS MoCA, 2003.

Heynen, J., and V. Liebermann, eds. *Juan Muñoz: Rooms of My Mind.* Düsseldorf: K21 Kunstsammlung Nordheim-Westffalen, 2006.

Hunter, Sam. "Josef Albers: Prophet and Presiding Genius of American Op Art." *Vogue* (October 15, 1970): 71–127.

Hyatt, Gordon. *Eye on New York: The Responsive Eye.* Columbia Broadcasting System, New York, 1965.

Institute for the Arts, Rice University. *Yves Klein: A Retrospective.* Houston: Institute for the Arts, Rice University, 1982.

James Hyman Fine Art. *Henry Moore and the Geometry of Fear: Robert Adams, Kenneth Armitage, Reg Butler, Lynn Chadwick, Geoffrey Clarke, Bernard Meadows, Henry Moore, Eduardo Paolozzi, and William Turnbull.* London: James Hyman Fine Art, 2002.

Joray, Marcel, and Victor Vasarely. *Vasarely: Plastic Arts of the 20th Century.* Translated by Haakon Chevalier. Switzerland: Éditions du Griffon Neuchâtel, 1965.

Joselit, David. "Molds and Swarms." In *Part Object Part Sculpture*, ed. Helen Molesworth, 156–177. Columbus: Wexner Center for the Arts, The Ohio State University, 2005.

Jouffroy, Alain. "Dorothea Tanning: le chavirement dans la joie." *XXe Siècle* 43 (1974): 60–68.

Judd, Donald. "In the Galleries: Julian Stanczak at Martha Jackson Gallery." *Arts Magazine* (October 1964): 69.

Katchadourian, Nina, "Artist Statement on Accent Elimination." 2005. Available at http://www.ninakatchadourian.com/languagetranslation/accent.php.

Kennedy, Brian P. "Letter from the Director." *Hood Museum of Art Quarterly* (Autumn 2005): 1.

———. "Sean Scully: The Reality of Abstraction." *Hood Museum of Art Quarterly* (Summer 2006).

———. *Sean Scully: The Art of the Stripe.* Hanover, N.H.: Hood Museum of Art, Dartmouth College, 2008.

Kent, Sarah. "Sol LeWitt." *Modern Painters* (July–August 2007): 66–71.

Kim, Christine Y., and Sanford Biggers. *Black Belt.* New York: The Studio Museum in Harlem, 2004.

King, Elizabeth. *The Sizes of Things in the Mind's Eye.* Hanover, N.H.: Dartmouth College Studio Art Exhibition Program, 2008.

Kramer, Hilton. "Leger's Modernism." *New Criterion* 16, no. 7 (March 1998): 5.

Kramer, Jane. "Self Inventions." *New Yorker* (May 3, 2004): 40–60.

Kudielka, Robert, ed. *The Eye's Mind: Bridget Riley, Collected Writings, 1965–1999.* London: Thames and Hudson, Ltd., 1999.

Kuh, Katharine. *The Artist's Voice: Talks with Seventeen Artists.* New York: Harper and Row, 1960.

Kuspit, Donald. "The Amorphousness of Being Other: Dorothea Tanning's Prints." In *Hail Delirium*, ed. Roberta Waddell and Louisa Wood Ruby, 8–13. New York: New York Public Library, 1992.

Kuspit, Donald, with introduction by William Corbett. *The Sky Below: Gregory Amenoff.* West Stockbridge, Mass.: Hard Press, Inc., 1997.

Lanchner, Carolyn. *Fernand Leger.* New York: Museum of Modern Art, 1998.

Lathrop, Churchill P. "To Promote Interest and Education in Art." *Dartmouth Alumni Magazine,* January 1951.

———. "The Dartmouth Collection," 1960.

———. "Artists in Residence: A History," June 1983.

Laursen, Steingrim, Juan Muñoz, and Asa Nacking. *Juan Muñoz: The Nature of Visual Illusion.* Copenhagen: Louisiana Museum for Moderne Kunst, 2000.

Lawrence, Jacob. "Oral History Interview with Carroll Greene." Archives of American Art, Smithsonian Institution, Washington, D.C.

Lewallen, Constance. "Cage and the Structure of Chance." In *Writings through John Cage's Music, Poetry, and Art*, ed. David W. Bernstein and Christopher Hatch. Chicago: University of Chicago Press, 2001.

Lingwood, James, Susan May, and Juan Muñoz. *Juan Muñoz: Double Bind at Tate Modern.* London: Tate Publishing, 2001.

MacAdam, Barbara J. *Marks of Distinction: Two Hundred Years of American Drawings and Watercolors from the Hood Museum of Art.* Hanover, N.H.: Hood Museum of Art, Dartmouth College, in association with Hudson Hills Press LLC, 2005.

———. *American Art at Dartmouth: Highlights from the Hood Museum of Art.* Hanover N.H.: Hood Museum of Art, Dartmouth College, in association with the University Press of New England, 2007.

MacNaughton, Mary Davis. "Adolph Gottlieb: His Life and Art." In *Adolph Gottlieb: A Retrospective*, ed. Lawrence Alloway and Mary Davis MacNaughton. New York: The Arts Publisher, Inc., in association with the Adolph and Esther Gottlieb Foundation, Inc., 1981.

Marcus, Evelyn. *Fumio Yoshimura: Harvest of a Quiet Eye.* Hanover, N.H.: Hood Museum of Art, Dartmouth College, 1993.

Martin, Lydia. "Artist Paints Dots as a Link to Cosmos, 'a Way to Infinity.'" *Miami Herald*, December 6, 2002, Arts Section.

Masters, Christopher. "Obituary: Enrico Baj." *The Guardian,* July 9, 2003.

Matta Echaurren, Roberto Sebastián. *Matta.* Cento: SIACA Arti Grafiche, 1974.

———. *Matta Coïgitum.* London: Hayward Gallery, 1977.

———. *The First Decade.* Waltham, Mass.: Rose Art Museum, 1982.

———. *The Logic of Hallucination.* London: Arts Council of Great Britain, 1984.

———. *Matta.* Paris: Centre Georges Pompidou, 1985.

MB Modern. *Bernard Chaet: Recent Paintings.* New York: MB Modern 2000.

McShine, Kynaston, et al. "Conversation About Work with Richard Serra," In *Richard Serra Sculpture: Forty Years*, ed. Kynaston McShine and Lynne Cooke, 15–40. New York: Museum of Modern Art, 2007.

Muñoz, Juan. *Segment.* Chicago: The Renaissance Society at the University of Chicago, 1990.

Mutu, Wangechi. "Artist's Statement." *Creatures by Wangechi Mutu.* Jamaica, N.Y.: Jamaica Center for Arts and Learning, 2003.

Nérét, Gilles. *F. Leger.* New York: BDD Illustrated Books, 1993.

Neri, Louise, Dave Hickey, John Berger, James Lingwood, and Marina Warner. *Silence Please!: Stories after the Works of Juan Muñoz.* Dublin: The Irish Museum of Modern Art, 1994.

Oakland Museum of Art. *Sculpture by Bruce Beasley: A 45-Year Retrospective.* Oakland Museum of Art, 2005.

Paik, Nam June. "Afterlude to the Exposition of Experimental Television." *cc fiVe ThReE* (June 1964).

Paul, April J. "Byron Browne in the Thirties: The Battle for Abstract Art." *Archives of American Art Journal* 19, no. 4 (1979): 9–24.

Pepper, Beverly. "Space, Time, and Nature in Monumental Sculpture." Edited transcript of speech at Dartmouth College, September 22, 1977. *Art Journal* 37, no. 3 (Spring 1978): 251.

Phillpot, Clive, and Jon Hendricks. *Fluxus: Selections from the Gilbert and Lila Silverman Collection.* New York: Museum of Modern Art, 1988.

Poirier, Maurice. "The Ghost in the Machine." *Art News* 85 (October 1986): 78–85.

Polcari, Stephen. "Adolph Gottlieb's Allegorical Epic of World War II." *Art Journal* 47, no. 3 (Autumn 1988): 202–207.

Prokopoff, Stephen. *Allan D'Arcangelo: Paintings 1963–1970.* Philadelphia: Institute of Contemporary Art, University of Pennsylvania, 1971.

Rand, Harry, Robert J. Bertholf, and Rudolf Arnheim. *Julian Stanczak: Decades of Light.* Buffalo: State University of New York Press, 1990.

Read, Herbert. "New Aspects of British Sculpture." In *Lynn Chadwick: Sculptor,* ed. Dennis Farr and Eva Chadwick. Oxford: Clarendon Press, 1990.

Reed, Sharon. Interview with Peter Irniq. March 2007.

Robb, Marilyn. "Ivan Le Lorraine Albright Paints a Picture." *Art News* 49, no. 4 (Summer 1950): 44–47, 58, and 59.

Roc, Dana. Interview with Terry Adkins. 2006. Available at http://www.danaroc.com/inspiring_020606terryadkins.html.

Rodman, Selden. *Conversations with Artists.* New York: The Devin-Adair Co., 1957.

Rose, Barbara. "Beyond Vertigo: Optical Art at the Modern." *Artforum International* (April 1965): 30–33.

———. "A Return to the Heroic Dimension in Sculpture: Mark di Suvero." *Vogue* (February 1973): 160–162, 202–203.

Rossen, Susan F., ed. *Ivan Albright.* Chicago: The Art Institute of Chicago, 1997.

Rubin, William. *Matta.* New York: Museum of Modern Art, 1957.

———. Letter from William Rubin to Jacquelynn Baas. March 7, 1985.

Ruscha, Edward. "A Conversation Between Walter Hopps and Ed Ruscha, September 1992." In *Romance with Liquids: Paintings 1966–1969.* New York: Gagosian Gallery and Rizzoli, 1993.

Russell, John. "The Several Selves of Dorothea Tanning." In *Dorothea Tanning.* Malmö, Sweden: Malmö Konsthall, 1993. 10–29.

Sanchez, Joseph M. Interview with Bob Haozous. 2008.

Sanchez, Joseph M., and John R. Grimes. *Relations: Indigenous Dialogue.* Santa Fe, N.M.: Institute of American Indian Arts Museum Press, 2006.

Sartre, Jean Paul. "The Mobiles of Calder." In *Alexander Calder: Mobiles, Stabiles, Constellations.* Paris: Galerie Louis Carré, 1946. Reprinted in *Calder.* New York: Buchholz Gallery/Curt Valentin, 1947.

Sawin, Martica. *Surrealism in Exile and the Beginning of the New York School.* Cambridge, Mass.: MIT Press, 1995.

Schmalenbach, Werner. *Fernand Leger.* New York: Harry N. Abrams, 1985.

Scholder, Fritz. "On the Work of a Contemporary American Indian Painter." *Leonard* (Spring 1973): 109–112.

Schuyler, James, and Simon Pellet. *Selected Art Writings: James Schuyler.* Boston: Black Sparrow Books, 1998.

Seckler, Doris Gees. "The Audience Is His Medium." *Art in America* 51, no. 2 (April 1963): 62–67.

Seitz, William C. *The Responsive Eye.* New York: The Museum of Modern Art, 1965.

Seley, Jason. *Jason Seley: Artist-in-Residence, Jaffe-Friede Gallery, Hopkins Center, Dartmouth College, February 8–March 4, 1968.* Lunenburg, Vt.: Stinehour Press, 1968.

Selz, Peter H., Joseph Masheck, Debra Bricker Balken. *Dimitri Hadzi.* Manchester, Vt.: Hudson Hills Press, 1996.

Selz, Peter H. *Mark Rothko.* New York: Museum of Modern Art, 1961.

Serra, Richard. "*Tilted Arc* Destroyed." *Art in America* 77 (May 1989): 34–47.

———. "If Not Now, When?" Williams College Commencement Address, June 1, 2008.

Shottenkirk, Dena. "Allan McCollum." *ARTFORUM* (Summer 1990): 164–165.

Silver, Kenneth E. "Logic and Liberalism," *Art Journal* 42, no. 2 (Summer 1982): 151–154.

Smith, Elizabeth, and Colette Dartnall. *Matta in America.* Chicago and Los Angeles: Museums of Contemporary Art, 2001.

Smith, Roberta. "George Segal, Pop Sculptor, Dies at 75: Molded Plaster People of a Ghostly Angst." *New York Times,* June 10, 2000, Arts Section.

Solomon R. Guggenheim Museum. *Mark Rothko, 1903–1970: A Retrospective.* New York: Solomon R. Guggenheim Museum, 1978.

Sosnowy, Sara. "Artist's Statement." (May 3, 2006). Available at http://lesleyheller.com/artists/sara_sosnowy/statement.html.

Spring, Justin. "An Interview with George Tooker." *American Art* 16 (Summer 2002): 61–81.

Stella, Frank. Convocation Speech. Dartmouth College, Hanover, N.H., September 23, 1985.

Stitch, Sidra. *Yves Klein.* London: Hayward Gallery London and Cantz Verlag, 1994.

Streitfeld, L. P. "Interior Exterior Vision: A Conversation with Howard Ben Tré." *Sculpture* 21, no. 9 (2002): 44–49.

Swarzman, Herbert G. Letter from Herbert G. Swarzman to Churchill Lathrop. October 10, 1966.

Sweeney, James John. *Soulages: Paintings since 1963.* New York: M. Knoedler and Co., Inc., 1968.

Sweet, Frederick A. *Ivan Albright: A Retrospective.* Foreword by Jean Dubuffet and statement by Ivan Albright. Chicago: The Art Institute of Chicago, 1964.

Sylvester, David, ed. *Alex Katz: Twenty-Five Years of Painting from the Saatchi Collection.* London: The Saatchi Gallery 1997.

Tanning, Dorothea. *Abyss.* New York: Standard Editions, 1977.

———. *Birthday.* San Francisco: Lapis Press, 1986.

———. *Messages.* New York: Nahan Contemporary, 1990.

———. *Another Language of Flowers.* New York: George Braziller, 1998.

———. *Between Lives.* New York: W. W. Norton, 2001.

———. *Chasm, A Weekend.* New York: The Overlook Press, 2004.

Tate, Greg. "Regal Depravities and Other Cavities." *Code Z: Black Visual Culture Now.* 2007. Available at http://www.codezonline.com/featurearticle/2007/04/regal_depravities_and_other_ca.html.

Tate Gallery. "Maquette for Monument for the Unknown Political Prisoner." In *The Tate Gallery 1984–86: Illustrated Catalogue of Acquisitions, Including Supplement to Catalogue of Acquisitions 1982–84.* London: Tate Gallery, 1988. 165–167.

Tejada, Roberto, Derrick R. Cartwright, and Donald E. Pease. *Luis Gispert/Loud Image.* Hanover, N.H.: Hood Museum of Art, 2004.

Temkin, Ann. *Alice Neel.* Philadelphia: Philadelphia Museum of Art, 2000.

Thompson, Dorothy Abbott. *The Spirits of Hyman Bloom: The Sources of his Imagery.* New York: Chameleon Books, Inc., in Association with the Fuller Museum of Art, 1996.

Thurber, T. Barton. *European Art at Dartmouth: Highlights from the Hood Museum of Art.* Hanover, N.H.: Hood Museum of Art, Dartmouth College, in association with the University Press of New England, 2008.

Tillim, Sidney. "Optical Art: Pending or Ending?" *Arts Magazine* (January 1965): 16–23.

Time. "Simple Form, Simple Color." July 19, 1963, 56.

Todoli, Vicente, and Juan Muñoz. *Juan Muñoz: Conversaciones.* Valencia: IVAM Centre del Carme, 1992.

Tomcic, G. *Booty Bass: Namoi Fisher/Luis Gispert.* Miami: Centre Gallery, Miami-Dade Community College, 1999.

University of Richmond Museums. *A Good Day for Painting: The Art of Bernard Chaet.* Richmond, Va.: University of Richmond Museums, 2005.

Valley News, Lebanon, N.H. "Dartmouth Has Part in IGAS Prints Program." September 17, 1958.

Van Dall, Dirk. *Storm King.* Dreamtime Productions, 1987, 22-minute videotape.

Van der Marck, Jan. "Arman: The Parisian Avant-Garde in New York." *Art in America* 61 (November/December 1973): 88–95.

———. "Ivan Albright: More Than Meets the Eye." *Art in America* 65, no. 6 (November/December 1977): 93–99.

———. "Sculpture around Campus: Dartmouth College." *Art Journal* 37, no. 3 (Spring 1978): 248–250.

———. *Acquisitions 1979.* Hanover, N.H.: Hood Museum of Art, 1979.

———. *George Segal.* New York: Harry N. Abrams, rev. ed. 1979.

———. "Christo: The Making of an Artist." In *CHRISTO.* La Jolla, Calif.: La Jolla Museum of Contemporary Art, 1981.

———. *Arman.* New York: Abbeville, 1984.

Von Clausewitz, Carl, and J. J. Graham. *On War.* New York: Taylor & Francis, 2004.

Wagstaff, Sheena, ed. *Juan Muñoz: A Retrospective.* London: The Tate Modern, 2008.

Waldberg, Patric. *Surrealism.* London: Thames and Hudson, 1965.

Waldman, Diane, ed. *Ellsworth Kelly: A Retrospective.* New York: The Solomon R. Guggenheim Foundation, 1996.

Weinhardt Jr., Carl J. *Robert Indiana.* New York: Harry N. Abrams, Inc., 1990.

Weiss, Jeffrey. "Dis-Orientation: Rothko's Inverted Canvases." In *Seeing Rothko,* ed. Glenn Phillips and Thomas Crow. Los Angeles, Calif.: J. Paul Getty Trust, 2005.

Whitechapel Art Gallery. *Mark Rothko: A Retrospective Exhibition, Paintings 1945–1960.* London: Whitechapel Art Gallery, 1961.

Wilkin, Karen. *Adolph Gottlieb: Pictographs.* Edmonton, Alberta: The Edmonton Art Gallery, 1977.

———. *Kenneth Noland.* New York: Rizzoli International Publications, Inc., 1990.

———. *Andrew Forge: Paintings.* Hanover, N.H.: Dartmouth College Studio Art Exhibition Program, 1999.

Williams, John A. Introduction to *The Art of Romare Bearden: The Prevalence of Ritual,* ed. M. Bunch Washington. New York: Harry N. Abrams, 1972.

Yee, L., and F. Sirmans. *One Planet under a Groove: Hip Hop and Contemporary Art.* Bronx, N.Y.: Bronx Museum of the Arts, 2001.

Index of Artists and Titles